WHEN MA ABRAMOVIĆ DIES

A Biography

JAMES WESTCOTT

WHEN MARINA ABRAMOVIĆ DIES

A Biography

JAMES WESTCOTT

THE MIT PRESS
CAMBRIDGE, MASSACHUSETTS
LONDON, ENGLAND

First MIT Press paperback edition, 2014
© 2010 Massachusetts Institute of Technology

MIT Press books may be purchased at special quantity
discounts for business or sales promotional use.
For information, please email special_sales@mitpress.
mit.edu

This book was set in Helvetica Neue LT Pro and Minion
Pro by Graphic Composition. Printed and bound in Spain.

Library of Congress Cataloging-in-Publication Data
Westcott, James, 1979–
When Marina Abramović dies : a biography /James
Westcott.
p. cm.
Includes bibliographical references and index.
ISBN 978–0–262–23262–3 (hardcover : alk. paper)—
978-0-262-52681-4 (paperback)
1. Abramović, Marina. 2. Performance artists—Serbia—
Biography. I. Title.
N7253.A25W47 2010
709.04′0755—dc22
[B]
 2009019821

10 9 8 7 6 5 4

To my mother and father and my brother

Contents

ACKNOWLEDGMENTS I ix
NOTE ON THE TEXT I xi
PREFACE I xiii
INTRODUCTION I 1

PART ONE I 7

YUGOSLAVIA 1946–1975

1 Birth Pains I 9

2 Partisan Stories I 17

3 Menstruation, Masturbation, Migraines I 25

4 Self-Management I 33

5 Life in Art I 39

6 New Art for a New Society I 49

7 Sound Made Flesh I 59

8 Rites of Passage I 65

9 Mark-Making I 77

PART TWO I 83

ULAY 1975–1988

10 November 30 + November 30 I 85

11 Artist Must Be Beautiful I 95

12 Mobile Energy I 111

13 Motor Function I 133

14 Who Creates Limits I 145

15 Aboriginals I 155

16 Snake Couple Go On I 165

17 Theater and Tragedy I 175

18 Abstinence and Affairs I 181

19 Revelations I 191

20 The Lovers I 199

PART THREE | 207

SOLO IN PUBLIC 1988–

21 Spiritual / Material | 209

22 Biography | 219

23 Balkanization | 233

24 Temporary Forever | 239

25 Normality | 247

26 Wolf Rat and Golden Lion | 255

27 Settlement | 261

28 Biographer | 273

29 Performance Art as a Performing Art | 287

30 Knowledge of Death | 299

EPILOGUE: BEFORE MARINA ABRAMOVIĆ DIES | 309
NOTES | 311
REFERENCES | 319
INDEX | 323

Acknowledgments

My deepest thanks to Marina Abramović for her absolute openness and cooperation from the very beginning of my research. Marina made any and all archival material freely and unconditionally available, together with the most intimate memories over weeks of intense interviews—all the while knowing that she would have no control over this biography and that it would be quite different from the story she would write of her life. It's a testament to her generosity, trust, and courage that she was willing to enter into such a process with me.

I'm extremely grateful to my editor, Roger Conover, for his immediate and unwavering commitment to the book and his principled support of its independent voice, for his help developing the book's concept and style, for sharing his knowledge of the Balkan art world, and for his guidance through the complex, sensitive, and unusual process of writing a biography of a living artist.

Very special thanks to the Sean Kelly Gallery for their kind support and assistance with my research. I am also very grateful to Sean Kelly personally for his incredible rigor, candor, and kindness during the interview process. Many thanks to Ulay for the inspiring and indispensable marathon interviews he so readily gave. Thanks to Paolo Canevari for sharing his very close perspective on Marina. Thanks are also due to the dozens of people who spoke so openly about Marina for this book (a full list can be found in the references), and in particular to those who went the extra mile in helping with my research: Velimir Abramović, Ivana Abramović, Ksenija Rosić, Tatjana Rosić, Chrissie Iles, Michael Klein, Michael Stefanowski, Miško Šuvaković, Hartmund Kowalke, Murray Grigor, and Marcus Ritter. Thanks to Dragica Vukadinović at the Studentski Kulturni Centar archive in Belgrade (and to her colleague Stevan Vuković for setting up and translating several key interviews), Nell Donkers at de Appel gallery archive in Amsterdam, Jasna Jakšić at the Museum of Contemporary Art in Zagreb, and to the Victoria Miro Gallery, London, for granting access to their archive. Jennifer Liese, the copy editor, was extremely perceptive and thorough in her attention to the text, for which I am very grateful. Many thanks also to Margarita Encomienda, the book's designer, for her excellent work, and to Jelena Stojković for her on-demand translations of Serbian texts. Thanks to the following for their practical, technical, and moral support: Davide Balliano, Kim Dhillon, Hannah Forbes Black, Claudia Gunter, Jens Koed Madsen, Scott Lamb, Ruby McNeil, Emma Pearse, Greg Stogdon, and especially Joshua Seidner.

Thanks to Meline Toumani and Astra Taylor for their example and guidance in the publishing process. And enormous thanks to my dear friends Matt Charman and Anwen Hooson for their nonstop enthusiasm, encouragement, advice, and love.

Images appear with permission of the following (see captions for full credits): Marina Abramović archive, New York; Sean Kelly Gallery, New York; Studentski Kulturni Centar, Belgrade; Ksenija Rosić; Uwe Laysiepen; Alessia Bulgari; Heini Schneebeli; Patrick McMullan Company, New York.

Every effort has been made to gain permission from copyright holders and / or photographers, where known, for the use of the images reproduced in this book, and care has been taken to caption and credit those images correctly. The photograph used on the cover comes from the personal archive of Marina Abramović, and like many of these images had no photographer credited. I attribute it to Milan Jozić since his name appeared alongside a very similar image in Abramović's archive; unfortunately, sources in Belgrade were not able to locate Jozić to confirm this with him. I will be happy to correct any image credits in future printings, if further information is brought to my attention.

Note on the Text

All quotes described in the present tense—Marina says, Ulay recalls, Velimir insists, and so on—are from interviews with the author, conducted between January 2007 and February 2009. When quoting Abramović, I've kept intact where possible her idiosyncratic English, with its dropped prepositions and excessive use of the definite article, and with most actions expressed in the present tense—no matter when they happened. Through her mangled syntax, Abramović achieves an off-kilter perfection and naïve charm and force that would evaporate with proper usage. She is a supreme storyteller, though as one person I interviewed notes, "Every time Marina tells a story, it gets better." Necessarily then, the testimony and insight of over sixty people who are or have been close to Abramović forms the basis of this book together with her accounts and my own deductions, opinions, and extensive original research in Abramović's enormous archive (she never throws anything away), and those of several museums and galleries.

Preface

When Marina Abramović dies, she requests the following procedure, as stipulated in her last will and testament:

In case of my death I would like to have this following memorial ceremony:
Three coffins.
The first coffin with my real body.
The second coffin with an imitation of my body.
The third coffin with an imitation of my body.

I would like to appoint that three persons would take care of the distribution of the three coffins in three different places in the world. (America, Europe and Asia.) The special instructions will be written and put in a sealed envelope, with their names and instructions to follow.

The memorial ceremony will be held in New York City with all three coffins present and sealed. After the ceremony the appointed persons will follow my instructions for the distribution of the coffins. My wish is that all three coffins should be buried in the earth.

Everybody at the final ceremony should be informed that they shouldn't wear black and that every other color is encouraged. I wish that my former students . . . create a program for this occasion. For the beginning of the ceremony I wish that Antony from Antony and the Johnsons will sing Frank Sinatra's song: My Way.

The ceremony should be a celebration of life and death combined. After the ceremony there will be a feast with a large cake made out of marzipan in the shape and looks of my body. I want the cake to be distributed between the present people.

WHEN MARINA ABRAMOVIĆ DIES

INTRODUCTION

Marina Abramović is naked in the shower, up on a platform in a gallery full of silent people gazing up at her. The only sound is the trickling of the water and the ticking of a metronome, placed on the floor next to the shower. Abramović is dead still as the water rolls down her placid face. Her eyes are closed and her hands by her sides, palms facing forward in a gesture of saintly openness. A few minutes disappear, eulogized by the slow ticking of the metronome, which seems to be straining, lurching, and out of time. Then Abramović screws up her face, drops her jaw heavily, and lets out a kind of silent scream. The force of her mute, airless projection seems palpable. After some time, she turns off the shower and begins to dry herself very slowly and with an attitude both robotically disinterested and indulgently autoaffectionate. Then, still naked, she sits on the toilet next to the shower and looks out at the all the people sitting on the floor beneath her. After a few tick-tocks of the metronome, a new trickling sound begins. Easing the tangible embarrassment of the audience is the knowledge that Abramović won't do anything other than pee—she hasn't eaten anything in 185 hours. It's late November, 2002, the eighth day of a performance called *The House with the Ocean View*, and my first encounter with Abramović.

Abramović is living, and starving, on full public display like this for twelve days in a New York gallery. She is not speaking, though a wall text explaining the conditions of the performance says singing is "possible but unpredictable." Abramović will not read or write. She may drink large quantities of mineral water, shower three times a day, and sleep for no more than seven hours a day. The public is instructed to remain silent and—verbatim from Abramović's idiosyncratic Serbo-English— "establish energy dialogue with the artist."

Abramović's bathroom is one of three open-face boxes attached to the back wall of the gallery like balconies, about six feet off the ground; there is also a living room with a table and a chair, and a bedroom with a bed and a sink. All the furniture is in warm wood tones and elegantly austere. The bed and the chair each have a large crystal set into the headrest, to deliver energy to Abramović in the absence of food. Each of the balconies has a ladder leading down to the ground—except the rungs are knives, with the blades turned feetward. She isn't going anywhere.

Abramović puts on plain white cotton trousers and shirt, steps across the small gap from the bathroom to the living room, and lowers herself into the chair, facing front. She settles and looks out at the audience again, which never stops looking at her. She stares at a telescope positioned near the entrance to the gallery, meant, with a knowing dash of absurdity, for people to inspect her even more closely. Through

the telescope Abramović's skin looks yellow against the bright white walls. There is the glaze of unformed tears in her narrow reddened eyes, but her face is a blank slate. She could be in a starvation-induced trance, aching for connection with or attention from the audience, or just insanely bored. After eight days of eating nothing and doing next to nothing, Abramović looks like she's slowly dying up there.

This is not an unfamiliar possibility for Abramović. In the 1974 performance *Rhythm 5*, she lost consciousness while lying inside the burning wooden frame of a five-pointed star—the symbol of the communist Yugoslavia she was born into in 1946. In *Rhythm 0* in 1975, she had a loaded gun pushed to her neck by members of an audience in Naples who were instructed that they could do anything they wanted to her with any of the dozens of objects laid out on a table; for six hours, she remained determinedly passive no matter what the audience chose to do to her. In *Nightsea Crossing*, a series of performances carried out with the German artist Ulay, her former partner, in which they sat at opposite ends of a table locked in a gaze for seven hours without moving, Abramović said there always came a point, as her shoulders and legs cramped up and she contemplated the horror of imprisonment in her static body in the empty hours lying before her, when she felt like she would die. "Okay, then. Just die. So what?" she would say to herself. Then she was able to go on.[1] Abramović and Ulay performed *Nightsea Crossing* ninety times between 1981 and 1986.

Eye contact is fundamental again in *The House with the Ocean View*. It is Abramović's nourishment and the audience's addiction. Everyone stares at her, hoping to be the next one she fixes her eyes on. Selecting someone for a few minutes of engagement, Abramović stands up and moves to the front, the better to concentrate on the starer. She sways agonizingly over the knife-ladder as she loses herself in the stare. When it breaks down, she rubs her face and the starer reels away. Later, Abramović sits with her bare feet dangling over the edge of the platform, quivering on the top of a knife blade. She starts singing a lullaby in her native Serbian, the words almost dying in her throat.

A gallery assistant appears, announced by the sound of the clattering stepladder she is carrying. The three video cameras fixed high on the wall—each one trained on a balcony—need their tapes changed. The beeping of the little machines and click-clack of the new tapes seems like a minor blasphemy: posterity looms even while attention is oriented obsessively on the present moment. Tick. Tock. Silence. The metronome seems to have given up, but Abramović won't allow it. She breaks her reverie and walks—slowly, as she does everything—back to the bathroom to tend to it. Pure silence crystallizes through the gallery as she turns the metronome's knob; a delicious tension rises as she taps the ticker, and it reluctantly starts rocking back and forth again, clumsily attempting to mark time. In her determinedly slow movements, Abramović seems to be challenging the metronome's version of time, parodying it.

The next day, I return to the gallery as soon as I can, eager to continue watching Abramović and give the support—just through being there—that she seemed to need in her ordeal. I enter and see that several people from the day before are there again too. Abramović is walking slowly back and forth across the platforms. Almost immediately upon sitting down to watch her, I catch her eye. Her gaze is searching but placid; it asks nothing and answers nothing. She breaks the stare after only a minute. I feel blessed, confused, and hungry for more connection, but Abramović continues walking back and forth in what is apparently her morning exercise routine. Her steps are loud and heavy because she's wearing big, worn-out old hiking boots, the boots she wore when walking the Great Wall of China in 1987, in a piece called *The Lovers*. Abramović started at the eastern end of the Wall and Ulay started in the west, and they simply walked toward each other. Three months later they met roughly in the middle. The performance marked the end of their thirteen-year professional and personal relationship.

Watching for several hours, I realize that Abramović is always in the middle of a routine: walking back and forth, getting ready to shower, showering, dressing, getting ready to sit, sitting, preparing herself to stand at the front, standing, brushing out the creases in her uniform (she wears a different single bold color each day), getting a glass of water from the sink in her bedroom, drinking it slowly in long, luxurious gulps, going to the bathroom to pee shortly afterward, sitting or kneeling on the edge of the platform, singing, lying under her bed partially hidden for a while from the public's gaze, moving her metronome between balconies, and, occasionally, turning the table and chair upside down. Everything is an entry into an activity or a passage out of it. There is hardly ever a sustained period of absolute stillness. Despite Abramović's apparent attempts to strip life down to the bare minimum and do as little as possible, there is always still something to be done.

Her habits and routines accrue fascinating nuances and ambiguity with each repetition. Every time she makes the slightest movement it is an edifying treat, like watching a dignified but captivity-weary rare animal in a zoo. Abramović is presenting herself up on her stage for complete scrutiny, but it is impossible to see enough. Watching Abramović is alternately frustrating, reassuring, nerve-wracking, boring, and awe-inspiring. She sets herself up as a screen to accept the various psychological projections from members of the audience, which, as on a screen, make no imprint on her. The audience wants something from her; she gives nothingness in return, exuding pure empathy, liberated from any specific content. But Abramović is extremely vulnerable up there on her platforms, and, as she and the public gaze at each other, the sense of guardianship is mutual.

The audience in the gallery has its rituals and choreography too. A core group of about ten people returns each day. A small old man with wiry gray hair and a manic demeanor frantically makes sketches of Abramović. Once, there is a triangulated gaze when a third person stares not at Abramović but at the person she is staring at. Then he turns and faces the wall, staying there for a long time. Every day, the

critic Thomas McEvilley, an old friend of Abramović's who walked a portion of the Great Wall of China with her, arrives with his fold-up chair and positions himself at the front to observe. Late on the penultimate day of the performance, a woman approaches Abramović with a rose and lays it against the knife-ladder. She kisses her own hand, and then crosses her heart. It is like a gift for the dead, or the dying, and also like a gesture of appreciation in the theater, or of devotion in a church. Abramović doesn't seem to notice the rose. The lights in the gallery dim, signaling closing time, and everyone shuffles out silently and reluctantly. No gallery staff stay with Abramović overnight. Outside the gallery, I stop the grizzly old man for a chat. He says he has a plan for tomorrow: to offer Marina an apple, though he is worried that it might be too much like obeisance.

The next day—the last day—the rose had been removed. Abramović looks stronger and more focused than ever. Only an hour remains of her performance and the gallery is crammed with about two hundred people. Abramović is wearing a red outfit and standing at the front, looking out at her ocean view. She breathes deeply, turns her palms upward and keeps twitching up onto her tiptoes, as if trying to take off. The audience reveres. While she fixes on no one's eyes in particular, she is clearly feeding off the silent excitement in the room. More people bundle in from the cold outside, rustling their coats, fidgeting and wriggling as they sit down on the floor, preparing to fall into the silent gaze.

A drink. A pee. Then Abramović sits inside the upturned table in the living room—she's been rearranging the furniture again, setting deliberate obstacles to keep herself alert. She starts singing again, the same song as always, in a loop. When Abramović walks over to the bedroom, the man I talked with the night before leaps up with a strange flourish, shakes out his arms, and holds out something wrapped in green tissue paper. Only Abramović can see what it is, but I guess it's the apple. Come down Marina, the fall is a happy one. She sits still on the bed, staring at the offering for about ten minutes. Then the man leans down and picks up a large, stiff piece of paper and holds it up for only Abramović to see. She smiles, nods—her first direct and legible response to a public gesture that I've seen—and then bursts out crying, her whole body convulsing.

As still more people arrive, everyone stands up, partly to make more room and partly as a demonstration of solidarity. Gallery staff shuffle through the crowd with a microphone and a big speaker and set them up at the front. Then they place a stepladder by her bedroom so Abramović doesn't have to use the knife-ladder to get down. The gallery owner, Sean Kelly, places a pair of slippers and a dressing gown up on her bedroom floor. It is past 6:00 p.m. on the twelfth day. Everyone in the audience seems to be begging: Marina, you can come down now. But she stands front and center for a few more minutes, floating, surveying the crowd. The tension, the nowness in the room is gorgeous, excruciating.

Abramović stops the metronome. She takes off her shirt and trousers and boots, puts on the dressing gown and slippers, and delicately walks down the stepladder.

It's over, but everyone remains silent. She steps up to the microphone, coughs once, then says: "Dear artists, dear friends, dear public. I am sorry to disappoint you by not using the knife-ladder." Everyone laughs. "I am not there yet, but hopefully one day I will be."

YUGOSLAVIA 1946–1975

PART ONE

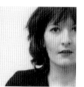

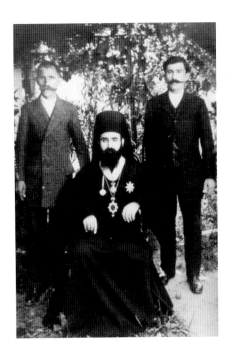

1.1
Varnava Rosić (center), who served as patriarch
of the Serbian Orthodox Church from 1930 until his
death in 1937, with his brothers Aleksa (left) and
Uroš, Marina's grandfather (right), 1927. Courtesy
Abramović archive.

BIRTH PAINS

Danica and Vojin Abramović made Marina celebrate her birthday every year on November 29, Republic Day in Yugoslavia. It was on this day in 1943 that the Anti-Fascist Council for the National Liberation of Yugoslavia declared itself the supreme authority in Yugoslavia—in defiance both of the occupying Nazi forces and the Yugoslav monarchy, exiled in London. And it was on the same day two years later that the communists, having defeated the Nazis and their Croatian henchmen, the Ustaša, were elected into government, the Federal People's Republic of Yugoslavia was proclaimed, and Josip Broz Tito installed himself as Prime Minister. Marina believed her parents that November 29 was indeed her birthday. So every year brought renewed disappointment when she wasn't invited to take part in the Republic Day parades, didn't receive extra presents and public adulation, and didn't get the chance to meet Tito, like all the other children born on the auspicious date. The blessed confluence that Marina's parents—or probably just her mother—had tried to imagine between their daughter and their new country was in fact not there. Marina was one day out of step with the clockwork of the Republic. She only discovered her real birthday, November 30, when she was about ten years old.

Danica Abramović, born Rosić, recently married, living in Belgrade, and busy building the new Republic after serving with Yugoslavia's Partisan resistance fighters in the war, was at a meeting of the Communist Committee for People's Health, where she was secretary, when her water broke on November 30, 1946. She had been determined to work throughout her pregnancy, and was proud to have fulfilled her vow. When she gave birth to Marina, the doctors didn't notice that the placenta hadn't come out completely, and she contracted septicemia. Danica was ill for much of the first year of Marina's life, but was able to secure a comfortable convalescence in Switzerland thanks to her position in the party and her status as a war hero. Yugoslavia was now full of them.

Marina was taken home from the hospital to the family's very large apartment in an ornate, elevator-serviced building on Makedonska street in central Belgrade, opposite the offices of the newspaper *Politika*, Tito's loyal mouthpiece, and adjacent to the city radio station. She was a weak and sickly baby, and was cared for by a nurse—the Abramović houschold always had hired help—who also had a baby of her own. Marina's grandmother, Milica Rosić, was concerned that the nurse's baby kept getting fatter and Marina kept getting weaker. When she was about eight months old, doctors mistakenly thought she might have tuberculosis. Milica took her in. It was not unusual in Yugoslavia at the time for grandparents to take almost

sole responsibility for their grandchildren in the first years of life, especially if the parents had demanding jobs, as Danica and Vojin Abramović did.

Vojo—the diminutive form of his name, which everyone used—was a war hero too, having fought with the First Proletarian Brigade. Immediately after the war he became chief commander of Tito's elite guard, accompanying the Prime Minister on his travels around Yugoslavia. Danica studied art history after the war, and was soon put in charge of a government agency responsible for monuments and artworks for public and government buildings. The agency was far on the other side of town from Milica's apartment. According to Ksenija, Danica's sister, Milica carried the infant Marina across town every day so Danica could breast-feed her. Marina, however, insists that she was never breast-fed. This disagreement is emblematic of the strained family dynamic during Marina's childhood, a dynamic that would in fact endure throughout Marina's life. The elder women in the family were obsessed with keeping up appearances—like the idea of making stoical daily treks across the city for the sake of a child's health—and Marina would dwell in the deprivation and emotional undernourishment that she felt was the price of her mother's rigid propriety.

Marina lived until she was six years old with her grandmother, or *baka*, in her small apartment. Milica Rosić had been rich until her daughter Danica, one of four children (three girls and a boy), became a Partisan in 1941 and, later, active in the Communist Party. Milica called the communists "red devils"; it was especially galling that after the war, when she had her property seized by the state like other wealthy families did, it was her own daughter who was the instrument of her impoverishment. This was not the first fluctuation in wealth in Marina's maternal lineage. Milica told stories about her childhood poverty: how her mother would put every pot on the stove and fill them with water, just to give the impression of a plentiful kitchen.

Milica escaped her early poverty through marriage. When she was sixteen years old, Uroš Rosić, a wealthy merchant, spotted her in the market in the town of Užice in Montenegro. They married in 1919. The Rosićs were an important family not only for their wealth. In 1930 Uroš's brother Petar was appointed patriarch of the Serbian Orthodox Church. Taking the name Varnava, he led a fierce popular protest against his country's concordat with the Catholic Church, which had been under negotiation for years. Varnava argued that the concordat would give rights and privileges to the Catholic Church, which was dominant in Croatia, that the Serbian

Породица Блаженопочившег Патријарха на јучерашњем помену

1.2
"Family of the deceased Patriarch at yesterday's service," July 29, 1937. Danica Rosić is second from the left. Courtesy Ksenija Rosić.

Orthodox Church was not granted in its own back yard. The crisis, which came to a climax in 1937, was in effect a struggle between Serbian and Croatian supremacy in the nineteen-year-old nation of Yugoslavia. In July of that year, just as Prime Minister Milan Stojadinović brought the concordat before Parliament, Varnava fell suddenly and mysteriously ill. A march in Belgrade in his support was violently broken up by police.[1]

From there, an apparent plot against the Rosić family began to unfold. Varnava's brother Aleksa visited him in hospital in Belgrade, and fell ill upon his return to Pljevlja, Montenegro, where the family lived. Shortly afterward, Uroš visited Varnava, and he too fell ill upon his return. Varnava died on July 23, the day the concordat was finally passed by the Parliament. Shortly afterward, Uroš and Aleksa also died. Danica, who was sixteen years old at the time, learned the news of her father's death at Varnava's funeral. The official verdict on Varnava's death was poisoning.[2] The Rosić family claimed that diamond dust had been sprinkled in his food—a fabled assassination technique causing death by internal bleeding—but the precise cause was never found because Stojadinović halted the investigation.[3] Though it was never confirmed, the likely culprits were agents of the prime minister. Varnava's stubborn opposition to the concordat was proving too awkward, and in fact it was posthumously successful: though the legislation passed on the day of his death, the upper house of the Yugoslav Parliament soon abandoned it, such was the intensity of the resistance that Varnava had stoked.[4] Uroš and Aleksa were apparently collateral victims, killed, the remaining Rosićs believed, because by law only a male member of the family could have ordered an autopsy on Varnava; thus to keep the assassination a secret, the brothers had to be eliminated too.

Though Varnava was Marina's great-uncle, over the years Marina simplified the story, merging him with Uroš so she could say that it was her grandfather who was the martyred Patriarch of the Serbian Orthodox Church. This conflation gradually made its way into the historical record, which Marina has been in no hurry to correct. A part of the story that never got told, not least because Marina didn't know about it, was Varnava's growing support for Nazi Germany in the late 1930s, mainly because they resisted the "poison" of communism.[5]

Marina's earliest memory is of looking out the window of her grandmother's apartment onto a crowd of people marching down the street in anxious silence, all of them dressed darkly in her recollection. "It was something so frightening," she says. The march was probably in response to Stalin's excommunication of Tito in 1948, when Marina was two years old. The Soviet Union expelled Yugoslavia from the Communist Information Bureau—the international forum for communist countries, known as the Cominform—as punishment for Tito's independent style of communism. In particular, Stalin disapproved of Tito's overtures toward Bulgaria for Slavic unity. The USSR cut off all relations with Yugoslavia, which was especially painful given the atavistic unity of the southern Slavs and the Russians, recently strengthened by their alliance in the Second World War. Tito's government reacted to the excommunication

1.3
Marina in 1948. Courtesy Abramović archive.

1.4
Vojo Abramović with Marina in 1950. Courtesy Abramović archive.

by inciting massive paranoia about the slightest Soviet influence, and persecuting anyone, especially those in the Communist Party, thought to have Stalinist sympathies. Victims of the purge during the Informbiro period, as it became known in Yugoslavia, were sent to a prison camp on a barren island in the Adriatic called Goli Otok ("naked island"). Tito's risky defiance of Stalin—Khrushchev later wrote that "Stalin was virtually ready to invade Yugoslavia"—soon galvanized his youthful country.[6] They had taken on the Nazis and won; now they were showing that they could stand independently of Stalin *and* independently from the West. But initially, fear of another conflict, only three years after the end of the war, was widespread. Marina felt it through the windowpane.

Like her late husband and brother-in-law, Milica Rosić was deeply religious. The rituals—religious and culinary—that guided the operation of the apartment where Marina spent her first years were a great source of stability for the vulnerable child. It was a house of strong, comforting smells. Every morning Milica would roast green coffee beans, grinding them by hand into a fine powder to make Turkish coffee. Then she would light a candle next to an icon and pray. She never made Marina pray, though she did take her along to church almost every day. Religion was grudgingly tolerated by the party spies who sat in the church making their lists—as long as it was practiced by the older generation. For everyone else, religion was a severe impediment to the development of a career, and impossible for party members. Milica, nevertheless, had secretly baptized Marina and always invited the family for dinner on January 6, Christmas Eve in the Orthodox calendar.

Milica was always cooking, and made endless jars of preserves and vats of soup. Marina would help make sour cabbage in wooden barrels full of salt water. She would pound the head of the cabbage in this solution with a stone and, after three days, change the water. It stank like dirty socks, but Marina relished drinking it. At 5:00 p.m. every day Milica lit incense (which stayed burning through the night), and began her hours of peaceful needlework. Early each morning, she would go with Marina to the market across the street to check prices on the produce. Only upon a second trip, mid-morning, would she make her purchases. On one occasion, Milica had to go on a longer excursion and for some reason couldn't take Marina with her. There was nobody to look after her—Danica and Vojo were at work—so Milica sat Marina down at the table with a glass of water, told her not to move, and said she would be back soon. Two hours later she returned to find Marina sitting in exactly the same position, without even having sipped from the glass. Marina was already demonstrating a formidable willpower, a trait that the Rosić family believed was an inheritance from Varnava.

But rather than such diligent compliance, Marina's willpower more often manifested itself in rebellion: she was reluctant to walk—even though she was perfectly able to—until she was around four years old. On a family holiday in the mountains in southwest Montenegro in August 1952, when Marina was five years old and Danica was pregnant again, they all got up before dawn one day to hike to the top of

1.5
Vojo with Danica's sister Ksenija and her
husband Luka and Marina in front,
May 1, 1950. Courtesy Ksenija Rosić.

Mount Lovćen and watch the sunrise from the mausoleum of the nineteenth-century Montenegrin poet and prince-bishop Petar Petrović Njegoš. As they got to the top of the mountain and the sun came up, illuminating a spectacular view of the craggy Adriatic coastline, Marina stopped walking (something she was practiced at), and began to cry. "Beautiful, beautiful!" she exclaimed. "I want to draw it." When the family returned to Belgrade, she did just that.

While living with her grandmother, Marina only spent Sundays with her mother and father, who worked every other day of the week. Their time together did not make a great impact on the young Marina: she has few early memories of her parents. She believed her mother was in fact pleased not to have to look after her, not least because Danica was obsessed with cleanliness, and considered Marina a potential carrier of germs into her apartment. The phobia worked the other way too: when Marina was a sickly baby, Danica made people cover their mouths as they leaned over her cot to coo at her.

Around this time, Marina's great-grandmother Krsmana Pejatović-Rosić (Uroš's mother) summoned the entire family, including the five-year-old Marina, to watch her die. She was over one hundred years old and had decided to call time on her life (her mother had lived to 116, the family believed though could never confirm). Krsmana cooked a meal for the family, and afterward lay down in bed, ready to will death upon herself. She expected it to happen quickly, and in everyone's presence, but it happened two weeks later, when she was alone. Though the young Marina hardly knew what was going on at the time, the event had a lasting impact. In retrospect, Krsmana's death seemed perfect: something close to but decisively different from suicide, an acceptance of expiration confronted and controlled head on, not an unnatural interruption of life but a consummation of it. She had willed the inevitable, and therefore conquered it. The seal on the perfection of her death was the fact that at the limit of her planning, something got away from her: she went on living, for a while, despite her best intentions.

Marina moved back into her parents' apartment on Makedonska street when she was six years old. Milica came with her. There was plenty of room, and Milica's help would be needed when the new baby arrived—which was just a couple of hours after they did. Looking forward to some sustained attention at last from her parents, Marina was confronted instead with a huge bundle fresh from the hospital. While everybody gathered around to admire the newer Abramović child, named Velimir, Marina sat sullenly in the corner, consumed with jealousy. Velimir was an enormous baby with a blotchy red face. Soon, he started suffering from epileptic fits. When foam started coming from his mouth and convulsions followed, everyone came running. Whenever he cried, it was blamed on Marina, and Danica would give her a beating. So Marina made a half-conscious attempt at fratricide by dropping Velimir—whom she could barely lift since he was so heavy—into the bathtub, submerging him entirely. Milica arrived on the scene to rescue him, and Marina got another beating. When

Ksenija moved into the apartment with her husband, Luka, a third disciplinarian was on hand to reprimand Marina for what she felt were the slightest violations.

Marina started getting abnormally severe bruises from her regular beatings, and when one of her rear baby teeth fell out, it wouldn't stop bleeding. The doctor advised that Marina should sleep sitting upright to avoid the danger of choking on her blood. When the bleeding still didn't stop after several days, she was taken to the hospital. The doctors feared she could be a hemophiliac. While this was a terrifying diagnosis—she could potentially bleed to death from any wound—Marina was delighted: finally the beatings would stop and the attention would flow toward her instead of Velimir.

Marina spent the next several months in the hospital as the doctors puzzled over her excessive bleeding, which could stop and start again with no apparent provocation. Hemophilia was highly unlikely since neither of her parents suffered from it— they shed plenty of blood during the war. Extensive tests eventually revealed either a deficiency of iron or of white blood cells in Marina's blood, but the exact cause of her sporadic bleeding remained a mystery, as did an effective treatment. What no one considered was that the excessive bleeding might be a psychosomatic reaction to Velimir's appearance on the scene, a hysterical ploy to win her parents' love and attention, which a later, similar medical case might support.[7] In any event, Marina did not quite succeed in meeting this goal. Her parents visited the hospital just once a week, and still seemed like strangers. Her aunt and grandmother though visited regularly and brought presents—a small victory. Ksenija read to her, and Marina took to books with a passion. She drew, invented games with shadow puppets beneath her sheets, and, when the husband of the woman in the bed next to hers returned from his excursions in the navy with a moldy brown banana, the likes of which she'd never seen, Marina began fantasizing for the first time about traveling to distant countries.

2

PARTISAN STORIES

The meeting of Vojo and Danica during the Second World War, as filtered through Abramović family folklore, is the stuff of Partisan movies. Nearly thirty years after the war, a slew of these nostalgic films celebrating the extreme heroism of Yugoslavia's resistance fighters—Stipe Delić's *The Battle of Sutjeska* (1973) starring Richard Burton as Tito, for example—emerged to ensure that the postwar generation then coming of age wouldn't dare forget their parents' achievements. But this domineering narrative was already encoded in Marina's DNA and proudly elaborated in her personal creation myth.

Before the war, Danica had begun studying medicine. Her few months' education were enough, given the desperate circumstances, for her to practice as a nurse when she joined the Partisans in 1941 as the Nazis invaded. She was nineteen. The ranks of the Partisans grew quickly as the Nazis carried out a policy of executing fifty civilians for every Nazi soldier wounded in resistance attacks, and one hundred for every soldier killed.[8] In the face of such inexorable and unselective brutality, joining the resistance outright became more attractive than the prospect of being killed in random reprisals. As a nurse and combatant, Danica took part in all seven of the Partisan battles in the war that were later enshrined into communist mythology, starting with the battle for her hometown of Pljevlja, in northern Montenegro, on December 1, 1941. Failing to recapture the city from the Italian occupation force, three hundred of the poorly trained Partisan forces were killed, and two or three times as many were wounded.[9] Danica was one of the nurses who had to treat them.

Vojo Abramović was born into a poor family in Cetinje, Montenegro, on September 29, 1914, and grew up in Peć, Kosovo. In the late 1930s he joined the Communist Party and tried to sail for Spain with some comrades to fight in the civil war against Franco. But he was caught en route and brought back to Montenegro, where he was imprisoned for several weeks since party membership was illegal in Yugoslavia. Vojo was released from prison when his father, Djordje, defended him, saying he had been deluded by the communists. In 1941 Vojo joined the First Proletarian Division of the Partisans and became an intelligence officer. During his service, a trick he would repeat was to ride into a German-occupied village in plain sight on a white horse, providing a distraction while the rest of his brigade would penetrate the village from the other side. Later, Vojo would scoop the bullets out of his skin with his knife and rub tobacco in the wound to numb the pain. This story probably originated with Vojo himself, who was skilled in the rhetoric of wartime hardship and heroism. Speaking in the 1990s about an expedition over Igman Mountain in central Bosnia, Vojo recalled:

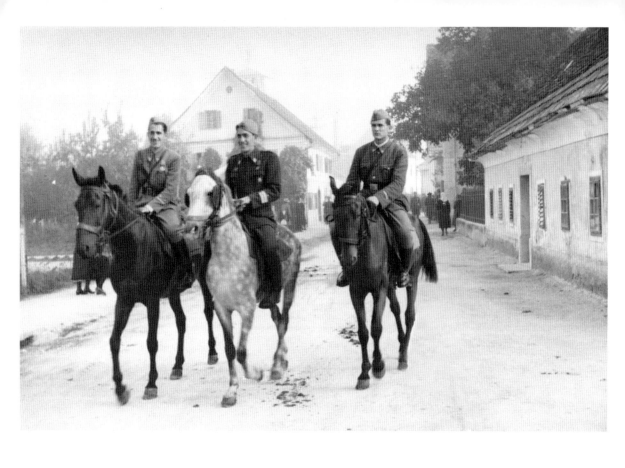

2.1
Vojo on his white horse in Valjevo, Serbia, 1944.
Courtesy Abramović archive.

[It was] 34 degrees below zero, it was horrible. But we Montenegrins from the First Battalion were fortunate to have Pero Cvjetković as our commander, since he was a captain, a mountain officer, who knew what must be done in the case of freezing and this terrible cold. Whereas Rajo Nedeljković, the commander of the Third Battalion, had no idea, he was a lawyer, so most people lost their legs and arms, their toes and fingers fell off and other body parts. But not our Pero. I even thought of taking a pistol to shoot him, when he started rubbing my nose with snow, it hurt like hell. . . . But he said "I will shoot you before I let you die from the White Death," from the cold—he knew that it should be rubbed, or it would become white, that is, first red, then white, and later, when it becomes blue, it is over, it just goes. And those who wouldn't listen to Pero Cvjetković, but went close to the fire when they were taking off their boots and shoes, their skin came off with them, leaving only flesh, bones and blood, so that people were helpless, some of them killed themselves. . . . But when Tito came through the door to see the Igman fighters, he could only hear us singing the "Internationale." He stood there, tears running down his cheeks, he couldn't utter a word.[10]

In 1942, Vojo was wounded in battle and arrived at a field hospital—Danica's—bleeding heavily. In Marina and Ksenija's version of the story, there was no blood available for the necessary transfusion, so Danica gave Vojo some of her own. Velimir contests this story, saying that Vojo's blood group was AB– (though this is extremely rare) and therefore incompatible with Danica's O+. Velimir concedes though that they did fall in love as Danica nursed Vojo back to health.

Marina and Ksenija add an extra installment to the story, in which Vojo and Danica's love actually began a year after the alleged life-saving blood transfusion, during the Battle of Sutjeska. In this most famous of Partisan battles, which took place from May 15 to June 16, 1943, 18,000 Partisans miraculously escaped encirclement by 120,000 German troops. "We leaders and soldiers were a brotherhood condemned to die, and which could be saved from utter destruction only by our collective heroism and personal sacrifice," wrote the commander Milovan Djilas.[11] This battle also produced the legend of Tito's German shepherd, Luks, taking a deadly blow on his master's behalf. Though Djilas called the story "pure myth," the legend endured.[12] And it was also during this battle, according to the more romantic version of the story, that Danica and Vojo met again and fell in love.

Riding through the forest, Marina and Ksenija recount, Vojo came across a group of sick and wounded Partisans, right in the path of the advancing Germans. Noticing an impressive mound of thick black hair emerging from the top of a blanket, he leant down from his horse, pulled back the blanket, and recognized the woman who had saved his life the year before. Danica had typhus and would probably have died had Vojo not picked her up and carried her to a nearby village where she could convalesce. Her life-saving favor had now been returned, and the apparently symbiotic couple fell inevitably in love. This romantic and movie-like story would be seamless were it nor for Velimir's insistence that his sister and his aunt are confusing Vojo's "rescue" of Danica with that of her friend, Marta Popidova. It was she, Velimir says, not

Danica, who had typhus during the battle of Sutjeska and whom Vojo rescued. Marina says she knows nothing about the rescue of Popidova. For her and Ksenija this could simply be an inconvenient detail better folded into a fabulous story, much like the conflation of her grandfather with her great uncle, the patriarch Varnava. Velimir though always resisted such family legend, especially when it concerned tales of Partisan heroism that were to him—and many others of his generation—tiresome cliché.

In any case, Danica and Vojo did fall in love at some point, and when the war was over got married and had Marina. Danica resented the choice of name for their daughter: Vojo had named her after a Russian soldier he'd been in love with, and who died in battle before he'd encountered Danica.[13] This affront may have been an underlying factor in the coldness Marina felt from her mother right from her earliest childhood. While Danica visited Marina infrequently—or so Marina felt—Vojo was almost totally absent at this time, traveling the country with Tito and his unit of guards. When the Informbiro period started in 1948, he almost disappeared for good. As Soviet influence was ruthlessly expunged from all areas of Yugoslav life, Vojo himself faced imprisonment on Goli Otok since many of his friends were Soviet sympathizers. He was saved from that fate when Aleksandar Ranković, the minister for the interior and head of military intelligence and political police, intervened on his behalf in honor of his service in the war. Instead of going to Goli Otok, Vojo was moved from Tito's elite guard into a less important military division. His sense of betrayal was kept in check by his belief that a truer version of communism was always on the brink of appearing. Only in 1968 would he abandon this hope. Much later, he cut Tito out of all the photographs they'd been in together.

The fairytale of Vojo and Danica's marriage amidst the beginning of a new Yugoslavia soon bumped up against a most awkward reality, given the couple's supposedly shared communist beliefs: intractable class differences. While Danica was at party meetings, exhibition openings, the opera, or the theater, Vojo would be at home with his old Partisan friends, doing something peasant-like such as "grilling the small pig in the kitchen," Marina recalls. Danica despised what she perceived as Vojo's philistinism, and he in turn was disgusted by her bourgeois aspirations. Vojo always did his best to reject the comfortable existence pushed on him by his wife,

2.2
Vojo and Danica Abramović, circa 1945.
Courtesy Abramović archive.

and by the state, as a war hero. Immediately after the war they lived for a short time in a luxurious villa in Belgrade's wealthy district of Dedinje, where Tito and the most important party members lived. Vojo didn't like it, so he and Danica moved into one of the properties emptied during the almost total liquidation of Jews in Serbia perpetrated by the Nazis (Belgrade was declared *judenfrei* in August 1942). Danica insisted on ornate furniture and decoration for their apartment. In the library the walls were lined with paintings, many of them proud family portraits, and in the living room stood the piano upon which Marina reluctantly attempted to play out her mother's fantasy of her as a refined little girl. The apparent orderliness and perfection in the apartment was however in a state of slow and unarrested decay. Danica insisted that nothing could ever be touched, changed, or improved upon; the walls of the apartment, never repainted, were left to turn ever grayer. Vojo once hammered nails into the high 1920s stucco ceiling in one of the rooms and hung a swing there for Marina and Velimir to play on. This was an unprecedented thrill for the two small children. When Danica arrived home she was horrified; Vojo argued that the pleasure of the children was more important than the perfection of the ceiling.

After being expelled from Tito's elite guard, during the 1950s Vojo still traveled regularly around Yugoslavia with the military. On the rare occasions when he was in Belgrade, he spent most of his time at his division's headquarters. "At headquarters" was Danica's automatic answer to Marina's perpetual pining question, "Where's father?" She would join him there at the barracks' social club on Sundays, where he taught her how to play chess and arranged drawing lessons for her. The family rarely spent any time together as a unit, much less a happy one: Vojo was usually in the midst of an affair, and when he and Danica were together, they would argue ferociously.

Danica and Vojo both slept with their pistols by their beds, and Danica never switched off her nightlight. When she was a child, she had imagined seeing an apparition outside her family home, and had been scared of the dark ever since. It was the one thing she allowed herself to be afraid of—apart from the opinions of society—and her vulnerability grew to outsize proportions. In all other areas of her life, Danica hardened. The rebellious teenager who had endangered her family by joining the Partisans and later bankrupted her mother now enforced a strict militaristic regime in her home. Early each morning, Danica delivered to Marina's room a list of instructions and questions for the day, which usually included some French vocabulary to learn. Danica never kissed her young daughter, fearing it would spoil her. Marina felt an enormous need to be loved, which her mother never met, and she became cripplingly shy and sad. In the face of what she perceived to be extreme neglect punctuated only by regular beatings, Marina early on developed an insatiable craving for freedom and a foot-stamping stubbornness that was in fact a genetic copy of her mother's. It was also a product of the political culture, Titoism, which forever trumpeted its heroic victory over the Nazis, its bravely independent strain of communism, and the courage of its supposed nonalignment either with the Soviet Union or the West (though Tito accepted favors from both).

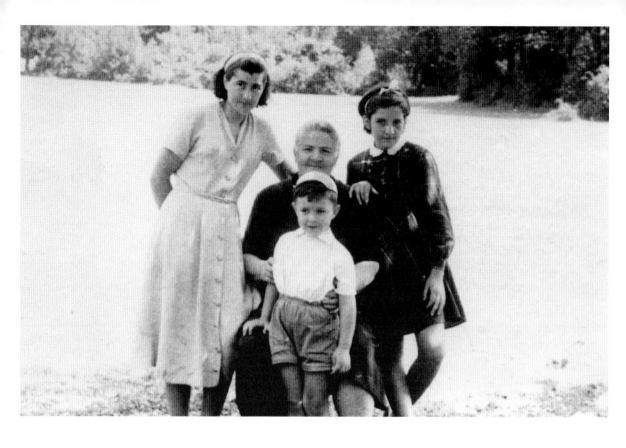

2.3
Milica Rosić (center), with her daughter Danica
(left) and grandchildren Marina and Velimir,
circa 1956. Courtesy Abramović archive.

Danica forced Marina to eat horsemeat, supposedly a good source of the iron that she lacked in her blood. Marina would pretend to obediently finish everything on her plate, but sometimes, rather than swallow the last mouthful of meat, stored it under her tongue all night as she slept, and spat it out in the morning. This was preferable to bending to her mother's wishes. Though she maintained her willfulness, Marina was in constant, cowering fear of breaking the multitude of rules in the house and risking a beating. Danica had unshakeable laws and rituals, imposed through mantras like "Bathroom is free," a phrase that was repeated every night before bedtime to order Marina and Velimir to wash themselves immediately. If Marina refused to wash, or did it half-heartedly, she would be beaten. After one particularly severe beating Marina was bleeding through the nose while locked in a cupboard for what felt like hours. Compounded with her fear of bleeding—she didn't know if or when it would stop—the cupboard was particularly terrifying because, just like her mother, Marina was afraid of the dark. She always felt the presence of an invisible yet threatening "entity" whenever she was alone. To keep the entity away, she would talk to an imaginary person. The entity's home, she believed, was her mother's wardrobe, which contained Danica's smart, starchy suits, most of which were beige or purple. Marina thought that her mother must know about the entity too since she never turned her bedside light off at night.

The fear of breaking rules pervaded Marina's dream life too. She started having nightmares about the terror (and secret delight) of breaking symmetry. Inspecting a squadron of immaculately dressed and perfectly regimented soldiers on parade, she would tear off a button from each of their uniforms, creating an illicit and horrifying asymmetry in an otherwise perfectly symmetrical formation. Breaking the rules in such dreams felt as unnatural and dangerous as "moving the heart from the left to the right side," Marina recalls.

Marina's strong memory of her childhood dreams is part of a larger retrospective sense of being touched by the flattering hand of fate as a child, of being a conduit for cosmic forces. The most powerful instance of this came when one day—not in a dream—she found a strange book with no pages on her bed. She had no idea where it came from; it was as if it had landed there from another dimension, just for Marina. It was an extremely high-gloss book jacket with a picture of the cosmos on it. Marina had never seen anything so shiny; nothing so shiny could possibly exist in Yugoslavia, where everything was drab and rough. When she returned home from school that day, the book cover had disappeared without a trace. She asked her mother and father about it; they didn't know what she was talking about. Marina never found out where the strange book came from. It might have been one of her father's mystery gifts (he once gave Marina a potted plant, without telling her that the real gift, a pair of tights, was wrapped in plastic and buried in the soil), or she might be conflating it with the pageless book that Velimir, a precocious young poet, once made, though this would have been a few years later. This incident created a dual sense in Marina of being singled out by the universe and of feeling extraordinarily small within it. She also had a

persistent mental image of the entire known universe as a tiny stone caught in the heel of a shoe worn by a "fat cosmic lady." She sat for hours engrossed in such fantasies, outwardly doing nothing, so that when her mother entered the room she immediately felt guilty and picked up a book or a toy to look like she was doing something useful.

Marina's vivid interior world clearly emerged to fill the vacuum of neglect she felt from her parents. But there was one form of close attention that she got from her mother: she would accompany her on her regular round of visits to artists' studios in Belgrade. The visits were part of Danica's duties for the Moša Pijade fund, state money that she controlled for the purchase of artworks, named after a painter and art critic–turned–Partisan and People's Hero of Yugoslavia. The ritual of studio visits with her mother continued right up to Marina's adolescence, when she would start going to the same studios by herself.

The studio that left the biggest impression on the young Marina belonged to the sculptor Vida Jocić. She had been in the Ravensbrück concentration camp in northern Germany, and Marina was fascinated by the number tattooed on her arm, and the story of how she became a sculptor: Jocić's friend was beaten to death by a guard, and as she was carried away Jocić saw that her face had left an impression in the mud where she had been pressed down into the ground. She knelt down and scooped out the imprint of her friend's face in the mud, but it fell apart in her hands. She tried desperately to reconstruct the shape again in the mud. That was her first sculpture. (Abramović would later take imprints of people's faces in clay in her 1993 series *Mirror for Departure*.) After the war, Jocić made scrawny, denuded figures, "like Giacometti but much less good," Marina recalls. The clutter and dirt in the studio and the ever-present classical music formed an enchanting world utterly different from the museum-like apartment Marina lived in. It was an incubator for her imagination; she was left for hours to play alone amid the studio detritus and strange collections of objects. Marina made in Jocić's studio a statue of Lola Ribar, the famous Partisan, for a school competition (her school was named after Ribar). Jocić gave Marina an extravagant amount of clay—enough to make an almost life-size figure of Ribar when most of the other children were making busts. Marina won the competition.

Danica in fact tried to expose Marina to as much culture as possible, hiring private tutors to teach her French and English, and taking her to classical music concerts, opera, and Russian ballet. From about the age of twelve, Marina started going with her mother to the Venice Biennale. Marina saw work by Robert Rauschenberg, Andy Warhol, and Louise Nevelson for the first time there. Her exposure to this radical new material was raw, and remained undeveloped. Danica, never one for conversation anyway, had no response to the art they saw at the Biennale, which was a world away from the portraiture and sedate modernism of the artists she supported in Belgrade.

Marina was too young and felt too unloved to appreciate or understand her mother's disciplined cultural grooming. Still, such was her mother's devotion to Marina's artistic refinement that one of the rooms in the apartment was given to her as a studio the moment she started showing a serious interest in painting.

MENSTRUATION, MASTURBATION, MIGRAINES

Nobody had ever told Marina about menstruation. She was wearing the rose-colored flannel underwear her mother gave her every year on her birthday, and noticed a damp patch that came up brown on the fabric. When she wiped it on her hand and saw that it was indeed blood, she panicked. Her brush with hemophilia and the subsequent years of paranoia in the Abramović household had incubated an awful fear of bleeding. She thought she was going to die when this unexplained and unstoppable fount began flowing. It would go on for ten days every month until her late adolescence, when her mysterious bleeding problem finally stabilized—though her fear of it endured.

It was the family's maid and not Danica who explained to Marina what menstruation was. When the buxom, full-lipped woman, Mara, took Marina up in her arms and began telling her the facts of life, Marina felt a sudden strange curiosity and tried to kiss her on the lips. Around this time, in early puberty, she began masturbating, which became a regular activity even though it was accompanied by predictable and well-practiced feelings of shame. Her entry into adolescence added new layers of awkwardness and misery to a childhood already marked by loneliness; her body was becoming her own, but ownership of it was a terrible burden.

Puberty also brought with it Marina's first migraines, inherited from her mother. About twice a week Danica would come home early from work with a monumental headache and cloister herself in her darkened bedroom. Though the pain was enormous, Danica never complained. Milica would put cold slices of meat or potatoes or cucumber on her daughter's head—"there was always something on her head," Marina remembers—and the slightest sounds in the apartment were strictly prohibited. When Marina's migraines began—she suffered from weekly attacks—she got no sympathy or support from her mother, who was busy with her own pain. For at least twenty-four hours, Marina would lie in bed, occasionally rushing to the bathroom to vomit. The retching was so violent that she would often shit simultaneously, and this explosive double evacuation went on until her system was completely empty. The uncontrollable heaving and straining magnified the headache further. When she was finished, for the moment at least, she staggered back to bed and started experimenting with ways to dwell in pain. Instead of writhing around or panting in panic, she trained herself to lie perfectly still in particular positions, perhaps with her hand resting on her forehead, or her legs perfectly straight, or her head tilted a certain way. The slightest movement within this precarious contract with pain would mean another descent into agony so overwhelming that it became terrifying—she felt like

she could die. Migraines were times of traumatic existential discovery for Marina: they meant getting intimate with her body as nothing more than a vehicle for pain, a vessel in which bare existence was nothing but punishment. The moment she accepted this situation, Marina was able to surrender and fall asleep.

The next day, she would wake up in ecstasy. "That feeling after a migraine was one of the most wonderful feelings in the world, like total happiness," Marina says. "Everything is still and wonderful and in the right place. You could not have a better feeling." The clarity of her mind, the luminosity of the world, the jubilation of deliverance—it was like being born again each time. Not least, there was the satisfaction of having triumphed over pain.

Menstruation, masturbation, migraines: Marina's private world of withdrawal was expanding and taking on new complexities that fascinated her. Having long felt sad and sorry for herself because her mother never demonstrated affection and there was no joy in family life, Marina now had these new reasons to remain sequestered in her bedroom, and more besides. She would get home from school on a Friday afternoon, go straight to bed and read books from the family library—she was a precocious reader, devouring Dostoyevsky, Kafka, Proust, and Gide—for the entire weekend, getting out of bed only for meals. Painting was becoming an obsession too. Her first paintings were portraits and still lifes, and, more imaginatively, diagrams of journeys from the outer reaches of the universe to the center of the earth. At night she would go with friends to the National Theater in Republic Square, not far from Makedonska street, and sneak round the back to steal the canvas stage backdrops to paint over. One of them was too long to fit in her studio and had to poke out the window. Perhaps it was on this canvas that Marina attempted her most fantastical painting yet: "It was a circle, like a cosmos, and then a string and an embryo developing into a human and then going back into a vortex." The smell of turpentine hung about her, and she had to wear gloves to school to cover the stains on her hands from the cheap, nearly unwashable house paint she used.

While still at the gymnasium (as school was called), Marina began going to the university to hear the annual lecture series delivered by the Hungarian lawyer-turned-explorer Tibor Sekelj. "He was like a door into an unknown place which I wanted to explore," Marina says. Sekelj spoke about South American tribes, expeditions in Nepal, and Indonesian storytelling rituals, stoking Marina's desire to escape the strictures of her mother's home and see the world. Such was Marina's passion for Sekelj's lectures that she thought nothing of going to the university by herself as a young teenager—and with no encouragement or assistance from her parents. "It's incredible, this grown-up feeling we had in Yugoslavia," Marina says. "Like you've never been a kid."

Art classes were the only pleasurable thing about school. Marina was pathologically shy, nervous even about walking on the street, and physically awkward—her ungainly early adolescent body earned her the nickname "giraffe." She was also educationally stunted by her unwillingness to admit that her eyesight was so bad she

couldn't read the chalkboard. Eventually she was equipped with glasses, though her reluctance to wear them would never diminish. She was too proud to confess that she needed them, too vain to be seen in them, and enjoyed too much the unique view of the world given by her astigmatism and shortsightedness. Figures appeared hazy and elongated, just like in the paintings of El Greco—a style some have attributed to an astigmatism. El Greco was Marina's favorite painter; she felt a special connection ever since Danica told her that his name had been the first words out her mouth (a story they both enjoyed believing).

Marina was a diligent, anxious student. When she got good grades in school, Danica would question the teacher who gave them, and demand that they be more stringent. Marina's one satisfaction in school, her captaincy of the chess team, quickly turned into yet another source of shame. During a school assembly, she had to walk on stage—decked out in orthopedic shoes for her flat feet (the shoes had a metal plate like horse shoes and made a clanking sound with each step), thick glasses (for once), and "hair cut in the wrong way"—to collect a prize for winning a chess tournament: a stack of chess boards for everyone in the team. Predictably, she tripped as she left the stage, the boards went flying, and everyone laughed hysterically. Marina stayed in her room for days after this embarrassment, and quit the chess club.

When she was about fourteen, Marina asked her father for a set of oil paints. She got these and something more: a painting lesson from the prominent Informel artist Filo Filipović, an ex-Partisan and a friend of Vojo. He arrived at Marina's studio carrying with him his paints and also a box of decidedly nonpainterly materials. Marina said she wanted to paint the sunset. Filipović cut up a canvas into a rough, irregular shape and smeared on glue and bitumen. He tossed some gravel into the mixture, and added some yellow, red, and white paint. Then—executing a radical Informel technique heralded by the Zagreb painter Ivo Gattin in the late 1950s—he poured turpentine and gasoline onto the concoction and set it alight.[14] "This is a sunset," he declared. When the fire went out and the canvas had cooled and hardened some hours later, Marina pinned the charred, crumbling mess to the wall and left it there in direct sunlight while she went on vacation with her family.

Marina took long summer vacations throughout her childhood, but these did not relieve her claustrophobia. With Vojo absent most of the time and Danica backed up by Milica and Ksenija, any home—winter or summer—was an oppressively matriarchal place. In the early 1960s, her mother bought a house in Premantura, on the southern tip of Istria in the Adriatic. It was next door to the house of Danica's friend Mirjana Krstinić, who was secretary for education and culture in Croatia. Danica's brother Djoko also had a house in the neighborhood. The idea of this summer residence was to bring the branches of her family together in a haven of fresh air and cleanliness (Danica had the impression that Croatia, being coastal, was a more hygienic place than Serbia), all in the presence of her distinguished friend. But somehow the visits of the families never coincided, and for Marina it was never

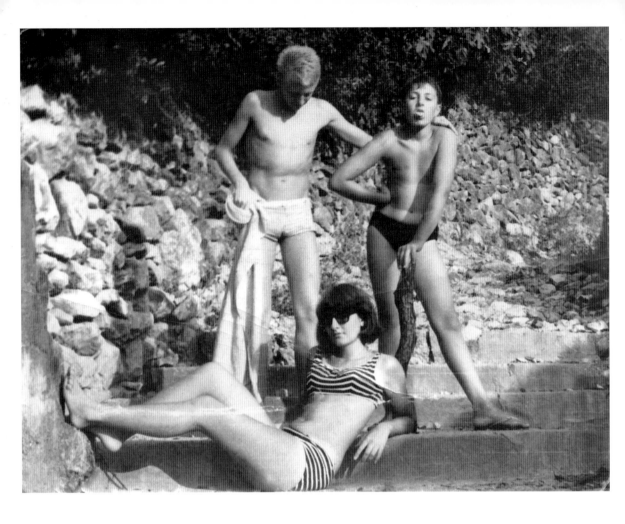

3.1
Marina and Velimir with a friend at
the beach in Opatija, Istria, 1962.
Courtesy Abramović archive.

the nurturing and idyllic spot it was intended to be. She was reluctant to swim in the sea because of an overwhelming, and narcissistic, fear of sharks: she believed they knew that *she* was swimming there and would deliberately come to eat her in particular. Velimir was unafraid, but more casually oblivious than cavalier. A pudgy child who rarely roused himself to any activity, he had already earned the lifelong nickname *buco*—fatso.

After spending some weeks by the sea each summer, Velimir and Marina would be sent to the mountains in Bosnia with their grandmother. Through Vojo and Danica's connections, they stayed in one of the dozens of residences Tito had built around Yugoslavia but rarely, or never, used. Tito had a thirst for opulence: his villas, even if he never saw them, were grotesquely luxurious, with taxidermied animals adorning the walls. There was always one master bedroom into which rental guests were never allowed; stories would accrue as to whether or not Tito had ever actually slept there. Even in the mountains, Marina felt like she was in prison. There were no other children in the neighborhood, and even if there were she probably would have been too shy to approach them. Instead she was stuck playing billiards with Butzo under Milica's strict supervision.

When Marina returned home from the vacation that followed her Informel painting lesson, the canvas she'd stuck on the wall had disintegrated into a pile of debris on the floor. She was fascinated by the transience and ephemerality of this material thing—just as she'd been captivated by Vida Jocić's story of how she became a sculptor, though Marina didn't make the connection at the time. The brazenness of the painting destruction got under her skin: she took a liking to demonstrative and dangerous activities. Around this time, Vojo gave her a pistol as a kind of coming of age gift. Marina thought of it as the type of small, elegant gun that would fit into an aristocratic lady's purse when she went to the opera. In the woods outside Belgrade, Vojo gave her a lesson in how to shoot, but Marina lost the gun in the snow. Nonetheless, now she had a feeling for a gun. One day while her parents were out, Marina and a friend, a boy, took Danica's pistol from beside her bed and decided to play Russian roulette. "He put the gun on his temple and shoot and nothing happened," Marina recounts. "I put it on mine and shoot and nothing happened. Then I took the pistol and I shoot into the library and the bullet go straight into a book." In one version of this oft-told story, Marina claims that the book was Dostoyevsky's *The Idiot*. A few years later she would make a proposal for a performance that involved her playing Russian roulette, this time alone.

When she was around sixteen, Marina returned home one evening and, while waiting at the bottom of the stairs for the elevator to arrive, heard footsteps and heavy breathing. Looking up, she saw a man she didn't know slowly descending the stairs with his hand inside his trousers. She couldn't decide whether to run or wait for the elevator. It arrived just in time. She got inside the car and pulled the lattice iron door closed just as the man got to the bottom of the stairs. The elevator was halfway to the second floor when the man reached up and held it. Marina was now perfectly

safe inside the elevator car looking down on the man, and she became fascinated by him and felt smugly powerful. "Just look at me," the man pleaded, while he masturbated inside his trousers. The next day Marina's mother arrived home from work flustered and furious. This was not an unusual state; 2:30 p.m. was always the time of day when Danica returned home and "restrictions arrive," Marina recalls. But as Danica called the police and started shouting hysterically about a perverted man, Marina knew that the same thing must have happened to her, and she found this very amusing.

Danica considered men unhygienic and untrustworthy. This outlook was informed, and perhaps justified, by Vojo's constant philandering. Danica was extremely lonely and fragile behind her rages and her rigid public mask, but Marina had little sympathy at the time for the way jealousy and bitterness "distorted" her mother's character. The arguments between Marina's parents were relentless and violent. On one occasion, Danica woke Marina up in the middle of the night and used her as a human shield so Vojo wouldn't beat her. Another devastating row came on one of their wedding anniversaries. They had just finished dinner and Vojo made the unprecedented gesture of washing the dishes, even though they had a maid to do it for them. Marina was on drying duty. Vojo accidentally dropped one of the champagne glasses they had been drinking from, and it shattered on the floor. Danica screamed that he didn't care for the marriage just like he didn't care for the champagne glass. Her tirade went on for minutes, with Vojo remaining uncharacteristically silent and calm. When it was over, Vojo took the remaining eleven champagne glasses and smashed them one by one on the floor, saying "I can't listen to this eleven more times."

When Marina was in her early teens, she found her parents' divorce papers hidden between folded sheets in the laundry cupboard. They didn't actually separate until some time later, and in the intervening period Marina never told her parents that she knew their secret. Ksenija believed that Danica and Vojo delayed their separation specifically to avoid hurting Marina, since she was at a vulnerable age. After a final epic fight between her parents in 1961, when Marina was fifteen, Vojo came into her room in the middle of the night and announced that he was leaving. He went to live in a hotel before moving in with Vesna Vukosavljević, a woman he had been having an affair with for several years; he later took charge of her child from her first marriage and largely disappeared from Marina and Velimir's lives. Marina suffered badly after the separation. She visited her father occasionally in his hotel and saw him at the university where he now gave lectures on military history. Marina would watch the end of the lecture and meet him for coffee, all the while waiting for him to tell her about the woman she knew he was in love with and planning to move in with. He never told her.

On one occasion, Marina snuck into the theater near the end of her father's lecture, hoping not to be seen, only for her father to point at her and declare, "This is my daughter." All the students turned around and laughed hysterically when they saw her—the realization of Marina's worst nightmares about public appearances.

She ran out of the theater crying, not knowing why everyone was laughing at her. Decades later she found out the reason from Goran Djordjević, a student who had been in the theater that day. Vojo had been in the midst of describing various war wounds. "I had a piece of grenade blow one of my balls out," Vojo said. "I was thinking it was a disaster. But you should see what kind of daughter I made." At this moment the dark-haired, svelte teenage Marina had entered the theater. Vojo's one-testicle story was legendary among the youth of Belgrade, since he told it to every class he taught. Everyone knew it except Marina.

In the summer of 1963, Danica sent Marina to Paris, a city she considered the pinnacle of culture and civilization, for some intensive language study at the Alliance Française. Marina stayed at the home of some Yugoslav diplomats who lived part-time on the same floor as the Abramović family at Makedonska 32. It was Marina's first time away from home alone, and she wrote dutifully to her mother:

> Yesterday I went to a reception in the residency in our embassy. There were some children from Zagreb there who had been visiting, and a chorus singing. It was received with great enthusiasm. I also met Milla and Vladimir—they are the son and daughter of the ambassador here in Paris, Miktor Miković. Today maybe we are going to see the car race Le Mans. Tomorrow we are going to the swimming pool, which is very luxurious. . . . For next week I got tickets for a Bach church organ concert.[15]

No unruly behavior for the sixteen-year-old Marina, free from her mother for the first time. Only Bach, days of long walks (from which she developed varicose veins that would bother her for the rest of her life), afternoons in the Louvre, and sitting in cafés reading classic French literature. Marina was the paragon of high culture that her mother had raised her to be. Still, the letter does not mention the incident that would be Marina's abiding memory of the trip: she was sitting in the Jardin du Luxembourg, about to eat a banana. Her hygiene-obsessed mother had always taught her to wash bananas before eating them, since they came from Africa and carried strange germs. Marina had never seen a pissoir before, and assumed it was something like a public washbasin. So she walked over and began washing her banana in it, only to glance over and see a man pissing in it. Not hygienic at all, but certainly instructional for the innocent Marina.

About a year after Vojo had left home, Marina saw him and Vesna kissing on the street. Vojo pretended he hadn't seen his daughter, though they had clearly registered each other. Marina ran home, crying hysterically. Ksenija recalls how there was "some kind of alarm in Marina's room": Milica was calling Luka, Ksenija's husband, to "save Marina"—she was threatening to jump out of her third floor window. They had to call a doctor to calm Marina down. While extreme, this was not atypical behavior. Marina was becoming increasingly histrionic, disaffected, and melancholic. Not knowing where to pour her excessive energy except into the ongoing battle with her tyrannical mother, she retreated to the fort of her studio.

One day, to defend it from Danica, she collected dozens of tins of brown shoe polish and smeared their contents all over the walls. This dirty protest worked: Danica opened the door to see what was going on in her daughter's studio, and turned away, mortified, slamming the door in horror and leaving Marina alone.

SELF-MANAGEMENT

Abramović passed her entrance exams to the Academy of Fine Arts in Belgrade and began studying in 1965 in the ornate white campus building near the old Kalemegdan city fort, overlooking the river Sava. Painting was the compulsory course at the academy, which was fine for Marina. She was painting radical subject matter but in a traditional style that suited the academy. She became fascinated with car accidents, and collected photos and articles from newspapers as preparatory material. She also used her father's police contacts to find out about serious crashes, and would arrive on the scene to make sketches and take photographs. Marina was absorbed by the narrative of the crash, by its violence and its immediacy, but was frustrated by her inability to translate this into painting. In her first year at the academy, she exhibited her truck accident paintings both at the Belgrade Workers' Union center and at the Dom Omladine (House of Youth) gallery.[16] She also exhibited paintings—probably still lifes and landscapes rather than car accidents—at the October Salon, an annual show of academic painters.

While Marina was striving to break into public life, Velimir was trying to withdraw from a brief moment in the spotlight. His gift for poetry had been evident since childhood. A Zen-like line of his that Marina always cherished described how "building the abyss under a bridge is a task for the most advanced builders." At the age of fifteen, a collection of his poems, SMEOP, was published by NOLIT (New Literature), and he had been interviewed about it on television. Velimir hated the attention and expectation that came from the exposure of his talent, and resolved never to be a public figure. "You go before the audience and the audience is conducting you," Velimir says. "Or, if you conduct the audience and you are completely dedicated to them, you are not you anymore." The contrast with Marina's nascent struggle for public recognition—and, later, for a kind of public service in her art—couldn't be greater. Theirs was a complementary sibling dynamic that established itself early and never changed: Marina was anxiously hyperactive, obsessively productive, and always striving for public recognition; Velimir happily assigned himself the opposing role of slowness, of private contemplation, and adopted an air of defeated contentedness.

During her time at the academy, Abramović painted bulbous nudes and brooding portraits as well as traffic accidents, most of them boldly signed "Marina" in large letters—the way her hero Picasso signed his canvasses. But the first time a firm idea emerged in her work is in the small 1965 painting *Three Secrets*, the earliest work—and the only painting—Abramović chose decades later to exhume from her archive and present in a monograph.[17] The painting depicts three pieces of fabric—red,

4.1
Abramović in her studio, circa 1969.
Courtesy Abramović archive.

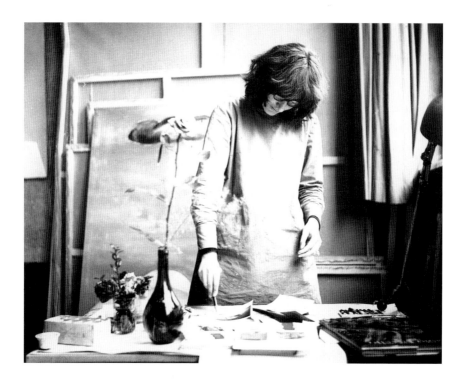

green, and white—draped over three mystery objects. The real unveiling of this painting came in a 1980 update where Abramović presented it alongside a sculpture that replicated the painting as precisely as possible, bringing it into three dimensions: three actual sheets of the same colors shrouding three actual unseen objects.

A portrait Abramović painted of her friend Evgenia Demnievski in 1968 shows her wearing a yellow scarf, her sickly pale face scrunched up in an expression of grave existential profundity, her frowning eyes looking defiantly away from us. Despite Abramović's strenuous expressionistic efforts in her paintings, and her growing interest in the body as subject matter, she hadn't yet found a way to express her charisma and power. She and her peers at the academy were starting to feel a vague ambition to create a new kind of art, but the academy was not the place to realize it. The events of 1968 were crucial in giving the students confidence in their cultural voice and, more importantly, a platform to use it.

Even though Danica and Vojo were so active in the Party, politics was rarely a topic of discussion in the household as Marina grew up. With her parents' illustrious war record and prestigious public roles, political and economic hardship were absent from Marina's life. Vojo's expulsion from Tito's elite guard and the threat of him being sent to Goli Otok had been kept secret from the young Marina and never discussed subsequently. His principled resistance to the pomp and propriety of Titoism was epitomized by an incident after Marina joined the Union of Pioneers—Yugoslavia's version of the ubiquitous communist youth groups in Eastern Europe. She was delighted to receive her *marama*, the red scarf that symbolized her passage into young adulthood and proud nationhood, and lay it by her bed so it would be close to her as she slept. In the morning the *marama* was missing. Vojo had taken it: he'd tied it around his head to sculpt his hair into his trademark backcomb. As a teenager, Marina was more interested in the "walk-through-walls" determination of communism than in its ideological intricacies. She cut out stories from the newspaper that she found funny but still inspiring in their blind earnestness. She gives the abstract example: "250 workers died in an explosion in a mine, but production goes on."

Joining the students' communist league at the Academy of Fine Arts was a way for Marina to follow in her mother and father's footsteps, although she didn't experience it this way at the time. The shyness of her early adolescence was falling away, and her exuberance and charm won her election as vice secretary of the academy's party organization. It was an ambitious beginning, but the year 1968 turned out to be both the apotheosis and the termination of her interest in politics.

Belgrade's part in the student uprisings around the world that summer began on June 2, sparked by a dispute with the university authorities and the heavy-handed police over the venue of a performance put on by a Youth Action group of Brigade Workers in the student accommodation complex in New Belgrade. The pettiness of the dispute reflected a deeper anger with the growing inequality in Yugoslavia, with the "red bourgeoisie" and interminable bureaucracy of the party oligarchy, and with the unfulfilled promise of democratic reform in the regime of "self-management."

4.2
Vojo Abramović speaking in Marx
and Engels Square in Belgrade, 1968.
Courtesy Abramović archive.

Though she hardly suffered from these issues, Marina shared the students' frustration as they saw strictures all around them in Tito's Yugoslavia and feared for their future as unemployment grew, especially for college graduates.[18]

Since the 1950s, Tito had enacted relatively laissez-faire reforms in the Yugoslav communist system, shifting from a Stalinist command economy toward a unique program of quasi-independence for municipal and industrial bodies in which the workers shared in profits and ran their own factories (though the state still had the final say). It was crucial for Tito to distinguish Yugoslav communism from Stalinist communism during the Informbiro period; and with his model of "self-management" he believed he was being more authentic to Marxism than the Soviets were: he was allowing workers to decide upon the results of their labor. In 1952, inspired by Marx's Communist League of 1848, the Yugoslav Communist Party had been renamed the League of Communists, signaling the attempt (which was ultimately half-hearted) to draw a boundary between party and state, and to decentralize government. It was hoped, or the hope was widely professed, that the state would "wither away."[19]

Instead, a "new class" of power-hungry bureaucrats entrenched themselves in power in Yugoslavia, and in every other communist state. This was the diagnosis of Milovan Djilas, who'd been a commander alongside Tito in the war. Djilas was considered a potential successor to the premiership of Yugoslavia until he published a series of articles in 1954 calling for much greater democratization than had been put in place already. He was expelled from government, and in 1956 was imprisoned for nine years for his support of Hungary's revolt against the Soviet Union, which was now on speaking terms again with Yugoslavia. One year into his prison sentence, Djilas's massively influential book *The New Class* appeared, defining from firsthand experience a "Communist political bureaucracy [that] uses, enjoys, and disposes of nationalized property" at the expense of the collectivization they originally advocated.[20] Djilas's determined dissidence—he never stopped writing books attacking the contradictions in communist power—was an inspiration for Marina and her fellow students in 1968.

After mass demonstrations through Belgrade, they occupied university buildings, most importantly that of the philosophy and sociology faculty. Leaflets were distributed demanding the "suppression of the great inequalities in Yugoslavia." Marina was part of the group occupying the art academy building at the university (separate from the Academy of Fine Arts where she studied). Buildings were covered with posters bearing slogans such as "down with the red bourgeoisie" and "show a bureaucrat that he is incapable and he will quickly show you what he is capable of."[21] The streets filled with riot police and the university campus was sealed off except for one exit point for students exhausted by the standoff.

Vojo Abramović attended many meetings in support of the students. Marina watched as he gave a speech in Marx and Engels Square, crowning his disillusionment with the embourgeoisement of communism in Yugoslavia by throwing away his party membership card triumphantly in front of the crowd. It was an indication

of the relatively liberal nature of Tito's regime that he felt able to do this at all; in any other Eastern European country he would have been arrested immediately. "I was very proud of him," Marina said. "And my mother was completely against him." She was also completely against Marina's participation in the protests, even though Danica had been far more politically radical in her day. The next morning Vojo's party card was returned to him by some comrades. He would need it if he wanted to draw a pension.

After another all-night meeting, the student action committee formalized a seven-point program, which called for full employment and democratic reforms to the League of Communists, and demanded that "Privilege in our society must be liquidated."[22] Significantly for Marina and her comrades at the Academy of Fine Arts, the program also stated that "Cultural relations must be such that commercialization is rendered impossible and that conditions are created so that cultural and creative facilities are open to all."[23] Specifically, the Faculty of the Arts at the university demanded that the social club of the secret police in Belgrade, where the wives of officers met on Sundays to play chess, do needlework, and watch films, be turned into a student cultural center.

Tito announced that he would address the nation on TV on the evening of June 10. At a general assembly that morning among all the student chapters, Marina was appalled that the only discussion was about arranging the party that night after Tito's speech. "I said: 'Excuse me, but we don't know what Tito is going to say—how can we make the party?'" Marina recalls. "And they said: 'Don't be so naïve. Whatever he says, it's over.' Then it clicked in my head that it doesn't make sense. Whatever he says, it's over. That means the whole thing was just a joke. I felt so unbelievably betrayed."

As it turned out, Tito's response to the students was remarkably positive, though tactically so. He praised their political engagement and declared it the fruit of self-management. While he gave no substantive response to most of the students' demands (apart from the major concession of doubling the $12-a-month minimum wage), the students felt vindicated by Tito's rhetorical support, which was at odds with the voice of the government and the newspapers up until that point (the media subsequently apologized for the tone of its reporting, saying they had misunderstood the students' message).[24] The students ended their occupation of the university buildings, set off fireworks, and paraded triumphantly across Belgrade, as they had always planned to do. Marina did what her father had done a few days before: she threw her party membership card away—but she threw hers into a fire. Despite the disappointing end to the protests, the students won something concrete and extremely important: the City Committee did indeed agree to turn the secret police social club into the Studentski Kulturni Centar. When the SKC opened nearly three years later, Abramović would use the space to leap from painting to working with objects, to sound, and then to her first performances—experiments she could not have undertaken anywhere else in Belgrade.

<div style="text-align: right; font-size: 2em;">5</div>

LIFE IN ART

After the demonstrations, Marina began joining in the intensive discussions about art held by four of her fellow students at the academy: Raša Todosijević, Gera Urkom, Neša Paripović, and Zoran Popović. These four had known each other since the early 1960s, having studied together in a drawing and graphics school in preparation for the academy. They were later joined by another student, Era Milivojević, and a group formed, more through natural cohesion than any firm decision. There was no manifesto, no declaration or publication, and not even a name apart from the retroactively applied "group of six" or Group 70, after the year they realized that together they were a force. Since the promised SKC still hadn't been delivered, there was no forum for them either. Marina's studio became a regular meeting place, and they would talk late into the night, reviling and ridiculing the sedate art practice forced upon them at the academy.

The establishment style was academic modernism, a holdover from the 1950s that addressed pictorial problems only and contained no real political or critical dimension. Marina's professor, Stojan Ćelić, a well-known artist in Yugoslavia at the time, was exemplary in this. He painted gestural geometric abstractions in muddy colors, usually beige. This nonthreatening academic art had emerged when the break with Stalin in 1948 ended Yugoslav artists' brief engagement with Soviet-style socialist realism. In 1950 the Third Plenum of the Central Committee of the Communist Party of Yugoslavia had resolved that free artistic expression was a necessary part of the nascent project of self-management. The Second Congress of Artists resolved the same year that "It is necessary to resist the uncreative naturalism which the artists of the USSR intend to impose on the whole world as Social Realism."[25] Popović for one was well aware of the achievement of the postwar artists in gaining the liberation of art from heavy political lifting duty. But the alternative, academic modernism, was "too formal, just playing with color and composition," Popović says. This conservative style of painting, which had represented Yugoslavia at the Venice Biennale since the early 1950s and was entrenched by the 1960s, was nonetheless looked upon suspiciously by Tito. In the mid-1960s, he made several speeches against abstract art, insisting that it "may only be used as a decoration" and "cannot be a tendency in painting that could negate realistic creation."[26]

Popović, Abramović, and the others in the group of six wanted to jettison these old debates about whether figuration or abstraction best served social and political ends, and whether political ends should even be served at all in art. Instead, Popović says, "Our generation in my opinion wanted to give eros in art, to put life in art." In

this sense—and only in this sense—did they agree with Tito when he lamented how young artists "escape into abstraction, instead of shaping our reality."[27]

Abramović in particular was ready to "put life in art" by somehow channeling her demonstrative personality, though she was some way off discovering a way to do it. Despite her portrayal of herself—in paintings and in later accounts of her life—as a shy and sad youth, her friends at the academy remember her as an exuberant young woman confident in her beauty, fabulously gifted in communication—"famous to get under your skin," as Popović puts it—and almost obsessively optimistic. During one of her first classes at the academy, her professor had declared, "To be an artist, you must have balls." Marina had felt bludgeoned by this prevalent attitude when she started her studies, but now as she approached graduation and had the support of the group of six, her self-belief and determination had grown. She carried her mother's social power and physical presence within her. She wasn't concerned about being the only woman in the group of six artists; if anything, she enjoyed the attention it got her.

Even as they talked about transcending pictorial painting, Abramović still painted figuratively—prolifically and with gusto. She used bigger canvases than any of her peers at the academy could afford, about five-by-five feet. Along with the car crash paintings, Abramović's interest in the ephemeral and the transient continued in a new series of paintings featuring clouds. These "clouds" were formalized shapes, symbols of clouds rather than realistic studies. Abramović developed a taxonomy of clouds: repeated, cookie-cutter clouds, clouds extracted from the earth, clouds as projections, dark clouds that "roll in and fall like bombs." And in many of these cloud paintings there appeared a giant, fleshy, lumbering body, heaving in the sky, and usually seen from behind. (Abramović made studies from the same model, a plump old woman, for years, but only once drew her portrait.) Eventually Abramović's sky emptied out and she painted a large white and silver canvas with just a single cloud in it.

While Abramović continued to work diligently at the academy, Todosijević was in a state of passive resistance. "My last two years in the academy I almost didn't work," he recalls. "This was the only way to beat the situation in the academy." The group still hardly knew what the new art they craved would look or feel like. One professor became so exasperated with Urkom's vague resistance to everything he was being taught that he once exploded and asked him point blank: "What do you want?!" Urkom replied calmly and assuredly: "I don't know. But I know what I don't want."

There were in fact plenty of indications of what they might want in the plethora of recent avant-garde groups in Yugoslavia, though none had penetrated Belgrade yet. The academy venerated only Paris; they had little regard for the progressive art groups, such as Exat 51, Gorgona, and OHO, that had appeared on their doorstep in recent years. The OHO group emerged in Kranj, near Ljubljana in Slovenia, in the mid 1960s when Iztok Geister (also known as IG Plamen) and Marko Pogačnik published a concrete poetry edition of their student newspaper. The name OHO was an elision of *oko* (eye) and *uho* (ear), and it heralded an art based on pure apprehension.

Pogačnik and Plamen wrote in the OHO manifesto: "Objects are real. We come close to the reality of an object by accepting the object the way it is. But what is the object like? The first thing we notice is that the object is silent. Yet the object has something to give!"[28] They believed that a subject-object relationship obliterated the qualities of objects as autonomous things. Following Duchamp's readymades, their notion also presumed the integration of an apprehension of art with an apprehension of life. But while Duchamp wanted to interrupt common objects, to allow new thinking to attach to them, Plamen and Pogačnik wanted people just to see the thing itself, unadulterated by any thoughts at all.

OHO's pioneering new mode of relations to physical objects and collapsing of art into life opened psychological territory for Abramović and her colleagues at the academy. OHO were also among the first to practice performance art in Yugoslavia. At the Moderna Galerija in Ljubljana in 1969, group member David Nez performed *Cosmology*, in which he lay down in a circle drawn on the floor, his limbs outstretched, with a light bulb hanging just above his stomach, and, through controlled breathing and meditation sought to harmonize his body with the cosmos. This was also the start of OHO's transcendental turn, which led to their final activity in 1970 and '71: a retreat, a way of life, which they called "Schooling." In a rural commune in the tiny village of Šempas, Slovenia, they analyzed and conceptualized all of their activities, from eating to breathing and walking. Life was not so much integrated with art as swallowed whole by an aesthetic and meditative sensibility; every nuance of behavior was understood as being profoundly important, and performative. Even conventional art practices like still-life drawing were conducted under the rubric of a larger exercise in observing and living life like it was art.

OHO participated in the fourth Yugoslav Triennial of Contemporary Art in Belgrade in 1970. When they gave a talk at Dom Omladine, Abramović was in the audience and stood up to speak in support and admiration of OHO's activities. "That was very interesting to us because we knew her pedigree," says Ješa Denegri, a curator at the time at the Museum of Contemporary Art in Belgrade, who would later champion the work of Abramović and her colleagues. "She was a daughter of a person who was absolutely unpopular here in this world," Denegri recalls, and he was impressed that she was standing so firmly with the avant-garde rather than the establishment art world that Danica represented. The group of six artists were curious about OHO to start with. But when they retreated into the commune for their Schooling and began growing tomatoes and potatoes in circles, "I thought it was ridiculous," Urkom says. "All the villagers were laughing at them."

Though the group of six talked feverishly about finding ways out of traditional painting, they were more interested in older figures like Kazimir Malevich and Marcel Duchamp (as were Gorgona and OHO), and, more contemporaneously, in Arte Povera, Conceptual art in the U.S., and the social-mystical nexus of Joseph Beuys. Abramović was also interested in Beuys, and more so in Yves Klein, but her real fascinations were Zen Buddhism, the theosophy of Madame Blavatsky, the

anthropological studies of Tibor Sekelj, and the writings of the Romanian historian of religion Mircea Eliade, rather than the work of other artists. "Artists are always inspired by something," Marina says, "so why should I be inspired secondhand? Rather than looking at artists for inspiration, I always wanted to look to the source."

In 1969 Abramović made her first foray into the Conceptual art that she and her friends talked excitedly about. She made a proposal to Dom Omladine to do a performance involving the public, called *Come Wash with Me*. It would be totally different from the genteel openings of her recent painting exhibitions in establishment venues like the foyer of the Dadov Theater, the Yugoslav People's Army House, and the gallery of ULUS, the Union of Serbian Fine Artists. Abramović wanted to convert the gallery into a laundry with sinks installed around the walls. Upon entering, the public would be asked to take off their clothes and give them to Abramović, who, taking on some of her mother's obsession with cleanliness, would wash, dry, and iron them. When visitors' clothes were clean and crisp (though how they would dry in a reasonable time isn't laid out in Abramović's proposal), they could get dressed again and leave. The proposal was refused.

As Marina was preparing for her graduating exhibition in 1970, she gave her studio over as a venue for a performance connected with the annual Belgrade International Theater Festival. Marina watched as a student broke eggs over a naked woman. The performance was filmed by the Croatian structuralist filmmaker and performance artist Tomislav Gotovac. The influence of Viennese Actionism and Yves Klein had arrived in Belgrade, but here such activities still fell within the realm of theater rather than visual art. Caught on camera in the background during the performance, Marina looks embarrassed and a little bewildered at this raunchy activity. The walls of her studio were lined with the paintings that were the culmination of five years' study: giant nude bodies lumbering around, stretching and reclining on bare architectural blocks, with peanut-shaped clouds hovering about them. Now, here was a real naked body right in front of Abramović, and yet: "I didn't get it. For me it was stupid," Marina says. It would take another year or so for the full revolution to take place and for Abramović to free herself of painting and start focusing on direct, unmediated objects, senses, and experiences, but in the film, you can see the wheels starting to turn behind her bemused countenance. "Who the fuck needs more paintings?" Gotovac said to Marina that day, which was the first time they met. "Today one has to paint with cunt and dick." She took an immediate liking to him.

Gotovac had been one of the protagonists in the first Happening in Zagreb, in 1967, which was a lot more raucous than its forebears in the U.S. in the 1950s, and closer in spirit to the provocations of Dada. According to later reports, the piece, called *Happ naš* (*Our Hap*), involved Gotovac and fellow artists Hrvoje Šercar and Ivo Lukas "drinking milk, eating bread, and smashing a kitchen cupboard on stage, as well as playing instruments they did not know, and throwing paper balls and live chickens into the audience."[29] Gotovac's physical exuberance and wicked sense of humor is also evident in an earlier action—this one done just for a photograph, not

for an audience—called *Showing Elle Magazine* (1962). Gotovac stands shirtless and shivering in the snow in a forest, holding open a copy of *Elle* to a page with a photo of a woman in an elaborate bra. In a brilliant transposition of a raw communist winter onto a media-consumerist fantasy, Gotovac is the one smiling; he is the one comfortable enough in his body to bear it triumphantly in ridiculous circumstances. Many of his films had the same gung-ho approach and deadpan humor: the only subject matter of *Blue Rider* (1964) was the awkward reaction of people in cafés and restaurants in Zagreb who suddenly found themselves under the observation of Gotovac's roving camera.

Gotovac was studying in Belgrade at the Faculty of Dramatic Art when he met Marina (Velimir would later study alongside him in the film department). He took her regularly to the Kinoteka cinema around the corner from Makedonska and gave her an education in film history. "He would know every single scene, every single character," Marina says. "He would know all the actors and even the extras in Kurosawa by name." Gotovac talked to Marina about the construction of scenes and compositional techniques. "He really gave me a kind of view on how to see," Marina says. He was the first to cultivate Marina's formal and dramatic intuition, which struggled to find expression in her sluggish paintings.

Marina was becoming increasingly frustrated with painting: she couldn't make it convey the clarity and emotion of her ideas. She considered creating an exhibition that would take her long-term interest in car accidents out of the pictorial realm. She wanted to park two huge trucks right in front of a gallery, their lights shining into the space. She would empty out the gallery, just as Yves Klein had done with the Galerie Iris Clert in Paris in 1958 for *Le Vide* (The Void), an event Marina was familiar with. "I wanted to create this paranoia situation with the trucks like huge strange enemies and the motors running and the smoke of the burning motor filling up the space," she recalls. But she could not find any space willing to take on the project. Klein was one of Marina's few beacons in the world of art since she shared his mystical sensibility mixed with a subversive sense of humor. She especially liked his declaration that his paintings were the "ashes" of his art—maybe it reminded Marina of her Informel painting lesson.

In 1970 Abramović made another proposal, again to Dom Omladine, for an absurdly risky performance. Had the proposal been accepted, it would have been her first performance; it could well have been her last. Abramović wanted to stand in front of the audience in her normal clothes, then change gradually into the kind of clothes her mother always bought for her: a dowdy skirt down to her calves, heavy synthetic stockings, orthopedic shoes, a white cotton blouse with red dots. It would be like putting on her own straitjacket. Then she would put a pistol to her head and pull the trigger. "This performance has two possible endings," Abramović wrote.[30] It seems incredible that she would have really been willing to risk her life so brazenly; she must have known that the proposal would be rejected. Still, the idea lays bare Abramović's war with her mother. "I dreamt to kill her. I felt I could not breathe.

5.1
Abramović at the opening of an exhibition of her
cloud paintings, probably at Dom Omladine, 1970.
Courtesy Abramović archive.

I had these wild dreams where I was on Hitler's side against my whole family and I woke up in sweat," she says. "Everything I was doing was always wrong. Always this terrible air of discipline. I had to escape that. I wanted to put all my destiny on the line." It was either Danica's vision of her, and death, or Marina's own vision, and life—even if it was cut short.

Abramović's radical ambitions continued in tandem with her public appearance as a harmless and charming young academic painter. Rather than the Russian roulette performance at Dom Omladine, she put on an exhibition of her cloud paintings there instead. The opening was a traditional affair, with classical guitarists entertaining guests as they politely sipped wine, and Marina dressed up smartly, which for her at the time meant wearing a neat wig over her long, thick hair.

Around this time, Danica was appointed director of Belgrade's Museum of Revolution. Whenever heads of state visited Yugoslavia, part of the itinerary would be a trip to the museum, and Danica would give the guided tour. (A few years later she gave Tito himself a tour, in front of a scrum of photographers.) Danica served simultaneously as the Yugoslav representative for UNESCO and would often travel to its headquarters in Paris. Though she was an intimidating figure, the extent of Marina's difficulties with her was never apparent to the group of six artists. They felt that Marina exaggerated Danica's beastliness, and rarely saw Marina as morose as she claimed to be. Urkom recalls how one evening around this time the group of six were chatting in Marina's studio as usual, and Danica suddenly entered—not with chastisement but with a plate of pancakes for everyone.

The frustration she was feeling—with her mother, with the artistic environment, with Belgrade's smallness—was in part sexual, and so was the energy behind her increasingly aggressive performance proposals. She was still a virgin, though it was not for lack of interest in sex. "Before I lost my virginity I really masturbated a lot because I had so much energy and so many restrictions and I could not have an output," she recalls. With a curfew of 10:00 p.m. enforced by Danica even though Marina was now in her early twenties, she could not go to the parties where liaisons were usually made. She decided to put an end to her virginity with a carefully thought-out plan that resembles a proposal for a performance—except this one she got to act out, finally. Marina had watched her friends get their hearts broken by their first loves, "so I always thinking: Okay, I will never lose virginity with someone I love. I have to lose virginity like a matter of fact." She went for a man in the art academy known as the biggest womanizer. She invited herself over to his house to "listen to records." Sure, he said. When? Sunday at 10:00 a.m., Marina suggested. Usually at this time she would be watching cartoons at the cinema—even in her twenties—so Danica wouldn't be suspicious about her whereabouts. Marina arrived at the man's apartment, made coffee, and laced it with the cheap Albanian cognac she'd brought with her. Predictably, the sex was painful and embarrassing—and made worse by the fact that the man quickly realized he was being used. "He threw me away and said, 'Who do you think I am?'" Afterward, "I could not even think of sex for one whole year; it was so horrible, the

5.2
Danica Abramović (right) gives Tito (second from
right) a tour of the Museum of Revolution, 1974.
Courtesy Abramović archive.

whole experience." But the encounter was successful in one sense: Marina's experiment in separating out her emotions from her body had worked, at least in the moment when she demanded it of herself.

In her last year in the academy, Marina fell in love with fellow artist and group of six member Neša Paripović. He was a quiet, contemplative man, a foil for Marina's extravagant energy and anxiety. He was not conventionally handsome, and looked older than his thirty years. Marina was maybe more pacified by him than attracted to him; his appeal may have been that he never competed for the oxygen of attention. Their relationship was not particularly passionate at first, and Marina had a brief affair with their mutual friend Era Milivojević during a bus tour, organized by the academy, of churches in Italy, France, and Spain.

After graduating from the academy—she received a grade of 9.25 out of a possible 10, entitling her "to the professional title of academic painter, and thus all rights associated with this title"—Marina immediately went to the Academy of Fine Arts in Zagreb for a post-diploma in the master workshop of the painter Krsto Hegedušić.[31] Marina's place there was probably secured by her mother's connections, since by this time it was clear that Marina had no special talent for painting. Marina despised the hint of favor, but went to Zagreb happily and urgently, thrilled to escape her mother's yoke for the first time. After she had been away from Belgrade a few months, Neša began suggesting in letters that he and Marina should not be together any more. Egged on, Abramović rushed back to Belgrade and married him on October 21, 1971. Urkom was Paripović's witness at the registry office; Vesna, an old friend from school, was Marina's. Danica did not approve of the wedding and didn't attend; neither did Marina's grandmother, which upset her more. Vojo provided the rings, and took everyone out to lunch afterward at a deserted restaurant on Mount Avala, just outside Belgrade.

Paripović followed Marina to Zagreb and also studied under Hegedušić, who had been teaching there since 1945. Traditional Informel painters like Ordan Petlevski and Ferdinand Kulmer, as well as members of Gorgona, had all passed through Hegedušić's master workshop. He may have represented the older generation of painters whose practice seemed irrelevant to Marina and her friends, but he welcomed

5.3
Marina marries Neša Paripović, October 21, 1971.
Courtesy Abramović archive.

experimentation from his students and Marina had great affection for him. "Artists basically have one good idea in their lives," Hegedušić told his class. "Two if they are lucky." Marina was still searching for hers; she mostly worked on plans for projects that could never be realized. Instead of painting clouds, she developed the idea to paint *with* clouds, using skywriting planes. She visited the airport to make enquiries about how she could hire a plane (it was too expensive). She also drew diagrams of installations that would expose people to sensory extremes—the brightest light and then the pitchest dark, the loudest noise and the most muffled silence. She also proposed a piece of transient land—or rather sea—art on a grand scale: an image with a small mountainous island creating a pyramid against the horizon, a speedboat moving toward the island and leaving a trail of white water, and, along the same axis, a plane flying away from the island leaving a trail of smoke. This would create the illusion of a continuous vertical line intersecting with the horizon over the island and forming a cross.

While she was staying in Zagreb, Marina got to know a fellow student named Srebrenka Ilić. "She was very disturbed mentally," Marina says. "She was constantly talking about suicide. I was always so fed up with her. I said go and do suicide and leave us alone." Srebrenka phoned Marina one afternoon, asking her to come over, but it was raining hard, Marina was reading, and she fell asleep. That night Srebrenka made triply sure of killing herself by cutting her wrists, turning the gas on in the kitchen, and hanging herself with an electrical cord. "I was so mad," Marina says. "Everybody was so mad on her. This funeral was so full of anger. I said, 'Come on, fuck it, she's beautiful, why do all this shitty stuff?'" After the funeral Marina went back to her tiny one-bedroom apartment—Neša was not there at the time—and lay down on the bed. When she woke up, or perhaps when she was still asleep, Marina saw Srebrenka sitting next to her amidst a blue light. "I really freaked out," Marina says, and she had to sleep somewhere else that night, though she continued to feel the presence of the woman when she returned to her apartment. This was a continuation of the sensitivity to supernatural energies Marina had felt since she was a child, when she feared the presence of the entity, and when the mysterious book of the cosmos appeared on her bed. But her response to Ilić's suicide also signals something rather more concrete. Marina always felt emotionally weak herself, and had difficulty engaging with this kind of vulnerability when she saw it in other people. Instead, an emotional severity emerged, a kind of ruthless and unforgiving love of life that ignored or obliterated weakness.

6

NEW ART FOR A NEW SOCIETY

The old secret police social club, in central Belgrade close to Nemanjina ulica, the street where government ministries were located, was a kitschy mock-castle building made from large yellow breezeblocks. It had a turret with a winding stair, a large theater space, a bar and lounge, a room ripe for conversion into a gallery, and a courtyard. Three years after the student demonstrations and the League of Communists' promise to hand over the building, it finally opened as the SKC in April 1971. It was significant that this building in particular, the epitome of the insidious oligarchy the students had been protesting, was now being handed over for student use. But Tito's reward to the students for their tenacity in 1968 was a tactical gift: let them have their voice, and let it be contained safely within this building. Zagreb and Ljubljana already had their student cultural centers; it was only fair that Belgrade should get one too.

Dunja Blažević, a recent graduate in art history from the University of Belgrade, was appointed director of the SKC's gallery. She was the daughter of Jakov Blažević, president of the parliament of Croatia since 1967—another factor in assuring tolerance for the SKC by city authorities. Blažević and the directors of the other departments of the SKC—film, theater, music—developed their programs over the course of a year before the SKC opened. The Institute of Contemporary Arts in London was their model for an experimental, multidisciplinary center like no other in Belgrade—more accessible than the Museum of Contemporary Art, more adventurous than Dom Omladine, and much bigger than Atelje 212, one of the only other contemporary art spaces in the city. Blažević's aim was nothing less than articulating a new art for a new society. There was a luxurious chandelier in the foyer, which was removed immediately, and Marina and her colleagues in the group of six tore down the elegant wood paneling on the walls of what would become the SKC gallery.

Blažević knew Danica before she knew Marina, since they were both well-connected figures in the art and party establishment in Belgrade. So Marina was well placed to persuade Blažević to allow her and her fellow graduates from the academy to start using the SKC gallery space. Here it was possible to make and exhibit their art almost immediately, without a bureaucratic process of application, review, approval, and wrangling over funding (which came from the University of Belgrade). This would be Marina's real postgraduate education.

The SKC became an open salon for ongoing discussions between Blažević, the group of six and many other artists, together with the new generation of art historians and critics recently graduated from the university, like Bojana Pejić, Jasna Tijardović,

6.1
Some of the artists who showed work in
"Drangularium" at the Student Cultural Center,
1971. Standing, from left: Gera Urkom,
Stevan Knežević, Raša Todosijević, Zoran Popović,
Neša Paripović, Srebrenka Ilić, Bora Iljovski,
Florijan Hajdu, Era Milivojević. Sitting, from
left: Evgenia Demnievski, Dunja Blažević,
Marinela Koželj, Marina Abramović. Courtesy
Abramović archive.

Biljana Tomić, plus, crucially, the more established figure of Ješa Denegri. They were all hungry for something other than the modernist orthodoxies of official Yugoslav art. For the first exhibition at the SKC, Blažević suggested the idea of a "Drangularium"—in English, a trinketarium. Around thirty artists of all generations were invited to exhibit everyday objects that they wouldn't normally consider to be art, but which held special significance for them. The concept was inspired by the Arte Povera of Jannis Kounnellis, whom Blažević had met on her many trips to Italy, and the idea that cheap or discarded materials could be the basis of sculpture. Marcel Duchamp's recategorization of found and appropriated objects in his readymades was another crucial influence, and more locally, OHO's belief in the power of banal objects may also have played a part. Abramović commuted from Zagreb, where she was finishing up her post-diploma, to take part in the exhibition. She brought a small rug made of lamb's fur that happened to be a similar shape as the clouds she was still painting at the time. She also exhibited a peanut shell, pinned to the wall, along with two objects she found on the street: a house number, 334, made out of metal, and a giant clownish pair of spectacles. "The question is: where is the truth?" Abramović wrote alongside her work in the small catalogue the SKC published for "Drangularium." "Is it really what we see that we actually see, or is it what we think we see that we see." Clearly, she was seeing clouds everywhere at the time.

Unlike Abramović, Urkom understood the brief to be to bring in a mundane object that had absolutely no artistic or even aesthetic associations. "Most objects which surround me and which serve me, when I single them out, acquire a meaning with no connection to my will—a meaning which I did not wish. For this reason I have exhibited my green blanket, which has not meaning against my will. It is only one green blanket." Abramović's friend Evgenija Demnievski brought in the door to her studio—"a practical object with which I am in contact every day through the door knob." Popović brought in a photo album, a radio, and a chess set. He later realized that these items represented his overarching artistic interests: picture, sound, mind. During the opening of the exhibition, Popović was at the local radio station making a broadcast that played through his radio at the SKC. Todosijević exhibited his beautiful girlfriend Marinela Koželj, who sat next to a blue nightstand with a bottle on it. "I have no rational excuse for the objects I have exhibited," Todosijević said. "I do not wish them to be interpreted as symbolic, associative or that they are given or taken away some attributes."[32] "Drangularium" wasn't a manifesto outlining the aesthetic ambitions of the artists at the SKC; it was barely even coherent. "As objects they were *comme ci comme ça*," Todosijević says. "But as an atmosphere it was a turning point. After 'Drangularium' everything became different." For Abramović, it was the first time she managed to do something other than paint.

Abramović was developing a formidable professional ambition. She created something called the Center for Amplified Art, which was barely more than the letterhead and logo that Popović designed, to try to make contacts with the art world beyond Belgrade. Abramović hired a friend who worked at the American embassy in

Belgrade to write letters in English (despite years of private tutoring, Marina's English was still poor) to museums and galleries around the world requesting catalogues and information on how to apply for exhibitions. Expecting a high volume of mail in return, Marina constructed a large wooden mailbox for the doorway of Makedonska 32. One letter sent out in 1971 was to the Institute of Contemporary Arts in London, written in urgent capital letters, asking to exchange material and information. The letter ended: "WE HOPE THAT WE SHALL MAKE A PERMANENT CONTACT."[33] Milivojević once visited Marina in her studio and found her making a list of the most important galleries in New York. He recalls, "Besides her art practice, she was always scanning the art system. She was doing two parallel things."

Marina relished the new independence she found through the SKC. She spent all her time there, and the decaying apartment she grew up in—void of any emotion or conversation, and, for ten years now, void of her father too—became just a place to sleep. She was stuck in a frustrating living arrangement: even though she was married to Neša, and even though the apartment was big enough to accommodate him, Danica would not allow him to move in (they could not afford a place of their own). She could not even get permission for him to stay overnight. Danica thought Neša was too lazy and drank too much to be a suitable husband for her daughter. On the rare occasions when Neša did sleep with his wife, he had to sneak out of the house in the morning before Danica woke up. Marina blamed her mother for not allowing Neša to move in; Ksenija, representing Danica's position, remembers the situation differently: it was Neša's equally tyrannical and overprotective parents who wouldn't allow Neša to move in with Marina or vice versa. What no one considered was the possibility that Marina was deliberately keeping her husband at a safe distance so that he could provide comfort without her having to order her life around him. Apart from their brief time together studying in Zagreb, they would never live together.

That summer Marina made a bid for freedom by purchasing a house in the tiny village of Grožnjan in Istria, inland and north of the Abramović holiday home in Premantura. Grožnjan was something of an artist colony, and Marina bought the house as a summer getaway from one of her old professors at the academy in Belgrade, Miloš Bajić. She made payments with money saved from the menial jobs she worked: in recent summers she'd restored historic mosaics and frescoes in Poreč, Istria, which was normal work for art students (Urkom also did it); she also helped set up conventions and trade fairs in Belgrade and cleaned the interiors of newly constructed buildings—another common job for students. The security of her background—the fact that all her basic needs were automatically taken care of—meant that she was able to save all the money she earned from these jobs and put it toward professionalizing her art practice and making her first tentative steps toward escaping Makedonska 32. But she remained living there nonetheless, only visiting Grožnjan occasionally. There were cultural and pragmatic reasons for this: it was normal for young adults to remain in their parents' home in Yugoslavia—most of her peers at the SKC did —and

on top of this Marina had her own free studio there. But the fact that she remained under her mother's roof for so long, even though she found it so oppressive, indicates an attachment to her mother that was much stronger than she cared to admit.

In August 1970 Marina and Neša had been in Grožnjan for the village's arts festival, where together they had made a painting after Piero della Francesca and hung it by a village restaurant. They returned to Grožnjan the next year to take part in the exhibition "Action T-71" organized by the local Gallery T-70.[34] Neša suspended a monochrome red canvas across the town square as the sun came up, and called it *Red Square*. Urkom and Popović also participated in that year's festival. Urkom proclaimed his mere presence in Grožnjan a work of art; Popović leaned three five-meter planks against a wall and painted parallel lines on them. Abramović's contribution was, for her, an unprecedented foray into land art: in a small area of scrubland, she painted all the stones blue.

Momentum was building after "Drangularium," and Biljana Tomić, who stepped into Blažević's role while she spent a year in the U.S., immediately put on the exhibition "Objects and Projects." Abramović's project was called *Liberation of the Horizon*: she took a photograph of Republic Square, and then whited out the surrounding buildings during the printing process. She developed this idea over the next couple of years, taking photographs of unremarkable, postcard-like street scenes in Belgrade and then erasing most of the buildings in the background. The National Theater in Republic Square gets blotted out, leaving a white void behind the statue of Mihailo Obrenović III (prince of Serbia twice in the mid-nineteenth century) on his horse. In another image, Abramović wiped out the Old Palace of the Obrenović dynasty, which was used as the city's political assembly. Nothing remains in the picture but the lawn in front, a few cars framed against the empty sky, and people walking by. Abramović may have been inspired by the persistent airbrushing that went on in her mother's Museum of Revolution, where purged ministers and party members were erased from the enormous official photo-murals on the walls. But she was turning this peculiarly violent technique in another direction. Her images give a sense of Belgrade's obliviousness to the outside world, the claustrophobia Marina felt in the city, and her desperation to get free—she changed the name of the series to *Freeing the Horizon* when exhibiting them in full two years later.

Just one month after "Objects and Projects," Tomić and the SKC artists put on an exhibition to coincide with the annual October Salon. Though not explicitly described as an alternative October Salon, the exhibition was an announcement that the SKC wasn't going to be the obedient institution the authorities had hoped. Abramović was still straddling both worlds: her paintings had appeared in the October Salon the previous year, as they had in 1968 and 1965.[35] Danica had recently enrolled Marina in the Union of Serbian Fine Artists (ULUS). Members were assured of exhibiting in the Salon, and they were also assured of state benefits and a pension at the age of sixty-five. On the fancy membership card, which came in a little wallet backed in fake leather, Danica signed on her daughter's behalf and described her

6.2
Era Milivojević tapes Abramović to a bench
at the Student Cultural Center, 1971. Courtesy
SKC archive, Belgrade.

(wishfully) as an "akademski slikar"—academic painter. Without Marina's knowledge, Danica continued to pay her membership dues to ULUS for the next thirty years. Even after Marina had left Yugoslavia, and not picked up a paintbrush in decades, Danica still wanted to preserve the image of her daughter as a proper painter, and guarantee her a pension should she need it.

When people arrived at the SKC after seeing the official October Salon, nobody could figure out where the art was. Popović simply presented stationery and called it *Office Art*. Urkom made photocopies of objects until they became faint to the point of invisibility. But the most radical and insidious works were Abramović's. After progressing from painting to objects in "Drangularium" a few months before (though she still tinkered with painting over the next few years), she now abandoned objects to work with the immaterial: sound. In a tree on the corner outside the SKC she set up a bullhorn speaker that emitted the recorded sound of birds singing—a knowingly gratuitous and comic overlay on nature. Inside the gallery she installed three cardboard boxes concealing tape machines playing the sounds of bleating sheep, the wind, and the sea. With sound, Abramović realized a way to remove the conventional art object that, for her, interfered with something more important: immediate physical and mental experience.

The exhibition in October 1971 also arguably marked Abramović's first performance, though it was more a spontaneous outflow of her normal extrovert personality, and it was a part of Milivojević's work, not her own. Milivojević had just covered a large mirror in the SKC lounge with packing tape, molding a kind of interstitial, fuzzy sculpture made of almost nothing on something else that was almost nothing: translucency over a reflection. It was a strenuously small gesture that generated a muffling effect on people's images in the mirror. Meanwhile, in another part of the lounge, Abramović lay down on a table for no particular reason other than that she was tired (and always physically demonstrative). Milivojević decided to mummify the prone Abramović with his tape. With no explanation, he began sticking strip after strip across her from her mouth down to her feet. Abramović immediately accepted what Milivojević was doing. Apart from her keen sense of fun, maybe she felt like one of the models in Yves Klein's *Anthropometrie* paintings—the beautiful passive tool in a domineering act of creation. This impromptu performance was a

6.3
Abramović's sound installation of collapsing concrete outside the Student Cultural Center, 1972. Courtesy SKC archive, Belgrade.

key moment for the cohesion of the group of six artists and their closest allies. "Everybody who was for it, stood there," Urkom recalls. About eleven people, including the group of six, Biljana Tomić, Ješa Denegri, Marinela Koželj, Jasna Tijardović, and Bojana Pejić, watched avidly. "But everybody else moved away because it was shocking. Evgenia [Demnievski] was standing there and then she moved away, disgusted."

While the group of six artists were close friends and consultants on each other's work, they never directly collaborated. Each work—even Milivojević's mummification of Marina—only ever had a single author. There was nothing like membership in the group of six, only a kind of voluntary commitment. Those who weren't so committed, like Demnievski, simply fell away. Urkom wrote in 1972:

> It's not that we shared the same attitude toward art, so much as we would say that the closeness of our views originated from similar viewpoints toward life. During the joint shows and frequent discussions over the past few years, we have worked to build a homogenous approach to art. Through our mutual effort we succeeded in establishing some elements of what we were after—thanks to the fact that the attitude of each one of us was, in a way, important to the others.[36]

What was this shared attitude—toward life, toward each other? The four original friends—Paripović, Urkom, Todosijević, Popović—were from working-class families, as was Milivojević, who in fact was homeless at this time, sleeping in squats or at the train station. Abramović came from a wealthy, high-ranking party family, but beyond the bare fact of this class difference, it didn't have any significance for the group's relationship. They all shared a frustration with the dreariness of Titoism, its stultification of individual expression, and a wish to move beyond the polarity of art's traditional roles as either purely aesthetically pleasing (as in academic modernism) or politically dutiful (as in socialist realism). Something was beginning to cohere at the SKC: a way of forcing art into life, and of enlivening art. It was part of the post-abstract, post-object work based on mental processes that critics like Ješa Denegri termed the New Art Practice. This term encompassed the process art, Conceptual art, land art, video art, sound art, and "actions" being carried out at the SKC in Belgrade and, a little earlier, by the Bosch+Bosch group in Vojvodina and the KOD group in Novi Sad.[37] But Abramović's increasingly dramatic and spectacle-based works somewhat defied the smaller, more cerebral actions common to the New Art Practice.

In 1971 Tomislav Gotovac, visiting from Zagreb, ran naked through the streets of Belgrade, as a performance. Actions by the group of six on the other hand were at this stage nondramatic gestures based more on mental concepts than physical or emotional exuberance. Popović's *Axioms*, a series of performances, photographs, and drawings, is indicative. He attached Christmas lights to each of his fingers, stood in the SKC theater in front of an audience, and had himself photographed while he made fleeting geometric patterns with the lights in the air. The time-lapse

photography rendered these patterns later as squares, circles, and crosses. No one in the SKC, not even Abramović, was yet pushing the body to extremes or trying to force a transformative experience. But when Abramović was cerebral, she was playful with it. In a group show called "Signalism" at the Museum of Contemporary Art in Belgrade around this time, she presented the concept for a computer program that would act like a "washing machine" for words—jumbling the syntax much like she would later when speaking English, reinvigorating the weary words with fresh meaning.

Abramović became almost as prolific with her new immaterial work as she had been with her painting. In February 1972 she created three new sound works at the "Young Artists and Young Critics" exhibition at the Museum of Contemporary Art. The first featured simply the sound of footsteps. Another was called *Forest*: a room with forest sound effects (wind, birds, animals), and the instructions—"This is a forest. Walk, run, breathe. Feel like you are in the forest. Write your impressions"—written on large sheets of paper tacked to the walls. This invitation to participate developed Abramović's drawing of the cosmos, *Rujan*, exhibited in Zagreb that year, which carried children's storybook-style instructions: "1. Connect stars and planets by pencil. 2. Describe your adventures in the cosmos."[38] Another participatory installation she made for her Museum of Contemporary Art show, *War*, was much tougher. Here she realized an idea conceived in Zagreb: a narrow corridor that rattled to the sound of recorded machine-gun fire as people walked through. Since her knowledge of the art world beyond Belgrade was still limited, and not many magazines were available, Abramović probably wasn't aware of Bruce Nauman's *Performance Corridor*—two plywood walls placed about two feet apart—first shown in 1969 in the U.S. Nauman's corridor was also meant for public use, but contained no special audio effects.[39]

Blažević returned to Belgrade from New York in September in time for the second exhibition coinciding with the October Salon. It proved just as provocative as the previous year's: on the glass door of the gallery, Urkom stuck a piece of paper with the declaration: "The definition of what art is not." Abramović continued working with sound, but in a more aggressively site-specific way: outside, she played the sound of collapsing concrete on a loop, giving the illusion that the SKC was falling down. She had originally wanted to install the piece on a bridge over the Sava; the Academy of Fine Arts building though, which the group of six had now happily left behind for good, might have been the most appropriate venue for the installation.

Abramović created another installation that October in a circular room opposite the main gallery of the SKC. *Sound Environment White* was not so much site-specific as site-erasing: Abramović completely covered the walls, ceiling, and floor of the room with hundreds of sheets of white paper. On the floor she placed a tape machine playing a tape that was blank except for one fleeting moment where Abramović had recorded the words "I love you." Not many people heard this message. In the end, Abramović couldn't quite leave this pristine minimal environment alone; she had to inject emotion into it. Later, Velimir made a film of Abramović and some friends

joyfully destroying the installation, tearing the paper down, tossing it in the air, and rolling around in the debris. Abramović was a natural on camera, grinning, prancing, and luxuriating coquettishly in the mess she was making.

Such playfulness was evident again in another sound piece she set up in the lounge of the SKC, which happened to resemble a departure gate at an airport. An insistent announcement played in a loop over loudspeakers: "All passengers on JAT flight to Karachi, Cairo, Paris, Rome are requested to go to gate 265. The plane is leaving immediately." This piece was a deliberate tease: as much as everyone in the SKC would love to escape the confines of Belgrade, no one would be leaving just yet. But a foreign jaunt was on the horizon for the group of six.

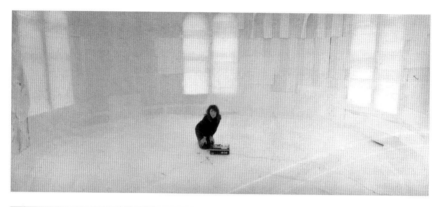

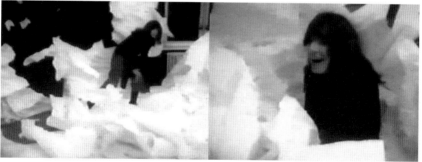

6.4
Abramović inside her installation *Sound Environment White*, at the Student Cultural Center, 1972. Photo: Miodrag Filipović. Courtesy SKC archive, Belgrade.

6.5
Abramović tears the paper off the walls in her *Sound Environment White*, 1972, filmed by her brother, Velimir. Courtesy Velimir Abramović.

SOUND MADE FLESH

In December of 1972, the Scottish gallerist and curator Richard Demarco visited Belgrade in search of promising young Yugoslav artists to present at the next Edinburgh Festival. Demarco had been to Poland, Romania, and Czechoslovakia in recent years to find artists for the festival and to try to establish links between Eastern European artists and those in the west. He went to Eastern Europe not so much to give help as to ask for it: "I realized that the British and American art world was suffering from lack of dialogue. The British art scene was weak-kneed and lacking in red blood," Demarco says. Abramović would provide some of that.

As with all his visits to Eastern European countries, when Demarco arrived in Belgrade he was shepherded by government officials and taken on studio visits of only the safest academic painters. He snuck off to the SKC, and arranged to meet the group of six artists. Marina made the biggest impression. "She was a very impressive human being, full of high voltage energy and bright as a button," Demarco recalls. He invited the group of six—plus Nuša and Srečo Dragan, artists from Ljubljana also working at the SKC, and the painter Radomir Damnjan—to participate in the next Edinburgh Festival. Demarco would accommodate the artists once they arrived in Scotland, but they would have to pay for their travel. All managed to scrape together the money, except Milivojević, who was living in a commune with another group of artists, who were far more marginalized than those at the SKC. "I had a very divided identity," Milivojević says. "There were two different ways I was getting involved: one was related to this art scene, the other was related to something that was despising the art scene." Milivojević didn't make the trip to Edinburgh and missed out on a galvanizing experience for the group, one that focused them—Abramović especially—on the possibility of becoming genuine international artists in an era when this was still an extremely difficult feat, especially if you lived in Yugoslavia.

Just before leaving, Abramović made her first video piece, though it was more concerned with audio than with visuals. *Sound Ambient White—Video* was simply a blank white screen and the sound of silence, as rendered by video and television: a scratchy hissing sound. It was a kind of portable version of the *Sound Environment White* she had just made at the SKC. In its microscopic attention toward the nuances of nothingness mediated through technology, the piece echoed Nam June Paik's blank film *Zen for Film* from 1962, though Abramović didn't know about Paik, and John Cage's silent composition 4'33" from 1952, which she probably was aware of.

Inspired by Black Mountain College, Demarco wanted to create a summer school where the Yugoslav artists could live and exchange ideas with other artists

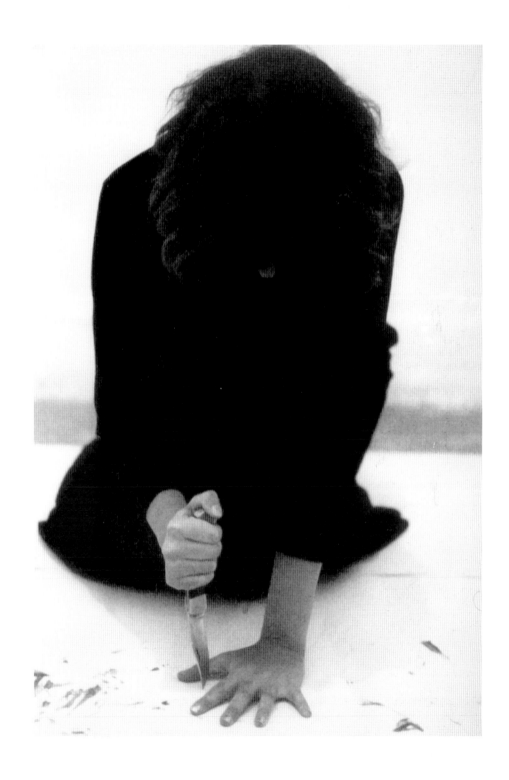

from around the world. He rented Melville College, and most of the visiting artists stayed there (though Marina and Zoran stayed with Demarco's friend Paul Ramsay). Joseph Beuys was in attendance, and gave lectures with notes and diagrams on the chalkboards—the first of his chalkboard works.

In the college's gymnasium, the Yugoslav artists made simultaneous but unrelated performances. It would be Abramović's first. She was so nervous she feared she would get a migraine from the stress—but even if that happened she was determined to perform anyway. She unrolled a large sheet of thick white paper on the ground, creating a kind of stage, and arranged on it two tape recorders and ten knives of various sizes. The sound she had been working with recently, since her progression from painting to objects to the immaterial, was about to be made flesh in a bloody and messy work called *Rhythm 10*.

Kneeling down, Abramović started one of the tape machines recording and splayed out her left hand on the paper. Then she took the first knife in the row of ten, and began repeatedly stabbing the gaps between her fingers. She had a penchant for dangerous games. Like Russian roulette, this one also had Slavic roots: it was a popular drinking game among Yugoslav and Russian peasants. The staccato sound of the knife was punctuated by occasional brief moans of pain from Abramović whenever she missed the gap and stabbed one of her fingers. Each time this happened, she put down the bloodied knife and picked up the next one in line. The blood showed up impressively on the white paper. When she'd inflicted ten wounds—none of them severe—and worked her way through all ten knives, she stopped the tape recorder and played back the results. Then, listening to the recording, she tried to replicate exactly the same rhythm again, with the same points of impact on the same hand. She recorded this second attempt on the other tape recorder. With formidable concentration, Abramović managed to turn the painful accidents of the first round into a strict program for the second round, only missing her cue to stab herself on a couple of occasions. When she'd finished the second round, she rewound both tapes, pushed play, and left her stage with the tapes running simultaneously—the rhythms of the stabs occasionally locking together.

Meanwhile, Popović set up a film camera hanging on a string and hid from its swinging gaze behind Sally Holman, Demarco's assistant. Next to Abramović's agonizing and dramatic spectacle, Popović's action was that of someone determined to avoid the spotlight. Todosijević performed *Decision as Art*, for which he placed a live fish on his prone and bare-chested body until it suffocated. Urkom made the second part of a trilogy of performances, called *Mental and Physical Works*, in which he slowly and contemplatively removed his shirt and used it to upholster a chair.

If Abramović's progression from painting to objects to sound and finally to performance in Edinburgh seems natural and logical in retrospect, she felt no plan unfolding at the time. In fact, given the proximity of OHO's performances, her exposure to her friend Tomislav Gotovac's forays into Happenings, and the proposals she had made for performances at Dom Omladine in 1969 and 1970, it had taken

Abramović a long time to make the leap into performing herself. Blažević's encouragement was crucial. "I felt that she could do more with herself than on the surface of a painting," Blažević says. "She was a born performer in front of the public. It was clear that it was not enough for her to paint."

Away from Yugoslavia unchaperoned for the first time, Marina had no intention of returning home immediately after her performances. She stayed a while longer in Edinburgh, indulging in a brief affair with Buddy Tiscano, a drummer in a jazz band that performed in the festival each night. Neša was in Edinburgh too, but even when freed from their parents' rules and on the other side of Europe, they didn't stay with each other during the trip, and Marina's excessive vitality and beauty clearly could not be contained by Neša. Tiscano's band was fronted by the artist Tom Marioni, who became a devotee of Abramović's work and later helped introduce her to the U.S. art world.

Marina and her colleagues were satisfied with what they had achieved in Edinburgh. The approval of those watching—like Joseph Beuys and the avant-garde Polish theater director Tadeusz Kantor—wasn't so important, Urkom recalls (as it happened, Beuys approved but Kantor didn't); what mattered was that after the performances the group of six artists approved of each other. In fact, Todosijević and his girlfriend Marinela Koželj were "pissed off" by the star treatment Beuys was receiving at the festival and decided to make posters of him emblazoned with the name "Josephine Beuys," which they tried to sell for £5 each. "We were expecting some reaction," Todosijević says.

After the festival, Marina found a job delivering mail. A couple of weeks in, she decided to throw away all the letters on her round that looked like bills and deliver only those with nice handwriting on the envelope. She was promptly fired. Demarco found Marina another job, even though her English was still poor, in an architectural firm that designed interiors for ships. After assuring her employers that she knew what she was doing, Marina set about making her first drawing. First, she spent a long time drawing lines on the paper to mark out a grid. When her employers realized what she was doing, she was presented with some readymade graph paper. "In my country we don't have," Marina protested in her broken English. She was asked to leave.

The group decided to move to London, taking up the offer of accommodation and employment made by a wealthy businessman they had met in Edinburgh. He was renovating a building on the Portobello Road into a restaurant, and he needed painters and decorators. The group of six happily took on the work, and Marina also wrote the menus in French. When that job was finished, Marina and Zoran began working in a factory that made the Newton desk toy with swinging steel balls. They were prolific in their production of the toys and outearned all the other workers there. Marina puts the success down to their communist work ethic, but Popović assigns it to his natural aptitude for fiddly tasks and the fact that the foreman of the factory was madly in love with Marina.

One Saturday afternoon, the smitten foreman took Marina to a cemetery adjacent to a football stadium. The funeral going on at the time was accompanied by cheering and singing from the nearby football fans. Marina loved the surreal contrast, as the foreman knew she would. He was on the brink of going to Belgrade to ask Danica for her daughter's hand in marriage. Neša already had that, though it was easy to forget the fact. Their relationship was becoming increasingly platonic and protective, a matter of expedience and security rather than passion. A price list of their paintings that they drew up together at some point during their relationship is a rare mark of their interdependency, and of a shared aspiration—though it was probably Abramović who typed it out. Among a couple of dozen works on offer, Abramović's *Plavo cveće* (*Blue Flowers*) was priced at 150,000 dinars (an ambitious $2,500), and Paripović's *Mrtva priroda sa satom* at 250,000 dinars. Neša did not work in London, but rather ambled around the house that the group of six-sans-Milivojević shared in Notting Hill while Marina and Zoran earned the rent. "Neša is a man who lets things happen," Velimir says. "He concentrates on his work, but he doesn't work very much. Whenever there is an inner compulsion to do something, he does something, but not like Marina, who always wanted to do twenty-five exhibitions at once."

Marina and Zoran went to the nearby Serpentine Gallery in Hyde Park and asked if they could show their work there. "We'll see," was the only reply they received. Marina began spending time at the nearby Royal College of Art. RoseLee Goldberg, who had just graduated from the Courtauld School of Art and would soon become a prominent historian of performance art and a close friend of Marina, was running the gallery at the Royal College, and she secured one of the college's video cameras for Abramović to use. Abramović came up with a fifteen-minute piece called *Television Is a Machine*, in which the camera intimately examines every surface of a TV from multiple angles, showing her hand turning it on and off. Gotovac's influence is palpable here, in the comically cold eye being cast over a seductive piece of technology. Marina's first experience with a TV—she and Velimir had gazed for hours at the test picture when Vojo first bought a television for the apartment—also played a role in her meditative fascination.

In the same period, Abramović also used a Super 8 camera for the first time, to make two films of swans swimming in the Serpentine, the lake near the Royal College. She projected the two reels side by side so it appeared that the two swans were swimming endlessly toward each other without ever meeting. The space between their loping curved necks made a perfect heart shape. The emotional, physical (as in physics too), and conceptual anticipation of two bodies meeting in the middle of a space would recur in her later performances.

While Marina was enjoying artistic and existential independence, back in Belgrade Danica was getting anxious. Marina had been away from home too long. Danica applied on her daughter's behalf for an assistant professorship at the art academy in Novi Sad. Danica being who she was, they gave her daughter the job. Marina received a phone call in London with an offer she was not permitted to refuse.

8

RITES OF PASSAGE

Since she was thirteen years old, Marina had kept every note left for her by her mother and father and every letter written to her. She had no purpose in mind, just an inability to let this evidence of attention and interest from other people slip through her fingers. But she also had difficulty in grasping onto it. She would wait weeks before opening letters; when she finally did, it was usually too late to answer. For a show called "Six Artists" at the SKC upon their return from London, Abramović retyped the first sentence of one hundred of the letters and notes collected over the past fourteen years, and displayed the truncated notes on the wall, creating a haiku-style profundity through reduction. The first note begins (and ends, in the exhibited version): "Dear little girl. In the fridge you have yogurt, milk, cheese, butter, and eggs"—indicating the typical mode of maternal nurturing in the house: well-resourced, but remote.[40] Other notes read: "Dear Marina. We received your letter, I can tell you that you keep surprising us more and more," "Dear Marina. I regret that I was obliged to call the police to trace you" (this one was from her mother; Marina had tried to run away from Makedonska 32), and "Comrade Marina Abramović, We remind you one more time that you have not accomplished your obligations toward the group" (this one was from the Union of Serbian Fine Artists). Through this systematic editing, Abramović managed to make the sender and subject matter of the letters mysterious but not the recipient—she was always center stage. Nonetheless it was significant that Abramović now felt able to convert the stored energy (and neurosis) of her youthful hoarding into artwork.

Marina was disappointed to be returning home after her adventure in Edinburgh and London, but in the following year she was prolific in a way she couldn't have been while working menial jobs in London, and ambitious in a way she couldn't have been without the support of her colleagues at the SKC. In order to leave Yugoslavia properly, she had to go back there first. She signed a contract with the Novi Sad Academy of Fine Art on December 22, 1973 for 1,995 dinars a month—more money than she'd ever earned before.[41] Her teaching workload was almost laughably small, so she immediately continued to concentrate on her own work. She performed *Rhythm 10* again in Rome late in 1973 as part of the exhibition "Contemporanea," curated by Achille Bonito Oliva. While in Italy, Marina met the American performance and video artist Joan Jonas, the Italian artists Gino de Dominicis and Francesco Clemente, and the composer Charlemagne Palestine, among many others; she was delighted to be plugging herself into the international art world again after Edinburgh. And in repeating *Rhythm 10*, she upped the stakes, using twenty knives rather than ten. "It was

8.1
Joseph Beuys talking to Abramović and other
artists at the Student Cultural Center, Belgrade,
1974. Courtesy Abramović archive.

a lot more bloody," she says, but as in Edinburgh, she managed to repeat in the second round almost exactly the mistakes she had made in the first round. This delicate balance of ruthless control and painful surrender characterized a whole series of *Rhythm* performances that Abramović was about to undertake.

Since 1972 the SKC had put on an annual festival called the April Meeting, in which international artists were invited to perform and exhibit work alongside SKC regulars. For the 1974 edition, Joseph Beuys was the star guest. Having already met him in Edinburgh, Marina made sure to spend a lot of time with Beuys while he was in Belgrade, and they were photographed together in deep conversation. Beuys was in the audience in the SKC courtyard the evening that Abramović performed *Rhythm 5*. First, she set out on the ground a large wooden-framed five-pointed star with a hollow inside, big enough to lie in. She then filled the frame with wood chips, poured on gasoline, and set the star on fire. Beuys warned Abramović that it would be dangerous to get too close, but she began her performance undaunted. A large crowd watched as she circled the star a few times, sometimes stretching out her arms in a crucifixion-like pose. Then she cut her nails, hacked off her long hair with scissors, and tossed it all into the flames. She stepped over the fire and lay down in the empty middle of the star, her arms, legs, and head splayed out into its five points—hence the "5" in the title of the piece (it was less clear where the idea of rhythm came into play). After a few minutes of lying motionless surrounded by the fire, a flame began to lick her leg but she did not react in any way. The onlooking Radomir Damnjan, the painter who was part of the Edinburgh contingent, and Urkom realized that Abramović must have lost consciousness due to the fire consuming all the oxygen from the center of the star. They jumped over the flames and hauled Abramović to safety. (It wasn't Beuys who rescued her, as rumor later had it—he was "too small to lift anyone!" Todosijević notes.) Afterward, Abramović was annoyed that the performance had been interrupted—not by Damnjan and Urkom, but by her loss of consciousness. She resolved that from now on, the possibility of losing control like this would be encoded into the performance itself and wouldn't halt it prematurely.

Marina asked Gera if he had liked the performance. "It was great," he said. "You are not lying?" Marina probed, even though they never sugared their responses to each other's work. Abramović had just demonstrated shocking mental and physical courage, but was still vulnerable in her craving for approval. Twenty-seven years old, she still had to be home that night before her 10:00 p.m. curfew, returning to what she felt was her "parallel reality" living under her mother's roof. Danica was outraged when she found out about Marina's performance. Not only had her daughter risked her life in a bizarre and brazen public ritual, she had also done something disrespectful and perhaps even dangerous with the beloved communist star. In Tito's (by now) fairly liberal society, there was no chance of any direct punitive response, though Danica probably feared for the subtle effects this act of iconoclasm might have both on her and her daughter's career.

8.2
Marina Abramović, *Rhythm 5*, Student Cultural
Center, Belgrade, 1974. Photo: Nebojša Čanković.
Courtesy Sean Kelly Gallery, New York.

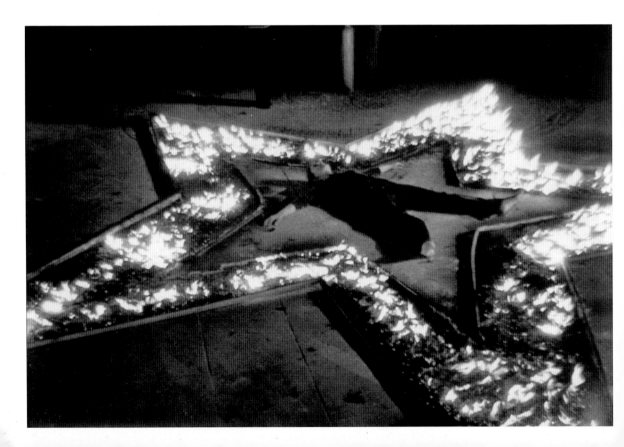

In setting fire to the five-pointed star and almost dying inside it, Abramović had symbolically exaggerated an obligation—self-sacrifice for the state—and enacted it to defeat it. She was taking on the heroism of her parents and the mythology of Yugoslavia, but most of all she was taking on herself. If politics was on the surface of the piece, more transcendent and primordial motivations lay beneath. It was a rite of passage—she would end up going through many of them in her performances—and a self-set test of courage that she passed, having pushed her body beyond the realm of will power and into unconsciousness. Cutting off the transient parts of herself—the hair, the nails—was a ritual of cleansing and regeneration, after which Abramović burnished herself in the fire. While everyone else saw communism in the star, Abramović saw an archetypal symbol with multiple ancient religious and mathematical associations from Mesopotamia to the Pythagoreans, to early Christianity and the occult. She was trying to harness the symbolic power of the star, or perhaps confront it. For Abramović, *Rhythm 5* was one stage of a desperate quest for personal more than political liberation. Through performance, she was learning a new and exhilarating feeling of freedom—a feeling that she would need to renew constantly.

Todosijević also made a spectacular and painful performance at the 1974 April Meeting. *Drinking Water—Inversions, Imitations and Contrast* was an adaptation of his performance in Edinburgh the year before, *Decision as Art*. He took a live fish from a tank and left it flapping on the ground. While the fish suffocated through lack of water, Todosijević tried to suffocate himself by drinking glass after glass of it—he managed twenty-six glasses in thirty-five minutes—until he reached a point where he was regurgitating every new gulp over a table in front of him, which he had covered with purple pigment and a white sheet of paper. When the paper was thoroughly soaked and the dye seeped through and covered the entire table, he allowed himself to stop, though his original aim had been to stop when the fish died (this took too long). More dramatic and polished as public spectacles than the elusive, gestural, and mental activities of other artists at the SKC, Todosijević's and Abramović's pieces were powerful mixtures of conceptualism and physicality. With Abramović especially, extreme emotion and catharsis made for a communicable, high-impact kind of art.

In *Rhythm 2*, performed at the Museum of Contemporary Art in Zagreb that October, Abramović atoned for her loss of control in *Rhythm 5* by making an entire performance based on a *planned* loss of control. She procured two pills from the hospital: one that forces catatonic patients to move, and another used to pacify schizophrenics. Sitting at a table in front of a small audience, Abramović took the first pill. She soon went into paroxysms and a mechanical grin spread tightly across her face. She was mentally aware of everything, but physically out of control—at one point doubling over and almost falling off her chair. The pill wore off after nearly an hour, and in a surreal interlude Abramović turned on a radio and listened to Slavic folk songs for a few minutes. Then she took the second pill, which plunged her into a stupor and put another grin on her face, this one more placid but equally vacant.

8.3
Marina Abramović, *Rhythm 4*, Galleria Diagramma,
Milan, 1974. Courtesy Sean Kelly Gallery, New York.

Abramović was totally unaware of herself during the five hours it took for this medication to wear off, which marked the end of the performance. Again, Abramović was taking a concept to the absolute limit, and again in the hope that some kind of liberation or illumination would result. If *Rhythm 5* had been a test of conscious courage, *Rhythm 2* (the title referenced the two pills) was a kind of tyrannical self-enforced surrender. Control was becoming Abramović's central theme. Each time she exerted control so maniacally that she forced herself to a point of involuntary, total surrender, it was like a preparation for death, even if the performance didn't always physically put her in danger of dying. She came out the other side humbled, emptied, and triumphant.

After performing *Rhythm 2*, Abramović was given several rooms in the museum to install a piece that would last for the duration of an exhibition. Returning to sound, and the sense of physical presence it could evoke, she positioned a metronome in each of the galleries and set them at a speed she felt appropriate to the dimensions and atmosphere of the room. She was casting herself as a kind of medium, giving an aural readout of invisible forces, and an echo of her memorable presence in the space.

Abramović was gaining momentum and professional determination. There seemed like nothing else to do but carry on, faster, harder, pushing her body to new extremes and taking greater, more exhilarating, but always calculated risks. Around this time, Biljana Tomić was traveling in Italy with Marina, and they were riding in a car with Giancarlo Politi, the editor and founder of *Flash Art* magazine (Marina was already adept at cultivating contacts). In Tomić's recollection, Marina said to Politi, probably preening and pouting only half-jokingly: "Do you think I am still young enough and beautiful enough to be a famous artist?" Politi said yes, definitely. (Marina has no recollection of this incident, and says she never felt beautiful and didn't care about being a famous artist, only a good artist. Increasingly though, recognition and fame would be a side effect she was very happy to have.)

In the performance *Rhythm 4*, at Galleria Diagramma in Milan later that year, Abramović continued her research into the limits of what she could control. Alone and naked in a room with a high-power industrial fan, she was recorded by a video camera that broadcast the images to the public in a room next door. Abramović pressed her face against the fan, attempting to fill her lungs to bursting point. She fully expected to pass out again, but made contingency plans so that when it happened the performance wouldn't have to stop. She instructed the cameraman to keep a tight zoom on her face, and not show the fan at all. So when Abramović lost consciousness, the wind from the fan would move her face, creating the illusion of consciousness for the public watching the TV monitor in the next room. But the cameraman couldn't bring himself to just passively film Abramović while she lay unconscious, and he and the gallery staff stepped in after a short time to assist her. This ethical imperative was recurring in Abramović's performances despite her efforts to submerge it within the aesthetic conditions of the piece. The public couldn't treat the events as a pure performance and respect the theatrical tradition of the fourth wall between performer

and audience. Indeed, behind the heroics and inward-focused stubborn strength, it was almost as if Abramović was testing the public: How far will you let me go before giving me the attention I need?

In 1974, as Abramović broke into the art world beyond the confines of the SKC, Dunja Blažević started getting phone calls from Danica, demanding an explanation of Marina's dangerous activities. How could Dunja possibly support this? What was she doing with her daughter? "You had your artists and your time," Blažević recalls saying. "We have a right to do this. We are adults, not kids." Blažević tried to explain the context of the work at the SKC to Danica, how her artists were attempting to bring art and life together. She could have also tried explaining the international context: in the early 1970s many artists around the world were using their body as material. It was a newly demonstrative and disturbing practice, but one that had deep historical roots in the twentieth century, running through the pointedly banal, absurd, and comic actions of the Fluxus artists in the 1960s, back to the raucous Happenings of Allan Kaprow and others in the U.S. in the late 1950s, and arguably stretching back even earlier, to the theatrical provocations of Dada, during the First World War and through the 1920s. Now there was body art. Around the time that Abramović was sacrificing herself in the burning pentagram, the Los Angeles–based artist Chris Burden also made a martyr of himself (though with a bit more irony than Abramović) in a piece called *Trans-fixed*, in which he lay on the back of a Volkswagen Beetle and had nails driven through his palms. The sexuality of Abramović's naked performances had more extreme counterparts elsewhere, too: in the 1972 piece *Seedbed*, the poet-turned-performance-artist Vito Acconci masturbated under a ramp in a New York gallery while his muttered fantasies about the people walking above him were amplified through the space. Blood too was hardly unusual in the context of avant-garde art: since the 1960s in Vienna, the "Actionists" Hermann Nitsch and Otto Mühl performed rituals involving the slaughter of animals and liberal pouring of blood over a troupe of naked, often bound, performers. And in terms of audience provocation, in Paris Gina Pane was trying "to reach an anaesthetized society" by cutting her body and her face in various performances.[42] For Marina, these radical actions from around the world had the allure of myth: news of them arrived slowly, verbally, and unreliably in Yugoslavia since documentation was fitful and communication channels in the art world, especially between the U.S. and Eastern Europe, were poor.

Abramović understood intuitively the irresistible potential and power of body art. It was a way of embodying the cerebral processes of Conceptual art that dominated the avant-garde (including the SKC) at the time, a way of investing mere concepts with the physical and psychic commitment of blood, sweat, and fear. Performance went beyond theory into the realm of excruciatingly real experience both for artists and audiences, which were presented with unfamiliar ethical challenges by the demonstration of real pain and danger in front of them. Performance art was a tool with so many uses: a way of acting out autobiographical trauma or social and

political alienation, of achieving ecstasy and forcing catharsis, and of working without a traditional, easily commodified art object. For Abramović, performance was most importantly a means of initiating herself—again and again—into a sharpened state of consciousness. Her performances were constructed traumas that served as rehearsals for death—and in the meantime made her feel much more alive.

While Abramović was making radical strides in the new territory of body art during this most active period of her career to date, she nonetheless felt that things were moving incredibly slowly. She still hadn't abandoned painting completely, occasionally making dutiful portraits of her grandmother and her young cousin Tanja Rosić and a few hopeless landscapes and still lifes. Between her travels, she was still teaching in Novi Sad. It was a painting class, but Marina used it as an opportunity to inform the students about contemporary art outside of Yugoslavia. Real progress seemed to come when, in the summer of 1974, the German curator Marlis Grüterich tentatively invited her to participate in "Project '74: Performance-Musik-Demonstration," an exhibition in Cologne that would include Vito Acconci, Abramović's compatriot Braco Dimitrijević, Valie EXPORT, Gilbert & George, Antonio Dias, Rebecca Horn, Joan Jonas, Allan Kaprow, Mario Merz (whom Abramović had befriended on her trips to Italy), Nam June Paik, and Lawrence Weiner, among dozens of others. Abramović, excited to be recognized alongside the most important artists of her generation, traveled to Cologne in the run up to the exhibition in the hope of getting the final nod from Grüterich. She met Rebecca Horn, a performance and installation artist who worked with padded fabric body extensions, including a large spike strapped to the top of her head in the video *Unicorn*, 1970/72. Marina was massively impressed by the image Horn cut as a powerful independent female artist: they were having drinks with Jannis Kounellis (whom Marina had met when he visited the SKC), and when he offered to pay, Horn stubbornly replied, "I pay for my own drinks."

Marina wasn't yet in such a position of strength. After a few days in Cologne, she found out she would not be participating in the exhibition. Her devastation turned to humiliation when the organizers failed to pay for her hotel or her train back to Belgrade, so she had to appeal to the Yugoslav consulate for the money (Danica probably sent it). When she returned to Belgrade, Marina was overwrought by Grüterich's rejection and hid away for days. Her "big pride" was hurt, she remembers, and she made a bitter resolution: "You will see: one day I will make it."

Critics—including her mother—were always saying to Abramović that performance artists were unhealthy masochists, obsessed with inflicting pain on themselves. So in *Rhythm 0*, in the Galleria Studio Mora in Naples in early 1975, she decided to do nothing and see what the audience would do to her instead.[43] For six hours, Abramović simply stood still and allowed herself to be manipulated by the public in any way they chose, using any of the seventy-two items laid out on a table, which included fork, a bottle of perfume, sugar, an axe, a bell, a feather, chains, needles, scissors, a pen, a book, honey, a hammer, a saw, a lamb bone, a newspaper, grapes, olive oil, a Polaroid camera, a rosemary branch, a mirror, a rose, lipstick, a large gold

8.4
Marina Abramović, *Rhythm 0*, Studio Morra, Naples, 1975. Photo: Donatelli Sbarra. Courtesy Sean Kelly Gallery, New York.

necklace, a bowler hat, and a pistol (and a bullet). There was some precedent to this dramatically passive martyrdom, although Abramović was unaware of it at the time: Yoko Ono's *Cut Piece*, first made in Tokyo in 1964, in which she knelt on the ground and invited the public to approach her one by one and gradually cut her clothes off with scissors.

About three hours went by before the audience took the inevitable step of removing Abramović's clothes. It gradually became clear that Abramović would be good to her word; they really could do anything they wanted to her and she would offer absolutely no resistance. Abramović was manipulated into a series of poses. Someone put the bowler hat on her head and made her hold the mirror, upon which "IO SONO LIBERO" (I am free) was written in lipstick. Someone wrote "END" across her forehead. Someone else slowly poured a cup of water on her head. An ally in the audience (a division formed between those who wanted to protect Abramović and those who wanted to have their fun) wiped the tears from Abramović's eyes. Her shirt was pulled open to reveal her breasts, and her cheek kissed by a short gray-haired man. Then, when she was totally bare-chested, someone entwined a thorny rose stem through the chain round her neck and sprinkled rose petals over her face. The Naples gallerist Lucio Amelio took Polaroids of Abramović and put them in her hands to display. All the while Abramović maintained a perfect thousand-yard stare through and beyond anyone in front of her. It was a kind of vacancy that only provoked the public to more extreme acts; eye contact would have reminded them of Abramović's humanness and the responsibilities that follow. When the loaded pistol was placed in Abramović's hand and pointed at her neck, the simmering ethical crisis in the gallery finally boiled over into a scuffle between the rival factions. Still, Abramović completed her allotted six hours. When she snapped out of performance mode, the people who were still in the gallery at 2:00 a.m. departed very quickly. The gallerist drove Abramović back to her hotel, where she stayed alone. The next morning, Marina noticed in the mirror that a clump of her hair had turned gray.

MARK-MAKING

Abramović exhibited photographs of her *Rhythm* performances at the Salon of the Museum of Contemporary Art in Belgrade in April 1975. Danica didn't go to the opening night reception, but she quickly heard about the photos of her daughter performing naked. Marina came home before her curfew as usual, and found her mother waiting for her, wearing her classic uniform of double-breasted suit with a brooch pinned obediently to the lapel. Danica began castigating her daughter: How could she make such disgusting work? How could she shame the family in public like this? She might as well be a whore. Danica picked up a heavy glass ashtray and declared, "I gave you life, and now I will take it away"—she was quoting a line spoken by a father to his son in Nikolai Gogol's novel *Taras Bulba* (Danica had as dramatic a sensibility as her daughter)—and threw the ashtray at Marina's head. Marina thought about letting it hit her, since she might be injured or perhaps even die, and then her mother would go to prison, and what sweet revenge that would be—but she ducked just in time, and instead the ashtray smashed the glass door behind her.

Undaunted by her mother's wrath, Abramović continued in her work with renewed energy. She proposed a performance called *Warm / Cold* for the Biennale des Jeunes in Paris, in which she would lie on blocks of ice with five electric heaters hanging above her. The proposal was refused by the jury at the Musée d'Art Moderne de la Ville de Paris because, according to Ad Peterson, a curator at the Stedelijk Museum in Amsterdam who was on the Biennale jury and who would later become a friend and supporter of Abramović, they feared the damage she could do to herself. So she exhibited her *Rhythm* photographs instead, along with the rejected performance proposal—which she titled in her warped English COULD / WORM. She got to do a simpler version of *Warm / Cold* the next month when Richard Demarco invited her

9.1
Marina in front of a photograph of her performance *Rhythm 0*, 1975. Courtesy Abramović archive.

9.2
Abramović performing in a piece
by Hermann Nitsch in Vienna, 1975.
Courtesy Abramović archive.

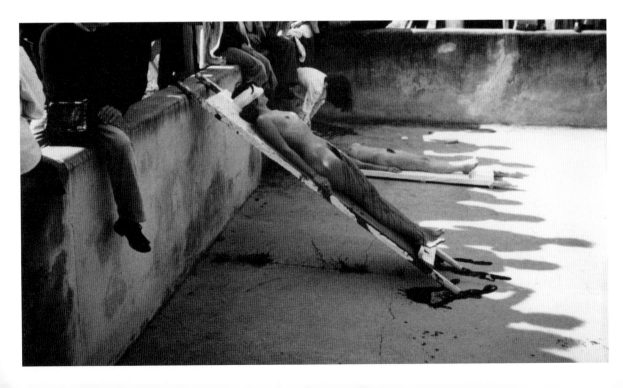

back to Edinburgh. Sitting at a table in the Fruitmarket Gallery she lay only her hand, not her whole body, on a block of ice, which was covered by a sheet of glass. A heater hung above her hand, gradually burning it while her palm froze. After a while (the performance lasted ninety minutes), Abramović smashed the glass with her fist, and then pressed her hand down flat again on the ice and broken glass. It was a simple and relatively restrained performance for Abramović, but it still presented the urgent ethical imperative for intervention that was becoming a signature. Cordelia Oliver, the theater critic of the *Guardian*, was so concerned by the harm Abramović appeared to be doing to herself that she switched off the electric heater and tried to pull her hand away from the ice. Demarco appreciated Abramović's aesthetic as well as ethical force. "I realized that she was a classic example of an artist who was a brilliant draftsman. All these actions, performances, whatever you want to call them, were really manifestations not of a performer but of a superb maker of marks. Whether she was using knives or an electric fire or a block of ice, she was actually producing exquisite visual marks."

By this point, Marina was traveling even more than she had the previous year for her *Rhythm* performances. Since Neša was a homebody, lacked the money to travel, and was too anxious to watch Marina's dangerous performances anyway, he saw less and less of her. But when Marina was in Belgrade, she and Neša would do the usual: try to circumvent their respective overbearing mothers and spend the odd night together. After one such encounter, Marina became pregnant. She immediately had an abortion. "There was not a second in my soul that I would keep the baby," she recalls. "I absolutely never wanted to have children. To me it was the biggest fear of my life. It would be the obstacle stopping me from making the work."

On her travels, Marina often had affairs; one was with a Swiss man named Thomas Lips, whose androgynous beauty fascinated her. She met him in the summer while in Austria participating in one of Hermann Nitsch's blood-soaked performances with his Orgien Mysterien Theater. Ursula Krinzinger, an Austrian gallerist, enthusiastic feminist, and friend of the Actionists had tracked Abramović down after reading about *Rhythm 10*, and arranged for her to work with Nitsch. On paper, they seemed a good match. Abramović, one of about ten performers in Nitsch's ritual, lay on a wooden stretcher, naked and blindfolded, while he poured sheep's blood over her belly and between her legs. "With other models he was very aggressive, not taking any care," Krinzinger says. "But he was taking a lot of care with Marina, trying not to frighten her." The participants in Nitsch's performances were usually men, and here was the outrageously beautiful Marina Abramović, who seemed vulnerable despite her growing reputation in the small world of performance art. As gentle as Nitsch was, Abramović left the performance prematurely. "I wanted to see how far I could work inside another artist's concept," she said later. "And I found out that I didn't have the motivation for this. I was irritated and repulsed by the smell of the blood, it was like a strange Black Mass. I felt something very medievally negative, without any solution or opening. I couldn't see through the piece, and so I had to

9.3, 9.4
Marina Abramović, *Thomas Lips*, Krinzinger Gallery,
Innsbruck, 1975. Courtesy Sean Kelly Gallery,
New York.

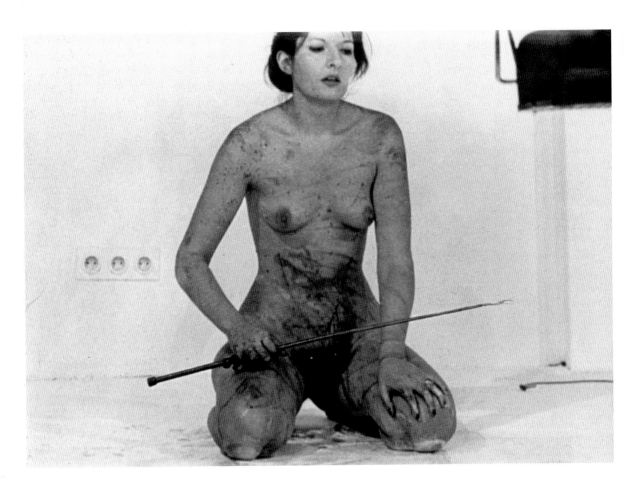

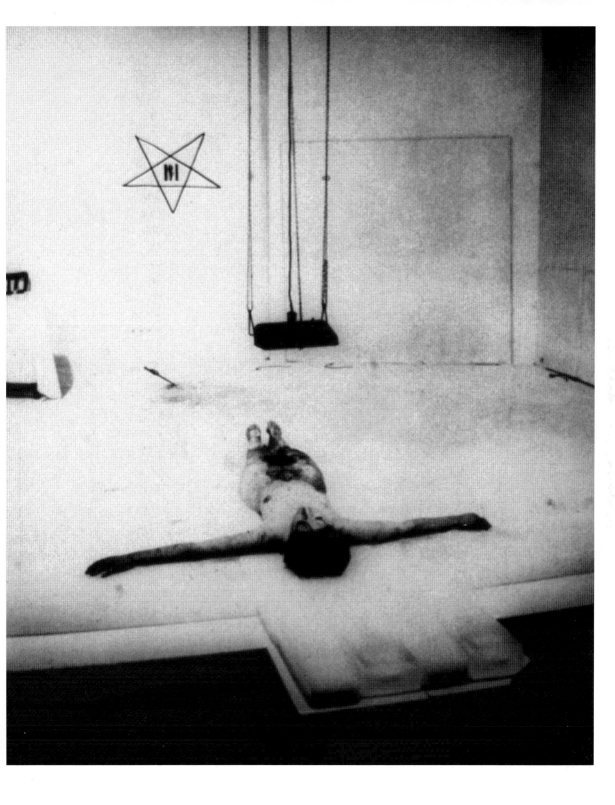

stop."[44] It was also cold; Krinzinger covered her up with a blanket as she left the performance. Later Marina indulged in some very Nitschean behavior at a party: she got uncharacteristically drunk and got down on all fours, proclaiming herself Nitsch's dog and following her master around, to the delight of everyone.

Krinzinger invited Marina back to Austria in October that year, and she made a performance called *Thomas Lips*. Originally meant as a demonstration, a plea, a play, and an offering for Lips, it became Abramović's most violent and baroque piece yet. Naked again, she sat at a table to eat a huge jar of honey and drink a bottle of red wine, breaking the crystal wine glass in her hand when she was finished. Then she got up and drew a pentagram—in the negative, goat head–like formation with two points up—around a photograph of Thomas Lips on the wall. Then she took a razor blade and cut a pentagram, also with two points up, on her belly, with her belly button in the middle. Abramović's lingering fear of bleeding from her childhood bout of hysterical hemophilia made this especially harrowing for her. After the cutting, she kneeled in front of the photo of Thomas Lips, as if in obeisance. Then she moved to the front of the performance area, knelt down, and flagellated herself with a whip, spattering the blood of her star-shaped wound all over her body, and making new wounds too. Finally, Abramović lay on blocks of ice in the shape of a crucifix, with a heater hanging over her, ensuring that the wounds on her belly would continue to bleed freely. After thirty minutes, with Marina probably very drunk and her body freezing, Valie EXPORT, an Austrian performance artist whom Marina had just met through Krinzinger, couldn't tolerate the scene any more. With others from the audience, she removed the ice blocks from under her, ending the performance. Afterward, Krinzinger's husband took Marina to the hospital to get stitches in a deep cut in her little finger from breaking the wine glass. She kept the doctor's report—a small trophy for her feat.[45]

This confusing, disturbing, and devastating performance was an unconscious accumulation of the religious, political, and pathological symbols that held a primal power over Abramović: the red wine of the Eucharist practiced by her grandmother and her assassinated great uncle, the patriarch of the Serbian Orthodox Church; the star of communism that her parents fought for, but which she preferred to think of as the pentagram of the occult (as in *Rhythm 5*); the childhood phobia of bleeding and the struggle for attention that it expressed; and then the final martyrdom in the icy crucifixion. There was also a nod to Joseph Beuys in her use of honey, which he had adopted as a potent and symbolic material. In the end, none of this had anything to do with Thomas Lips the man. He didn't even show up to watch the performance. Had he been there though, he would have gotten a very full picture of Marina Abramović at the age of twenty-eight. Having distilled and attacked her culture and heritage so viciously, along with her body, Marina was at a loss for what to do next. An answer was about to present itself.

ULAY 1975–1988

PART TWO

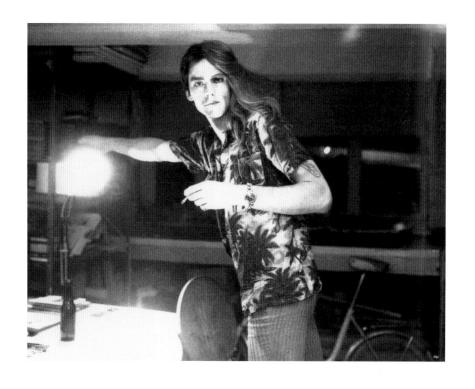

10.1
Ulay, *Hermaphrodite*, auto-Polaroid, 1973.
Courtesy Ulay.

NOVEMBER 30 + NOVEMBER 30

On her twenty-ninth birthday Abramović received an invitation from de Appel gallery in Amsterdam to make a performance for a Dutch TV program, *Beeldspraak* (Picture Speech), on performance art. She was already due to perform in a festival in Copenhagen in mid-December, so she requested a few extra days of leave from teaching at the academy in Novi Sad to take a longer trip to northern Europe. Wies Smals, the founder of de Appel, met Marina at the airport and introduced her to a man who would be her guide in Amsterdam and assist in preparations for her performance that day: a German artist named Uwe Laysiepen. Ulay, as he was known, was wearing his long hair tied back and held together by Mikado sticks; so was Marina, and she immediately latched on to the coincidence. Abramović reperformed *Thomas Lips* in the gallery for the cameras. Afterward she answered questions from the audience, explaining that she ate the kilo of honey specifically because she "had an enormous hatred of it."[1] Later, Marina went with Ulay, Smals, and others from the gallery to a Turkish restaurant, and mentioned there the serendipity of receiving the invitation for the performance on her birthday. "When is your birthday?" Ulay asked. She told him November 30. "That can't be your birthday," he replied. "That's *my* birthday." To prove it, Ulay reached for his diary and showed her that he had torn out the page for November 30, something he did every year. Marina showed him her diary, which also had November 30 torn out.

Frank Uwe Laysiepen was born on that day three years earlier than Marina, in 1943, in a bomb shelter in the town of Solingen, in the industrial conurbation of the Rhineland. He had moved to Amsterdam in 1968 and began taking photographs, mostly Polaroids. As he tentatively started conceiving of himself as an artist, he adopted the name Ulay, an elision of his first and last names. He must have shown Marina some of his work on the day they met, because she later transposed the memory of him in a photograph onto how he appeared that day in public.[2] Periodically since 1972, Ulay had taken portraits of himself divided into a half-male, half-female compound: on his left side he was cleanly shaven, with pale foundation caked on, false eyelashes, plucked eyebrows, a thick wavy auburn half-wig, red lipstick, purple eye shadow, and a fox pelt draped over his shoulder; on his right side he was default Ulay, with a cigarette in his mouth and his normal stubbly face and greasy hair, with a hard-bitten, wry hint of a smile. Just as Marina had been fascinated by the androgynous Thomas Lips, she was immediately attracted to Ulay's overt embrace of femininity.

For years, Ulay had been going to transvestite parties in Amsterdam, "in a guise that would pass there without notice—lipstick, wig, stockings, garter belt, and a Garbo-like hat, with my 180 Polaroid, a heavy metal camera, around my neck."[3] His camera was his ticket into the scene. It got passed around at parties like a drug. And it justified his experimentation with his identity, which had always felt murky to him. His father, Wilhelm, having fought in both the First and Second World Wars, had died in 1958, when Uwe was fifteen; his mother, Hildegard, traumatized after being raped by Russian soldiers at the end of the Second World War, retreated from society, leaving Uwe—who had no siblings or other family—alone in a boarding house for most of his teenage years. He was an apprentice for a year or so in a factory that made meat grinders and other kitchen equipment, then he studied engineering briefly before dropping out and traveling around Scandinavia by himself. Whereas Marina always felt like she had too much family (and not enough love), Uwe actually had no family. Polaroid photography became Ulay's self-conscious and often self-lacerating means of discovering who he might me, since he had no one to tell him.

In 1965, he'd married Uschi Schmitt-Zell, a young woman with short boyish hair who "acted like a man," Ulay says. They quickly had a child, Marc Alexander, and Ulay used some of his engineering skills to start a photo lab business in the town of Neuwied. By 1968 he found the stress of running the business and providing for his wife and newborn baby intolerable. Despite his heavy drinking and car-racing around town, he feared that he was starting to lead exactly the bourgeois existence—married with child and small business—he had always theoretically despised. He was also due for military service, but wanted to obey the advice of his father, who fought in Stalingrad, and avoid it. Uwe packed a bag with a camera and a typewriter and drove toward Prague, with the intention of joining the film academy there. He didn't make it further than the Czech border. The Prague Spring had just ended; the Soviets were occupying the country and weren't letting anyone in. Uwe remained at the border for three days, drinking with the Russians. He had no idea what direction to go in. Then he read in a newspaper about the rioting going on in Amsterdam—as it was in other cities that summer—and decided to drive there and join in.

Shortly afterward, he followed an old friend from Neuwied, Jürgen Klauke, to the art school in Cologne. Uwe had plenty of technical knowledge about photography having run his own lab; what he wanted to learn was how to be an artist. He led a determinedly transient existence for the next two years—as with his study of engineering, he never finished art school—drifting between apartments in Amsterdam and Cologne. He fell into a drug scene along the way and used heroin a few times. "I accepted the needle because I didn't want to be an outsider," he later recalled of the first time he injected. "Twenty-four hours later I woke up and I was like newborn. I felt so great, yet I was scared to continue that. So I left that place and went somewhere else."[4] Ulay cleaved to Klauke, who was excessively charismatic, a heavy drinker with a "very heavy ego"—the perfect figure for the withdrawn and imitative Ulay to shadow. Klauke was working on a book, *Ich und Ich*, with cartoon drawings

of deformed figures engaged in outlandish autoerotic acts. Ulay contributed his photos of Amsterdam's transvestite scene to the book. Klauke was the first in a long line of collaborators with Ulay. The pair spent most of their time together, drinking, partying, and seducing women, just as they had in their younger years in Neuwied. They dressed up as women together, managing somehow to look even more like brawny German men in the process. Their flirtation with femininity always had the air of a ballsy experiment, a decadent game, rather than a deeply felt psychological need. Klauke could also be a devilish dandy, prancing and preening in Ulay's adoring photographs. He moves with a reckless, vicious confidence that Ulay adopted in the photographs but never quite assimilated no matter how debauched and desperate he got. In one series of Polaroids, Klauke and Ulay assume a variety of sarcastically theatrical poses, apparently trying to outdo each other in nihilism. In a triptych, they stage a duel by a river: they start back to back, both immaculately dressed in tight suits that accentuate their taut, somehow explosive frames (image one), then step away from each other (image two), and then turn and draw (image three)—Klauke points a gun, but Ulay can only make the shape of a gun with his empty hands.

Ulay felt residual loneliness from his childhood and yearned for collaboration and connection, but fled from it too, "to avoid disappointment," he says. In 1971, he began a relationship with a woman named Henny Löwensteyn, a bartender in one of his regular hangouts. "The way we were together was sort of divine. In a way it was a perfect love relation," Ulay says. But by the time Henny gave birth to Ulay's child on November 9, 1971, he was long gone. He would not meet his second son, Jurriaan, or ever speak of him, until 1987.

Rather like Abramović's dual practice in the early 1970s of proposing radical performances and events while simultaneously exhibiting traditional paintings in establishment venues, Ulay also had a double life. He took his portfolio of more easily digestible photos of Amsterdam (street life and graffiti rather than transvestites) to Polaroid's European headquarters, which was located in the city. Manfred Heiting, the director of creative design, and Erwin Wulf, the marketing manager, took a liking to Ulay's work and invited him into the Polaroid Artist Support Program. Since the first Polaroid camera was made in 1948, Edwin Land, the inventor and founder, had always given artists free cameras and film to work with. The benefit was mutual: artists got free material, Polaroid got expert feedback on their equipment, good photographs with which to promote their product, and the basis of what would become one of the most important photography collections in the world. Ulay was given several cameras and all the film he needed. Alongside the official photographs he started making for Polaroid, he used their equipment for his private photos of transvestites and of himself cross-dressing and, increasingly, self-harming.

Heiting and Wulf gave Ulay a dream assignment: visit five cities—London, Paris, Rome, New York, and Mexico City—and take photographs for a Polaroid book that would be simply titled *Uwe's Polaroid Pictures of 5 Cities*. All expenses would be paid up front, along with an extremely generous fee: a "pack" of money that Ulay

threw triumphantly around his squalid apartment. Ulay spent several weeks in each of the assigned cities, skipping Mexico City, because, he confessed to his sponsors, if he went there he might never return. The fifth city would instead be Amsterdam.

In New York in the summer of 1971 (while Henny was pregnant), Ulay stayed at the Warwick Hotel near Central Park. In the Sheep Meadow one day, he photographed a preternaturally beautiful young woman in couture hippie clothes and with bare feet. She was Bianca Pérez-Mora Macías, the daughter of a diplomat from Nicaragua, and a nascent human rights activist. She carried with her a small brown paper bag with the keys to her Upper East Side apartment and a credit card in it. Bianca spent a couple of weeks with Ulay, though their relationship remained platonic. He took Polaroids of her in his hotel room, on the phone, on the bed, always looking astonishingly beautiful. Their schedules didn't match up—Ulay got up early to start walking the streets and taking photographs just as Bianca was returning from the Oscar Brown Junior club, where David Bowie and Mick Jagger were hanging out. Still, it's a measure of Ulay's charisma, rugged, man-of-mystery attractiveness, and aura of calm strength, that Bianca asked him if wanted to take a sojourn to India with her. Ulay agreed, and they went to the KLM booking office. In the revolving door of the building, Ulay decided to play a practical joke: he suddenly held the door closed. Bianca's bare foot got caught, and "she screamed like an animal." Her foot was bleeding badly. Ulay panicked and ran away. "I just freaked out," he recalls. He jumped in a cab, went back to the hotel, packed his things and checked out, and never saw Bianca again. Back in Amsterdam a few months later, a friend told him that Mick Jagger had just got married to a woman named Bianca Pérez-Mora Macías.

Ulay's photos of her didn't appear in the book. It consisted of safe tourist shots with a dash of street photography—serendipitous confluences of people, signs, traffic, and random street life. Ulay wrote short captions, most of them trite and sweet, though one about a photo he took in London is telling: "After my simple friends and dart games at my first pub, the posh crowd at this one on Kings Road frightened me a little. They talked about art and revolution and drank Hock, while their minds silently guessed the price of everyone else's clothes."[5] Ulay had a hunger for authenticity, one that made him silently scathing beneath his exterior placidity. Just as often though, his anger was turned against himself.

Another partnership that came to a premature end was with a friend named Jan Stratman. With the money Ulay was earning from Polaroid—he continued to get regular assignments to test new equipment, including a trip to Sardinia—he and Stratman rented a building on the Herengracht in Amsterdam with the intention of setting up a space for showing new media: photography, Super 8 film, video, and performance—all the work that they were interested in but institutions and galleries were not. But while transporting some equipment for Polaroid back from Germany, the car Ulay was driving collided with a truck, and Stratman, riding in the passenger seat, was killed. Ulay was thrown through the windscreen, and cut up his forehead and damaged his spleen.

Ulay abandoned the idea of opening an art space, and used the building instead as a venue for transvestite parties. He met other photographers, musicians, and a fashion crowd, and tried to do some commercial photography for magazines. In 1972 he used the house as a stage for his biggest and most public work yet. He took a large-format black-and-white photograph of a petrochemical plant in Amsterdam's west harbor that resembled Bernd and Hilla Becher's shots of industrial structures in its matter-of-factness. With his technical expertise at processing and expanding photographs, Ulay developed a ten-by-twelve-meter print of the image on multiple sheets of photographic linen, and employed a sail-maker to stitch them together. Then he hung the enormous photomural over the façade of his house. A TV crew filmed the installation, which Ulay called *The Metamorphose of a Canal House*, and he was interviewed on the news.

Ulay wanted to inject something other than aesthetics into his photography: he wanted to create challenging situations that prompted ethical questions. This one would jolt people out of their routine movements around the city and confront them with an image of industry usually pushed to the periphery of the city, and of their consciousness. More often though, Ulay worked on the small scale of Polaroids. With instant photography, the artisanal and arduous process of film development that he'd been used to in Neuwied was replaced by ninety seconds of pure anticipation, or about sixty seconds if he stuck the imminent image under his arm. Polaroid excited Ulay because it was an almost immediate transcription of reality. Everything about it was intimate, raw, and authentic: the hand-size format of the pictures, the warm color tones of the prints, and most important, the fact that one didn't have to hand over the film for someone else's perusal to get it developed. This gave him implicit permission to take more private, experimental, salacious, sad, and shocking images.

In 1972 Ulay got a large tattoo on his left forearm that read GEN.E.T.RATION ULTIMA RATIO. The first part was an opaque pun on "generation"; the last part means *last resort*, as in the motto of war being the "last argument of kings." Ulay got the tattoo specifically so he could have it removed and photograph the process. One Polaroid shows blood and muscle glistening in a perfect rectangle cut out from his arm. The next in the sequence shows a skin graft held in place by angry looking black stitches. The rectangle of new skin would never heal into his arm properly. This action indicated Ulay's growing frustration with the tendency of photography to rest on surfaces. "I wanted to invest more," he says; he wanted to pierce the skin. He demanded interiority and authenticity from photography, and the only thing that could be indisputably real in a photograph, he thought, was this kind of self-inflicted pain. "I put the piece of skin in formalyne for some time, preserved it. Then I air dried it." Then he photographed it.

Around this time Ulay met a woman named Paula Françoise-Piso. She was married, but to an airline pilot who was absent most of the time. Paula was "hyper female," Ulay says, and he was "absolutely sexually dominated" by her. He was

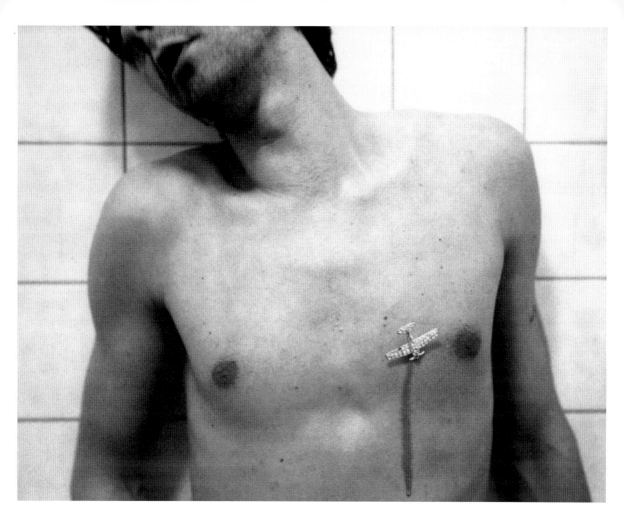

10.2
Ulay, *The Plane*, auto-Polaroid, 1974.
Courtesy Ulay.

attracted to her "not conventionally as a man wanting sex. I had a very strong female positive tendency toward women." He wasn't just attracted to her—he wanted to *be* her, and began signing some of his Polaroids with a new composite name, "PA-ULA-Y." The first of these photos featured only himself—shirtless, pensive, and shrouded in smoke. Paula crops up only occasionally in the photos signed with part of her name, most notably in an alcohol-fueled frolic in a plush Amsterdam apartment, with Klauke in the background, like a ringmaster. In this romantic-artistic relationship, Paula played the role of distant muse rather than active collaborator. Ulay used the signature PA-ULA-Y off and on until April 1975, just a few months before he met Marina.

The Polaroid Corporation gave Ulay an ID card that read: "PHOTO CONSULTANT 1973 PRESS AND ART DEPARTMENT." It is signed "Ulay," though it bears his full name, Uwe Laysiepen, in print. In the ID photo, Ulay has something between a snigger and a sneer on his face—he had contempt for the idea that identity could be expressed or contained in a small card. He began making satirical, gruesome Polaroid IDs, the first of which features a photo of Paula with a stocking over her head, giving a subtle facial distortion and compression underneath a kind of ghostly veil. Where Paula's name should be on the card there are instead large faint letters: "MONSTER." The date of birth is typed as "look owner," birthplace "in between," nationality "unknown," and profession "lost."[6] Ulay also made an ID card labeled "GILBERT & GEORGE." He had never met the London-based artist duo, famous at the time for posing as "living sculptures," but Ulay was fascinated by the idea of doubleness that they represented. Later Ulay picked up the idea of fake ID cards again, making perhaps his most explicit photos: of a carrot inserted a couple of inches into somebody's anus; another one in a vagina; a scrotum pulled up and over a penis, creating a smooth bulbous membrane; of a man's backside, with his genitals tucked back between his legs and poking freakishly out from under his anus. In these ID cards only the photo is shown; the rest of the card is blacked out with marker pen.

In 1974 Ulay's self-mutilation for the camera reached new extremes, just as Abramović's performances were becoming more dangerous. One Polaroid shows Ulay cutting his belly and sticking a paper towel over the wound; a series made around this time shows him in a tiled bathroom, slicing the tips of his fingers with a box cutter and smearing the blood over the pristine walls. He took a cheap, jewel-encrusted brooch in the shape of an airplane (Ulay loved planes) and pinned it directly into his bare chest, photographing the blood running down his torso. A still life of Paula's sexy little boots, with fur-lined insides and pixie-like points, is pregnant with something—and as this series of Polaroids unfolds, we see that it is Ulay's fanatical longing and loneliness that charges the image. He first tries to put the boots on, but his feet are much too big. Then he cuts the top of his feet to mark the shape they would have to be if he ever wanted to truly walk in Paula's shoes (the laceration of his feet may also have been a kind of penance for what he'd done to Bianca). A simple self-portrait he took in 1974, signed PA-ULA-Y, this time with

no autoaggression, no desperate drama or camped-up artifice, shows downcast eyes and an interminably melancholic expression.

That year, Wies Smals and her colleague Mia Visser persuaded Ulay to show his "Auto Polaroids," as he called these experiments, in an exhibition at their first gallery, called Seriaal. Ulay reluctantly agreed, and the public's reception—shock and no little disgust—confirmed his fears about doing it in the first place. The images were made in private and he felt it was a betrayal to show them in public. He righteously promised himself not to exhibit his work again. Perhaps it was this kind of innate reticence that led to Ulay's non-inclusion in the coming-out exhibition that defined the gender experimentation going on at the time, "Transformer—Aspekte der Travestie," in Lucerne, Switzerland, that same year. Klauke and his close contemporary Urs Lüthi were in the show, along with Andy Warhol and Mick Jagger. Ulay counted himself out of the zeitgeist, even though his work and cross-dressing lifestyle epitomized it as well as anyone.

Something that particularly irritated Ulay about the ritual of exhibiting was the standard declaration on the invitation to the opening: "The artist will be present." Rather than understand this in the normal way—as a polite offer to meet the artist while sipping wine at the vernissage—Ulay wanted to interpret this phrase on a more fundamental level. Neither the conventional format of an exhibition, with the work abandoned in an empty space, nor his chosen medium, photography, could evoke the real presence of the artist. But "if you are doing a *performance*, you have to be present."[7]

In the winter of 1974, Ulay was in Paris taking photographs of the Père Lachaise Cemetery, where Oscar Wilde, Jim Morrison, Honoré de Balzac, Edith Piaf, and dozens of other luminaries were buried. On Christmas day he sent seasons' greetings to all his friends in the form of mourning cards. They read: "ULAY *1943 †1974. Mein Abschied als einzige Person"—my farewell (or parting) as a single person. The notice served as a declaration of Ulay's symbolic suicide as a single, unified identity. Not only did he consider himself a fragmented person—male and female, fierce purist and indulgent hedonist in one—the mourning card was also a declaration of his deep need to work and live with someone else (Uschi, Klauke, Henny, Stratman, Paula, anyone), enfolding, dissolving, and perhaps wishing to annihilate himself in that other person.

Simultaneous with his entanglement with Paula, Ulay remained a duo with Klauke. In September 1975, at de Appel, they undertook a complex performance, *illusion theater*, that in part restaged a probably apocryphal drink- and drug-fueled game of Russian roulette that Ulay claims he and Klauke once played in Cologne—just as Marina once played it when she was a child. (Klauke has no recollection of the incident.) In the gallery, Ulay and Klauke, dressed in white, wore masks molded into their respective features. They distributed transparent versions of these masks to members of the audience and then stood either side of a screen, onto which was projected the many photographs they'd made and posed for together. Then they had each other's image projected onto themselves. Ulay later described the next action in the third person: "Ulay picks up the revolver from behind the screen, places it

against his masked head and pulls the trigger—nothing happens. Ulay and Klauke exchange the revolver five times. The sixth time, Klauke shoots at Ulay (with a blank). Both stand immobile for thirty seconds. Ulay takes off his uppermost white mask. A bloodied mask appears. Klauke falls down."[8]

Ulay was becoming increasingly interested in the materials and the act of photography, rather than in subject matter alone. In *Exchange of Identity*, at the Galerie Het Venster in Rotterdam, members of the public stood in front of a sheet of light-sensitive photographic linen hung on the wall. Ulay took a photograph of his subject using a flash, which exposed the linen around them, leaving a blank body shape in the middle, like a negative silhouette. He threw a bucket of developing fluid, then a bucket of fixative, and then a bucket of water over it. Then Ulay, wearing a blank white body stocking and white mask, stood against the wall in the empty shape left by the member of the public, and, using an episcope, projected onto himself the Polaroid portrait he'd taken of his subject—an attempt to erase himself entirely and make a blank canvas out of his body. After he had repeated the process a few times with different people, everybody left to escape the unbearable ammonia stink from the developer and fixative fluids mixing together.

Shortly afterward, Ulay made another performance out of photography—actually, out of something more immanent than photography: pure light. In a dirty garage space used by the Beyer Gallery in Wuppertal, Germany, he strapped onto himself a mirror that had been cut into a rudimentary body shape, and faced the audience so they could see themselves reflected in him. As he became nothing but a surface to reflect people's own presence back at themselves, his own body was effectively erased. He slowly turned from left to right for a few minutes, making sure everyone in the space saw their reflection. Then he fell forward, smashing the mirror strapped to his body onto another body-shaped mirror laid on the floor, thus destroying the audience's reflected image. Ulay was trying to be a human camera, capturing an image in a life-size shutter, but then swallowing that image up, erasing it, and leaving people with reality instead.

Even though he deemed the exhibition at Seriaal a disaster, Ulay developed a working relationship with its founder, Wies Smals. When the Dutch TV station VARA approached Smals about making a program on performance art with de Appel as the locus, she recommended Ulay as one of the artists they should feature. Ulay accepted the advances of the directors, Frans Zwartjes and Simon Mari Pruys, on the condition that his interview should be conducted in one nonstop twenty-four-hour session, with no food and no escape from his apartment. After two hours of taped conversation, one of Zwartjes's assistants snuck out to the store and brought back snacks. Ulay was furious, kicked the camera crew out, and quit the project. It was at this point that de Appel, in need of a replacement, called in a shocking young performance artist from Belgrade to perform for the program instead. Her name was Marina Abramović.

Ulay was captivated by Abramović even before she arrived in Amsterdam: he had seen photographs of her performance *Warm / Cold*, in which she had splayed her hand on a sheet of glass over a block of ice before smashing the glass. When Abramović arrived in the city, Smals asked Ulay to help her gather materials for her reprise of *Thomas Lips*. She carried out the same elaborate ritual of self-harm for the cameras that she'd performed in Innsbruck earlier that year. Zwartjes and Mari Pruys used the footage of Abramović cutting the star in her stomach as the trailer for *Beeldspraak*, which was meant to air on January 18, 1976, but the clip sparked such controversy in the newspapers—which mistook the pentagram for a Star of David—that the show was cancelled.[9]

Abramović's first iteration of *Thomas Lips* had been loosely intended as an incantation of, or a violent ode to, an absent, androgynous-looking lover. Now in de Appel, it was a primal display of power—a mating ritual—directed at the very present Ulay. The critic Antje von Graevenitz remembers Ulay talking excitedly to her about Abramović during the performance. "He was so impressed, he had to tell somebody," she says. After the performance, Ulay says, "Marina withdrew into a guestroom where she was staying. I withdrew with her and I nursed her wounds." But the real consummation of their fate came that night with the discovery of their shared birthday, and their shared antipathy toward their birthdays. Now, rather than a date to be ignored as a depressing annual reminder of lost time and inevitable oblivion, November 30 quickly became a cosmic guarantee of a shared destiny and a symbiotic union.

10.3, 10.4
Ulay, *Fototot*, Beyer Gallery, Wuppertal, 1975.
Courtesy Ulay.

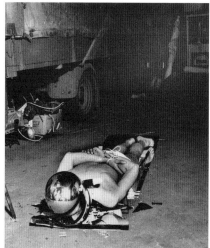

ARTIST MUST BE BEAUTIFUL

Just as she was becoming entwined with Ulay, Marina had to take a side trip from Amsterdam to honor her invitation to perform at the Charlottenborg Arts Festival in Copenhagen. Her memory of what occurred in and around the performance *Art Must Be Beautiful, Artist Must Be Beautiful* is fuzzy, despite the misleadingly singular and steadfast video documentation that exists of it. No doubt she was distracted at the time by her recent meeting with Ulay, and subsequently by the new phase of her career that she was about to plunge into. In the official video documentation of the performance, Abramović sits, naked, holding a brush in each hand. For just under an hour, she brushes her hair very hard, yanking and tugging and even tearing at it, while repeating the mantra "Art must be beautiful, artist must be beautiful." For several minutes at a time she falls silent and still, gazing blankly into the distance before recommencing the punitive beauty routine. The camera remains static, framing Abramović's head, neck, and bare chest, forming a crisp and cutting video self-portrait.

But this video that etched itself into performance art history only tells one part of the story of *Art Must Be Beautiful*. The video was made in private, immediately *after* Abramović's original performance of the piece, which was made in public and also filmed. Eager to see how it looked, Abramović watched the footage straight away. She was not pleased. Despite instructing the cameraman to keep the camera still, framing only her head and chest, he had moved around, making dramatic close-ups of her anguished expression before pulling back and revealing the banal backdrop of the small room around her. Abramović hated the lack of precision in the video so much that she did the performance again right then, with no audience except the heavily chastised cameraman, who this time kept his lens static. This is the version of the piece that Abramović would use exclusively to represent the performance.

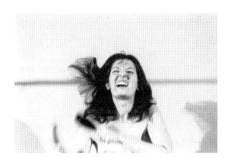

11.1
Marina Abramović, *Art Must Be Beautiful / Artist Must Be Beautiful*, Charlottenburg Art Festival, Copenhagen, 1975. Courtesy Sean Kelly Gallery, New York.

But the original, messy version still survives. Here we see not only the small room Abramović was performing in—which, unlike in *Rhythm 10* or *Rhythm 4*, for example, she failed to stage manage in any way, hence her desire for a more aesthetically controlled image later—but also the bemused public filtering in and out. One audience member begins mimicking Abramović in sarcastic tones: "Ahh, artist is so beautiful." Abramović makes not the slightest reaction to the ridicule, and it quickly stops.

The frame of *Art Must Be Beautiful* can be pulled back even further: the first, public version was cut short because a fuse blew and the lights in the room went out. So Abramović was asked to repeat the piece (now for a third time, after her performance for the camera) in the large hall of the Copenhagen Academy of Fine Arts a couple of days later. Here she performed on a stage in front of around a thousand people, lending the piece a theatrical air that she hadn't originally intended. Here she also incorporated the whipping element of *Thomas Lips* into the piece. After flogging herself, she sat down in the chair and hacked at her hair with a steel brush more violently than ever, this time drawing blood from her scalp. Early on in the performance, a woman in the audience, apparently drunk, stormed onto the stage shouting, "I know what is going on here," and lunged at Abramović, grabbing her by the hair. It was unclear if the woman was trying to stop the performance in order to protect Abramović from herself—though yanking her hair even more was a strange way of going about it—or if she was indulging in some *Rhythm 0*–style aggression toward the vulnerable performer. Regardless, Abramović "furiously broke loose" from her assailant and continued the performance.

After the performance, Abramović told the newspaper *Ekstra Bladet*: "The woman who pulled my hair made me so angry I could have killed her. She wasn't invited to participate in my play on symbols. She misunderstood everything. Because I am not a masochist. To me the pain and the blood are merely means of artistic expression. It was ironic when I shouted the art must be beautiful. Neither the art nor reality is necessarily beautiful."[10]

An orthodox feminist reading of *Art Must Be Beautiful, Artist Must Be Beautiful* would have it that Abramović was acting out the pain involved in fulfilling a societal—and art historical—beauty imperative, and ironizing and attacking it at the same time. But we might do better to rest on the surface of Abramović's words, even if she herself wished them to be ironic. She was savagely fighting with her beauty in this performance, but still, she *is* beautiful in it, all the more so for making a feminine martyr of herself. And she was certainly aware of this effect. Beauty had been of serious, borderline pathological, concern to Marina ever since she was a young child and despised her "big" nose so much that she tried to engineer an accident that would destroy it: she spun around in her mother's room, hoping to get dizzy and fall face-first onto the bed post; had she hit her mark, she planned to give the doctor a picture of Bridget Bardot as a guide for reconstructing her nose. Even though Abramović's art dealt with pain and trauma, she believed on some level that yes, she as an artist, and in her everyday life, must be beautiful.

Ulay didn't go with Marina to Copenhagen in part because he had no invitation to perform, but also because he had little sympathy for the feminist basis of the Charlottenborg Arts Festival. Ulay was a different kind of feminist, and so too was Marina. Both of them identified strongly with the classical—even archetypal—image of femininity that the movement was trying to shake off. Abramović had never felt victimized by the fixed gender roles that feminism protested. Later, she said: "I think that all energy, all power is so much in the hands of women and it always has been genetically like that. I feel the complete opposite [to feminists]. I feel I have to help men."[11] Her mother had never been held back in her career because she was a woman; in Titoist Yugoslavia, Western-style feminism never seemed necessary since there was a theoretical commitment to a more radical equality. And in art, Abramović saw feminism as limiting rather than liberating. She was more interested in the power of sex than in gender, or anxiety over gender roles. Marina disapproved of Gina Pane's repeated self-cutting (at de Appel in 1975, Pane had cut her lips as part of the performance *Discours mou et mat*), which was in part a feminist response to the male gaze. "If your sex isn't good, everything's wrong," Marina said around this time, "and then you do things, for instance, like Gina Pane. And when you repeat things like her, the work's sick. The message of art should be wider than that."[12] Still, Abramović was happy to fulfill the opportunities that arrived from feminist curators and gallerists like Ursula Krinzinger and festivals like the one in Copenhagen.

After a few more precious days with Ulay in Amsterdam, Marina returned to Belgrade, and felt it even more of a prison house than before. "I could not even breathe from love," she says. She avoided Neša and didn't tell him what had happened in Amsterdam. She spent most of her time lying on her bed making phone calls to Ulay, and then suffering her mother's fury about the phone bill. But she did rouse herself during these miserable weeks of Balkan winter to contribute to a film, *Kino beleške* (Film Notes), about the SKC and its circle of artists. The director, Lutz Becker, was assisted by Zoran Popović, who had recently returned from New York. Dunja Blažević opened the film reading a statement: "As long as we transport art works from studios into basements and closets, treating them like stillborn children, as long as we are creating, through the private market, our own version of petit-bourgeois, we have an art which is a social appendix, something that does not serve anything or anybody." The goal of Blažević's generation was "new art for a new society on the mental level." Ješa Denegri spoke about his aspirations for an art that, instead of providing "metaphors of freedom," reached "the deeper strata of comprehension and consciousness of basic changes that ought to be made on the social level." Art along these lines "should reject all mystical, transcendental, and formalist attributes, which have permanently reduced its fragile possibilities for social action." Mystical, transcendental, and formal—these were fundamental characteristics of Abramović's performances and installations, even though she didn't work in the traditional pictorial or object-based realm that Denegri was referring to.[13]

For the first part of her contribution to the film, Abramović reperformed *Art Must Be Beautiful, Artist Must Be Beautiful* (just as she had reperformed *Thomas Lips* for the Dutch TV cameras earlier that month), this time reciting the mantra in Serbo-Croat. It was by far the most aggressive and dramatic piece in *Kino beleške*. But it was her second contribution to the film that demonstrated a frustration with Yugoslavia that was much more primal and existential than her friends' theoretical meanderings. She simply read out the TV schedule for the recently passed Day of the Yugoslav Republic, November 29 (her old fake birthday), a few days before she had fallen in love and seen the possibility of a life beyond Yugoslavia's borders. Naturally, the TV schedule was full of official, obedient, celebratory shows; Abramović read them out in a slow monotone, accusatively, almost relishing the boredom, as images of the frozen, drab streets of Belgrade in winter, filmed from a car, rolled slowly across the screen. Marina's feeling of suffocation in Belgrade on returning from Amsterdam was evidently due to more than lovesickness.

Marina was losing patience and sympathy with the tiny Belgrade art world orbiting the SKC. "All the people around the SKC, the young critics and us, were basically the only public we had," she says. "It was the same people constantly going around. We didn't really integrate in any cultural situation in Belgrade." There was only a tiny gallery and museum scene, and no art market to speak of—certainly not one that the SKC was involved in. The vast majority of art acquisitions were made by the governmental Purchasing Committee, and usually ended up decorating bureaucrats' offices. The Purchasing Committee was obliged to buy something from every major exhibition, with the exception of "new art" exhibitions like those at the SKC. The lack of public interest, commercial pressure, or even political pressure—Blažević relished deflecting such unwanted influences—ended up making the SKC artists feel isolated, unable to gain any traction in an art world other than the cloistered one they inhabited.

But it was Marina's unforgiving view that her colleagues could have everything they wanted if they just stopped complaining and started extending themselves and their work beyond Belgrade. Marina believed that what hindered her colleagues was not intractable social problems or the difficulty of accessing the "deeper strata of comprehension and consciousness," but a simple lack of ambition. Marina was particularly frustrated that Popović, who had spent a year in New York in 1974 living in Joseph Kosuth's studio making films and photographs, had chosen to return to Belgrade. In her eyes, he had squandered his opportunity to break out. Popović felt that he had to return to Belgrade because he needed to live in a place where he had a mastery of the language. Marina, on the other hand, made a virtue out of her trainwreck English: she was able to be more direct, blunt, creative, and charming with the language than most native speakers. Serbo-Croat was just plain old Serbo-Croat. Soon, she would go for years hardly speaking it at all.

Around this time, a photograph of *Rhythm 4*, showing the naked Abramović bent over the industrial-strength fan, appeared on the cover of *Europa*, an Italian

art magazine. The faculty at the art academy in Novi Sad got their hands on a copy and were scandalized. Marina heard that the faculty was about to meet to resolve on firing her, so she quit first to take away their pleasure. Marina managed to find restrictions everywhere she turned in Yugoslavia, but she was happy now to be free of one more of them.

During one of their long phone calls, Marina and Ulay arranged to meet again, this time in neutral territory. Ulay suggested the halfway point between Amsterdam and Belgrade, and the city he had tried to reach in 1968: Prague. From the very beginning, Ulay / Abramović were conceptualizing their relationship. This first planned encounter, like many of their performances later, was a choreographed meeting of two bodies in both geopolitical and intimately physical space. Before the trip, Abramović bought a blank book with a communist-red hard cover, upon which she had the names Marina Abramović and Uwe Laysiepen embossed. She clearly had a feeling that they were about to write some history together. They stayed at the Hotel Paris, a luxurious presocialist relic, equipped since the start of the Soviet occupation in 1968 with radios in every room that couldn't be switched off because they were also listening devices. Ulay squeezed pillows around the speakers while he and Abramović made love. They didn't talk yet about collaborating, but they made their first work together. In the cemetery of Vyšehrad, Abramović stood before a long leafy avenue flanked by graves with her back to Ulay's camera. She was wearing a huge, thick fur coat and looked over her shoulder at Ulay with a blankly seductive pout. In the next photograph, identically framed, she's a few paces further away, looking back again with the same expression. In the third image, she's a little further away, and so on, until the twelfth image, in which Abramović has disappeared from view entirely at the end of the avenue of graves. It was a coldly conceptualist piece in terms of structure, but the location and Abramović's deportment charged it with romance and eroticism. It must have been instinctively clear that they had more to explore together, because near the end of their stay in Prague, Marina decided to move to Amsterdam and live with Ulay.

When she returned to Belgrade, Marina procrastinated with her destiny. "Every single day I had to get ready to go but I could not," she recalls. She began a new trilogy of performances that constituted a rite of passage out of the city and out of the first twenty-nine years of her life. The first was *Freeing the Voice*, which she performed at the SKC at the 1976 April Meeting.[14] Abramović, dressed in black, lay on a small mattress with her head tilting off the edge, and primal-screamed until she lost her voice. It took three hours. She was internalizing all the work she'd done in recent years with sound: now her body itself was the instrument, and the vehicle, of sound. "In my life I saw a thousand performances," says Popović, who was watching that day, "and after a while you get bored. But only Marina can time her performances. This one was nothing but screaming, but nobody could move." Abramović's primal wailing gradually got deeper and the sound more abstract, less recognizably human as her voice broke. The frustration Abramović was trying to release was sexual as well as

familial and cultural: stuck in Belgrade, she couldn't find anyone to match her eros and passion, which transposed directly into her enormous artistic ambition.

Freeing the Memory, performed later that year at the Galerie Dacić (run by a Yugoslav couple) in Tübingen, Germany, was another form of forceful, self-administered therapy. This piece was done just for video. With a camera trained close up on her tilted-back head, eyes vacant in concentration, Abramović attempted to speak every word she could summon from her memory, in a semi-random sequence of hundreds of isolated words. Telling chains of association occasionally formed: "proleter, partisan, ustaša, četnik"; "zen-budizam, El Greko"; "mestruacija, masturbacija, med [honey], Mikloš Jančo [a Hungarian filmmaker]." After one and a half hours, Abramović ran out of words and the performance came to a natural halt. It was her first performance of purely mental activity. Though her life wasn't at risk as it often was in her physical performances, *Freeing the Memory* was still harrowing—all the more so because it was a situation that couldn't be confronted through brute will power alone. Plucking words from her memory required concentration and painful dredging, with renewed panic between each word, until she reached the point of emptiness, or at least mental exhaustion. The completion of the trilogy, which would involve exhausting the body, would come a few months later.

Lingering in Belgrade, she still couldn't bring herself to tell Neša about Ulay. She told him she was going to Amsterdam for a while because she had been offered an artist's residency there, which was sort of true—de Appel had scheduled an exhibition for her—but it was a long from way the truth. After several more weeks of hesitation, she finally bought a second-class train ticket to Amsterdam. Only Velimir knew she was leaving for good. She certainly didn't tell Danica her plans. The night before she left, Marina consulted a clairvoyant, a middle-aged man who called himself Aca Student, who happened to be visiting the family upstairs from her apartment. He read the dregs of Marina's Turkish coffee—a Balkan tradition. Marina did not tell him what she was doing the next day, but he divined it anyway. He told Marina she should not go: the relationship with this man would be a disaster. After he left, Marina spent a long time obsessively washing out the coffee cup and crying. But now, because there was a degree of defiance involved, she was able to resolve upon leaving Belgrade for Ulay.

Marina arrived at Ulay's apartment in the north of Amsterdam with an invitation she'd just received to perform at the Venice Biennale that summer. It seemed natural to extend this invitation to Ulay. In an interview a couple of years later, Marina reflected, "In our early individual work, you can clearly see that we were unhappy."[15] Whatever the objective and transcendent conceptual ambitions of their solo work, it had been in essence self-destructive, anguished, and unrelentingly dark. Abramović's violent energy was for the most part focused narcissistically inward when she cut herself, ingested drugs, or pushed herself to the brink of suffocation; likewise Ulay's focus was internal, private, and depressive as he took photos of himself as half-woman, half-man, or piercing his bare chest with the pin of a brooch.

Now, confronted with a kind of mirror image of themselves, Ulay / Abramović realized that they could channel their formerly destructive energy outward into constructive, relational experiments.

They unfurled a long roll of paper and pinned it to the wall of the apartment, and spent hours making sketches and writing, trying to find out what a collaboration might look like. At one point somebody gave Ulay a gift: a Newton desk toy with its swinging balls, the kind that Marina had made in London three years earlier. Marina and Ulay were fixated with the collision and clean transfer of power between two bodies, and the entropy as the oscillating energy inevitably waned. They began rehearsing the idea of colliding bodies outside the new housing development they lived in. They ran into each other, experimenting with different speeds, finding their pace, seeing what would happen. Ulay would later insist, for purity's sake, that this wasn't a rehearsal but the exploration of a concept. The idea of rehearsal was antithetical to the regime Abramović and Ulay wanted to build for themselves. They didn't want to be able to predict the results of their performances.

In the end, the collaboration they came up with for Venice wouldn't be so much a Newtonian demonstration of a clean and efficient transfer of energy between two bodies as a violent and halting collision with nowhere for their combined energy to dissipate. Abramović and Ulay performed *Relation in Space*—a title that was deliberately provocative in its neutral, nondescript casualness—on the island of Giudecca in Venice at the beginning of the Biennale, on July 16, 1976. A few hundred people gathered in a large derelict warehouse to watch. The performers were naked—not because of a hippie idea of naturalism, but for better sound effects when they collided: the flesh slapping against flesh was amplified throughout the space by microphones placed where Abramović and Ulay collided. Nevertheless, it helped that they both had such striking figures: the towering Ulay taut and wiry without an ounce of wasted or suspended energy stored in him; Abramović slim and nubile, with thick dark brown hair flowing majestically behind her as she ran. They started around twenty meters apart and first trotted at each other and simply brushed past when they met. Then they repositioned themselves and began a slightly faster approach, a slightly harder collision, until after about half an hour they were running at each other and smacking together with such force that Abramović was thrown to the ground at least once. "It was horrible," recalls Pat Steir, an American artist who was watching that day and who would later become a close friend of Abramović and Ulay. "Chris Burden hurt himself, but this was two people hurting *each other*."

Ulay had to restrain his full power, otherwise Abramović would have been knocked down too easily. They didn't want the piece to be a competition of strength or determination, but a test in sustaining an uneasy equilibrium through the repetition of moderated violence. The crucial reason for Ulay restraining his force and not knocking Abramović to the ground more often was their mutual fear and hatred of weakness; they wanted to create a compound strength between their two bodies and their two wills. Afterward Ulay was in agony—not from bruises or soreness from the

11.2
Abramović and Ulay in Amsterdam,
rehearsing for *Relation in Space*, 1976.
Courtesy Abramović archive.

11.3
Ulay / Abramović, *Relation in Space*, 1976.
Photo: Jaap de Graaf. Courtesy Sean Kelly Gallery,
New York.

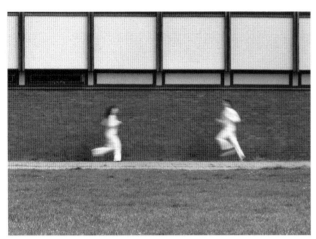

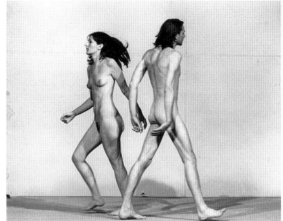

collisions, but from tiny pieces of glass stuck in his feet from running barefoot on the postindustrial floor. His feet swelled up and for days he walked around with bandages wrapped around them. He subsequently established a lifelong habit of sweeping the floor of any space before he performed or worked there.

After the performance the couple retreated to Marina's house in Grožnjan, a short distance away across the Adriatic. One morning Neša showed up unexpectedly. He naturally had keys to the house since he was still married to its owner, but he didn't know Marina was going to be there—he didn't know anything about her movements by this time. And he still didn't know about Ulay. When she heard Neša's keys rattling in the door, Marina got out of bed and rushed downstairs to tell him he couldn't come in. They went to a nearby café and Paripović drank a large grappa while Marina told him, eight months after the event, that she had fallen in love with someone else.

That summer, Ulay built a concrete bench and table for the kitchen (they both loved the severity of the furniture). They stole wood from the neighbors' pile, and went on rambling walks together. On one of them, they came across a quiet cemetery in which Marina declared she wanted to be buried. They also had fun choreographing more photos. Following the motif of their photos in the cemetery in Prague, Marina posed on a dirt road facing Ulay's camera. This time she wore Ulay's large raincoat with a fur collar and a cap. After each photo, she receded a few paces further back until she had disappeared over the brow of a hill.

Ulay took the film back to Amsterdam and made an exhibition out of it at de Appel. Just before the opening of the show, called "Fototot," he made nine large prints of Marina gradually disappearing over the hill, but did not put any fixative on the images. He hung them on the wall of the darkened gallery and at the scheduled moment invited the public in, guided only by a couple of soft yellow-green lights designed for darkrooms. When everybody was in, Ulay turned on the overheard lights and visitors got a fleeting look at the receding figure in the photos before the unfixed images faded to black and disappeared entirely in the light. Photo death. From a balcony overlooking the gallery, Ulay took photos of the audience straining to get a look at the dissolving images. In exposing the vulnerable image to the ravages of time and light, *Fototot* revealed the chemical secrets of photography and finally achieved what Ulay had aimed at for years in photography: the transplant of what he

11.4
Marina and Ulay in Venice, 1976. Courtesy Abramović archive.

considered a formal, sentimental, lie-prone, and complacency-inducing medium into the realm of the real and the ethical.

Fototot was the last event at de Appel before the gallery's August break. It re-opened in September with *Fototot II*, in which Ulay placed on a table a folder filled with photographs he'd made of the audience a few weeks earlier. These documentary photographs were also unfixed. As soon as people flipped through the folder and exposed the images to the light from the desk lamp on the table, these images also disappeared. Marina was extremely impressed by this second, emphatic and almost violent erasure. She understood it as a brilliant demonstration of Buddhist principles of transience. It was that, but it was also typical Ulay: his self-destructive streak and desire for deletion was only partly sublimated in the work. Just as Marina had gradually abandoned her earlier media—paint, objects, and then the immaterial of sound—Ulay felt there was no need to dwell on photography any more, having pushed it into a much more fertile area: performance. When there was literally no material left to work with in what had been their most fruitful media, Abramović and Ulay both turned to the body as the ground zero material for making art. It was the only thing left, the only thing that couldn't be denied, couldn't be erased.

Abramović also had a couple of solo works to get out of her system before she surrendered completely to collaboration. In July an exhibition of photographs of the *Rhythm* performances and the video of *Freeing the Voice* opened at de Appel. Abramović didn't show up for the opening; she used it as the occasion for a new performance called *Role Exchange*, sending a prostitute named Suze to the gallery in her place.[16] Abramović chose Suze because she had been working as a prostitute for ten years, the same length of time Abramović had been practicing full-time as an artist (since she joined the academy in 1965). She had originally wanted to take a prostitute's place between 5:00 p.m. and 5:00 a.m., but in the end could only afford to pay Suze for three hours of her lost earnings while she chatted to people in the gallery rather than working. Meanwhile Abramović sat in Suze's window in the red light district. Suze had instructed her not to accept offers below her normal price. She advised her on using the mirrors on either side of the window to see who was approaching in advance. If it was a meek-looking man, she should make a "mother face" and give him lots of confidence. If it was a sexy guy "you should be busy," and so on. Ulay took photographs from across the street of Abramović while she sat in the window, smoking cigarettes and looking nervous, and occasionally fielding enquiries from men. Abramović had three potential customers during her three hours, and all of them fell through: one was looking for Suze, another didn't want to pay the price, and the third was drunk. Afterward, Suze said Marina would starve to death if prostitution were her real profession.

While *Role Exchange* seems to fit into a trilogy of feminist works alongside *Rhythm 0* and *Art Must Be Beautiful*, Abramović didn't make the piece explicitly as a remark on the status of female artists. She did it because she wanted to know what it felt like to be a whore. This was an epithet and a warning that her mother used

constantly as Marina was growing up. "My father was with a whore. If I do these performances it's because I want to be a whore. My mother was calling me so many times a whore," Marina recalls. Her entire education and upbringing had forced on her the importance of being somebody respectable. "So I wanted to see what it feels like if really you are a whore, and you're like nobody." She was at the mercy of the public, and in a far more intimate way than she had been in *Rhythm 0*. "It was mentally so heavy for me, more heavy than any of these violent performances," Marina says.

In October that year Marina and Ulay were in Berlin—perhaps preparing for two performances they would execute there individually a couple of months later. While they were there, Marina had a pregnancy test, the results of which Ulay would faithfully keep for the next thirty years: Marina was indeed pregnant. As with Neša, she believed having a child would be an insurmountable obstacle in her career as an artist. Ulay recalls Marina saying, "I'm a full blood artist and it's not possible for me to share my emotions for being an artist with a child." Ulay agreed with the decision to terminate the pregnancy, which Marina did in Amsterdam. Her decision was not only a professional one: she had an inkling, not really conscious at that time since their love was still in its prolonged utopian phase, that she could not trust Ulay to help raise a child (she knew he had already left his son Marc Alexander). But more importantly, if Ulay did indeed leave, she didn't trust that she had the emotional strength by herself to be responsible for a child.

On November 30, 1976, their respective birthdays (Marina turned thirty, Ulay thirty-three) and roughly the first anniversary of their meeting, Abramović and Ulay made a birthday performance for invited friends, a tradition that would continue for the next few years. *Talking About Similarity* took place in the studio of a photographer friend named Jaap de Graaf. Ulay and Abramović arranged chairs in a classroom set up. Ulay sat at the front and opened his mouth wide while the sound of a sucking dentist tool played out for a few minutes. Then he took a needle and thread and pierced the skin just beneath his lower lip; he had to push much harder to penetrate the tough skin above his upper lip, but he did it without flinching and, astonishingly, without drawing so much as a spot of blood. He tied a knot in the thick thread, securing his mouth shut, and then sat down in the audience. Abramović, looking a bit shocked, took his place at the front of the room.

The audience was instructed to ask her questions, which she would try to answer in Ulay's "I" voice, channeling his thoughts. It was both a test of surrender and empathy—could Abramović think and speak on Ulay's behalf, and could she do it accurately?—and of the telepathic understanding they felt they shared. The first question was predictable and unavoidable: "Does he feel pain?" Abramović made the questioner repeat his question three times, partly because she still didn't understand English very well, but mostly to demonstrate that she and Ulay felt it wasn't an answerable question, that it was absurd, irrelevant. The issue of pain in Abramović's performances, and now with Ulay, was complex and ultimately circular: they used pain as a tool to reach a different kind of consciousness where they wouldn't feel

11.5, 11.6
Marina Abramović, *Role Exchange*, de Appel,
Amsterdam, 1976. Photos: Ulay. Courtesy
Sean Kelly Gallery, New York.

11.7
Marina in 1974. In the background is a photograph
of her performance *Rhythm 2*, 1974. Photo attributed
to Milan Jozić. Courtesy Abramović archive.

pain. What mattered was reaching the sharpened state of awareness and control that came beyond pain, but only the threat of *possible* pain could induce this. Ulay had demonstrated the fruits of this state of mind by not bleeding a drop even though he had just skewered a hole in a very sensitive, bloody, and fleshy part of the body with a needle designed to pierce leather. Their performances were not masochistic; if there was any psychological unhealthiness going on, it was more like a perfected sadism inflicted on a maniacally disciplined self, an addictive thrill at mastering the body's sensitivity to weakness. Abramović finally replied to the audience member, in her broken English: "It's not a question of like or not or why or pain. It's a decision."

A video camera was pointed directly at her throughout, and she looked blank and vulnerable, like a deer in headlights. Someone asked why Ulay is the silent one and Abramović the one to try to channel his voice. "She can close mouth too. The concept is important. Who play which role is not important. He or her. He or she." The audience is remarkably unperturbed and relaxed in the delivery of their questions, given that they just witnessed Ulay pierce holes in his mouth (Marina would often complain that the Dutch were unshockable). After a few more minutes of halting dialogue, a slip of the tongue, shaky English, or Abramović's increasing exasperation with the questions causes her to slip Ulay back into the second person: "The concept is I am in place of him and talk for him because he decide to close his mouth. Very simple." This moment, when Abramović's voice diverged from Ulay's, was supposed to have been the end of the performance, but Abramović carried on fielding questions anyway, and started to become much more relaxed.

> —So what she is doing for you is really an act of love?
> —It's nothing to do with that kind of sentimental question. It just exists the fact about sewing, about giving answer, about open mouth, about close mouth, about sound.
> —What about trust?
> —Trust is because of similarity . . . I just want to say nobody ask the right question.
> —What do you think was the right question?
> —I only want to say what is not. It's all formal question about form, about sewing, about pain, about sentiment, about women, about emancipation, about men, but Ulay is the right question.

As Abramović's ultraserious, trancelike façade began to crack, her friends started asking more playful and revealing questions. One speculated as to whether she was continuing with the performance merely to fill up the one-hour videotape they were using to record it. In response, Abramović half-confesses the unspeakable in performance art: that the performance might be influenced or constrained in some way by its documentation, by consciousness of posterity. But even this she admitted in a brilliant theatrical turn that made the performance nicely symmetrical:

—That means if tape exists one hour, the action exist one hour [laughs]. No, I made joke. You are asking about time of tape and our time.

—You could make an hour out of this? That's what you mean?

—Why not? It's not color. [smiles]

—So you identificate as long as the tape is?

—Please can you ask question again?

—So identification lasts as long as tape is? It ends the moment the tape ends?

—Can you ask the question again? [laughs]. Stop.

With that, Ulay switched off the video camera. After the performance there was food and drink for the guests. Ulay kept his mouth sewed shut and sucked a drink through a straw. He didn't want to show the public his reversion back into a normal person after the performance—a habit that he and Abramović would continue.

Around this time, Ulay and Abramović decided to move out of their Amsterdam apartment. They bought a Citroën HY van to live in instead. Boxy, with ribbed metal sides and a long snout, it was so tall that even Ulay could nearly stand up straight in it. Ulay painted the van matte black, making an already conspicuous vehicle suddenly appear extremely suspicious: it could be a military or police van, or a street vendor's van-turned-getaway-vehicle. They installed a single mattress in the back, a filing cabinet for their paperwork, a stove, and a box for their clothes. Abramović and Ulay would use the van as a mobile home for the next three years—Marina couldn't drive, so Ulay was always at the wheel—traveling around Europe making performances together. When they'd customized the van, Abramović and Ulay drew up a manifesto for living in it, which they called "Art Vital":

No fixed living place.
Permanent movement.
Direct contact.
Local relation.
Self-selection.
Passing limitations.
Taking risks.
Mobile energy.
No rehearsal
No predicted end
No repetition
Extended vulnerability
Exposure to chance
Primary reactions.[17]

Abramović and Ulay decided to commit their entire lives, right down to the most basic conditions of daily existence, to the idea of performing together; and, since they had no material security, nothing to fall back on, they gave themselves no choice but to succeed. Living on the road meant freedom from quotidian distractions like rent and utility bills, and freedom to integrate their lives into an ascetic and extremist concept of performance art that allowed them no rest and no stability. Together, Abramović and Ulay at last found a way to formalize the nomadic fantasies they had each held since they were young. Two children of the Second World War, already in voluntary exile from their respective stifling cultures, set out on the road, treating Europe as something their parents could never have imagined: free territory, full of promise.

11.8
Marina and Ulay's Citroën HY van, kitted out for living in. Courtesy Abramović archive.

MOBILE ENERGY

Ulay and Abramović packed up their van with clothes and some cans of food and headed for Berlin. Not for the first time, Ulay was detained at the border for two lingering offenses: evading military service when he left the country in 1968, and failing to make child support payments to Uschi for his son. This gave Marina her first real taste of Ulay's murky history—a history that he kept mysterious even to himself. Twenty-four hours later, as usual, Ulay was released: as a registered resident of the Netherlands—and not West Germany—he couldn't be held any longer. He and Marina headed east on the badly maintained highway to the divided city of Berlin, where they both made their final solo performances before immersing themselves in collaboration.

Abramović performed the last piece in the *Freeing* trilogy, *Freeing the Body*, at the Künstlerhaus Bethanien, a complex of artist studios in an old hospital in Kreuzberg. She set herself the task of dancing, naked again but with a black scarf over her head, to the rhythms of a bongo played—significantly, she thought—by an Afro-Cuban man. When Abramović collapsed from exhaustion (according to her subsequent documentation, this was after six hours; Ulay remembers it as something more like one hour), Ulay felt it was premature and somewhat theatrical. There was pathos in it, a cry for help and an exposure of weakness.

Abramović's trilogy was now complete: she had exhausted her voice (by screaming until she couldn't produce any more sound), emptied out her memory (through reciting every word she could recall), and now she'd surrendered her body to a basic rhythm until it couldn't move any more. She had made herself an empty vessel, ready to start afresh—and it happened that she now had a new and compelling reason to do so: Ulay, with whom she was in all-consuming love.

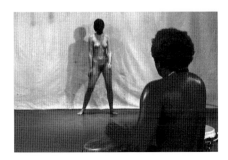

12.1
Marina Abramović, *Freeing the Body*,
Künstlerhaus Bethanien, Berlin, 1976.
Courtesy Abramović archive.

Kreuzberg, surrounded on three sides by the Berlin Wall, was a borderline ghetto for the immigrant Turkish population. "The Turks were in very bad shape," Ulay recalls. In the performance he was planning, he "wanted to relay between contemporary art and ethnic problems, social problems." On display in the Neue Nationalgalerie there was an awkward symbol of the divided Germany's confused self-image: a painting from 1839 by the German romantic Karl Spitzweg, Hitler's favorite artist, called *Der arme Poet* (*The Poor Poet*). It had been Germany's most iconic painting; Ulay knew it from his school textbooks. The poor poet shivers under piles of blankets in his garret, holding an umbrella to protect him from the leaking roof, struggling for inspiration while old manuscripts burn in the stove to keep him warm. No wonder Hitler loved the painting, Ulay thought: it depicted a prototypical book-burning. Ulay was appalled that the painting was hanging in the Neue Nationalgalerie, which was supposed to be dedicated to modernism. The cultural opportunity to jettison the romantic past—and its slippage into fascism—had been missed. Ulay decided to take the opportunity himself.

He spent several days lingering around the room where *The Poor Poet* hung, studying the habits of the security guards, and the exit routes through the museum. On Sunday, December 12, he entered the museum with Marina, who carried a Super 8 camera and two rolls of film. Ulay went downstairs and stood in front of a painting of a chess game near *The Poor Poet*, pretending to study it for a long time, waiting for the guard to lose concentration or move away. He didn't move, so Ulay spontaneously tried something else. He started laughing, pointing at the painting. He turned to the security guard and said, "It's wrong. The painter depicted the chess set wrong." The doddery old guard took out his reading glasses and came over to inspect. He was puzzled and said that his colleague played chess and he would know. He left the room to go and get him. With the room unguarded, Ulay took some wire cutters from his pocket and snipped *The Poor Poet* free. The alarm went off immediately, as he knew it would, and Ulay tucked the painting under his arm and ran. Marina filmed him bolting upstairs. A team of security guards gave chase across Mies van der Rohe's wide ground floor, but Ulay, with his extremely long legs, was a very fast runner, and he slammed through the door and out into the snow toward the getaway car, the HY van. He slipped and fell, and his adrenaline-overdosed legs turned to concrete for a second before he regained his control and jumped in the van, which he had left running.

Police were arriving en masse at the front of the museum; with the Red Army Faction operating at the time, they were mobilized to respond to acts of terrorism, and this looked like one. As the police stormed into the museum, Marina took the film of Ulay out of the camera and hid it in her sock (Ulay remembers, more sexily, that she stashed it in her bra). Knowing that the contents of the camera would be confiscated, Marina put in fresh film and started filming the police as they arrived. Meanwhile Ulay sped away from the museum. Another vehicle drove alongside him; in it was the cameraman Jörg Schmidt-Reitwein, who was filming Ulay's getaway.

Schmidt-Reitwein was used to extreme situations, having worked with Werner Herzog in the early 1970s. Still, he struggled to keep up with Ulay's van as he drove to Kreuzberg, where he got out of the van and hurried down the street, with Schmidt-Reitwein filming him. He hung a poster reproduction of *The Poor Poet* at the front of the Künstlerhaus Bethanien (earlier, he had also hung a large print of it outside Berlin's Akademie der Künste). Then he went to a nearby apartment building and knocked on the door of a Turkish family whom he had arranged to film beforehand. He went to the mantelpiece, took down the kitschy painting that lived there, and replaced it with the historical kitsch that was *The Poor Poet*. Germany's most treasured piece of art was now hanging in the run-down apartment of an immigrant family in its most ghettoized community. Ulay's job was done. He called the director of the Neue Nationalgalerie to tell him where he could find his painting. The director arrived with the police shortly afterward and Ulay was arrested. He had with him a statement he had drafted a few days before, declaring that the action was an artwork and not simply— or not only—a theft.

The next day the incident was on several front pages, one of which read: "Leftist radical steals our most beautiful painting." Another report featured a picture of Marina, naked and hooded during her recent performance *Freeing the Body*, with the caption: "Friend of painter [Ulay had never painted a picture in his life] filmed Spitzweg robbery." One paper declared, with derision and disappointment in equal measure, "Kunstraub war eine 'Aktion.'"[18] Ulay called the action *There Is a Criminal Touch to Art*, extending its ethical implications far and wide.

It gave Marina a charge to see her new lover racing out of the museum and through the snow with a ghastly treasured work of art under his arm. Despite his heroism though, she preferred Ulay's disappearing photos at de Appel for their Buddhistic embrace of transience. While Marina was coming to believe more strongly in an ethical and social role for her art, Ulay's theft of *The Poor Poet* was a more directly political act than she would ever consider—either for herself or for their collaborative work. Their work together would confront instead the ethics of romantic relationships, and indeed any human relationship where one is laid bare before the other in a total way, exposed, vulnerable, and willing to be undone by that person.

In January 1977 Marina and Ulay drove on to Düsseldorf to perform *Interruption in Space*, an evolution of their first piece together, *Relation in Space*. Naked again, they ran toward each other, but this time there was a meter-and-a-half-thick wall between them (the audience could see on both sides of it), which they crashed and slapped into at increasing speeds, pressing themselves up against it as if trying to push through to meet each other. The concept recalled Bruce Nauman's *Body Pressure*, 1974, which consisted purely of instructions: "Press as much of the front surface of your body (palms in or out, left or right cheek) against the wall as possible. Press very hard and concentrate. Form an image of yourself (suppose you had just stepped forward) on the opposite side of the wall pressing back against the wall very hard." Abramović's image of herself on the other side of the wall was Ulay, and vice versa.

12.2
Marina peeing in the sink at Christine Koenigs's
studio in Amsterdam. Courtesy Abramović archive.

After forty-five minutes, Abramović left the scene, but Ulay, unknowing, continued running at the wall alone for a while.

Ulay and Marina lived on the road, but Amsterdam remained their home base. Their mail was delivered to Wies Smals at de Appel; when they couldn't pick it up, they would phone to see if any performance invitations had come in, then plot the next move on their European tour. When they did return to Amsterdam, they would drag the mattress out of the van and plunk it down in the corridor at the studio of the artist Christine Koenigs. Marina and Ulay had met Koenigs through Jap de Graaf, in whose studio they had performed *Talking about Similarity*. Marina's charisma was spreading through Amsterdam, and in Christine Koenigs she found a strong ally in exuberance. Koenigs first met Marina and Ulay early one afternoon in a bar, where they were celebrating the completion of a performance, probably *Interruption in Space*. Ulay still spent a lot of time in bars; Marina didn't drink much but she so desperately wanted to be in Ulay's presence—and to keep an eye on him—that she would accompany him while he drank. While Marina thrived on social contact, it had to be the right kind, and drinking in Ulay's old haunts in Amsterdam seemed to her an absurd waste of time, a frustrating impediment to artistic success. She could be at home working on ideas, drafting letters, or she could be sharing a genuinely nourishing time with her friends around a dinner table. To pass the time in bars, she doodled and wrote notes on beer mats, which she kept as evidence for her archive. One of the beer mats has part of the "Art Vital" manifesto scrawled on it—either an early version of it or a reiteration, meant to remind Marina of what she wanted to be doing rather than sitting in a bar.

Koenigs gave Marina and Ulay rent-free accommodation in her studio, which was in an old school on Second Nassau Street, whenever they needed four walls and a roof around them for a few nights or a few weeks. There was a large oil-heated stove and only the most rudimentary of bathrooms, in which the plumbing often froze up. (Marina once improvised by perching on the edge of the kitchen sink and nonchalantly peeing in it.) When they returned to Christine's studio after their travels, they would host dinner parties, often putting on mini exhibitions of photo documentation of the performance they'd just done. Marina thrived under the attention she got during these social situations, while Ulay, with his slow-burning appeal and subtle, probing sense of humor, took a habitual backseat. "Marina was the absolute charmer," Koenigs remembers. Marina enjoyed entertaining friends with her bawdy Balkan humor and her personal theatrics. She would spontaneously start acting out an imaginary commercial for soap powder, or, the next minute, ask in a quiet voice and with a straight face: "What do you think has more value: vertical or horizontal stripes?" After lulling her audience into a dutiful aesthetical-philosophical reverie perhaps informed by French artist Daniel Buren's weighty questions, she would say: "Because I'm having difficulty choosing which bathing suit to buy."

Having grown up under the drab asceticism of communism in Yugoslavia, Marina was dazzled by the material pleasures on offer in western Europe. They spoke to her natural vitality and playfulness—the frivolity that struggled to find expression in her work. But the sudden vacuum of duty and responsibility in her new life in the West felt troubling. Now that she was away from Titoism and away from her mother, she felt she had too much freedom, and hardly knew what to do with herself. The iron rules of her performances with Ulay provided an answer.

Ulay had been a reluctant, peripheral figure in the Amsterdam art world since arriving in 1968, but with Marina as a strengthening compound, together they were becoming a center of gravity, attracting attention, admiration, and favors. Gijs van Tuyl, who was on the city's arts council and had contacts in the ministry of culture, helped Marina register to become an Amsterdam resident, and helped Ulay / Abramović secure the generous grants available for artists living in Holland. Marina and Ulay also became friends with the performance artist Ben d'Armagnac. An aristocratic and beautiful bohemian, half French and half Dutch, d'Armagnac made harrowing, elegiac, often blood-spattered performances, always dressed in white and usually in a space draped in white sheets. When d'Armagnac used blood—for example smearing it on the wall of a padded white cell at the 1975 Paris Biennale, or clutching a cow heart in a piece with his frequent performance partner Gerrit Dekker—the influence of the Viennese Actionists morphed into a more melancholy sense of the sublime, without the brutal macho yawping.[19] In a performance Ulay may have seen at de Appel in 1975, d'Armagnac crouched in a glass vitrine full of flies; the vitrine was painted white on the inside and d'Armagnac scraped off the paint with a razor blade, using his bloodied, bandaged left arm.[20] D'Armagnac was shy but a popular figure in Amsterdam. He lived for several years in a kind of commune just outside the city on the coast with the artist Anton Heyboer and Louwrien Wijers, a critic and artist close to de Appel who would later write d'Armagnac's biography. Wijers had known Ulay since the early 1970s, but only vaguely—it is telling of Ulay's reticence that she didn't even know he was an artist until he performed *Fototot* at de Appel in 1976. D'Armagnac introduced Wijers to Marina. Wijers remembers d'Armagnac reporting: "'I have found a friend for you. I think she'll be a friend till the end of your life.' Immediately we were close friends, and our subject was Madame Blavatsky."

Marina and Wijers shared a hunger for esoterica. After exploring Blavatsky's theosophy and the occult together, their interest turned toward Buddhist and Hindu mysticism. Wijers was friendly with the Indian guru Harish Johari, who often stayed in her tiny, tilting canal house on Herengracht. Johari introduced Marina and Ulay to Vedic numerology, in which adding the individual figures of the birth date together continuously produces a single, predictive number. Marina's (and Ulay's) birth date added up to three (November 30 = 3 + 0), which indicated that they were both natural teachers; Marina's complete birth date produced a seven (11 + 30 + 1946 = 25; 2 + 5 = 7), which indicated an even higher calling for pedagogy. Johari taught Marina how to read other people's numbers, which became a lifelong

habit. It was a charming and flattering social performance, strategic and sincere at the same time, ingratiating her with people who were complete strangers a few minutes earlier. Wijers saw in Marina the same thing Koenigs had recognized: someone who must have people around her, who had the power to attract them, and who needed constant activity and attention.

As she'd done at the SKC, Marina quickly and effortlessly embedded herself in a venue and community that could nurture her artistically and socially. De Appel was the center of Amsterdam's art world, and Europe's most important venue for performance art. Wies Smals, a dynamo much like Marina, was constantly inviting local artists like d'Armagnac, Gerrit Dekker, and Sef Peeters to make work in the space. She also hosted the most prominent artists of Abramović's generation from around the world, among them Carolee Schneemann, Laurie Anderson, Chris Burden (who in 1975 built a car in the gallery that he intended to drive to Paris, but couldn't get a license to use on the road), Vito Acconci (who also made a vehicle, *The Peoplemobile*, out of a VW pickup, in 1979), and James Lee Byars (whom Marina had met on a visit to New York with Ursula Krinzinger just before moving to Amsterdam; it was a hot day and Byars had asked Marina to bring to his apartment a watermelon, but instead of eating it, they sat there contemplating it while Byars read Zen poetry). When Marina and Ulay weren't traveling, they would spend much of their time at de Appel chatting with Wies, meeting other artists, and watching performances. One that they missed was *Imported American Artists Take the Money and Run*, by imported American artists Robin Winters and Carlene Fitzgibbon, who literally took all the possessions—money, wallets, handbags—from everyone in the gallery and left, only returning them a few hours later after a negotiated settlement. Winters fell ill with hepatitis shortly after the performance, and he stayed at the apartment downstairs from de Appel while he recuperated. "We were all in a family situation" at de Appel, Winters recalls. He lived intermittently in Amsterdam through the late '70s and befriended Marina and Ulay.

Winters meant his money-stealing piece as a parody of what he felt was the "rather fascistic" provocation of audiences that performance artists like Chris Burden were perpetrating at the time. Burden was the most extreme body artist working in the U.S., and maybe the world. He had curled up inside his locker at UCLA for five days (*Five Day Locker Piece*, 1971), disappeared for three days without telling his friends and family (*Disappearing*, 1971), spent twenty-two days lying in a bed in a gallery (*Bed Piece*, 1972), attempted to electrocute himself while standing in his studio doorway on the busy Venice Boulevard (*Doorway to Heaven*, 1973), crawled on broken glass with his hands behind his back and only underwear on (*Through the Night Softly*, 1973), and bought an ad slot on local TV to broadcast a ten-second excerpt from the performance. In *The Visitation*, 1974, Burden set himself up in the basement boiler room of a gallery, meeting visitors one by one, who, it turned out, he merely chatted to politely despite the expectation of some kind of extreme act or confrontation. Like Gina Pane's self-harming performances in France, Burden's

pieces in the early '70s were motivated in part by—or at least had a counterpart in—the agony and impotence widely felt over the escalating Vietnam War. This was less apparent for Burden than for Pane, who turned the violence she saw in the world against herself in a demonstrative, martyr-like fashion. In a text accompanying her 1971 performance *Escalade non-anesthésiée* (Unanesthetized Climb), in which she climbed a step ladder studded with metal barbs, Pane wrote: "Internal pain joins physical pain, suffering becomes moral pain."[21]

As Ulay / Abramović's performance regime began to cohere, pain became less important than it had been in their solo careers. They were becoming more interested in sheer duration and the strange freedom that came with constraints. As soon as they created a structure of strict rules, they could surrender to those rules. Pain was subsumed into this structure so that it wasn't an end in itself but a tool to reach a transcendent state of mind. Still, the role that Vietnam played for Pane as a driving force and, on more structural and perhaps also subconscious levels, for Burden too, was taken by the Second World War for Abramović and Ulay. As they grew up, the historical and familial weight of the war always hung over their heads as both an accusation and an aspiration. Internalizing and mastering pain in their performances was a way of purging the legacy of their parents. For Marina in particular, performance allowed her to assert her body against the stultifying, omnipresent example of her parents' wartime generation, which had heroically sacrificed itself for a higher cause. But as RoseLee Goldberg points out, this was not necessarily how audiences thought about these kind of extreme performances as they witnessed them: "You almost didn't talk about things like that at that time . . . when you're right there and in the moment, it would have seen so peculiar to say 'Why are you doing this? What does it mean?'" The immediate experience was visceral, not cerebral and interpretable in psychological or historical ways. Plain competitiveness was also an important motivation—disavowed at the time—behind the extreme acts of many performance artists. The compound of Ulay / Abramović was powerful and self-contained, but they no doubt kept half an eye on the escalating exploits of Chris Burden and Gina Pane, wondering how they could go further.

Ad Peterson, a curator at the Stedelijk, was another of Ulay's old acquaintances with whom Marina activated a stronger friendship. Marina had "incredible vitality and energy," Peterson says. "Unbelievable. Very impressive. Funny also. She saw very clearly what she wanted in the art world. I had the idea that Marina really was the engine in the couple. She was always very excited and Uwe was more calm. But they had the same kind of intensity." Peterson wasn't a fan of many of the performance artists who passed through de Appel. But there was something about Abramović and Ulay's performances that he loved: the dynamics of their personal relationship, the pure charisma they exuded, perhaps also the didactics of energy cultivation and hyperconscious living that they came to embody. Peterson had something like a fan's crush on them as a pair.

Marina's charisma beguiled almost everyone she met. She was also capable of absorbing enormous amounts of dedication and demanding constant indulgence. Marina was the mysterious immigrant, forever the guest star, and she enjoyed the attention as other people—like Ulay—took care of the banal details of life, leaving Marina to float free. Those willing to indulge her were rewarded by being drawn up onto her "cloud," as Christine Koenigs described it. It was an exhilarating and blessed place to be, bathed in Marina's aura, charged by her hyperactivity, affectionate generosity, and restless curiosity. As for the few people who didn't care to get swept up in Marina's cloud, and who resisted her overwhelming, domineering vitality—Koenigs saw this as a deficiency in them rather than an indictment of Marina's ego.

Just as Marina was establishing herself in the Amsterdam art world, she paid a visit to Belgrade in 1977 to perform with Ulay at the SKC at the April Meeting, the festival that had been her crucible a few years earlier. By now she had outgrown the place, and it must have felt odd—intrusive, presumptuous even—to return there with a bigger reputation in the art world than any of her former colleagues. The SKC was full to overflowing for Ulay / Abramović's performance *Breathing In / Breathing Out*. Most people couldn't fit into the gallery and instead listened to the amplification of the performance that was piped out into the lounge. Abramović and Ulay had small microphones taped to their throats and had pushed cigarette filters up their noses to block the passageways. They knelt opposite each other. Abramović emptied her lungs and Ulay filled his, and they locked their mouths together. Ulay breathed into Abramović's lungs, and in turn she exhaled the secondhand air back into Ulay's lungs. They continued, passing this same original lungful of air back and forth. It was a game of rapidly diminishing returns. After a few minutes, the regular rhythm of breathing in and breathing out turned more urgent as they drew deeper on each other's lungs, reaching for the disappearing traces of oxygen in each other's breath. The gasping, gargling, and heaving sounds reverberated throughout the SKC and the audience watched in concerned silence as Abramović and Ulay's symbiosis quickly degenerated into a deadly entropy. After nineteen minutes, with strings of thick saliva dribbling from their connected mouths, Abramović and Ulay burst apart, heaving for breath and from nausea too from the carbon dioxide they had just fed each other. It was an ominous picture of overreliance: of what happens when one person becomes the sole source of nourishment. Like all their work, the performance had a universal aspect as an illustration of the limits of human interdependency: "Something harmonic turns out to be poison," Marina says. But there was also a private defiance of these natural limitations: Marina was totally enmeshed in her ideal and ultimate relationship, encompassing love and work. She and Ulay seemed willing to enfold and collapse themselves in each other, and even to die within each other if that was the price.

Marina and Ulay did not stay at Makedonska 32 during their trip. Marina had enough difficulty bringing a husband there (she finally divorced Neša in September that year), let alone a boyfriend—a *German* boyfriend—with whom she was flitting

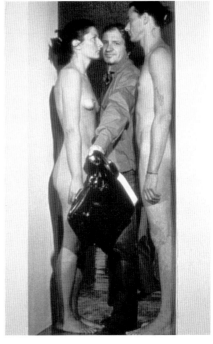

12.3
Ulay / Abramović, *Breathing In / Breathing Out*,
Student Cultural Center, Belgrade, 1977.
Photo: Nebojša Čanković. Courtesy Sean Kelly
Gallery, New York.

12.4
Ulay / Abramović, *Imponderabilia*, Galleria
Communale d ' Arte, Bologna, 1977.
Photo: Giovanna dal Magro. Courtesy
Sean Kelly Gallery, New York.

around Europe making bizarre and shameful performances. They stayed instead with Bojana Pejić, Marina's friend from the early days of the SKC. Ulay was warmly welcomed by Marina's old circle of friends. But like Marina, he detected in the Belgradians of her generation something prematurely aged and defeatist, something that "felt a little bit like collective masochism. Drinking a lot, eating too much, and being depressed." The heavy atmosphere of political oppression—and self-oppression—that Ulay sensed in the way people lowered their voices in restaurants whenever they wanted to say something critical of the government had festered into a general lack of self-confidence and ambition. "Marina was different," Ulay says. "Marina gave a shit for that."

The morning after *Breathing In / Breathing Out*, Ulay took Marina to the city dog kennel, where they found an Albanian shepherd nursing a fresh litter. Marina took the smallest puppy, the runt, in her hand, and that was that. The dog was already named Alba, and they stuck with the name. Alba became an uncomplicated object of affection for Marina, something that required an acceptable degree of sacrifice and devotion—and reciprocated it. Marina loved taking Alba on walks. She became a kind of talisman, traveling everywhere with Marina and Ulay in the van. Once, Marina dreamed that Alba was driving the van.

Early that summer they spent some time in Grožnjan, where Velimir paid a visit since he was serving in the army nearby. He took an immediate liking to Ulay and the dynamic he had with Marina. "They were full of unexpected volcano eruptions of emotions or ideas or initiatives," Velimir recalls. In June Marina and Ulay headed to Bologna for the International Performance Week, a festival featuring many artists they already knew personally—Ben d'Armagnac, Joseph Beuys, Charlemagne Palestine, Gina Pane, Laurie Anderson—and artists they hadn't yet met, including Chris Burden, Nam June Paik, and Czech artist Katharina Sieverding.[22] The Galleria Communale d'Arte Moderna, where most of the performances took place, allowed Marina and Ulay to sleep in the janitor's closet as they spent a few days preparing their piece, *Imponderabilia*.

They decided to act like sentries, or rather doorposts, standing naked opposite each other in the narrow entrance to the museum. The gap between them would be too small to pass through normally; visitors would have to turn sideways as they shuffled through, deciding whether to face the naked Ulay or the naked Abramović. Shortly before the performance was due to start, Abramović and Ulay still hadn't been paid the fee the museum had promised. So, already naked, Ulay strode into the office of the museum and demanded his money. Having difficulty arguing with a naked man, the secretary handed over the money, which Ulay wrapped in a plastic bag and stored in the cistern above the men's toilet, since he didn't have a pocket to put it in at the time. "I was the bad guy whenever we didn't get paid," Ulay remembers. The fee was 750,000 lira (about $550), enough to sustain them in their frugal existence in the van for a long time.[23]

Ulay and Abramović took up their positions in the doorway and visitors began to arrive. Their decision about who they would press themselves up against frontally as they passed through was perhaps not so imponderable after all: nearly all the men, and the vast majority of women too, chose to face the lithe figure of Marina. No one looked at either Abramović or Ulay as they passed through; in fact most people acted as if the bodies were inanimate, routine obstacles they had just passed through, like a turnstile on a subway. Abramović and Ulay remained unmoving and apparently unmoved the entire time, looking blankly into each other's eyes.

Only when the visitors went upstairs into the main gallery space did they realize that they had been filmed making their decision in the doorway. Two TV monitors embedded in the wall showed live footage of the public entering the building through Ulay and Abramović. Once inside the gallery, the main event was already over and there was nothing left but the difficulty of pondering what had just happened in the doorway. On the wall of the gallery space, Abramović and Ulay had written in cursive script: "imponderable. Such imponderable human factors as one's aesthetic sensitivity. the overriding importance of imponderables determining human conduct." After an hour and a half, two handsome young police officers passed through the door (both chose to face Marina), and shortly afterward returned with two staff members from the museum, who told Abramović and Ulay that they would have to stop the performance because the police deemed it obscene. Ulay walked away; Abramović, with a hint of petulance, lingered a bit longer.

From Bologna, Marina and Ulay drove north to Kassel, in West Germany, for the sixth edition of Documenta, the enormous exhibition that took place in the town every five years and served as a barometer for contemporary art. Ulay / Abramović had sent a proposal to the curator, Manfred Schneckenburger, and in correspondence he had given the impression that the proposal was accepted. Though they never received formal confirmation or discussed how the performance would be produced, they decided to show up in Kassel anyway. "And we found that we're not on the fucking list. So we organized everything our fucking selves," Marina remembers. It was like "Project '74" in Cologne all over again, except this time, galvanized by the emotional and organizational strength of Ulay, she managed to execute the piece despite not being a part of the official proceedings. Ulay and Abramović found an underground car park where they could carry out their performance, *Expansion in Space*, which was an elaboration of *Interruption in Space*. Ulay built two columns twice the weight of his body and about four meters high, touching the ceiling. The columns were about three meters apart and were mobile—they could be shunted along, given enough force. Ulay installed microphones inside the columns, and set up an amplification system as he had done in Venice. He finished building the installation minutes before the performance was due to begin.

In front of a crowd of a few hundred people Abramović and Ulay stood, naked as usual, back to back between the columns. Simultaneously, as if sharing a telepathic prompt, they both trotted toward their pillars and slammed into them. A hollow

thud reverberated around the space, and they each trotted backward to meet in the middle again. They gradually increased their speed, thudding harder and harder against their columns. With each impact, the columns sometimes yielded an inch or two, and sometimes remained stubbornly static. After about twenty minutes, the space between the columns opened up substantially, but then Ulay's column got stuck. He repeatedly slammed himself against it to no avail and then suddenly, decisively, stepped away from the performance. Abramović carried on by herself, although her column was now also stuck. As she prepared to run against it again, a member of the audience stepped in front of her column holding a broken bottle in his hand, challenging Abramović to run into it. The interloper was quickly shoved out the way—by the artist Scott Burton—and Abramović, unmoved by the interruption, continued to slam up against the jammed column for a couple more minutes until she finally decided to depart the scene. The audience applauded—a gesture that audiences of performance art usually refrained from since it was associated with the theater. But on this occasion it was unrestrainable.

It was never about competition, Abramović and Ulay would always claim of their performances together. It was about relation, pushing each other to go harder and faster and longer in order to break through to the bulletproof performance state of mind they both loved. Audiences, however, could not resist latching on to the competitive edge in their performances. In *Expansion in Space* Marina had "won" because she lasted the longest. This irritated Ulay because, he recalls, nobody knew about the energy he'd expended in building the installation just before the performance. Marina was not in prime physical condition at the time either, she says, since she was menstruating, which was especially awkward for her given her nakedness in the performance. Despite these retrospective justifications, Abramović and Ulay's efforts at the time to avoid competitiveness in their performances should be taken at face value. They were inextricably linked in love and work, living in the van, together twenty-four hours a day. Their closest friends, like Christine Koenigs and Louwrien Wijers in Amsterdam, regarded them as one personality, one being. Marina and Ulay began calling each other "Glue." Ulay was growing his hair longer, like Marina's.

After the performance, they returned to the van to find that it had been broken into. Alba, apparently not an effective guard dog, was asleep in her habitual spot: the driver's seat, with her head resting on the steering wheel. Their tape recorder, Ulay's camera, and some clothes and blankets had been stolen—material losses that merely fortified Marina and Ulay in their asceticism. They did not stay long to assess the situation. "We drove away immediately," Ulay said in an interview with *Flash Art*. "You know why? Because people always have pathetic questions, like 'Didn't you hurt yourself? Didn't you feel pain?' And so on. But you know the pain didn't exist." Marina engaged the question of pain more readily: "It's like an operation, when they cut you with a knife, but at the same time the operation's positive. And that's why the knife is OK. . . . When I come to the limits of my resistance, I feel terribly alive."[24]

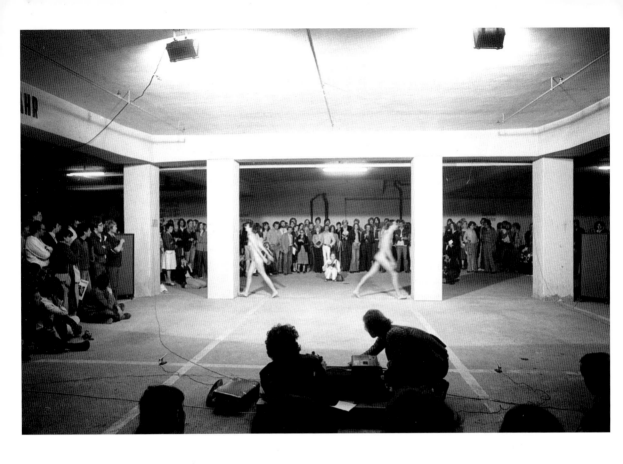

12.5
Ulay / Abramović, *Expansion in Space*, Kassel,
1977. Courtesy Sean Kelly Gallery, New York.

One thing Abramović and Ulay never spoke about in interviews was which of them came up with which particular ideas: they couldn't pinpoint who came up with what, and didn't want to; they were so entwined that ideas seemed to emerge spontaneously, exponentially, telepathically. For balance, they tried to alternate the order of their names in the credits for each performance, though this system proved difficult to enforce.[25]

The 10th Biennale des Jeunes in Paris that September brought another opportunity for Marina to redress a past injustice. The committee that rejected her proposal for *Warm / Cold* two years previously had accepted her and Ulay's proposal to drive their van in a circle around a small sunken public square outside the Musée d'Art Moderne de la Ville de Paris (their friends Gijs van Tuyl and Ad Peterson were on this committee). But *Relation in Movement* ended up being a lot more trouble than anyone had anticipated. The predicted end of the performance would be either when the van broke down or they did. They made a ramp down into the square and drove the van into position. Ulay was at the wheel, and Abramović held a megaphone out the window. At 3:00 p.m. on September 15 they started driving slowly in circles. Marina steadily and consistently barked through her megaphone the number of revolutions. Their friend from Amsterdam Hartmund Kowalke accompanied them to Paris and was charged with the responsibility of documenting the marathon performance. He set up his Super 8 camera in a fixed position and at certain intervals recorded a few revolutions of the van. The van looked delightfully absurd in the documentation, like a little toy going round and round in determined but pointless circles, or like a dog chasing its tail. (Kowalke was taking care of Alba on the sidelines.) After a few hours the strain started to show in Marina's voice, and her militaristic shouting turned plaintive. Deep into the night the van started to slow down as well. A dark oily circle began to form on the pale stone surface of the square. Ad Peterson spent part of the night watching on the sidelines with Kowalke. "It was so crazy and interesting. But also a little bit boring," he recalls. Late the next morning, after sixteen hours and 2,226 revolutions (a number Abramović and Ulay deemed auspicious since its single digits ultimately added up to three), the van finally sputtered to a halt.[26] Exultant, Marina, Ulay, and Kowalke—the only one to watch the entire performance—abandoned the van and went back to the apartment where they were staying for some sleep.

When they returned to the square, the van still would not start. Ulay solicited the officials of the Biennale to pay for the repairs. They refused. So Marina and Ulay simply continued living in their house-van right where it was, which soon caused a minor public outcry: first they stain our square, now they squat in it. While the authorities stumped up the money to pay for the repairs, Marina and Ulay went to the tattoo artist Ruth Martins, and each got a small red "3" tattooed on their ring fingers. It was the nearest Marina and Ulay came to actually getting married. Marina remembers that they often talked about marriage but could never quite arrange it—some document was always missing. Ulay remembers that they didn't get married because

12.6
Ulay / Abramović, *Relation in Movement*, 10th
Biennale de Paris, 1977. Photo: Hartmund Kowalke.
Courtesy Sean Kelly Gallery, New York.

they thought they had discovered something better than marriage. (Both of their tattooed "3"s wore off after a few years.) The van was repaired sufficiently to trundle back to Amsterdam, though once it was there it had to be retired. Ulay immediately replaced it with an identical model, painted it the same matte black, and the road show went on.

They headed back to Bologna, this time to the gallery Studio G7 to perform *Relation in Time*. As in *Imponderabilia*, Abramović and Ulay were static and symmetrical, but this time they were back-to-back and sedentary. And as in *Imponderabilia*, the response of the public, rather than any particular action carried out by Abramović or Ulay, was the crux of the piece. Their thick dark hair, by now nearly equal in length, was tied together at the back to form something like an umbilical cord between them. They remained in this position, at first in private and without an audience, for the next sixteen hours. Echoing her installation in Zagreb in 1974, Abramović placed a metronome in the gallery, and it was a cruelly effective tool for marking the slow passage of time. A video camera took periodic footage of Abramović and Ulay, registering the gradual slump in their posture and the mussing of their tight braid of hair as the hours crept by. The camera's profile view revealed a striking similarity in their angular features: the sloping forehead and low, jutting, almost beaklike nose. They were almost mirror images of each other. Only in the seventeenth hour was the public allowed into the gallery. Abramović and Ulay's idea was to see how much they could charge the space with a certain atmosphere simply through their prolonged presence. Confronted with the static image of the exhausted but intensely focused Abramović and Ulay, the public could only tiptoe around respectfully and murmur quietly.

Late that summer, Marina and Ulay drove to Croatia with Hartmund Kowalke and his girlfriend, Elke Osthus, a model whose beauty intimidated Marina. It was a lazy, idyllic few weeks. They island-hopped around the Adriatic, sunbathing and picnicking naked on the beaches. It was extremely hot, and Alba was suffering with her thick fur. Kowalke constructed a makeshift wooden shelter against the rocks and laid down a cool bed of seaweed. Alba immediately knew it was meant for her and lay down in the shade, panting. The simplicity, spontaneity, and improvised comfort of Kowalke's temporary dog kennel encapsulated the delight in bare existence that

12.7
In Paris, after performing *Relation in Movement*, Marina and Ulay had the number "3" tattooed on their ring fingers by Ruth Martins. Courtesy Abramović archive.

12.8
Marina in Amsterdam, 1977. Photo: Ulay.
Courtesy Abramović archive.

Marina and Ulay were taking in their travels in the van. They could carve out a wholesome and nourishing existence by adapting to whatever circumstances they found themselves in, melding with their environment, putting aside the normal demands and desires of life, surrendering to spontaneity. It was a totally opposite mindset to the fanatical control and will power they brought to their performances.

At the end of October it was back to Germany, and, significantly for Ulay, back to Cologne, for a performance at the city's annual art fair. His old friend Jürgen Klauke hosted them. Marina resented the way Klauke threatened to bring out Ulay's old drinking habits. When he was traveling in the van and working, Ulay was teetotal and puritan, and in the run-up to their Cologne performance he wasn't interested in partying like before. He and Marina went to bed early one night while a party went on downstairs, but in the middle of the night a drunken Klauke woke them up by climbing into bed between them. Ulay was furious and immediately left with Marina to stay in a hotel. (Klauke has no recollection of this.) He felt Klauke, as a former collaborator, was jealous, trying to literally get in between him and Marina both sexually and professionally. He and Klauke would never speak again.

Ursula Krinzinger, who had organized Abramović's appearance in Hermann Nitsch's performance and her piece *Thomas Lips* in 1975, also had trouble accepting the new Ulay / Abramović collaboration. She was the one who had arranged for them to appear in the "Performance Section" at the Cologne Art Fair. But as an ardent feminist, Krinzinger resented the fact that Abramović had brought a man into the equation. "I always said: 'Don't do this. You are really such a strong wonderful artist. Don't collaborate with somebody,'" she recalls, regretting that she often "forgot" to credit Ulay along with Abramović in documentation of their work. Krinzinger believed that Abramović should continue to cultivate her feminine power alone, though she gradually became convinced of Ulay's value. Their performance in Cologne was called *Light / Dark*: they knelt opposite each other in a dark space but with strong spotlights pointing at them, and took turns slapping each other's faces. They were both dressed in small white T-shirts, and their long, dark, tied-back hair looked almost identical. After each slap, gentle and slow at first and gradually gaining aggression and speed, they would slap their hand down on their thigh, creating a rhythm that drove the performance inexorably forward. They had stated that the performance would end

12.9
Ulay / Abramović, *Light / Dark*, Cologne art fair, 1978. Courtesy Sean Kelly Gallery, New York.

12.10
Ulay / Abramović, *Balance Proof*, Musée d'Art et
d'Histoire, Geneva, 1977. Photo: Catherine Duret.
Courtesy Abramović archive.

as soon as one of them flinched; it turned out they both stopped slapping immediately and simultaneously after twenty minutes, even though Marina didn't flinch from Ulay's final slap. There was some other, invisible cue, an instant understanding that it was the end of the piece.

On November 30, 1977 Ulay / Abramović did another birthday performance, carrying on the tradition started in Jaap de Graaf's studio with *Talking About Similarity*. Marina was turning thirty-one, Ulay thirty-four. At the Stedelijk Museum—the most prestigious venue they had performed in yet—they reperformed *Breathing In / Breathing Out*, but this time with a variation: Abramović breathed into Ulay's lungs first rather than vice versa, so they flipped the title of the piece to *Breathing Out / Breathing In*. On this second attempt at symbiosis-turned-suicide-pact, they lasted fifteen minutes—four minutes less than in Belgrade—and Ulay rushed to the toilet afterward to vomit due to the overdose of carbon dioxide he'd just shared with his lover. Ulay thought it was a mistake to reperform the piece, though for Marina it was more like a necessary sequel than a repetition—which would have violated their "Art Vital" manifesto—something that achieved a symbolic symmetry on their birthday.

In December their last performance in an extraordinarily prolific year was an outright test of the telepathic connection they believed they shared. Based on a dream Marina had one night in the van (she wrote down her dreams every morning), it was called *Balance Proof*. In the Musée d'Art et d'Histoire in Geneva, they stood facing each other with a seven-foot-tall mirror propped in between them, so they were in fact facing their own mirror image directly. Their aim was to step back from the mirror simultaneously and spontaneously, without any prior agreement about when they would do it—leaving the mirror to smash on the floor. After thirty minutes Abramović felt certain that Ulay had stepped away from the mirror, so she walked away. But the mirror remained upright. Her intuition had failed. After about another minute, Ulay felt that he was starting to bear the full weight of the mirror; he realized Marina must have left, so he too stepped back and walked away. The mirror fell to the floor but amazingly did not smash as they had expected it to.

13

MOTOR FUNCTION

Marina was getting to know every gas station along their regular routes between Holland, Germany, and Italy, and remembered the ones that had showers. True to the "Art Vital" manifesto, she and Ulay continued their nomadic existence in the HY van. If they needed to recuperate after a performance, they would retreat into nature, where they could also save money. Early in 1978 they spent two months in Sardinia, where they often helped shepherds milk sheep at 5:00 a.m. in exchange for cheese and sausages. Marina knitted pullovers for her and Ulay, read a book on macrobiotics, and mused in her journal: "Health is nothing but a good equilibrium established between two antagonistic systems yang-yin. Could we control this balance by our daily diet, we would then be able to be our own masters."[27]

In the back of the van, Marina and Ulay shared a mattress that was barely a meter and a half wide. "It was a nest; it suited us very much," Ulay says. "We loved each other tremendously, and we had a frequent and vital sex life. Our sex life was like that of poor people who don't have a television." Sex was also a way to warm up the van as they parked for the night on the frigid high planes of Sardinia. Shortly after bedding down one night, Ulay suddenly and inexplicably woke up, terrified of some noise or presence. Alba was also extremely distressed. "A few minutes later, Marina herself woke up in fear," Ulay later wrote. "We both tried to imagine whether it came from the outside or the inside. We had a look outside but could not recognize anything in particular. We decided to leave that place, and drove off the valley to park the car in the village."[28] The next day, they discovered that they had been parked near a Neolithic burial ground. On another night, they were woken by a more primal and more concrete anxiety. Marina was crying her father's name in her sleep. It wasn't the first time she'd woken Ulay like this. Marina still felt abandoned by her father, though she had all but shunned him for the past few years. Ulay persuaded her to try to reconcile with him, and she wrote him a letter saying that she accepted that he loved his new wife, Vesna—sixteen years after he'd left Danica for her. Vojo never replied to the letter, but when they visited him in Belgrade later, Marina saw the letter dog-eared in his pocket.

Around this time Marina also wrote an important letter to her mother, who sustained a fantasy that her daughter would be back in Belgrade soon enough. Danica had recently moved out of Makedonska 32—the place was too big and too full of memories of Vojo. Instead she rented three separate apartments in different parts of the city: one for her, one for Velimir, and one for Marina (in her absence, Milica

13.1
Marina and Ulay with the van and Alba, circa 1977.
Courtesy Abramović archive.

13.2
Knitting in the back of the van, circa 1977.
Courtesy Abramović archive.

lived there). Danica had asked Marina to sign papers that would put the apartment in her name. Marina reluctantly agreed, but replied:

> This declaration doesn't mean anything to me because I don't want this apartment anyway and I don't need it. I don't want to come back to Belgrade. . . . It was enough for me to be ridiculed by the stupid milieu in my life in Belgrade about my work. In all your telephone calls to me about your apartment you never thought to ask me about my work. And after all of your phone calls I had less and less desire to go to Belgrade. All your phone calls and especially your letters never change. They are exactly the same like I had when I was fourteen years old. I could tell you so many more things but at this moment they're not important any more. I will make my existence on my own and I don't need anything from any of you. Please write me all the accounts which you pay for me—social security, electricity for Grožnjan and whatever else and I will send a check. . . . I am living for my work and this is the most important thing for me in my life. And you are ashamed of my work. This is why we have nothing to talk about.[29]

Although the letter is a bold statement of intent and a powerful and final declaration of independence from her mother, it still sounds like it was written by someone in late adolescence, striking out into the world for the first time. But Marina was now thirty-two years old and had been practicing as an artist around Europe for the last five years. Such was the lag in Danica's acceptance of her daughter's career, which was now being propelled to new heights by her integration with Ulay and their design for life that was the "Art Vital" manifesto.

One of their rules in this system was proving more complex than they had thought: "no repetition." Abramović and Ulay approached performance art with religiosity, and to repeat a performance would be anathema to the transient essence of the medium. The emotional and physical response to a performance would become predictable for them, and for the audience the result of the performance would become a point of mere comparison rather than revelation. "If you are not only going to produce the performance once, then you are doing things for the market and not for yourself anymore," Marina said in an interview with Louwrien Wijers. Repetition, Abramović continued, "is for me very dangerous in a way, because it touches theater."[30] But there were different kinds of repetition, some more acceptable than others, as Abramović's take on *Breathing Out / Breathing In* suggests. And documentation presented a particular exception to the "no repetition" rule. Abramović and Ulay were meticulous in their creation of a thorough archive. But getting decent documentation of a one-off performance was extremely difficult in the unpredictable circumstances of a performance, with the public likely to stand in the way of the camera, and the cameraman likely to disregard their instructions. So on several occasions, Abramović and Ulay repeated a performance, usually just for video, but sometimes with a new audience as well. In her solo works, Abramović had already repeated *Art Must Be Beautiful* and *Thomas Lips* for the camera without any qualms.

13.3
Marina and Ulay, circa 1977.
Courtesy Abramović archive.

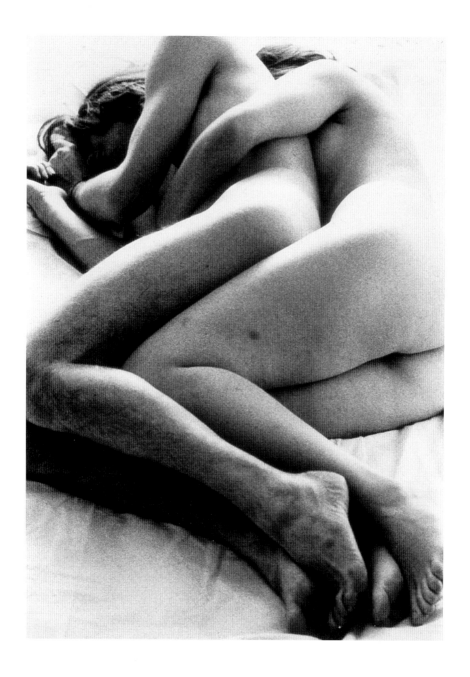

In Liege in February 1978, invited by a Belgian TV show to make a piece in the studio, Abramović and Ulay performed together without an audience—only for the camera—for the first time. *AAA-AAA* was born as a private performance, so they had little conflict about repeating it in Amsterdam one month later, again in private but this time purely for their own documentation in case they never got their hands on the original TV footage. *AAA-AAA* continued the controlled aggression of *Light / Dark*, and was also a perfect inversion of the back-to-back symmetry of *Relation in Time*. They knelt opposite each other, and screamed at each other close up—practically in each other's mouths—until one of them lost their voice. At the end of the first performance, in Liege, Ulay was left screaming into Abramović's now silent but still open mouth. She could no longer produce any sound (as with *Freeing the Voice*), but she would not submit and end the performance. The sounds they made were primal and disturbing, like babies wailing at nothing but the bare fact of existence—but with the powerful voices of adults. In the second performance of the piece Abramović screamed longest; maybe to compensate for being outscreamed the first time around.

In April Marina and Ulay headed to Vienna in the van to take part in a performance festival coorganized by Ursula Krinzinger. In the middle of the huge equestrian hangar of the Viennese Riding Academy, Abramović and Ulay stood arm in arm, each holding the ends of a rope that was attached to a horse ten meters behind them. Every time the horse moved, it pulled on the rope, threatening to sunder them. The piece was called *Kaiserschnitt*, the German term for Cesarean section. The challenge was to try to remain arm in arm, locked together, resisting the force of precisely one horsepower. In the periods where the horse did not move, Abramović shouted, "I have nothing to say," and after a long pause Ulay replied, "Ask anyone." Wies Smals was in the audience, and noted in her diary that while the performance was impressive, the presence of the horse trainer, trying to be inconspicuous next to the horse, spoiled the clarity of the image.[31] For Abramović and Ulay, it was a rare concession to safety considerations.

Their next stop was nearby, in Graz, where they performed *Incision* in the H-Humanic gallery. Ulay was naked and strapped loosely against the wall across his waist by a long and thick elastic cord. He ran repeatedly against the cord, stretching it to its limit about ten feet away from the wall, where Marina was standing, fully clothed, totally passive, and staring into space. She made no response to Ulay's strenuous (though deliberately futile) efforts to get free of the cord. When he reached the limit of the cord's elasticity, he trotted backward to the wall to try again, then again, and again. After about fifteen minutes of Ulay's unrewarded efforts and Abramović's annoying inaction, a man dressed in black walked out of the audience and executed a neat and quick flying karate kick to Abramović's left leg. She collapsed dramatically to the floor, and the audience did nothing either to assist Abramović or to detain her attacker, who strode away. Abramović stood up again, trying not to be perturbed, and continued exactly what she was doing before, as did Ulay.

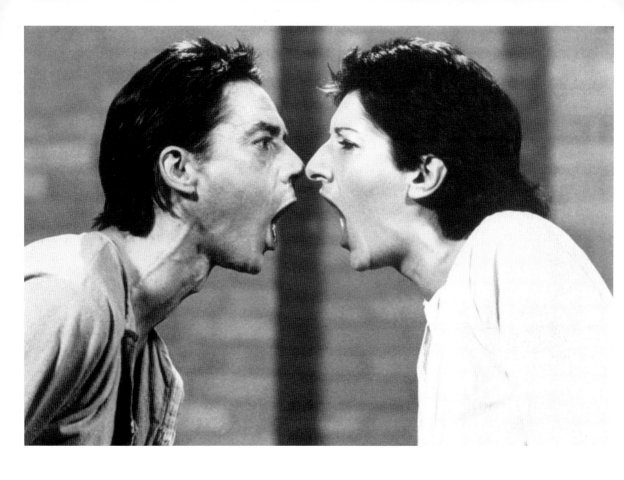

13.4
Ulay / Abramović, *AAA-AAA*, RTB TV-Studio, Lüttich,
Belgium, 1978. Courtesy Sean Kelly Gallery,
New York.

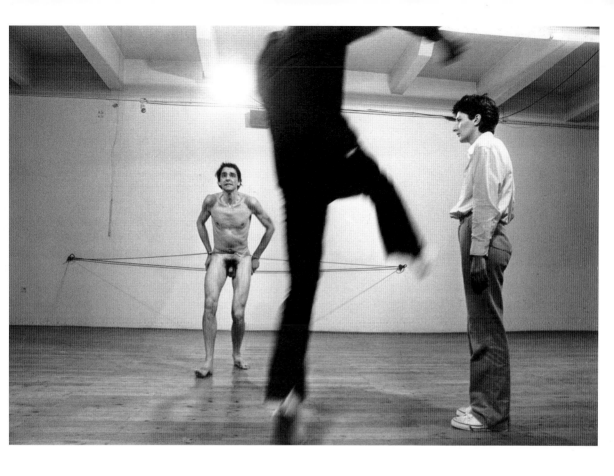

13.5
Ulay / Abramović, *Incision*, H-Humanic gallery, Graz,
1978. Photo: Hans G. Haberl. Courtesy Sean Kelly
Gallery, New York.

What no one in the audience knew at the time is that the karate attack was set up by Abramović and Ulay. It was their attempt to embody the anger they knew the audience would feel toward Abramović for her passivity while Ulay was working himself into a frenzy. At the end of the performance, which came about fifteen minutes after the kick, Abramović limped away, martyr-like. Afterward the audience lingered to discuss what had just happened, their anger growing as they realized they'd been tricked. Abramović and Ulay gathered no less than three different records of *Incision*: black-and-white video, color video, and color film. The fleeting moment of the karate kick would not be allowed to escape documentation.

Exhausted from so many performances in quick succession and looking for a change of continental scenery, early in May 1978 Marina and Ulay packed up Alba in a cage and flew to New York. There they effortlessly plugged themselves into an avant-garde scene, staying in SoHo with Edit Deak, the publisher of *Art-Rite* magazine, whom they had met the previous summer in Bologna before performing *Imponderabilia*. Deak was immersed in the New York punk world and introduced Marina and Ulay to the Ramones. Joey, Johnny, and Dee Dee adored Alba, and used her in a video they were shooting. Deak also introduced Marina and Ulay to the artist Hannah Wilke. Along with Marina's compatriot Sanja Iveković, Wilke was one of the few female artists of her generation working in performance (though she began in sculpture) to directly employ—and exploit—her beauty and sexuality rather than negate it. Wilke posed in smiling, model-style topless photographs with vulva-shaped pieces of chewing gum stuck over her body like tribal markings. The photos were satirical and scathing, but still radiant—much like Abramović had been in *Art Must Be Beautiful, Artist Must Be Beautiful*. Wilke was stunningly beautiful, and Marina immediately felt her as a rival in personal terms (artistically, she was never too concerned with what others were doing). While visiting Wilke's apartment, Marina thought she was flirting with Ulay, trying to entice him into her bedroom. Marina was furious; Ulay played innocent.

Ulay and Abramović had been invited to participate in the European Performance Series at the Brooklyn Museum, organized by Jan Brand from Amsterdam and the New York gallerist Sharon Avery. Ben d'Armagnac was also on the roster of performance artists representing Europe; for his piece, he wore a black suit and lay on a square of white tiles out in the courtyard with his limbs splayed out and moving slowly while a constant jet of water fired onto his chest in a kind of water torture; after some time he went rigidly still as if dead, before leaping up and ending the performance.[32] Ulay and Abramović performed *Charged Space* in a large gallery at the museum, with the walls covered in huge, meaty American landscapes and paintings of a bison and a moose. It was an unusual venue for a performance—they were used to small public institutions or just empty industrial spaces—and also a risky one given the nature of the piece. Barefoot but fully clothed, Abramović and Ulay joined hands in the center of the room and began spinning round and round, picking up speed and building up a force that pulled them ever outward. After a few minutes of

spinning they lost their grip of each other and peeled off toward the edge of the room, where the audience was standing in front of the paintings, which they could have easily collided with otherwise. Still, they kept spinning by themselves, slower and lurching around more, sick with dizziness, staggering drunkenly, stupidly. Ulay began barking out "Move!" at irregular intervals to Abramović, who circled round in small, pattering balletic steps. "Move!" Ulay shouted as he collapsed to the floor and shuffled back against the wall. "Move!" By now the scene—in the video documentation at least—is hilarious. This was an unforeseen quality that would haunt much of the video documentation of Abramović and Ulay's performances, super-serious at the time and affectionately amusing because of it in retrospect. Abramović looks absurd as she twirls around like a little doll. She can't pick up any more speed, the dizziness is debilitating, but Ulay keeps shouting "MOVE!" in a particularly severe German accent. At the time though in the room, Louwrien Wijers, who made the trip to New York with Marina and Ulay, remembers: "It was a tough piece. Their movement was enormous and we were afraid that something would happen to the paintings. There was always a lot of energy when Abramović and Ulay performed and therefore you were a little bit afraid."

That evening, Marina and Ulay went to a kind of preemptive funeral party thrown by the artist Gordon Matta-Clark, who was dying of cancer. He stood on a table and displayed an operation scar for all the guests to see. "It was not a dinner, more a Buddhist-oriented meeting," recalls Jan Brand. There was a stage and people were dressed in white. Marina and Ulay were so impressed by Matta-Clark's choreographed, public, and unflinching confrontation with death that they dedicated their performance *Charged Space* to him and his wife, Jane Crawford.

After their performance duties were done, Marina and Ulay picked up a car from an agency to deliver out to the West Coast. America was a wider open road for Abramović and Ulay than Europe. Marina adored the anonymous trashy motels along the way, without a trace of character or history, dedicated to a utility of pleasure and convenience—so different from the stolid and dutiful attitude of Belgrade. She and Ulay were dazzled by the waste and plenty of America: a regular portion of T-bone steak in a roadside diner would be enough to feed all three of them heartily—the third party being Alba. In Las Vegas, they had a marathon session at the slot machines, and after every little winning streak Marina would take their winnings and blow it all at the roulette wheel on three red—like the tattoos they'd got in Paris the year before. Eventually, Ulay had to drag Marina away from the casino. He still wasn't drinking, and his white-knuckle teetotalism wouldn't tolerate addictive or indulgent behavior in others. The gambling session, which made Marina lose all sense of time and place, was a kind of depraved version of the trancelike state of mind that she entered in her performances.

When they delivered the car in San Diego, Ulay bought a 1959 Cadillac Coup de Ville for $900. They immediately headed down to Mexico, and Ulay, remembering his car-racing days in the dense, drab, and cold Rhineland, and exhilarated by the

sunny open road, thrashed the Cadillac so hard that the gearbox burned out. It was late at night and they were stranded on a desolate stretch of road. In the morning, they woke up to find a crowd of people peering into the car. Without a word of Spanish they managed to explain the problem. Some men pushed the car to a small village, where Marina and Ulay were presented with a shack in which they could get some rest. They woke up in the early afternoon to find Alba having hysterical fun with the neighborhood dogs and the '59 Cadillac in pieces in the dusty driveway. No problem, they were assured. So began an unexpected rest stop in which Marina and Ulay went to the beach every day and enjoyed rustic Mexican food every night with their hosts. Eventually their car had to be hauled back to San Diego, where Ulay confronted the dealer who had sold it to him. The gearbox was fixed, and they headed back across the continent to New York. Upon arriving, they cruised around SoHo and the East Village, shouting out to people that their car was for sale. Ulay remembers pulling up outside CBGB and selling it to their new friends the Ramones, who, he says, wrecked it within a couple of days. Everywhere they went, Abramović and Ulay seemed to leave mythic traces. But Marina—usually the principal myth-maker—remembers a less illustrious ending to the Cadillac: a garage on Houston wouldn't take the car since they didn't have any official documentation for it; so they just dumped it there instead, and flew back to Amsterdam shortly afterward.

One day in September, Ben d'Armagnac called Louwrien Wijers in Arnhem and said he would be a day late for the performance festival that was about to start there, where Abramović and Ulay were also performing. He said his performance was going to be about death, and he needed one more day to prepare. That night, d'Armagnac slipped into a canal and drowned. Wijers saw his death as the preparation he was talking about, though she didn't see it as a suicide. Just as with the death of d'Armagnac's old school friend and performance peer Bas Jan Ader, who was lost at sea in 1975 attempting to sail single-handed from Cape Cod to Ireland in the performance *In Search of the Miraculous*, d'Armagnac's death was something more like a surrender.

Marina and Ulay stayed in Arnhem with Jan Brand, who was back from organizing the Brooklyn Museum performance series in New York, to help organize the festival (the world of performance art was a small one). They went ahead with their performance, *Workrelation*. The absurdity, determination, and ritualistic nature of the piece was somehow palliative in the wake of d'Armagnac's death. For two hours, Abramović and Ulay carried ninety-nine large masonry bricks back and forth in metal buckets across a long hall. A pile gradually built up at one end of the hall, and then diminished as they returned it bucket by bucket to the other end. They started out carrying two buckets each, but then discarded one of them and carried the third bucket between them. This was a picture of relational efficiency—sharing the burden. Despite the appearance of industriousness though, nothing was constructed, produced, or achieved through their efforts—an exquisite idea of "useless work" that they absorbed from the American artist Walter de Maria. *Workrelation* was another

piece that Abramović and Ulay repeated, not for documentation purposes this time but for a workshop context: they invited the local students to help them carry the buckets of stones back and forth. Later they repeated the performance in Ferrara, Italy (for three hours) and then in December at the Badischer Kunstverein in Karlsruhe, Germany (for eight hours).

Ulay's love of Beckettian absurdity seemed to underpin the piece; there was also a political element in it—a somewhat bitter acting out of alienated labor, manual and professional (in the Arnhem version, Ulay wore a tie and Abramović a smart white shirt and black skirt)—that has more of Ulay's fingerprints on it than Abramović's. Before one of the *Workrelation* performances in Arnhem, Joseph Beuys, who also attended the festival, took it upon himself to anoint Abramović and Ulay's performance space by sweeping the floor. Ulay interpreted this as something more like territorial pissing than a shamanic act of ritual cleansing, and he resented the gesture. Since Ulay had cut his feet performing at the Venice Biennale two years earlier, he was already in the habit of sweeping his own performance space, and didn't need a shaman to do it for him.

D'Armagnac's death was the first jolt for Marina and Ulay since they began living and working together, and it was particularly sobering after their jaunt across America. Their friends in the Amsterdam art world slipped into a mourning period and there was a general retraction of creative energy. The center had disappeared, but Abramović and Ulay would gradually take on d'Armagnac's role. "They had a motor function for the Amsterdam art world, especially after Ben was no longer there," Wijers says. In October 1978, a month after d'Armagnac's death, Ulay wrote a letter to Smals from the hills outside Bologna. "I am writing this strange night because we love you, because we think of you and dream about you." Whenever he and Marina were away in the van for long periods, Ulay would write deeply affectionate letters to Smals and her colleague Aggy Smeets at de Appel. Ulay had always been searching for a surrogate family since his own had withered away in the Rhineland, and at de Appel, he had found one.

For their 1978 birthday performance, Abramović and Ulay lay down on opposite sides of the Harlekin Gallery in Wiesbaden, with a four-foot-long python in between them. The performance, called *Three*, was an experiment to see who the snake would be most attracted to, Abramović or Ulay. They each tried to entice the snake toward them by making resonating sounds: blowing the top of a glass bottle and twanging a piano wire that was stretched across the space close to the ground. Ulay had a high fever during the performance. He was sweating and had a glazed expression as he belly-crawled around the small arena. Abramović was playful, even childlike. She started crawling behind the snake, demanding its attention. She was actually frightened of snakes—just as she was terrified of bleeding—but this fear dissolved when she was in a performance frame of mind. The snake turned around to face her and stuck its tongue out. Abramović stuck hers out too, and edged closer to the snake, hoping to make contact. They got to within an inch of each other, but the kiss never

quite came. Still, the experiment was over, and as in the Bible, the snake went for the female. It was the same as in *Imponderabilia*, when the public was more attracted to Abramović than Ulay, and as in *Incision*, when Ulay did all the work for no reward—and Abramović was dramatically punished for it. Somehow Abramović always ended up with the starring role in the performances while Ulay took on the role of the un-celebrated, dogged worker.

14

WHO CREATES LIMITS

In early January 1979, Marina wrote to her mother: "Please continue to write to me at de Appel gallery, but the new address where we are going to live is Zoutkeetsgracht 116 / 118, Amsterdam."[33] Abramović and Ulay were making a significant adjustment to their "Art Vital" system of nomadic living. While they would keep the van and continue to travel in it, their increasing success—which meant more grants from the generous Dutch government, and more performance fees—enabled them to set up a base of their own in Amsterdam, rather than relying on Christine Koenigs's corridor.

Marina and Ulay took out a lease on a large, low-ceilinged, tunnel-like apartment in an old salt depository on Zoutkeetsgracht, in the quiet west harbor area of the city. They rented out two rooms to Edmondo Zanolini and Marinka Kordič—artists in a theatrical trio called Maniac Productions, who met Marina and Ulay through de Appel. Michael Laub, a theater director and the third member of the group, was Marinka's boyfriend, but he only stayed intermittently. A Polish artist named Pjotr Olszanski slept in a tent in the central, windowless and womblike living space, or "middle space," as they called it. Olszanski kept a Bible in the freezer, and every day made a performance out of prying it open and reading a new passage. The American artist Barbara Bloom lived in the apartment next door and often joined in festivities in the middle space. Marina and Ulay had the biggest room in the apartment, and it doubled as their office. There was a desk with a typewriter on it and a lucky number "3," a table number snitched from a restaurant.

Moving into the apartment on Zoutkeetsgracht signaled a professionalization of the Ulay / Abramović regime. Instead of the little filing cabinet in the back of the van and relying on de Appel to receive their correspondence, Marina and Ulay now had a fixed command center. The roles they'd already defined in the relationship became more entrenched in their new domestic setting. Ulay was the practical one: he typed the letters to various institutions and galleries (his English was technically much better than Marina's, though she often dictated to him the essence of the letters), dealt with all the finances (for years, Marina didn't have a bank account in Amsterdam), and made appointments, which Marina attended more often than he did. As well as cooking, cleaning, washing clothes, and walking the dog (tasks that she loved), Marina was the public relations person for Ulay / Abramović: her exceptional charm and the force with which she could describe their mission won them invitations to perform and began to propel them into the limelight as a fascinating and sought-after artist couple.

The first piece they conceived in their new Zoutkeetsgracht office was made at de Appel in March that year. *Installation One* consisted of a six-foot-long propeller rotating on the floor of the gallery, like an oversize inverted ceiling fan. They hoped it might generate a similar kind of menacing energy as they'd made with their own bodies, spinning around in the gallery at the Brooklyn Museum for *Charged Space*. They also projected a film of themselves naked in de Appel: Ulay is lying down with what appears to be a perpetual erection (if you don't notice the looping of the film) and Abramović sits next to him, also naked, staring into space passively and provocatively as she did in *Incision*. "[T]he installation creates the possibility of generating . . . a 'mobile energy' without the necessity of our physical participation," they wrote. "This 'mobile energy' can lead to an 'energy or existence dialogue' with the 'inhabitants.'"[34] In December, at the Harlekin Gallery in Wiesbaden (where they had performed *Three*), they presented *Installation Two*. Again, Abramović and Ulay substituted objects for their own physical presence: an iron hotplate on the floor burned off slow, periodic drops of water from the ceiling with metronomic and vicious efficiency.

The middle space at Zoutkeetsgracht was the venue for the 1979 birthday performance, *Communist Body / Fascist Body*, in which Abramović and Ulay tried to symbolically bridge the ideologies they'd been born into. They invited about a dozen friends to the apartment shortly before midnight on November 29. There were three tables set out: one had pages of *Pravda* as a tablecloth, three bottles of Russian champenoise, some cheap aluminum army-style mugs and cutlery, bread, and Russian caviar; the other table had three bottles of German sekt sparkling wine and crystal glasses, silver cutlery, and German caviar. On the third table, Abramović and Ulay's birth certificates were joined together with tape. Abramović's birth certificate sported the communist red star; Ulay's was stamped with the swastika. At the back of the room, some distance away from the tables, Abramović and Ulay were in bed asleep under a large red blanket. Among the guests to encounter this scene were Hartmund Kowalke and Elke Osthus, Louwrien Wijers, Ad Peterson and Gijs van Tuyl from the Stedelijk, and Josine van Droffelaar of de Appel. Tomislav Gotovac was in town, and he filmed the event. The guests were initially confused at having been invited to a birthday party where the hosts were not exactly present. Everyone shuffled around nervously. A small pile of presents formed by the wall. Nobody knew what to do. Were Abramović and Ulay really asleep? Would they get up in a minute and start the celebration? It was more like a marriage, with the conjoined birth certificates, or a funeral, with its static center of attention, than a birthday party.

Wies Smals arrived shortly after midnight, and she and Van Droffelaar decided to open the sparkling wine and start a little party. The atmosphere loosened up and people ventured over to the bed to see if Abramović and Ulay were really asleep. Antje von Graevenitz sung Ulay a German lullaby. He was sound asleep throughout, but Abramović remained awake behind her stubbornly closed eyes. "I was concentrating very much on the idea of falling asleep," Marina told Gotovac later, in an interview for his film. "But at a certain point many people kept coming and coming.

I started to feel their energy. My eyes were closed, but I was completely conscious of the situation and of the kind of vibrations I was getting. And there was less and less possibility that I would fall asleep. During the whole night, I did not sleep." There was a party going on in her honor, and she couldn't rest knowing she was not immersed in the social throng. Ulay on the other hand was probably pleased to be out of it.

Shortly before this performance, Marina had received an invitation from Tom Marioni of Crown Point Press in San Francisco to a gathering of artists on the Micronesian island of Ponape. Marioni had first met Marina in Edinburgh in 1973 and then again at the April Meeting at the SKC the next year. There, Marioni performed a piece called *Sculpture in 2/3 Time*, in which he polished a rusted surface into a resonant drum head and beat it rhythmically with a stick. Marina watched the piece and afterward congratulated Marioni on having "liberated light and sound from material." It was a complement that Marioni didn't forget: five years later he named a performance *Liberating Light and Sound*, and he featured some of Abramović's late solo works in the second edition of *Vision*, the publication of Crown Point Press. The artists invited to Ponape, including John Cage, Chris Burden, Laurie Anderson, Joan Jonas, Brice Marden, and Pat Steir, would each deliver a lecture or presentation on the trip, which would be collected in a 12-inch record called *Word of Mouth*.

The Press could not afford to invite both Abramović and Ulay to Ponape, but that wasn't necessarily the whole reason why Marioni invited only Marina. The fact that he could even conceive of separating Ulay / Abramović into individuals after they had been working together so intimately and notoriously for the past three and a half years was telling, and hurtful—to Ulay. If Marioni couldn't afford to invite both elements of the compound, the logical and proper thing to do would have been to invite neither of them. But he and Marina had a history, and "I still rated her as the brains or the artist behind the duo," he says. Abramović had a reputation in the art world that stretched back beyond her meeting with Ulay, whereas outside of Amsterdam Ulay remained an unknown quantity as an individual.

14.1
Marina and Ulay in their Zoutkeetsgracht apartment, circa 1979. Courtesy Abramović archive.

Marina felt guilty that she'd been invited and not both of them. So she tried to redress the imbalance by tossing a coin to decide which of them should take up the one available invitation. Predictably, Marina won the toss. Before she left though, Ulay spoke some words into a tape recorder so he could contribute at least something to the talk that she would give. In a stern and slow voice, Ulay recorded the question: "Who creates limits?" As well as addressing his and Marina's practice in stretching physical and mental boundaries, the question snidely referred to his noninvitation to Ponape. It also reflected something ingrained and intractable about Ulay, and a fundamental difference between him and Marina. For her, limits were only imposed from outside, and were therefore pretty easy to defeat through relentless will power, attrition, and charm. While Ulay also loved transgressing limits—of gender, of the law (by stealing the Spitzweg painting), of endurance—his fixation with life on the margins and his stubborn conception of himself as a lone wolf meant that the idea of limits retained an outsize power over him. Limits came from within, in the form of a self-lacerating method of doubt: unlike Marina, he never wanted to be a figurehead in the art world, and he had a history of doubting whether he wanted to be an artist at all. As with the "Transformer" exhibition in Lucerne in 1974, which broadcast the artistic gender experimentation that Ulay was exemplary in, but without including him, he missed out on an experience that might have drawn him into closer community with his artist peers. But the fact that he was left in the miserable gray midwinter of Amsterdam while Marina basked in the tropics in the company of a dozen art stars actually suited his script well.

In her speech to the artists in Ponape, Abramović began by reading a poetic list of numbers: "8, 12, 1,975, 12, 12, 1,975, 17, 1, 1,976, 17, 3, 1,976" and so on, each number spoken as if it carried massive significance in the growing chain. Then she explained Ulay / Abramović's new concept of "that self," which would soon take precedence over their "Art Vital" manifesto:

> Our interest is symmetry between male and female principe [sic—the French that Marina's mother made her learn as a child still inflected her English]. With our relation work we cause a third existence which carries vital energy. This third energy existence caused by us does not depend on us any longer but has the own quality, which we call "that self." Three as a number means nothing else but "that self." Immaterially transmitted energy causes energy as a dialogue, from us to the sensibility and mind of eye witness who becomes an accomplice. We chose the body as the only material which can make such an energy dialogue possible.[35]

Abramović's deep voice had a toughness that isn't attributable to only her Serbian accent. There was a kind of preemptive defiance in it, and, in front of these illustrious artists, an emphatic, almost theatrical embrace of the role of a no-nonsense Conceptual artist, as if she is challenging anyone to doubt her sincerity and authenticity. At the same time, there's an undertone of playfulness in the delivery, a feeling that

Abramović could have just as easily burst out laughing at any moment. About halfway through her allotted twelve minutes (twelve minutes each for twelve artists—the organizers too had an exacting conceptual sensibility), Abramović declared: "And now one very important thing I want to say . . ." She then started rambling in a made-up language, which at first sounded harsh and accusatory, like a political declaration after a coup on some Micronesian island, perhaps. While the sounds were nonsense, the rhythm and cadences were measured, repeating and elaborating until gradually Abramović's tone softened and became first poetic and then almost like a song. At the end, Abramović stops making noise and presses play on a tape. Ulay's slow voice crackles through the speakers as if he's being patched through from the other side of the world, or the other side itself: "Who creates limits?"

Though the only audience for the performance was the other artists and the dozen or so art world people who tagged along on the trip, Marina—typical of her fondness for exaggeration and outright fantasy—remembers the audience consisting of natives, and them approving of her address. "The natives listened and three or four times they applauded because it [her language] is made up and sometimes it hits"—meaning she spoke a few words of their language by accident. But on the *Word of Mouth* record, there is no applause until the very end of her address.

In Ponape Marina grew close to Pat Steir, who had witnessed *Relation in Space* and *Imponderabilia*, where she had enjoyed being diminutive enough to shove straight through Abramović and Ulay without having to turn and face either of them. Laurie Anderson had also passed through Abramović and Ulay in that performance, and had found the concept brilliantly funny. She and Marina began a strong friendship on the trip, and Marina also drew closer to Joan Jonas and John Cage. One artist who Marina didn't hit it off with in Ponape was Chris Burden. He had been her closest counterpart in body art, a guiding light, a fellow pioneer, a disavowed competitor. But he'd stopped performing in 1975, just as Abramović was about to gain fresh momentum with Ulay. In Burden's last performance, *Doomed*, he set a clock on a gallery wall at midnight, and lay down on the floor under a leaning sheet of glass. He aimed not to move until somebody interfered with these conditions in some way. This interference only came after forty-five hours and ten minutes—by which time Burden had soiled his pants—when a museum guard placed a container of water within his reach. Burden got up, smashed the clock on the wall with a hammer, and left. With this performance, he felt that he had exhausted his investigations into the body and public provocation. Nowadays he was pursuing his interest in machines, systems, and the politics embedded in both—something that had begun with his construction of the *B-Car* in 1974: a car that he wanted to achieve a hundred miles per hour and a hundred miles per gallon.[36]

In Ponape, Burden read out a text written by a Californian glider flyer—like Ulay, Burden was fascinated by aviation. It was an account of the incredible amount of training and discipline it takes to "soar," and the fear and exhilaration of it. "My mind is an ocean," the glider repeats whenever he hits an area of uplift. He reports

how his brain "feels bigger and smoother" at the end of the flight.[37] Burden delivered the account with characteristic nondrama, but it was incredibly gripping nonetheless. He was describing a freedom and transcendence achieved not through pure will power and endurance, but by quiet dedication, expertise, and precision. The text hints at how Burden had loosed himself of the ever-escalating demands of performance art (demands that were more draining for being self-imposed) to explore work beyond the realm of his own body, and beyond the limits of his own physical and mental commitment. No wonder he and Marina had nothing to talk about. (Marina says the original source of awkwardness between them, and one that would never completely dissolve, had nothing to do with their artwork. She had stayed in Burden's studio in Venice, Los Angeles, the night before flying to Hawaii together on their way to Ponape. She'd spent hours on the phone to Ulay in Amsterdam, never paid Burden for the enormous phone bill, and felt terribly guilty about it.)

Later on the trip, Marina and Laurie Anderson paddled a canoe out to a nearby small island, where a large gathering was taking place in a hut. Marina and Laurie were invited in, introduced to someone who was described as the "king" of the island (he was wearing jeans), and offered a meal of dog meat served in leaves. "We said no, but we would like to bring to our friends," Marina says. "They say no, for your friends we give you whole dog." They wrapped the bloody and stinking meat in leaves and brought it back with them, repulsed and amused. John Cage, a notoriously circumspect eater who had brought with him to Ponape a suitcase full of rice to eat, wasn't impressed with the dog meat. "Marina and I were laughing hysterically the whole time," Anderson recalls. They also brought back with them some tree bark, the sap of which was supposed to be a narcotic. They ingested it and for the next twenty-four hours Marina had incredibly heightened hearing: "We could hear our heart beating, blood flowing through our veins, grass growing, everything," she says. Anderson doesn't recall these effects, though she was desperate for the drug to work.

While Marina was on her solo adventure, Ulay decided to have one of his own, to a deliberately polar opposite destination and in deliberately polar opposite circumstances. With a group of tourists—rather than with famous artists—he went to the freezing midwinter of Moscow. While communism held no romance for Marina, having grown up under Tito, Ulay had always been fascinated by the Soviet Union. He brought with him his Super 8 camera. In Red Square, Ulay noticed a diplomat in a long black coat and fur hat carrying an official-looking briefcase, striding across the square toward the Kremlin. Ulay began filming immediately, and as the man entered the Kremlin, he swung the camera back to film two men in civilian clothes, who seemed to be following the man. Later, Ulay set this short film to some Russian folk music and called it, riffing on a joke Tomislav Gotovac told him, *An Abstract Painter Walks Across Red Square Followed by Two Figurative Painters in Civilian Clothes*. While Marina's piece in Ponape had at least a shred of collaboration in it, with Ulay's distant voice, this piece was a true solo work for Ulay—his first since stealing the Spitzweg painting. Though the film was somewhat throwaway, it reflected Ulay's

enduring political and art historical interests, which couldn't find expression in his more primal physical collaborations with Marina. It was an intimation of individuality in the face of their all-consuming union, but not quite an assertion: Ulay never exhibited the work. It would have been conceptually awkward for either of them to punctuate such an intense collaboration with solo works, but the reasons for Ulay's reluctance to exhibit the work ran deeper. In his early solo career, he had always been happier just to make work—endless Polaroids—without a vision of how it would be produced, edited, and exhibited. With his Red Square film, he could revert back to this comfortable mode of making work without an end product in mind, something that Abramović could never tolerate—she saw such casualness as an abandonment of the artist's duties, a disregard for the public, even as laziness and weakness.

A few months after Marina's return from Ponape, one of her final childhood connections to Yugoslavia perished: on May 4, 1980, Josip Broz Tito died at the age of eighty-seven. He was still Prime Minister of Yugoslavia, at least nominally, when he died, and still held in great affection by Yugoslavs, no matter their individual republic, including voluntary exiles like Marina, even though she had struggled so hard to escape from the heavy mental burdens of communism. She and Marinka, a Croatian, watched the four-hour-long funeral on TV in the middle space in the Zoutkeetsgracht apartment, and wept for the duration, much to the puzzlement of Ulay and Michael Laub.

Marina and Ulay began a course of hypnotherapy. Eager to elaborate on the concept of "that self," they approached their sessions not as a way of untying psychological knots, but as a fount of ideas for performances. They recorded the sessions (Ulay remembers them involving "a lot of crying"), and generated four performances from them, all except one made only for video. In the nine-minute video *Nature of Mind*, Abramović stands for a few minutes on the edge of a canal with her arms held aloft, then suddenly there is a flash of color as Ulay falls—apparently from the sky—in front of Marina, and splashes into the canal. The movement took only a few frames of the 16mm film's twenty-three frames per second. This is the nature of mind according to the Zen Buddhism that Abramović and Ulay were interested in: a fleeting, ungraspable image flashing across the mind's eye for a split second, and best let go. In *Point of Contact*, Abramović and Ulay stood face to face, locked eyes, and simply pointed at each other's index fingers, with only a miniscule gap between them, for six minutes. In one hypnotherapy session, Marina had a vision of how she would like to die: by rowing a boat toward a misty horizon and simply disappearing. *Timeless Point of View* was a dress rehearsal for this death scene. Abramović rowed a boat on the IJsselmeer (a large lake in central Holland) while Ulay stood on the shore, watching her fade into the distance and listening on headphones to the radioed sounds of the oars slapping the water and Abramović's heavy breathing.

Their final hypnosis-inspired piece, *Rest Energy*, was performed for the public in Dublin in August. Between them, they hold a large bow and arrow: Ulay took the arrow and string; Abramović held the bow. With the arrow pointing at Abramović's

14.2
Ulay / Abramović, *Rest Energy*, National Gallery
of Art, Dublin, 1980. Courtesy Sean Kelly Gallery,
New York.

heart, they both leaned back so that the string was tight and primed for release. They held the precarious balance for four minutes. Small microphones were attached to their chests, amplifying their quickening heartbeats around the space. It was maybe their simplest and most searing image of deadly—but also death-defying—interdependence, a motif of their entire oeuvre that brands itself on the brain. It was Abramović's closest performed, controlled confrontation with death so far. *Rest Energy* also foreshadowed an imminent shift in their relationship: the innocence would evaporate, Marina really would be at risk of being undone by Ulay, such was her attachment to him, and Ulay would feel like a potential murderer—the guilt of which would gradually make him withdraw and turn cold.

Abramović and Ulay collected the four works into a film called *That Self*, which they screened late that summer at 4:00 a.m. in Amsterdam's Vondelpark. The film included intermissions consisting only of the primary colors: red for nine minutes, blue for seven minutes, then yellow for three minutes. Abramović and Ulay had been hypnotized to produce this work, and now they were trying to hypnotize the audience in turn—it was a full-moon night, and they thought that would make the viewers even more receptive. The didacticism that had been latent in their work since the beginning was getting stronger. Behave this way, their work seemed to say, and by extension, live this way: hyperaware, uncluttered, bold.

15

ABORIGINALS

By the beginning of the 1980s, nearly all of Abramović and Ulay's peers in body art had stopped performing. One of the most important, and often disavowed, reasons for the retreat was the difficulty of sustaining a practice out of which there was almost nothing to sell. There was also no one to buy it. Abramović and Ulay were fortunate to be based in a country with an incredibly generous policy of grant-giving to artists, even to nonnationals. And when money had been short in the '70s they were able to absorb their poverty into a performative ascetic lifestyle in the van—cooking on their portable stove, showering in service stations—and offset it through the generosity they charmed out of the people they encountered on their journeys. But now that the contemporary art world was becoming a moneyed place, Marina saw many performance artists being tempted into materializing their formerly ephemeral practice, and took the harsh view that "all the bad performers started making bad paintings instead." Money became acceptable, and artists could be comfortable. Female artists could even allow themselves to use makeup and wear fine clothes (a situation Marina would later relish).

Apart from earning a living, there was another pressing and ethical reason why performance artists were shifting to a more material practice. The expectation of spectacle and extremity, and the art world's growing familiarity with their activities, became intolerable. Vito Acconci explained later: "I think the reason I stopped doing live performance was that it started to seem strange to me that everybody who knew a piece of mine knew what I looked like. . . . I started to feel that my work was about the formation of a kind of personality cult rather than the doing of an activity."[38] Acconci and Burden had long since stopped performing to pursue sculptural, architectural, and conceptual practices. Apart from Ulay / Abramović, Joan Jonas was the only major performance artist to continue performing, but her practice had always been grounded in poetics and private performances for video rather than in physical endurance or public provocation. Performance artists found that the constant reinvestment of will power, the repeated risk of physical and mental health, and even the nonrisky but still exhausting use of the body simply as a carrier of ideas, was yielding diminishing returns. It seemed like the body was a finite and expendable material after all.

Abramović and Ulay though felt no such doubts (and Marina felt no qualms about the development of a personality cult around her and Ulay). In October 1980 they sold the van, which had been their totem and their womb for the past four years, and put Alba into the care of Christine Koenigs. They were leaving Amsterdam,

15.1
Marina and Ulay in Australia, 1979. Courtesy
Abramović archive.

Holland, Europe, and to some extent the twentieth century, in search of something in the Australian outback that would sustain them in their practice. They had been on a brief visit to Australia in 1979 to perform a piece called *The Brink* in the Sydney Biennial (Ulay walked back and forth along the top of a twelve-foot-high wall; Abramović walked in step with his shadow on the ground until the sun went down). But their principal interest had been in spending time with Australian Aboriginals. With a grant of $12,000 from the Australian Visual Arts Board, Abramović and Ulay now planned to spend six months in the Great Victorian Desert living with Aboriginals, and then six months touring Australian cities giving lectures and performances inspired by whatever they found in the desert.[39]

Just before leaving for their year in Australia, Marina and Ulay took delivery of their first monograph (or duograph), called *Relation Work and Detour*. They couldn't afford to pay the printer, so instead they made him the beneficiary of the life insurance policy they had taken out for their trip to Australia. He was so touched that he printed the book for free. The book contained photographs of their performances from 1976 to 1980 together with documentation of their everyday lives: photos of Marina's little stone cottage in Grožnjan, the preparation for *Relation in Space*, their van in situ across Europe, their office in Zoutkeetsgracht, and travel anecdotes like the one about their terrifying night in the van in Sardinia.

Marina and Ulay arrived in Alice Springs, a dusty and depraved town isolated precisely in the center of Australia, surrounded by immense desert. Alice Springs was inhabited by alcoholic members of the local Pintubi and Pitjantjatjara tribes, redneck and racist cattle ranchers, well-meaning and exploitative Aboriginal art dealers, and a minority of activists and lawyers campaigning for Aboriginal land rights. Phillip Toyne was one of the latter. He would introduce Marina and Ulay to the local tribes, in exchange for their help with his work on the land rights bill for the Aboriginals in the region. Toyne quickly warmed to his unusual European charges. "They were very stimulating and interesting people," he says, "but they had a sense of reality that didn't match mine. I found it really hard to understand what their artistic endeavor was all about." Nevertheless, he trusted them enough to take them "out bush," which was a rare thing for him to do at the time. "I didn't want to turn it into a rolling pageant. So there must have been something about them that gave me confidence that they were going to handle the situation well and with sensitivity."

Abramović and Ulay were fascinated by the Aboriginals' mystical and practical connection to the land they'd inhabited for at least forty thousand years. The Pitjantjatjara were the most preserved of the Aboriginal tribes in Australia, a result of their lands in southwest central Australia seeming too barren for cattle grazing and therefore unexploited by farmers. There were many settlements built for them by the government, but in 1980 the Pitjantjatjara, especially the elders, still led something of a nomadic lifestyle, adhered to traditional laws and ceremonies, and determinedly kept alive their songlines—the ancient melodies and stories that evoked their totemic ancestral creatures, and which served as their maps of the country. Toyne was drafting

and lobbying for the Pitjantjatjara Land Rights Bill, which would pass the following year, granting freehold title to the Anangu, Pitjantjatjara, and Yankunytjatjara people over a hundred thousand square kilometers of land in the southwest—the land near Alice Springs.[40] But there was no commonly accepted, up-to-date map of the region—Toyne had already had disagreements with the South Australian government about the extent of the Pitjantjatjara lands. Marina and Ulay spent two weeks driving with Toyne in his jeep along the borders of the tribal lands to help him check and correct the maps he did have, which were mostly made by the British in the 1950s in preparation for their nuclear tests. The old maps naturally made no reference to sacred ancestral sites—a particular tree or a rock that would be anonymous and meaningless to anyone other than the local tribes. They drove for several hours alongside the dingo fence, which ran for 3,300 miles, cordoning off the southwest of Australia, to protect its sheep. Ulay was fascinated by the seemingly endless fence and got up on the back of the jeep with his camera to record it as they sped by, with the idea of making a video loop. Ulay may have been thinking of the Berlin Wall, a device that still filled him with disgust, as he filmed this mysterious and apparently futile borderline, penning in a desolate desert that was indistinct on either side. It also set him thinking about the Great Wall of China.

Just before they were due to leave Toyne's stewardship and enter the Pitjantjatjara group they'd be living with, Marina wrote a letter to her mother. The break Marina had with her mother in 1978 over her willful obliviousness to her career appears to have been reconciled. Marina persisted with a defiant intimacy and a fervent need to justify and explain herself, as if maybe *now* Danica would understand what she was doing with her life:

> Today is our last day in civilization and I will write to you again at the end of the year. In any case I live a very healthy life, much better than in the city. The nature here is incredibly beautiful. We eat rabbits, kangaroos, ducks, worms, leaves, ants that live in the trees. This is pure protein and is very healthy. On my feet I have canvas boots, which are very good protection from snakes and spiders. This year we will celebrate our birthday in the desert around the fire. I will be thirty-four years old and Ulay thirty-seven. I never felt as young in my life as I do now. Traveling makes a person young because he doesn't have time to get old. . . . The temperature at the moment is 40–45 Celsius. We are really feeling this temperature. I wake up before sunrise and go to sleep with the sunset. We sleep under the open sky full of stars. We feel like the first people on this planet.[41]

Marina had never felt so harmonious—with nature, with herself, and with Ulay. Even Toyne noticed the "incredible wavelength" they seemed to share. They bought a jeep, and were even considering buying some land in Australia, since it was so cheap. Marina was fascinated with how, under Australian law, the titles to even the smallest parcel of land theoretically extend all the way down to the center of the earth.

For much of their time in the desert Marina and Ulay had to live apart, following the protocol of the Pitjantjatjara, in which men and women went about their daily lives—and especially their ceremonies—separately. Early on, both Marina and Ulay found it nearly impossible to communicate with the tribe. The younger Pitjantjatjara spoke pidgin English, but didn't use it much, and the elders spoke no English at all. Ulay took Polaroids of the Pitjantjatjara but their interest was fleeting: they tossed the photos on the floor "where the dogs pissed on them," Marina recalls. Marina eventually managed to ingratiate herself by giving wild, geometric haircuts to the children. Their hair was thick, and, Marina thought, sculptable. The tribe rarely came into contact with water, mostly because of its natural scarcity in the desert, but also for fear of disturbing the mythic Rainbow Serpent, which inhabited the waterholes. To wash, they rubbed themselves with sand instead. This gave them an overpowering smell, which, Marina says, "close up was a pure painful thing, enough to make you cry."

The overwhelming heat precluded most activity. Marina and Ulay would simply sit still, for days on end, getting friendly with the relentless flies. No dangling cork hat and no amount of brushing away could deter them. Marina started naming particular flies: the one who lived on her nose, George, the one on her ear, Fred. After several weeks in the desert without washing regularly, if at all, Marina noticed that suddenly her friends the flies no longer paid her any attention. She had lost the alien smell of the city, and was now to them just another part of the desert, like the Pitjantjatjara.

At first, Marina and Ulay slept on a canvas sheet on top of their jeep, wary of what could get at them in the night if they slept on the ground like the Pitjantjatjara. But they soon learned the proper technique for keeping snakes, spiders, and scorpions at bay: light a fire in a protective radius on the ground around the canvas, then put it out. The heat, ash, and the smell of burning was enough to keep most creatures away. One night though they were woken by a gentle thumping sound on the ground, and found themselves surrounded by "hundreds" of wallabies. "We just sat there motionless. Looking at that, you think you are in paradise," Marina recalls. "It can't get better."

At one point when she and Ulay were together, Marina got an acute migraine attack. She had no painkillers left, and sunk down into her familiar private world of pain. The medicine man from the tribe came to examine her. He asked her for some kind of container, and Marina groped around in her backpack for an old Sardine tin. Then the medicine man held his hand over her head and, before Marina could tell him which side of her head the pain was on, he said: "Big fight on this side." He told Marina to close her eyes and leaned down, pursed his lips and began gently sucking at the point where Marina's brow met the top of her nose. Marina felt his lips soft and cool but apart from that, "I hardly felt anything," she says. She just heard him repeatedly spitting into the can. Then he moved to a second point, on her left temple, and gently sucked from there too. "Finally, when I opened the eyes, the can was full of dirty blood, like dark blood. I immediately took my mirror to look and I had two blue spots, no cut at all." The medicine man told her to bury the sardine tin

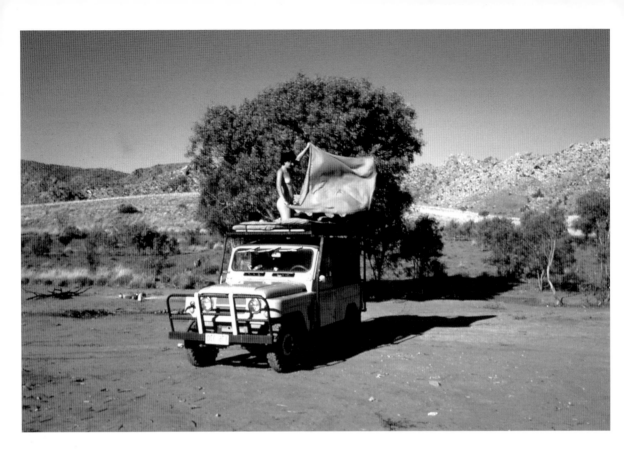

15.2
Marina in the Great Victorian Desert,
Australia, 1980 or 1981. Photo: Ulay.
Courtesy Abramović archive.

15.3
Ulay drinking from a puddle in the Great
Victorian Desert, Australia, 1980 or 1981.
Courtesy Abramović archive.

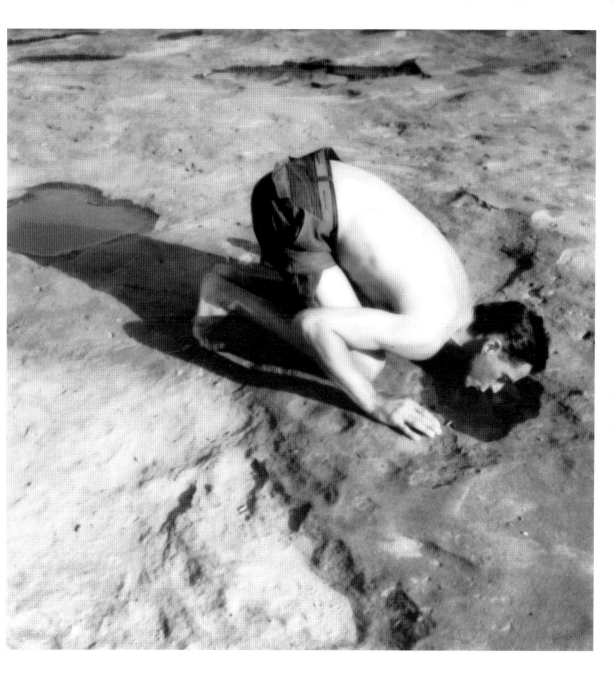

immediately. Afterward, Marina felt an "incredible lightness, incredible happiness. Everything so clear and luminous. I never had a headache after that while I was there. The moment I arrived in the city, I got one straightaway." Ulay witnessed everything and was just as stunned as Marina. Toyne was gone by this point, but verifies that this is a traditional technique of Aboriginal medicine men.

It was the first of many shattering experiences Marina had in the desert. She and Ulay spent most of their time doing absolutely nothing. Surrounded by the vast emptiness of the desert, freed from daily concerns and what she felt was the energy interference of city life, Marina felt her senses sharpen, and new ones emerge. She wrote down her vivid dreams and daydreams in these months. She dreamt there was an earthquake in Belgrade, in the midst of which "I feel that something is guarding me from death," she wrote. Shortly after the dream, Marina heard the news of an earthquake in southern Italy, on November 23. "I realize that I dreamt about it all one day before it happened," she wrote. "This discovery disconcerts me very much." Marina noted another possible explanation for the earthquake dream, apart from intercontinental precognition. "I have been sleeping on a rock that has a crevice surely made by an earthquake—a million years ago." Marina had another dream about the Pope being shot; on May 13 the next year there was an attempt on Pope John Paul II's life.

Marina's most disconcerting experience in the desert occurred while camping close to Ayers Rock (or Uluru, as it was originally called). She was gathering firewood when suddenly she had a total memory and identity blackout. "I didn't know who I am, where I am going, why I was there," she says. "For maybe five minutes I was completely paralyzed in that spot, absolutely displaced." Later, she speculated that this episode was caused by being close to a source of "great energy"—Ayers Rock. (A couple of years later, she had the same experience upon meeting the Dalai Lama in Pomaia, Italy.) Marina also felt that she was becoming attuned to the telepathy that she was sure the Pitjantjatjara used—a popular theory for how Aboriginal tribes communicated across the desert. Sitting around the fire at night, nobody would speak, but she felt sure that they were communicating mentally. Ulay recalls an incident where the group he was sitting with one night suddenly all got up, extremely agitated. "They started screaming in a certain direction. I wanted to go with them." Later he heard that there were two Aboriginal boys from that community who had died of exposure around the time the elders at the camp had jumped up. "They felt it. Telepathic abilities."

Marina's curiosity and emulation of the tribal cultures she came into contact with, as in Ponape earlier that year, led to a sincere, credulous, and also knowingly comic fascination for more outlandish and borderline primitivist myths, like that of Aeroplane George. George was an Aboriginal who was making his way from Alice Springs to the mining town of Coober Peddy. Just outside Alice Springs, so the story goes, a territory inspector who knew George offered to give him a ride to Coober Peddy. George refused, saying, "I will be there before you." The inspector arrived in Coober Peddy after driving fourteen hours, and sure enough Aeroplane George

was already there. Marina had heard a theory that Aboriginals could release a kind of ectoplasm from the soles of their feet—kadachi (high-ranking medicine man and law-enforcers) did stick feathers to the freshly burned and bloody soles of their feet—that supposedly allowed them to glide across the desert at enormous speeds.

Marina watched the daily ceremonies of the women she lived with, in which they acted out the dreams they had the night before. If there was too much to act out on one day, they would carry on the next, and source material for the dream theater would accumulate. Marina loved the idea that there was nothing more important for the women than inspecting their dream life. Marina helped the women forage for honey ants and witchetty grubs, cooked on the fire and peeled like prawns. She liked that the tribe kept almost no material possessions, and appreciated the custom of never mentioning the names of the dead (everyone with the same or a similar name as the deceased took up a new name upon bereavement).[42] Despite her fascination with the culture, Marina had difficulty forging any strong relationship with her hosts, telepathic or otherwise. For once, Ulay was able to form a stronger bond with his companions than Marina with hers. He was given the tribal name Tjungurrayi, and was offered full initiation. This would involve first circumcision then subincision—slicing the underside of the penis to the urethra, meaning a future of sitting down in order to urinate. Ulay was honored by the offer, but even his lifelong search for identity and community wouldn't go to such extremes.

Near Christmas, Marina and Ulay left the tribe for a few days and drove their jeep into the desert. They were interested in finding a spot with a lot of meteorites and craters: Marina wanted to try to absorb their special energy; she posed for one photo on top of an enormous, twenty-foot-high rock, naked and curled up in a tiny ball. They stopped for the night at a watering hole, and burned an area on the ground as usual to put the canvas on. As they made a fire to cook their dinner an eagle began circling overhead. It landed a short distance from them, on the other side of the fire, facing them. "We decided not to cook, just to be silent, see what happens," Marina says. The eagle remained perfectly still as the sun slid under the horizon and the moon came up. The fire died down. Still the eagle didn't move and still Marina and Ulay sat in silence staring at it. Eventually they got tired and lay down to sleep. They woke up just before sunrise and the eagle was still there. Ulay walked over and touched it with a stick. It fell over; it was already being ravaged by ants. "There was such a strange feeling about the whole thing, so we just packed right away, just left," Marina says. Later, Ulay discovered the meaning of the tribal name, Tjungurrayi, that he'd been given just before this unnerving encounter: "dying eagle." The name had been a prophesy; they were both astonished.

Ulay's thoughts turned to the enormity of the space they were in. He loved the feeling of nothingness that the desert gave him. He felt swallowed up, annihilated, empty. Nothing a human could do in this arena could have much consequence, though the dingo fence was a good attempt. In terms of an indelible mark in the wilderness, the Great Wall of China was much more trenchant. An idea occurred to

Ulay with the premonitory power of one of Marina's visions: they should walk the Great Wall of China. Marina immediately tuned into the idea and they agreed that Ulay should start at the western end of the Wall, in the desert, and Marina at the eastern extreme, and they would walk toward each other for however long it took until they met in the middle, where they would finally get married. The concept was audacious, monumental, and Marina instantly saw its mythic power. It would be both a piece of land and performance art on a cosmic scale—they believed the myth about the Wall being visible from the moon, and that its haphazard shape resembled that of the Milky Way. At the same time it would be their most ephemeral and personal performance yet, with no audience whatsoever. It would just live in the minds of anyone who heard about it as an almost ridiculously romantic dream.

Marina loved the feeling of her various quotidian needs—including her need for achievement and acclaim—evaporating in the desert, even more than they had in the weeks and months living ascetically in the van. Maybe it was the fact that in the desert ambitions were irrelevant, and for a while she was freed of them gnawing at her—even as a new one was born with the idea of walking the Great Wall of China. In late March 1981, as the time approached to leave the desert and deliver the lectures and performances they'd promised in their grant proposal, "I was very much in panic," Marina says. "Why am I leaving now? Why I have to go back and make all this work? Somehow the answer came almost like a bomb in my head. Yes, why I have to do this? Because I'm an artist and that is my function. Whatever I experience here I have to translate and bring it out of here."

SNAKE COUPLE GO ON

Marina sat very still as Ulay cut her hair. They were on the island of Rottnest, off the coast near Perth, recuperating after their time in the desert. Marina thought shorter hair might give her some relief from the heat. Out of Marina's sedentary stillness, an idea suddenly crystallized. The concept of walking the Great Wall of China was one thing, but they wanted to channel their experience of stillness and duration in the desert into a performance they could realize immediately. Their period of relation work, with its intensely physical and often combative scenarios, was now drawing to a close. It wasn't difficult *enough* to create a certain energy force field in a space through determined physical activity. After five years of performances together, Ulay / Abramović had mastered that task. They wanted to see if they could charge a space and an audience by doing next to nothing, using their minds more than their bodies. They realized that the simplest form of human presence that they could enact would be just to sit opposite each other, staring in each other's eyes, motionless and immovable as Ayers Rock. In between them, there would be a table—as a marker of space and a clearing in which their energy could manifest. This was *Nightsea Crossing*, a portable performance concept that Ulay decided they should repeat an auspicious ninety (nonconsecutive) days in museums and galleries around the world. It would take six years to achieve this goal; they looked upon it as a spiritual discipline. The idea of sitting for extended periods probably reminded Marina of passages she'd read as a teenager in Mircea Eliade's studies of world religions. Eliade quotes a student of Zen on the "importance of sitting":

> In the pursuit of the Way [Buddhism] the prime essential is sitting. . . . Just to pass the time in sitting straight, without any thought of acquisition, without any sense of achieving enlighten-ment—this is the way of the Founder. . . . There have been some who attained enlightenment through the test of the koan, but the true cause of their enlightenment was the merit and effectiveness of sitting. Truly the merit lies in the sitting.[43]

Their inaugural performance of *Nightsea Crossing* was at the First Sculpture Triennale, in Melbourne—an appropriate event, given that they were about to prac-tice turning themselves into static objects. Just before the public opening of the gal-leries, Abramović and Ulay sat down at opposite ends of a table, on chairs that were deliberately not too comfortable and not too uncomfortable, and settled into what would be an eight-hour staring match. The stare would only be broken, and the per-formance ended, after the gallery had closed and the public had left. Abramović /

Ulay didn't want the audience to see the banal human life on either side of the performance, only the aesthetic and experiential perfection of the tableau vivant.

The first performance of *Nightsea Crossing* was a nightmare, made worse by the knowledge that they had vowed to do it eighty-nine more times and couldn't possibly default on this commitment. The first two or three hours of sitting still were not particularly difficult, but then cramps set in. They did not permit themselves the slightest movement to alleviate their pain. There was nothing to do but ride it out. While their physical performances had decharged them of energy, aggression, and even pain, *Nightsea Crossing* was a *charging* performance, through which they accumulated intolerable and unreleasable energy, agony, ecstasy, and even hatred toward each other. *Nightsea Crossing* was the opposite of catharsis. It was in a sense a meditative practice that was—initially—too highly advanced for its practitioners.

Shortly after the first performance of *Nightsea Crossing*, they made another piece at the Sculpture Triennale, called *A Similar Illusion*. This piece was *almost* a tableau vivant. Abramović and Ulay were surrounded by a rectangle of long tables at which the small audience sat looking inward, as if at a political conference or an austere wedding banquet. Inside the rectangle, Abramović and Ulay held each other as if dancing the tango and captured in a freeze frame. The sole action of the performance was the gradual wilting of their outstretched arms over the course of an hour and a half—they knew that they wouldn't be able to maintain the effort of keeping them erect. It was a tragic piece, on a small scale, and one that turned out to be prescient.

Even though they had already notched up one day out of the ninety, both Marina and Ulay would always remember the next iteration of *Nightsea Crossing*, in Sydney, as the real beginning of the ordeal. In the Art Gallery of New South Wales they were scheduled to perform the piece for sixteen consecutive days. This also meant fasting for sixteen days—broken only by juice or yogurt in the evenings—in an attempt to focus and purify their energy. They also tried to speak as little as possible or preferably not at all for the entire period. Eating and talking would distract them from their task, and would only make it more painful by reminding them of the sensual pleasures of everyday life. "In order to endure these performances you have to totally withdraw into yourself," Ulay remembers. "If you communicate, you may get a conflict. You have to stay very tight to yourself. It's a very egoistic exercise."

On the table between them, they placed a boomerang, some nuggets of gold (which they had found using a metal detector in the desert), and a one-meter-long live diamond python, which they named Zen. During a rehearsal, the snake kept slithering toward Marina—as in the birthday performance *Three*. "I have this strange thing with animals," Marina told a reporter from the *Sydney Morning Herald*.[44] During the performance though, the snake spent much of its time nested between the small of Ulay's back and the chair. The items on the table were intended to contribute to the energy field building between them, or at least were meant to symbolize it. This first major manifestation of *Nightsea Crossing* had the semi-ironic subtitle *Gold Found by the Artists*. Marina had the notion that it was the objective of every artist

to be a kind of alchemist, turning base stuff into gold for the benefit of individuals, society, humanity. But here was some gold they had found readymade. The fact that it was artists who found it, declared it, and displayed it, somehow gave the gold even more value. It was an amusing conceptual tangle, but it had little to do with what was going on at either end of the table.

After just two hours of uninterrupted staring—she even tried to stop herself from blinking—on the first day of the sixteen, Abramović started seeing Ulay's "aura." She recorded in her diary that the aura was "a clear shiny yellow luminous color." To train herself to sit absolutely still during the performances, Abramović imagined someone was pointing a gun at her and would pull the trigger if she moved. "For me the public represents that gun." By the fourth day, she was suffering terrible pain in her neck and shoulders. But she also realized that "no position is more comfortable than another," so stillness was the best option. She started having more extreme hallucinations of Ulay: "In fractions of seconds his face would change into hundreds of faces and bodies," she wrote. "This lasted till he became an empty blue space surrounded by light. . . . This empty space is real. All other faces and bodies are only different forms of projection."[45]

The audience saw two statuesque figures displaying a kind of placid intensity. But they could know nothing of the battle with pain raging inside both of them, and the meditative revelations they were undergoing. Confronted with this stubborn exterior blankness, the public veered between awe and awkwardness, or between irreverence and outright indignation at being so ignored by the performers. On the seventh day, someone came close to Abramović and said to her, in Serbo-Croat, "How are you, Marina?" The shock of this very personal address, reminding Abramović that she was a normal human being, and a Yugoslav, sent her into a panic. It was a long time before her heart slowed down to normal and she could concentrate fully again—though she never broke her stare with Ulay. Despite the intrusion of what

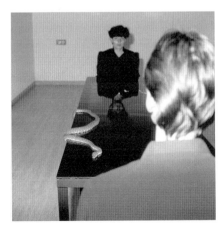

16.1
Abramović / Ulay, *Nightsea Crossing*, Art Gallery of New South Wales, Sydney, 1981. Courtesy Abramović archive.

Marina called in her diary "the red devil," in the early performances of *Nightsea Crossing*, Abramović and Ulay insisted on there being no cordon separating them from the audience. They hoped that a natural energy field would be enough to secure a radius around the table. This is exactly what Chris Burden had reported of his twenty-two-day *Bed Piece* in 1972: "[I]t was like I was this repulsive magnet. People would come up to about fifteen feet from the bed and you could really feel it. There was an energy, a real electricity going on."[46]

Ulay found the performances much more difficult than Marina. With his naturally high metabolism and already skinny figure, he lost weight faster and more painfully than Abramović. For Ulay, sitting still for long periods on his boney backside was excruciating. Into the second week of the fast, he got so skinny that his ribs were digging into his pelvis and his organs as he sat. On July 14, the eleventh day of the performance, the pain became intolerable and early in the afternoon he got up and left the room. Abramović remained staring at the spot where Ulay had been, and she hallucinated him in his absence. Soon, a gallery assistant pressed a note from Ulay into Marina's hand. She cast her eyes down to read it. It said, redundantly, that Marina must decide for herself whether to continue the performance, but he couldn't carry on that day, since the pain in his pelvis was unbearable. Abramović finished the day's performance alone.

Ulay claims that he was more angry with himself for leaving the performance than with Marina for continuing without him. But on some level he must have felt that she was trying to show him up as the weaker party, that she was trying to humiliate him, or at the very least that she should have stopped out of solidarity. Apart from this, it destroyed the symmetry of the scene and the logic of the performance: two people relentlessly returning each other's gaze. But Abramović thought that since she was able to complete that day's performance, she should. That evening, she wrote Ulay a letter, since they were trying not to speak:

> Our rational minds want us to stop. Your mind never before had this treatment. Concentration drops down, temperature drops down, this is all possible. Ulay, we are not having a good or bad experience. We are having an experience in a period of sixteen days. Whatever comes— good or bad—we are in it. I also think that a bad experience has the same importance as a good one. It is all in you. It is all in me. I don't agree with you, if we continue that it would fulfill a quantitative promise and not a qualitative one. I see sixteen days as a condition, fasting as a condition, not talking as a condition. When the Tibetan said: twenty-one days in silence and fasting, do you think it is not very difficult? But he said twenty-one days. We said sixteen days. We also could have said ten or seven but we said sixteen days.[47]

Early the next morning they both went to the hospital. Ulay had a swollen spleen—which was already damaged by his car accident in 1972—and he had lost twenty-six pounds (Marina had lost twenty-two). They ignored the doctor's advice to

stop the performance. "Snake couple go on," read the headline in the *Sydney Morning Herald* the next day.

The performance continued, and the pain continued. A rumor, untrue, circulated that Abramović had passed out in her chair one day and stayed there slumped over. It was astounding the amount of pain that the body could generate just from being still and doing nothing. Pure existence in its most stripped-down form was turning out to be a horrific thing to confront so regularly. The cramp in Marina's legs was so bad and her shoulders so tense that at a certain point in every performance she felt like she would lose consciousness. But she found that if she accepted this possibility and continued to dwell within the pain, then she would transcend into an ecstatic state—she reported 360-degree vision a couple of days after the hospital visit. The passage into this post-pain state was like dying, again and again. Ulay had to leave the table again the next day. "For me it is incomprehensible," Marina wrote in her diary. He was back though to complete the remaining days, and he also often achieved a post-pain state of ecstasy, an unbelievable lightness. "I was wearing heavy Australian leather army boots in order to stay on the ground," he says.

After their sixteen days was up, Abramović and Ulay continued to tour around Australia and New Zealand for the rest of that hemisphere's winter. They gave lectures on their experiences in the desert and made two new performances. One of them, *Witnessing*, was in Christchurch, New Zealand. In an empty church hall, Abramović stood on a plinth about three feet off the ground, and simply pointed at Ulay, who was sitting cross-legged, looking a little forlorn, on the ground about twenty feet away. They remained static until the light that had flooded through the enormous stained-glass window started to fade, and only ended the performance when the hall was completely dark. As with *Nightsea Crossing*, the audience couldn't see the moment when the performers broke their molds, when the spell was broken and they turned back into human beings.

Abramović and Ulay were becoming more and more interested in the anachronistic power of the tableau vivant: how it slowed down time almost to a standstill and demanded an unfamiliar level of attentiveness from the audience. It was also an awkward genre, perhaps because of the extreme artifice of the scenes mingled with the undeniable reality of the human beings playing them out in such close, inspectable proximity. *Nightsea Crossing* and *Witnessing* were minimalist tableaux vivants drained of meaning rather than saturated with narrative as the medium traditionally demanded, but they were the most theatrical pieces Abramović and Ulay had ever done, and they were the roots of an interest in the theater that would grow throughout the 1980s.

Marina and Ulay arrived back in Amsterdam refreshed and ready, they thought, for the new decade. They had created an ambition structure that would sustain them for years: the distant but definite desire to walk the Great Wall of China, and the more quotidian task of fulfilling the seventy-three remaining days of *Nightsea Crossing*. Abramović and Ulay became like a touring rock band, packing up the table and

16.2
Marina and Ulay about to leave Australia in 1981.
Courtesy Abramović archive.

chairs that Ulay designed for the piece as soon as they returned to Zoutkeetsgracht, and performing elaborated or adjusted versions of *Nightsea Crossing* for a few days here, a few days there, in welcoming and bewildered museums around the world. It was a punishing schedule for an excruciating performance, and it began to take a toll on their relationship. The next year, 1982, was the busiest of all: from March to September they performed the piece a total of forty-nine days in museums in Marl, Düsseldorf, Berlin, Cologne, Amsterdam, Chicago, Toronto (where they performed outdoors), and Kassel—at Documenta 7. Here, they performed *Nightsea Crossing* for the first, middle, and final weeks of the exhibition. In the time between performances they hoped that the fabric canopies they hung from the ceiling over their chairs would somehow conserve—or at least represent—the energy they believed accumulated during the performance. On the wall, they made a swastika out of four boomerangs, but struggled to break through the local historical connotations to the Hindu origins of the symbol. Before one of their performances at Documenta, the pressure of the performance exploded into a violent argument. "He slapped me in the face," Marina says, "because he could not stand that I would do it [the performance]," and suffer less pain than him each time. Ulay denies ever hitting Marina (outside of a performance), but says: "I had a complete breakdown because *Nightsea Crossings* were about the most difficult performances. What few people realize is that sitting is easier for a female anatomy than for a male. Marina has a bum; I am sitting on my bones. I still have scars." Throughout their years of touring *Nightsea Crossing*—without the van, they took planes and trains instead—the piece opened, or exposed, a chasm not only in their fundamental physical constitutions and capabilities, but in their psyches and ambitions. "He somehow didn't benefit from that pure presence like I did after a performance," Marina says. "He couldn't find that stillness in himself." Ulay had to leave the *Nightsea Crossing* table on another occasion that year, during a twelve-day performance at the Stedelijk in Amsterdam. "I was so impressed with the way Marina carried on sitting there as if he was there," says Dorine Mignot, a curator at the museum. "She didn't let the energy go."

There was no need to do *Nightsea Crossing* ninety times, apart from the need to fulfill their arbitrary target. A handful of times or even once would have been enough to demonstrate and explore the concept. What motivated them to literally pursue the performance to the ends of the earth? As Ulay said, it was an egoistical exercise, where will power morphed into a kind of defiant narcissism. But within the narcissism of obsessive withdrawal and confrontation with pain, there was also the sweet promise of freedom and release from the tyranny they imposed on themselves, from the relentless ego calculations. Marina lived for the hard-wrought moments in the performances when "all the pain disappears and the body is like a shell, and you're really free inside," she says. They also had the powerful fuel of denial to keep them going. *Nightsea Crossing* was a way to continue together when it felt like everything else was collapsing in their relationship over the next few years. If they allowed the concept of the piece to

fail, then they too would fail, and that was something that Marina especially could not tolerate.

In the midst of their grueling schedule of punishingly serious performances, Abramović and Ulay managed to make a couple of refreshingly light and funny pieces. *The World Is My Country: The Sex Life of Flowers* was a demanding video installation at Time Based Arts in Amsterdam, in which a TV monitor placed on the floor showed a documentary about plant reproduction. But to make the video start playing, the viewer had to ascend a stepladder, strap herself into a pair of space boots attached to the ceiling, and hang from them upside-down. Here, for once, Abramović and Ulay didn't have to do any of the work. In another playful piece, they decided to test the theories of Luther Burbank, a botanist, born in 1849, who dedicated his life to demonstrating that plants respond to affection. They placed a large cactus in the Kabinett für aktuelle Kunst gallery in Bremerhaven and surrounded it with barbed wire. They hoped that this new layer of prickly protection, together with the daily love and kind words of the gallerists, would make the cactus feel comfortable enough to shed its natural defenses against the world. "The experiment failed," Abramović recorded.[48] If these two largely forgotten works seem like whimsical aberrations in a tyrannical regime of grueling performances, that would mask the fact that Marina and Ulay required a sense of humor to sustain their more harrowing work. Humor was a parallel, often disavowed, and overlooked aspect of their serious practice. How else could they have carried on with what they were doing? A photo taken before they assumed their position at the *Nightsea Crossing* table shows them laughing at something, almost conspiratorially.

Marina and Ulay took a break that year to visit Bodhgaya in northwest India, where, in 500 BC, the Gautama Buddha had sat perfectly still under the Bodhi tree for forty-nine days to gain enlightenment. Marina's understanding of how the Buddha achieved this is significant. In her retelling of the story, it is only after the Buddha had given up on his fast, drunk some milk, and fallen asleep under the tree—rather than meditating under it—that he woke up enlightened. This was the ideal structure of an Abramović performance: extreme asceticism and self-control pushed to the point where will power becomes irrelevant. "For me the most interesting lesson of this is that you have to go 100 percent to the real end of what you can do, and then after that it's not up to you any more."

Bodhgaya was like a training ground for Marina and Ulay, where they could absorb strength, expertise, and wisdom to carry on in their performances. A ten-day Vipassana meditation retreat was particularly instructive for continuing in *Nightsea Crossing*, and inspired them in other performances in the 1980s. The meditation involved fasting and reducing their activities to fundamentals: sitting, standing, lying, walking—all done in contemplative slow motion, the better to observe, and conquer, their distracting thought patterns. One incident demonstrated explicitly the power of mastering their bodies. Marina and Ulay were staying in the Chinese temple at Bodhgaya. Walking to the toilet one night in the pitch dark, Marina tripped and

sprained her ankle. They were due for a consultation with a Sufi master the next morning; Marina resolved on hobbling up the seemingly endless steps to his temple. They talked for a while, and Marina told him about her sprained ankle. When she got up to leave, she was suddenly free from pain—somehow the Sufi master had healed her, she believed. "This was the moment I realized that anything can be done with the body," she says.

They also had an encounter with the Dalai Lama, but more significant for them was a blessing they received from Kyabje Ling Rinpoche, the senior tutor to the Dalai Lama. He had a chubby, pale face, and seemed "like a thousand-year-old baby," Ulay recalls (he was seventy-nine). Ling Rinpoche wrapped Ulay on the side of his head with his knuckles, hard, which Ulay took as a sign to stop thinking so much and to start feeling more. Then he simply touched Marina on her forehead, and she immediately began crying—and continued for hours—because she was so struck by the "innocence" of the man.

After Bodhgaya they traveled west to Rajasthan to spend some time in the Thar Desert. The trip was shorter and less arduous than their time with the Aboriginals. Near the town of Jaiselmar, they stayed in a hut with a family and made excursions by camel into the desert. A photo shows Ulay extremely tanned and leathery-looking, dressed like the locals and almost indistinguishable from the camel guides he is holding hands with. In the stillness and emptiness of the desert, Ulay found "more confirmation that we were doing the right thing. That nothing is not nothing."

On their birthday in 1982 Ulay and Marina's car—a cheap replacement for the van with none of the symbolic importance—was stolen from outside their apartment. Later that day Ulay got a phone call from his ex-wife, Uschi, in Germany, who told him his mother was dying in a hospital in the town of Daun, close to where she had lived in isolation for more than twenty years. Ulay went to her immediately, refusing Marina's company. He stayed by his mother's bedside for her final few days, brushing her hair, and giving her pedicures. After she died late at night, Ulay refused the priest, as his mother had asked, and went back to his hotel where he collapsed on the bed, exhausted. When he got up the next day, his trousers were very loose, almost slipping off, even though the belt was still buckled. He'd lost about four pounds overnight. It was another instance, perhaps the most primal, of Ulay's propensity for symbiosis. His psychic, physical, and artistic well-being had been integrated into Uschi, Jürgen Klauke, Paula, and currently Marina; now he had lost the original umbilical bond with his mother. Marina joined Ulay for the funeral a few days later. That night, Ulay wanted to try to conceive a child with Marina. She refused; nothing had changed in her belief that she was a "full-blood artist," and she did not want to pour her energy into anything else.

16.3
Marina and Danica in Amsterdam in 1982.
Photo: Ulay. Courtesy Abramović archive.

16.4
Marina with Ulay and his mother, Hildegard,
in Daun, Germany, circa 1981. Courtesy
Abramović archive.

THEATER AND TRAGEDY

Ulay stood motionless at the top of some steps in a public square in Bangkok, his arms outstretched, ready for embrace. Abramović, wearing a billowing red dress, was at the bottom of the steps, also with her arms outstretched. They both remained static for as long as it took for Abramović's shadow to slide up the stairs and touch Ulay. When it did, they took up positions in another tableau vivant: Abramović sat on the top step, holding Ulay's limp body across her lap. It was a classic Pietà pose, imitating the way Mary holds Christ's body in Michelangelo's sculpture. In the original, Christ's right arm is hunched up across Mary's leg. Ulay however let his arm hang down dead straight, making his body form a perfect letter M: for Mary, for Marina.

It was February 1983, and Marina and Ulay were in Thailand upon the invitation of their old friend Michael Laub, who had been commissioned to produce a video work for a TV program. The shadow play and Pietà scene was a preparatory work, called *Anima Mundi*, meaning "soul of the earth." Afterward, Marina and Ulay traveled with Laub to the ancient town of Ayutthaya outside of Bangkok to shoot a video in the temple ruins and gardens of Wat Mahathat. *City of Angels*, as the twenty-minute piece would be called, was a series of tableaux vivants involving locals: a rickshaw driver, a beggar, two fruit vendors, and a little girl.[49] Two men, maybe the fruit vendors, lie on the ground as if dead, holding between them a dark blue banner, and the camera pans over them languorously from above. In another scene, the camera floats above a chain of prone bodies, young and old, until it rests on a strategically placed turtle, which serendipitously emerges from its shell just as the camera arrives, and walks off—too fast for the soporific camera to keep pace. *City of Angels* was Abramović and Ulay's first video work in which they did not appear. They were expanding the frame beyond themselves, even if their hand was still very much in evidence. The piece also suggested new ways of working with other cultures; they had absorbed their experience in the Australian desert into their own practice, but they now realized that they could use protagonists from other cultures directly in their work.

In Bruce Chatwin's account of his travels in the Central Australian Desert, *The Songlines*, he describes meeting an exuberant Aboriginal man named Joshua (Chatwin changed names for his book), who was known as a "'performer' who could always be counted on to give a good show." Chatwin sits down with Joshua in the sand just outside his settlement, and asks him to describe some of the local "Dreamings"—the Aboriginal creation myths attached to every contour of land and every creature in the desert. After the story of the parenti and the porcupine, Joshua recounts his "Quantas dreaming." He draws a diagram in the sand to explain a trip he once took to

Amsterdam. Chatwin, unsure of the truth of the story, asks him why he was there. He draws a diagram of a large circle with four smaller circles around it and wires running from each of them to a small rectangular box in the middle. Chatwin writes:

> Eventually, it dawned on me that this was some kind of round-table conference at which he, Joshua, had been one of four participants. The others, in a clockwise direction, had been 'a white one, a Father one,' 'a thin one, a red one,' 'a black one, a fat one.' . . . The picture I pieced together—true or false I can't begin to say—was of a 'scientific' experiment at which an Aboriginal had sung his Dreaming, a Catholic monk had sung the Gregorian Chant, a Tibetan lama had sung his mantras, and an African had sung whatever: all four of them singing their heads off, to test the effect of different song styles on the rhythmic structure of the brain. . . . The episode struck Joshua, in retrospect, as so unbelievably funny that he had to hold his stomach for laughing. So did I.[50]

What Joshua was trying to describe, and what he now found so hilarious, was *Nightsea Crossing Conjunction*. In 1983, Ulay and Abramović had the idea to expand their dual meditation exercise into a multicultural quartet of performers: an Aboriginal would stare at a Tibetan monk, while, crossing the field of their gaze, Ulay and Abramović would stare at each other as usual. Now, in Chatwin's account five years later, the performance had become a kind of Dreamtime event.

Ulay and Abramović approached the Fodor Museum, an affiliate of the Stedelijk, for support for their idea to bring together an Aboriginal and a Tibetan for what they believed must be the first time in history. The curators there, Frank Lubbers and Tijmen van Grootheest, were immediately excited by the idea—as well as by the charisma of the duo, and by Marina's beauty. "When she appeared at the museum to discuss this piece," Tijmen says, "I remember she came in a most elegant, blue Pierre Cardin–like thing and was so beautiful I fell in love with her immediately." Van Grootheest was also chairman of the municipal art acquisition committee, so he could secure the money for the project by "acquiring" this ephemeral, transient performance. Some of the money he raised also provided a stipend for Marina and Ulay as they prepared for the piece.

Lubbers and Van Grootheest tried to make arrangements for a monk to come to Amsterdam from Tibet, but discovered that monks there didn't have passports. Instead, they contacted a Tibetan monastery in Switzerland and made arrangements for a monk named Ngawang Soepa Lueyar, originally from western Tibet, to perform with them. Meanwhile Ulay returned to Australia and reunited with the tribe that two years ago had given him the name Tjungurrayi. They were so fond of Ulay, with his taciturn and sincere manner, that they once again offered to initiate him with circumcision and subincision so that he could become a true white-Aboriginal. He asked instead if one of them would like to come to Europe to perform with him, and Watuma (whom Chatwin had named Joshua, and whose full name was Charlie Watuma Taruru Tjungurrayi) happily agreed to it. After an unsuccessful attempt to

get him to wash—for the benefit of the other passengers on the plane—he and Ulay made the journey to Amsterdam. Ulay and Marina hosted Watuma at Zoutkeetsgracht. Marina was worried about how Alba would react to this strange-smelling man because "she was really like wolf, wild." But Alba ran straight to Watuma and licked his feet. "I know this dog long time," he joked. Marina cooked dinner the first night, but as they were about to eat it, Watuma seemed uncomfortable with Marina's presence. She realized that she—and the female dog—would have to move out of Zoutkeetsgracht while Watuma stayed there: he wasn't accustomed to being indoors at all (he left every door open in the apartment), let alone to sharing an indoor space with females.

Nightsea Crossing Conjunction was scheduled for four days in April, in the cupola of a former Lutheran church. The performances lasted four hours rather than the normal seven. The first performance began at dawn, the second at midday, the third at sunset, and the last at midnight. Abramović and Ulay this time used a large circular table, and covered it with gold leaf. While the Tibetan monk sat in a perfect placid lotus position the whole time, Watuma often sat hunched up and crooked, with his legs reared up or twisted beneath him, ungainly but also poised, ready to spring, or so Marina thought. "If there was a rabbit passing by, in one second he would jump and eat it. That kind of sitting." Ulay and Abramović sat as usual in their learned European postures, straight and upright on chairs, hands in laps, and they stared at each other across the path of Lueyar and Watuma's gaze. Marina and Ulay both thought that Watuma had the stronger presence and generated the most "energy," much more than Lueyar—although it was never meant to be an intercontinental contest of spiritual strength. (Van Grootheest, who watched all the performances, was most impressed by the monk's concentration and presence.) After the piece was finished, Ulay gave back to Christine Koenigs the cushions he'd borrowed for the lama and Watuma to sit on during their four days of performance. Koenigs remembers Ulay joking: "I think we should throw these away now."

17.1
Abramović / Ulay, *Nightsea Crossing Conjunction*, Sonesta Koepelzaal, Museum Fodor, Amsterdam, 1983. Courtesy Sean Kelly Gallery, New York.

The performance generated much public interest, and no little indignation, since these four days of deliberate nothingness had been publicly funded. Frank Lubbers was summoned onto a TV show to explain himself. After listening to complaints from members of the public and from artists who thought the work was of less value because there was no physical product, he said: "With the same amount of money that would buy you a middle-class car, you got a Rolls Royce." Marina delighted in this justification and would never forget it.

The tableaux vivants of *Nightsea Crossing*, *Anima Mundi*, and *City of Angels* had hinted strongly at the theater, and almost immediately after the *Conjunction* performance, Abramović and Ulay began preparing for their first full-blown theater piece, *Positive Zero*. It would turn out to be overblown. An expensive and complex production, it was made in conjunction with the Holland Festival and de Appel, filmed by VPRO television, and funded by the Goethe Institut, the Austria Council, and the India Arts Council.[51] Again, it involved Tibetan lamas (six of them) and Aboriginals (two of them—not Watuma though; he'd gone home), and also representatives of what Abramović called the four ages of man—from youth to old age, one from each gender. Abramović and Ulay rented a house outside Amsterdam for the large cast and crew to live and rehearse in. They wrote and directed a series of elaborate tableaux, but where *Nightsea Crossing* and *Witnessing* had been minimal, these were laden with narrative and heavy symbolism. The scenes—meant to be illustrations of Tarot cards and archetypal male-female dramas—were underscored first by the chanting of lamas and then by the droning of the Aboriginals' didgeridoos. In one tableau, an old man kneels on the ground apparently holding Ulay captive, while about ten feet away another man approaches with a sword. The danger is no longer the real thing, as it was in Abramović and Ulay's earlier performances; it's now a picture of the real thing, a dramatization and an illustration. In short, it was acting.

Just before the performances began, at the Carre Theater in Amsterdam, a Tibetan doctor named Lobsen Dormer visited the house where the cast was staying. Marina asked for a purification treatment, but got sick from the herbal tablets she was given. She saw this as a necessary part of the process—getting sick in order to get better—and was determined to perform. On stage that night in front of the packed auditorium, Marina's nausea gave her expression a spiritual intensity: she gazed out at the audience with a concentrated vacancy, her face deathly pale and her eyes damp. The critic Thomas McEvilley, who was there to write on the performance for *Artforum*, was struck by the caught-in-headlights look in Abramović's eyes—even though the performance itself was best forgotten. The fear in her eyes was all too real. She knew the piece was awful. The Tibetans and Aboriginals were isolated from each other on stage—unlike the direct confrontation of *Nightsea Crossing Conjunction*—and the four ages of man motif belabored a dull point. *Positive Zero* was drowning in symbolism, flailing around in desperate gestures at spiritual profundity. The work was too interpretable; it had none of the raw and blunt madness of the earlier performances. Still, Abramović was determined to see it through. They were scheduled to

perform it for several more nights in Amsterdam and then in Utrecht and Rotterdam. Abandoning the concept and the commitment would be a worse crime than simply making a bad piece of art, Abramović believed.

At the end of the first night's performance, Marina looked out over the crowd and noticed a seat in the front row that was conspicuously empty. This was McEvilley's assigned seat, but he had decided to sit elsewhere and watch his empty seat in a kind of personal play on the title *Positive Zero* (how could zero be positive, he wondered?). That night, he stayed with Marina and Ulay in their rented house. The morning after, he drank coffee with Ulay out on the porch (they were served by the Tibetans). "One thing I liked about him right away," McEvilley later wrote of this first meeting, "was that he was almost as suspicious as I was."[52] They shared a dry humor and skeptical nature, but one that was merely the flipside of a passion for esoterica and a hard-bitten dedication to poetry, the sublime, and sentiment. Ulay told McEvilley about his and Marina's intention to walk the Great Wall of China next year (it would actually take four more years of planning). "You must come," Ulay said. "We'll get a helicopter for you to go back and forth along the wall, so you can spend time with each of us." Ulay could be persuasive, effusive, and charming too, when he chose.

That summer, their Zoutkeetsgracht housemate Edmondo Zanolini invited Michael Laub, Marina, and Ulay to his dilapidated farmhouse in Tuscany. They brought with them Michael Klein, an artist agent whom Marina and Ulay had recently met in Amsterdam through Pat Steir. While Abramović / Ulay were becoming more adept at securing fees from public institutions and grants from the government to support themselves, they were still quite poor relative to their growing stature in the art world. If they had been painters with the same level of success, they would have been very wealthy by now. They had a familial relationship with de Appel, which had helped them make contacts over the years with curators, museums, festivals, and alternative spaces, but Abramović and Ulay were now ready for some commercial activity. Their practice wasn't suited to the normal art market mechanisms: there was very little to sell, and what could be sold was strictly speaking of a second or third order to the experiences they produced live in a particular moment and in a particular space (although Abramović had always conceived performances that would photograph well, and ensured that they *were* photographed well). An agent along the lines of Michael Klein was appealing to both of them: unencumbered by his own fixed gallery space, he liaised with museums and collectors, and organized projects and exhibitions. Nevertheless, Klein remembers having to endure a long rant from Ulay about dealers over lunch one day in Italy. Klein talked about what they might do collectively, especially in the U.S., where Abramović / Ulay were largely unknown despite their 1978 performance at the Brooklyn Museum. The trio agreed to work together.

Italy was by no means a business trip though. The group had enormous fun camping outside Edmondo's farmhouse—it was too full of rats to bear sleeping

in—and listening to his insane stories about being in love with one of his pigs, named Rudolfina. The trouble was that Rudolfina wasn't in love with Edmondo but with one of his donkeys. It was in the midst of this pastoral picaresque atmosphere that a telegram arrived from Barbara Bloom in Amsterdam. Nearly everyone involved with de Appel had been killed in a plane crash: the private jet they were traveling in had gone down in Switzerland. Josine van Droffelaar, Gerhard von Gravenitz, Martin Barkhuis, Wies Smals, and her six-month-old baby Hendrik Smals, had all died. Smals had been like family to Marina and especially to Ulay, since giving him his first exhibition at the Seriaal Gallery. Marina and Ulay returned immediately to Amsterdam and went to de Appel for a kind of vigil. While people talked quietly and tried to console each other, Marina began scrubbing the floors. She had to perform some kind of activity as a vehicle for her grief. Whether it was cathartic or suppressive in its strenuousness and repetitiveness didn't matter. It offered some tiny and necessary distraction, and the knowledge that if nothing else at least she was producing something, anything, out of despair. No one stopped her scrubbing and no one needed to ask why she was doing it.

The deaths of her friends at de Appel also devastated a belief Marina had recently been cultivating about the protective power of happiness. Wies had recently given birth to her baby boy, and Marina thought: "When you're happy you can't die, because you're protected. By her being killed in the accident and the little baby and all the others, it was so distressing for me to believe that actually your own state of happiness doesn't matter. Death can happen any moment." Nothing could be controlled, despite her best efforts in art and in life, and not even surrendering to fate would make it any easier. No pattern of behavior could give her any consolation or any insurance against pain and death. This was a realization that in a way was even more sobering than the Tibetan philosophy that Marina felt such an affinity with. Buddhism taught that suffering was immanent existence but also preached myriad ways of attempting to avoid and transcend it, and the programmatic placidity that Marina took into performances like *Nightsea Crossing* was in itself an attempt at consolation.

In October Abramović and Ulay performed another two days of that marathon performance, this time in Helsinki. Seventy-four days down, sixteen to go. But even after they reached the target of ninety days locked in static eye contact, there would be more ambitions, more strictures, more suffering, planned and otherwise, to contend with. At least in the vessel of a performance Abramović could measure pain, grasp it, and occasionally feel transcendent over it.

18

ABSTINENCE AND AFFAIRS

In October 1983 Abramović and Ulay sent a proposal for walking the Great Wall of China to Frank Lubbers and Tijmen van Grootheest, the curators at the Fodor Museum who had managed to secure public funding for an Aboriginal and a Tibetan monk to travel to Amsterdam for *Nightsea Crossing Conjunction*. Maybe they could pull off another production miracle. Abramović and Ulay's proposal immediately focused on the mystical importance of the Wall:

> That edifice which best expresses the notion of the Earth as a living being is the Great Wall of China. In the case of the Great Wall it is a mythical dragon who lives under this long fortress like structure. . . . The dragon's color is green, and the dragon represents the unification of two natural elements, earth and air. Though it lives underground, it symbolizes the vital energy on the surface of the earth. The Great Wall marks the dragon's movement through the earth, and so embodies the same "vital energy." In modern scientific terms the Wall lies on what are called geodetic force lines, or lay lines. It is a direct link to the forces of the earth.[53]

Their walk would interact with this mythology in a somewhat subversive way: Abramović would start in the east at the Gulf of Bohai on the Yellow Sea, believed to be the female end of the dragon, but would wear the "male" color of red, representing fire; Ulay would start at the Jiayu Pass in the Gobi Desert, the male end of the dragon, but wearing the "female" color of blue, representing water. They predicted that the walk would take one year and planned to get married when they met in the middle. They wanted to have satellite photographs taken of themselves walking on the Wall. First, Ulay and Abramović had to raise a lot of money, and get permission from the Chinese government.

They created a foundation called Amphis with Lubbers and Van Grootheest, who wanted to separate the Great Wall venture—and its liability—from the official business of the Stedelijk and the Fodor. Lubbers made contact with the Netherlands-China Friendship Association, and, together with Van Grootheest, consulted a scholar of Chinese studies at Leiden University, Erik Zürcher, on how to go about organizing the project. "He almost fell off his chair from laughing and said, 'Forget it,'" Van Grootheest recalls. But Dr. Zürcher did connect them to the Chinese embassy in The Hague, where Van Grootheest picked up some useful advice on the quiet: they should pitch the project more as a research expedition for a film—there would be a film too—than as a heroic piece of performance art. And they should remember the

Confucian theory that one can never walk a road that has never been walked before. The embassy also connected Amphis with the real power brokers for such a project: the China Association for the Advancement of International Friendship (CAAIF), a clique of ex-ambassadors based in Beijing. They were indeed uncomfortable with the idea of foreigners walking the length of the Wall before someone Chinese had. In 1984, shortly after the CAAIF received Ulay and Abramović's proposal to walk the Wall, an adventurous Chinese man named Liu Yu Tian achieved the feat. Marina believed Liu must have been coerced by the government. Ulay called it plagiarism.[54] Walking the entire Wall was no longer an unprecedented achievement, but that hardly mattered given the specificity of Abramović / Ulay's concept: no one had ever walked toward their lover from opposite ends of the Wall.

Over three years and at least two visits to China, Lubbers and Van Grootheest managed to persuade the CAAIF to agree, in return for a fee of $36,000 from Amphis, to organize everything with the individual provinces Abramović and Ulay would walk through: guides, security, food, accommodation, and transport to and from the Wall. The Association also assessed where Abramović and Ulay were allowed to walk, since in many places the Wall ran through nuclear waste sites and restricted military zones on the Mongolian border. Also, the Wall was neither singular nor contiguous: there were many different stretches of Wall built over about 2,500 years, and there were many gaps; the Association would have final say over the route Ulay and Abramović could walk.

For funding, Van Grootheest brought Marina with him to talk to a city alderman for finances named Walter Etty. "We took him to a Chinese restaurant with Marina and it was up to her from there," Van Grootheest says. "She did a very fine job. He liked the looks of Marina very much and he said OK." The city of Amsterdam and the Dutch cultural ministry ended up giving $150,000 for the project. Meanwhile, Abramović and Ulay's *Nightsea Crossing* ordeal continued. In March 1984, they performed a few days in Gent, and Ulay again had to leave the table because of pain in his pelvis and lower back.

In July that year Marina and Ulay wound up in New York, perhaps to visit Michael Klein or Thomas McEvilley. Marina, without Ulay for some reason, went to see the performance artists Tehching Hsieh and Linda Montano cutting the six-foot-long rope that had tied them together for precisely one year. Hsieh, an undocumented immigrant in New York from Taiwan, had an unfairly small reputation given his saintly powers of endurance, discipline, and deprivation: he'd lived in a cage in his studio for one year (1978–1979, *Cage Piece*), he'd punched a time clock every hour for a year (1980–1981, *Time Piece*), and he'd lived outdoors for a year, never having a roof over his head (1981–1982, *Outdoor Piece*).[55] His collaboration with the artist Montano was entirely different from Abramović and Ulay's: in their year of being tied together, they had never once allowed themselves to touch each other, they fought often, and, near the end, their communication degenerated into grunting and yanking on the rope.[56] It was never meant to be a utopian union or an exploration of

symmetry and symbiosis, more of irreconcilable difference. In that sense there was no comparison with Abramović / Ulay, but still, as Marina watched the rope being cut, she was astonished and humbled by Hsieh, the undisputed king of endurance. On the other hand, the spectacle of performance partners linked together so long, now sundered, may have fortified her faith in her collaboration with Ulay. Their seven-year collaboration was already unprecedented for an artist couple. Only the Polish duo Przemysław Kwiek and Zofia Kulik (who called themselves KwieKulik) and London-based artists Gilbert & George had worked together for longer, but their practices weren't based on interdependency and mutual endurance like Abramović / Ulay's. Valie EXPORT had worked briefly with Peter Weibel, and Ben d'Armagnac had performed with Gerrit Dekker, in the 1970s, but no artist couple came close to the sustained intensity of the Abramović / Ulay collaboration, where the relation and the work were so inextricably linked. The art world began to think of them as the perfect couple.

Marina and Ulay went to Trapani in western Sicily later that summer to make another video work along the lines of *City of Angels*. For *Terra degli Dea Madre*, they employed a steadycam to create smooth, drifting shots in which the camera appeared to be a disembodied roving eye, hidden from view, as it floated through a dining room full of elderly women, and then through a ruined cemetery with a group of men talking languorously (Abramović and Ulay were enthralled by the interior/exterior separation of genders in Sicily). At the end of one day's shoot, Ulay asked the head cameraman if he could try the steadycam—it looked like fun, and Ulay was always curious about photo and video technology. He strapped himself into the heavy construction and wandered around for a while. Something cracked in his back, but there was no pain yet. At a restaurant later that evening, a gust of wind blew the bill into the air. Ulay twisted around to grab it and suddenly froze. It was as if he'd had a heart attack or a stroke, such was the fear in his eyes. But it was his back. He had to be carried to the car, then placed on a door as a stretcher and carried up the stairs to their hotel room. The hospital was on strike, so their local mafia fixers arranged for a retired doctor to see Ulay. He botched a painkilling injection in Ulay's spine, paralyzing his legs. Ulay was terrified, Marina helpless. They were driven to Palermo, where they flew to Rome and then to Amsterdam, where Ulay was taken to hospital and diagnosed with a hernia in one of his discs. They would have to operate immediately. Despite his unbearable pain, Ulay refused. "I don't want to be operated on in certain parts of my body," Ulay says.

Ulay's physical breakdown heralded, or embodied, a similar breakdown in his relationship with Marina. She remembers trying to comfort him and bring him food in the hospital, but Ulay always rejecting her—"It was never good enough," Marina says—along with his constant, almost geriatric, complaining. For her, Ulay's reaction to his injury—and maybe the injury itself as well—was symptomatic of a psychological blockage. No matter how many times he confronted pain and suffering in performances, he was always terrified of confronting emotion and weakness in everyday

18.1
Abramović / Ulay, *Nightsea Crossing*, Museum
van Hedendaagse Kunst, Gent, 1984. Courtesy
Abramović archive.

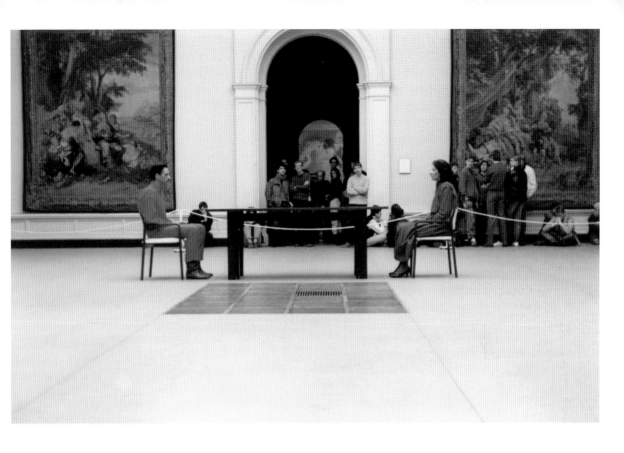

life; Marina was vulnerable emotionally, but she didn't shrink from emotional experiences like Ulay did. Now Ulay was refusing the treatment that would make him better. Instead, he found an Ayurvedic doctor named Thomas Punnen. After a few treatments, Dr. Punnen was able to relieve Ulay's pain, though it would recur from time to time over the years with stress or prolonged sitting. Despite Ulay's recovery, he and Marina were hardly talking, and weren't finding solace in each other as before. And they weren't having sex either.

Abstinence started as an experiment in 1982, as their *Nightsea Crossing* commitments escalated. Along with fasting and not talking during a period of performances (they also became vegetarians as part of the regime), they would refrain from sex too. But abstinence gradually achieved the force of law between Marina and Ulay, and by 1984 they hadn't had sex in almost a year. Their disagreement over how this happened is telling. "It was a mutual decision to enhance our spiritual capabilities," Ulay insists. "What we wanted to do in *Nightsea Crossing* demanded much more than simply having a couple of hamburgers and doing a wild performance. That was the reason. *Nightsea Crossing* was our vow to get into different qualities of physical and spiritual being." Marina recalls abstinence as something that was inflicted against her will, inexplicably, causing her untold insecurity. She remembers that it more or less began with the death of Ulay's mother, after the night when Marina refused to try conceiving a child with Ulay. "She was hurt and stung and wounded and inwardly furious," says McEvilley, whom Marina confided in. McEvilley recalls that around this time Ulay was reading books on tantric practices whereby one could, through a strictly controlled diet, meditation, and abstinence, develop crystals in the bloodstream, which would awaken the kundalini life force in him. (Ulay says he has no recollection of this.) Ulay's "spiritual" ambition was also a very practical and conveniently passive way of distancing himself from Marina and the mounting responsibilities he felt with the Abramović / Ulay institution. Their years of spontaneous, stripped-down living and unbridled extremist expression had to have a cost, and Ulay felt they were now paying for it in the form of servicing the art world's expectations and invitations. "The entire art world was referring to us like a perfect couple, which was fine with me but not with him," Marina says. "He was not ready for it." She felt that their increasing duties were a natural part of artists' public responsibility to communicate their ideas as widely as possible and educate their audience. Ulay's withdrawal from sex and from Marina generally was perhaps a way for him to feel loyal to himself for a change, to travel inward and tap the source of the original power (and pain) that had led him and Abramović to such accomplishments. The rejection left Marina miserable and desperately battling a feeling of frumpiness as she was approaching her forties.

In the summer of 1984 Marina was invited to teach a course at the San Francisco Art Institute. She'd half-joked to a friend before leaving that she needed to lose weight, so she planned a five-day fast for her students in California, which she would gladly participate in. This would be part of a performance art "workshop," in which Abramović tried to pass on techniques for improving concentration and will power.

Ulay had also been invited to teach in San Francisco, but chose to stay in Amsterdam. Starved of sex and desperate for attention and comfort, Marina reunited with her (and Ulay's) old friend Robin Winters, who was also teaching at the Institute, and had an affair with him. An unspoken mutual attraction had already been established back in Amsterdam a year or so earlier. Marina, Ulay, Winters, and Michael Klein had all been riding in a car together, gorging on praline from Belgium, Winters recalls, and getting hyperactive and giggly on the sugar. Bouncing along in the fun atmosphere, Marina's habitual scattershot seduction, probably ignored by Ulay, was actually planting some real roots. While most people perceived Marina and Ulay as inseparable lovers in 1984, Winters had a different impression—perhaps given out by Marina, perhaps a convenient construction of his own. "You know, that really didn't seem to be that big a deal at the time," he says, referring to her partnership with Ulay. "They were pretty separate at that moment, I thought."

The affair was a kind of irrepressible cry for attention from Marina, as well as an instrument of revenge, and she was wretched with guilt over the course of it. But she still managed to inject some lasting ethical benefit into the relationship, for Winters anyway. "I was emotionally rather damaged at the time and she was very giving and healing," Winters recalls. He was mired in a protracted and painful fight with his parents, but Marina told him that he should forgive and love them regardless of anything—an amazingly generous and hypocritical piece of advice. What she had been bitterly unwilling to do with her parents, she was ready and able to help Winters achieve with his. She baked an apple strudel for his mother and accompanied him on what turned into a peace mission to his parents' house. "Marina just charmed the pants off of them," Winters says. "But it was very much showbiz, so I was partly skeptical." Marina's overwhelming charm with Winters's parents and the lightly bullying therapy she administered on him was part of the same drive that powered her art: an insatiable need for love and attention that she sublimated into a generous-aggressive pedagogy and friendly shamanism. When the delicate equation functioned, both in the social and artistic realms, it was an irresistible force.

Immediately upon returning to Amsterdam, Marina told Ulay what had happened in San Francisco. The guilt was overwhelming, and she needed his absolution. He took it with Zen-like calm and instantly forgave her. He understood, she was a very sexual person after all; it was a shame, but it was natural. His forbearance and her guilt melted her heart—incapacitated it—and locked her helplessly back in his orbit. Just as when she'd first met Ulay, "I was so much in love I couldn't breathe." The immediacy of his absolution should have rung alarm bells though. The next day, she saw Christine Koenigs in a café and joined her. Didn't Marina know about the Suriname woman who had been staying with Ulay while she was in San Francisco? (As well as breaking his long abstinence with her, the affair was made doubly intense by the fact that Ulay had nearly died with this woman: he cooked some mushrooms that he'd collected months previously in Italy; they both got violently ill and had to have their stomachs pumped.) Marina stormed back to the apartment they had

recently moved to on Lauriergracht and trashed the place. What infuriated her even more than the affair was Ulay's placid and pious manner when she'd told him about Winters, and his failure to reciprocate her honesty with his own. Marina decided a break—perhaps a breakup—was necessary, and packed her bags for India. She toured around, met up with some friends from the trip she'd taken there with Ulay in 1982, and gravitated to Dharamsala, the home of the Tibetan government-in-exile. After a few weeks, Marina recalls that Ulay came out to India and persuaded her that they should try again. Ulay has no recollection of going on this rescue mission, though they did get back together. Marina couldn't imagine living or working without him. She also didn't want to admit the possibility of professional failure, especially since they had a growing reputation as an invincible couple.

Modus Vivendi—meaning a compromise enabling two adversaries to live together—was a personally apt title for a new theater piece Abramović and Ulay began working on, though the play strived for universal, archetypal significance. Inspired by their Vipassana mediation retreat in India a few years before, Ulay lay down on cardboard boxes and slowly recited all the things he was doing in that present moment: "Lying, touching, breathing, remembering, intending, moving, lifting, breathing," and so on. After some time, he got up and walked over to a roll of paper, which he unfurled to reveal a photograph of two conjoined skeletons (he'd taken the photo before he met Marina). Now it stood perfectly—though certainly unintentionally—for a new stage in Marina and Ulay's symbiosis, which drained rather than nourished them. Marina felt that *Modus Vivendi*, which they performed in Bern, Arnhem, and later in Baltimore, made them old. Her role in the piece was to stand motionless, swaddled in a large piece of green fabric, then, as she later described: "At one unpredictable moment I raise my arms abruptly." The sudden revelation of an image or a movement and then the somber contemplation of it ended up being underwhelming; they still hadn't found a way to translate their force onto the stage.

The question is why did they persevere with the effort? It may have felt like the stage was the natural—terminal—destination for their work, which was becoming more symbolic and more controlled. Alternative spaces, garages, warehouses, and gym halls no longer seemed adequate for the supposed gravity of these pieces. The theater was an environment that could support the overbearing meanings they were projecting onto their work, encompass and properly communicate their elaborate choreography, and prepare the audience to pay sufficiently close attention. But in the theater, all ethical conundrums were blocked by the fourth wall. With performance art the only kind of disbelief the audience had to suspend was the feeling of *how can they be doing that to themselves?* But with theater the audience had to suspend their disbelief in the artifice of the events unfolding in front of them. Working in the theater answered some deep desires for Marina: for confirmed adulation (it wasn't proper to clap after performance art, and Abramović and Ulay usually remained performing until after everyone had left anyway), for bold demonstrative acts, and, later, for extravagant fun.

In January 1986 Abramović and Ulay went to Cambridge, Massachusetts, for a residency at the List Visual Art Center of the Massachusetts Institute of Technology. There they made the last installment in what was congealing into the *Continental Video Series*, a twenty-minute video called *Terminal Garden*. Like *City of Angels* and *Terra degli Dea Madre,* this one featured a slow-moving camera drifting dreamily over a near-static environment. This time it was one of the computer labs at MIT. Abramović loved the pathos of a single spindly potted tree placed in the middle of this bunker of technology. The camera lingers over the cables tangling around the tree like suffocating vines. Dazed-looking children are slouched against computer terminals. Over this claustrophobic footage a computer voice recites lines that Abramović extracted from ads on American TV, removing brand names to create an abstract mantra: "Before you dress caress. Joining two worlds together. Extra smooth. We know your taste better than you. Twenty-four ways to make beautiful eyes. This vacation comes with a new set of dishes. It only happens once in a lifetime. . . ."[57] Consumerism still held a hypnotic sway for Marina, even as she lamented its deracinating power. She also fed into the computer some lines from a Sanskrit text, which had a similarly dreamy, indoctrinating force: "Consider any area of your form as limitlessly spacious. Feel your substance, bones, flesh, blood, saturated with essence. Suppose your passive form to be an empty room with a wall of skin. . . ." Though the tone of the ads and of the Sanskrit philosophy were similar, Abramović understood the advertising instructions to be seductive and superficial instructions for increasing success, whereas the Sanskrit text demanded profound internal reconfiguration. She had an ear for both.

After finishing their project at MIT, Marina and Ulay headed to New York to perform another three days of *Nightsea Crossing*—leaving just two more before they met their ninety-day target. There was quite a bit of media interest in Abramović / Ulay by now. They gave an interview to the performance critic Cindy Carr for the *Village Voice*, telling her that *Nightsea Crossing* represented their faith "in the art of the 21st century. No object between the artist and observer. Just direct transmission of energy."[58] Marina told the *New York Times* what *Nightsea Crossing* meant in a place like New York: "People are overloaded in cities. There is too much to think about, too many telephone calls. People are not capable of relaxing. They feel guilty if they sit for three minutes and they aren't doing anything. This is showing another way."[59] This anxiety over stillness was something Marina herself felt acutely in everyday life, Ulay less so.

Despite the publicity, not many people visited the New Museum to see the performance, but word did get round among artists, and John Cage spent a few hours watching. Ulay knew without looking (of course, he was focused on Marina), that Cage was there because "I recognized his soap: this natural olive soap he buys in a Greek shop."[60] Marina and Ulay stayed with Pat Steir, who had moved back to New York from Amsterdam. "They were easy guests," Steir says, since they were in their habitual silence and fasting mode during the performance. But Steir recalls that

during the fast, "Ulay got weaker and weaker and Marina got stronger and stronger. Ulay was freezing cold, shivering, but Marina seemed cheerful enough." Again, Ulay's lithe frame and quick metabolism made fasting more difficult for him than for wide-hipped Marina. Ulay also worried that long periods sitting in the same position might aggravate both the hernia in his spine and his sensitive spleen. Marina was unsympathetic, believing that Ulay's difficulties with *Nightsea Crossing* came from a lack of mental resolve. "I think that in his entire life he doubts so much," Marina reflects. "He doubts that he wanted to do this or that, to be an artist or something else, that he want to travel around the world or want to go into a cave and meditate. He never made the choice of what he really wants. I think in this kind of activity like *Nightsea Crossing* you have to be 100 percent sure if you want to make it, then you can make it."

Before they slipped into their silence and fasting, Marina and Ulay gave comfort and counsel to Steir, who was in the midst of difficulties with her husband, Joost Elffers. If Marina and Ulay's relationship was in dire straits at the time, Steir certainly didn't notice it. "They were very fond, very helpful, very kind, very sympathetic, very filled with good advice. So I thought they had the perfect relationship, enviable. Then later I found out what was going on."

REVELATIONS

While Abramović / Ulay tended toward the stage in the 1980s, Ulay's proclivities and expertise also drove them toward a parallel practice that sustained them through the decade: the production of large-scale Polaroid photographs. "Photography was absolutely his domain," Marina says, in terms of technicalities. But in terms of content and composition, the ideas came from both of them, indistinctly, as usual.

Their first Polaroid work was a diptych made in 1981, which recalls Abramović's early painting, *Three Secrets*. In the first image, she holds a small piece of fabric over her hand, apparently concealing something; in the second image, Ulay has pulled off the sheet, revealing Abramović's empty hand. In 1985 Ulay used his old connections at Polaroid to secure the use of their special room-size camera in Boston, the only one in the world. The camera took eighty by eighty-eight-inch photographs—producing images at a life-size, one-to-one ratio. With Abramović and Ulay's full figures in the frame, the medium came close to providing a verbatim transcript of reality and summoning the physical presence of performance (even though it was a permanent object that was easily made into a commodity—the exact opposite of performance). Under the same title as their stage play that year, *Modus Vivendi*, Abramović and Ulay made a huge tetraptych of silhouetted images. In the first image Ulay's shadow, cast on a crumpled, tan-colored studio backdrop, theatrically spears something on the ground; the next one shows Abramović pointing at the ground, with her other hand cupping the sky; in the next, the two lovers lean against each other back to back; finally, we see the shadow of a new tree growing from the earth— at the point where Ulay had done his killing. Another series of Polaroids, also made in the Polaroid camera-room in Boston, features Abramović in silhouette making Egyptian hieroglyph-like poses. Ulay also took portraits of a worker from the cafeteria. For another set of images in the *Modus Vivendi* series, Abramović and Ulay dressed up like weary traveling salesmen. Abramović stood in profile in a worn-out man's suit, wearing wiry spectacles and hunched over as if on a long journey, holding a closed box under her arm. In the complementary image, Ulay assumes the same pose, except his box is open and empty. The image is emblematic of their attitudes to life: Abramović always wanted to collect things—experience, love, acclaim—while Ulay's tendency was a more militantly Buddhist (or simply self-effacing) one: jettison everything, travel light through life.

While their relation works invoked intensified versions of themselves—*That Self*, as they called it—and demanded a transformative effect on the performers and the audience, in the Polaroids the emphasis was purely on aesthetics. This should

19.1, 19.2
Abramović / Ulay, *Modus Vivendi*, Polaroid,
1985. Courtesy Sean Kelly Gallery,
New York.

have freed Abramović and Ulay up, taken a burden off. But somehow the work got heavier, not lighter, as a result of its new aesthetic and actorly disposition. They substituted the demand of physical and emotional authenticity for a raft of overdetermined mystical associations.

In 1985 Klein organized a traveling exhibition schedule for the various series of Polaroids, which went to the Fodor Museum in Amsterdam, the Düsseldorfer Messegelände, the Hirshhorn Museum and Sculpture Garden in Washington, DC, the Pori Art Museum in Finland, the Stedelijk in Amsterdam, and the Kunstverein in Frankfurt. And that was just a taste of the even busier schedule, taking in nine museums and galleries across the U.S., that Klein set the next year for a new Polaroid series, *Tuesday / Saturday* (a reference to the planets: Mars for Tuesday, Saturn for Saturday, and their respective astrological colors, red and black). These images featured the silhouettes of classical-looking vases, urns, and jugs—again set against a tan studio backdrop. They had a rare warmth in color that was hard to achieve in normal photographic processing. And since they weren't multiple editions, they were highly valuable and collectible. Klein sold some of the Polaroids to the corporate collections of the Bayer Group, Chase Manhattan Bank, and Progressive Insurance, some to private collectors, but most to museums. The Akron Art Museum in Ohio paid $20,000 for the *Modus Vivendi* tetraptych. Pairs of images usually sold for $15,000. Klein took a normal 50 percent cut, and, much to Ulay's annoyance, the cost of production too. Klein recalls: "He was pissed off in general because he didn't like the commercial aspect of this stuff. It was contrary to his thinking. Marina saw it as a way to support their activities and a viable way to develop their work."

While the Polaroids were touring the U.S. in 1986, Marina and Ulay took their first trip to China. They met up with Tijmen van Grootheest, who was in Beijing negotiating with the China Association for the Advancement for International Friendship over the details of their Great Wall project. China reminded Marina of the drab and constricted atmosphere she'd run away from in Belgrade. "But for me China was even worse: this was communism with Eastern fanaticism." They stayed in characterless apartment blocks; a decaying concrete compound with outdoor toilets lingered miserably in Marina's consciousness. Ulay took better to the communist situation in China—at least to the communal if not the bureaucratic aspects of it. Their days were taken up with endless meetings with party officials. It was impossible to know if the meetings were meaningful or not. Marina was accustomed to straight talking, and using her charisma to persuade people in the art world of their projects and plans; in China negotiations worked on more complex, symbolic, and unspoken levels that she had no patience for.

In October Marina and Ulay packed up their *Nightsea Crossing* table and chairs for the last time and took them to Lyon to perform days eighty-nine and ninety at the Musée Saint-Pierre. It was the end of their longest and most arduous performance ever, and was accompanied by an exhibition of relics and documentation from the previous six years of work: a grid of photographs of the different color fabric

they'd worn for each performance, which corresponded with Vedic astrological and color theories, and pie-shaped segments of the huge circular table they'd used for the *Conjunction* performance with Watuma and Ngawang Soepa Lueyar. The museum bought many of the pieces. Abramović and Ulay should have felt an enormous weight lifted from them at the end of the *Nightsea Crossing*: true to their word, they had completed the full ninety days of uninterrupted, silent, and static eye contact. Their vow had been fulfilled. But by this point they were both buckling under the collaboration, though Marina was still determined to live it out to the letter.

During a meeting one day at their apartment with the director of the Groninger Museum, who was interested in buying an Abramović / Ulay Polaroid, a young couple appeared at the door. They were dressed in motorcycle clothes and asked to see Ulay. "Please, refresh my memory," Ulay said, not recognizing either of them. "I'm your son," the young man said. It was Marc Alexander, visiting unannounced from Germany. The people from the museum left in a hurry. Ulay had last seen Marc Alexander in the late '70s on one of his and Marina's occasional visits to Germany. Now, he was a grown man.

A more severe parental shock came in June 1987. Christine Koenigs was talking to her friend Jean Ruiter, a photographer, about the strain between Marina and Ulay. Koenigs said Ulay had lately been "harsh and unapproachable." Ruiter, who had known Ulay since long before he met Marina, said that he had always been a distant and detached person: didn't she know that in the early 1970s he had left a woman while she was pregnant to raise the baby alone? The woman was named Henny Löwensteyn and the son, now fifteen years old, whom Koenigs had never heard about—let alone Marina—was named Jurriaan. Koenigs broke the news to Marina, and she confronted Ulay. "He denied it, saying that people are gossiping and trying to break us up," Marina recalls. But shortly afterward, Ulay met Jurriaan for the first time. "It was very strange, but not so exciting as everybody expected," recalls Jurriaan, who shares his father's taciturn yet charming nature as well as being a physical carbon copy. Jurriaan had always known who his father was and what he did for a living.

For Marina, the revelation of Jurriaan's existence was the final blow to her relationship with Ulay. From the moment they'd met in 1975, he had been keeping from her a crucial part of himself. Finally Marina had confirmation of what she had always suspected on the fringes of her consciousness but summarily repressed: the feeling that she didn't know Ulay, that there were areas of him that would always be kept dark and secret from her because he kept them dark and secret from himself. All the times in their early years when she hung around Ulay's old bars in Amsterdam, got tired, went home, and worried about what he was up to, and in more recent years when she sensed him flirting with other women—these were not only incidents of standard jealousy, but the expression of a longing to know him better, to strip away the mystery that he insisted upon shrouding himself in. For Ulay though, who had known only his mother and father as family, both of whom melted away very early in his life, mystery was his modus operandi. "She didn't know about a very important

part of me, and neither did I—because I did not have contact with Jurriaan," Ulay says. "It didn't matter so long as she didn't know. It was blanked out. I never had the feeling that it would be a big issue."

What upset Marina most was the harsh retrospective light this knowledge cast on what she thought had been a utopian relationship—at least until the past few years. Even when she'd felt a symbiotic and telepathic communion with Ulay, and through all the moments in life and in performances when their lives had depended on trusting each other, he had kept this fundamental secret from her. And why, when the existence of Marc Alexander had never been a secret, had Ulay kept Jurriaan hidden from Marina? Ulay never explained; instead he would perform verbal acrobatics, speaking sanctimoniously and circuitously around the subject. Now, he reflects: "It was not about being secretive but maybe more because of the feeling of shame. Because if I'd have mentioned Jurriaan then I would have had to admit that I am a bad father. I was a bad father for the same reason that Marina didn't want to have children: I had given priority to my artistic career. I couldn't combine my role of being a father with my outrageous career." By choosing not to tell her about Jurriaan, Ulay had deliberately planted a time bomb in his relationship with Marina. He must have known that it would go off at some point, and that it would probably blow open an exit route from the relationship. And while the secret festered for ten years, it also provided a point of differentiation from Marina. Holding something back was a way of guaranteeing that the relationship wouldn't swallow him up completely.

Around this time, Marina's aunt Ksenija and her cousin Tanja paid a visit to Amsterdam. Marina and Ulay put on a good show for them, trying to give the impression of a happy relationship. But over lunch one day Ulay said something unprompted that set alarm bells ringing for Tanja: "I have been married already [referring to Uschi in the 1960s] but Marina is the first and the only one for me," Tanja remembers him saying. She thought he was protesting too much, but said nothing about it. Marina smiled awkwardly, and the strange moment was passed over in silence. Later, Ulay made another spontaneous declaration in front of the twenty-four-year-old Tanja: "There are only two ways to be in relation to the opposite sex: completely promiscuous or completely monogamous." This time Tanja asked him why he was saying such things. "Because I've had experiences and now I am completely devoted to Marina and I know what I am talking about."

Still, Marina and Ulay quarreled in front of their guests about matters as trivial as being late for dinner (Ulay insisted on punctuality), and as weighty as the sale of a pair of Polaroids that were recently on exhibition in the Stedelijk. They were contractually obliged to give the museum first choice of two large-scale Polaroids diptychs, but Marina had just unilaterally and preemptively promised one of them to an American collector couple. Ulay was furious. What if the museum chose *that* diptych to buy? Marina said she would just persuade the museum that the other, available, one was by far the superior piece. This might be how you do business in the Balkans, Ulay said, but not in the West. Marina countered by asking Ulay how they expected

to support themselves in the run up to walking the Great Wall of China if not through the sale of *both* Polaroids?

The unraveling of their relationship, played out in such arguments and accelerated by the revelation of Jurriaan, had really begun during their period of abstinence a few years prior—a withholding that had led them both into short-lived affairs and into the temporary breakup when Marina escaped to India. While Marina clung miserably onto the relationship ever since, terrified of the idea of its failure, Ulay was now closer to completing his very slow decision to leave Marina. They made another preparatory trip to China in early 1987, and afterward spent some time in Bangkok, but stayed in separate places. Ulay was having an affair with Barbara Whitestone, a wealthy American woman who managed finances for the Grateful Dead. On this occasion, unlike with the Suriname woman in Amsterdam years earlier, Ulay volunteered the information about his lover to Marina. She invented a counterstory that she was having an affair with a French writer and that they were having fantastic sex. But she was lunatic with jealousy, and asked Ulay not only if she could meet his new girlfriend, but if they could make love together, all three of them. "She wanted to get in between us by throwing herself in with her body, and then enjoying it," Ulay says. Marina says she wanted to do it "just to hurt myself the maximum I can." It was an emotional self-flagellation worse than any physical pain she'd inflicted on herself in a performance. There was no doubt a maniacal competitiveness in the decision too, but this didn't play out in the bedroom. "It was not even making love together. It was him fucking her basically and me watching. Then I'm lying in this bed, we were sleeping three of us. There was so much pain that I really had numbness. This was the moment when I could not put any more pain on myself."

Abramović / Ulay was disintegrating, but they continued to grind out work together. They made a series of mostly undocumented performances in 1987 called *Die Mond, der Sonne*. In the first of these, in April that year at the Centre d'Art Contemporain in Geneva, Ulay sat on top of three chairs balancing one on top of the other. Abramović approached the chairs very slowly until, after an hour, Ulay finally lost his balance and fell from his precarious perch. They repeated the performance in Bern, where it was accompanied by object-surrogates: two identical six-foot-high vases, one in matte black, the other in reflective black. They made one more iteration of *Die Mond, der Sonne*, this one a tragic reprise of *Nightsea Crossing*. In a venue called The House in Santa Monica, California, they sat opposite each other at a table, silent and motionless as usual, except this time the planned end of the performance was not when the museum closed and everybody had left, but simply when one of them chose to get up and leave the table. Marina was suffering from a migraine at the time, so for once she left the table first. "Ulay was really lucky I had migraine," Marina says.

There was one task left for Abramović / Ulay: the Great Wall walk. It was scheduled for the summer of 1987. Marina had given the aging dog Alba to Velimir to look after, and she and Ulay moved out of their apartment, planning to sublet the place while they were away. In the meantime they were staying with Pat Steir and

Joost Elffers in their house on Binnenkant, a quiet leafy canal street in a wealthy neighborhood (Steir had now returned to Amsterdam). Everything was in place for Marina and Ulay's imminent departure when a message arrived from China. The Association for the Advancement of International Friendship was demanding a huge additional sum for the project, to pay authorities in the provinces for "security and soft drinks" as Abramović and Ulay walked the Wall. The Association had got wind of the full amount Amphis had raised from the Dutch government, and were now attempting to squeeze more money out of them. But Amphis had little of the original budget of $150,000 left—much of it had been spent on the preliminary trips to China, and as a stipend to sustain Marina and Ulay in the lead-up to the walk. The walk was postponed while they raised the extra money, but by the time the cultural ministry had stumped it up it was winter—unwalkable weather. Marina and Ulay would have to wait until next spring before they could walk the Wall. They knew by now that this grand performance would mark the end of their relationship. Marina even half-joked that they should start in the middle, together, and walk away from each other.

Unable to face a winter in Amsterdam with Ulay, Marina returned to Dharamsala in India, but this time she remained alone. The trip was full of signs and wonders: walking in the forest one day, she got lost and came across a monastery. Inside she saw the preserved body of Ling Rinpoche, the lama who had touched her forehead in Bodhgaya five years earlier, making her cry for hours with his innocence. She went on a retreat in the Tushita meditation center, where she stayed in isolation for three months, repeating a mantra addressed to the Hindu-Buddhist goddess Green Tara: *om tare tuttare ture svaha*. Green Tara seemed an apt goddess to worship: she was invoked as a means to clear away dangers and obstacles, to encourage quick thinking and vigor. Sequestered in a wooden hut in the forest, with food left on the porch each day, Marina set about her hours of repetition. She hoped the regime would give her the mental resolve necessary for the Great Wall walk and for the life without Ulay that lay ahead of her. Afterward, she burned all the possessions she had with her.

Ulay spent his winter in Morocco with Barbara Whitestone. Ulay and Marina both returned early in the New Year to find that the money had been raised by Frank Lubbers, full permission had been granted, and they were finally set to leave for China in March. Before she left, Marina laid plans for the future. She noticed a huge rundown house for sale on Binnenkant, near Steir's place. She spoke to the landlord, who had a floor to himself, from which he sold drugs to the inhabitants of the house. She arranged to clean up the place and evict the tenants and squatters so that she could get a mortgage on the house. Demonstrating her economic pluck, which, with Ulay controlling their finances, had been largely dormant since her purchase of the house in Grožnjan seventeen years earlier, Marina pursued a different strategy with the bank that owned the building. She knew they would only sell it if it looked dirty and squatted—so she moved some of the squatters back in. The plan worked; Marina made a deposit on the house with a $9,000 loan from Michael Klein, who was apparently happy to see her getting free of Ulay.

The night before leaving for China, the Amphis foundation put on a farewell dinner for Marina and Ulay in a Chinese restaurant, with Frank Lubbers and some of the donors to the project in attendance. During the meal, Marina and Ulay started arguing and Ulay stormed out of the restaurant, declaring that he wasn't going to walk the Wall. Lubbers chased Ulay down outside. Ulay was pacing the streets, and Lubbers fell in step, telling him: "You should be professional. You can have your row but this is an artistic project. I have not spent all this time working so hard and getting all this money for you to finally not go. That is not what you're going to do to me." Marina and Ulay took the plane the next day.

<div align="right">

20

</div>

THE LOVERS

At the auspicious time of 10:47 a.m. on March 30, 1988 (the year of the Dragon), Abramović stepped onto the head of the dragon where the Shanhai Pass rises from the Yellow Sea, and began walking west. At the same moment, in another time zone at the other end of the country, Ulay stepped onto the tail of the dragon at the fortress at the Jiayu Pass in Gansu Province, in the Gobi Desert, and began walking east. It was a journey that had begun in the Central Australian desert as 1980 turned into 1981, when the idea to walk the Great Wall of China occurred to Ulay, and Marina seized upon its mythic potential. In a way, the journey had begun even earlier, in the summer of 1976 in Giudecca, Venice, when Abramović and Ulay first performed together by running into each other repeatedly in *Relation in Space*. Now, in their final performance after twelve years together, they were in a sense restaging that first piece in slow motion and on a stupendously huge, mythical, and—though they hardly expected this—geopolitical scale.

Everything had changed since they first conceived the idea of walking the Wall. It would mark the termination rather than the culmination of their relationship. They couldn't afford to be photographed by satellite as they'd originally intended. And it was logistically impossible to make the film as they walked; they would have to come back with a crew later and reconstruct parts of the walk. Other preconceptions they had about walking the Wall would also disintegrate, especially for Ulay.

Something that hadn't changed, but which they had barely considered until starting the walk, was that there would be no audience—no one to provoke into ethical crisis or into transcendent empathy, no one's energy to feed off when they ran out of their own. But there would be two assigned chroniclers of the walk, their old friend Thomas McEvilley and the *Village Voice* performance critic Cindy Carr, who, at different times, each accompanied Ulay and Abramović on the Wall as they walked toward each other. McEvilley's epic yet remarkably plain and unpious text— given the grandiosity of the project—"Great Wall Talk," appeared in a catalogue for the post-walk exhibition at the Stedelijk; Carr, who had cashed in her life savings to fund her trip, wrote a text that took over nearly a whole issue of the *Voice* a year after the walk. Apart from this, there was no coverage of the walk in the press—not in the Western media, and especially not in the Chinese media, since the authorities already felt awkward about this heroic, romantic, and hard-to-fathom feat being undertaken by foreigners on their soil. The art world was hardly aware of Abramović / Ulay's mission either. For the 2,400 miles Abramović and Ulay were allowed to walk of the

Wall's total length of 3,750 miles, they were alone both literally and conceptually—in terms of recognition for their task.

Alone that is except for the huge entourages that the Chinese authorities forced upon them. McEvilley counted fifteen people walking with Abramović: guides, translators, government officials, representatives from the CAAIF, plus various hangers-on wanting to live royally on the Amphis foundation's budget. Ulay had to cope with similar crowds. To be the lonesome romantic pioneer he'd envisioned himself as, and to inject himself into the unadulterated sublime of the landscape, he had to determinedly stride ahead of his bumbling minders, out of sight and earshot of their happy chatter and frequent tomfoolery. Abramović and Ulay were accustomed to controlling all the conditions of their performances. Even the expectation of losing physical control was a measured calculation within known boundaries. Now they found themselves subsumed in a version of Kafka's short story, which Ulay had read, *The Great Wall of China*—in which workmen building the Wall have no idea how it will be completed, and become tiny cogs in an unfathomable imperial plan—and were for the first time pretty much powerless over the conditions of a piece. Will power alone could not determine the result. Diplomacy, humility, and surrender would be just as important in achieving their goal.

Early on in the walk, Abramović injured her knee and had to rest up for several days; Ulay got pleurisy from the cold air and overexertion at high altitude, and had to be taken to a hospital. They both recovered quickly and continued walking. Abramović faced incredibly steep and rocky terrain in the mountains, often with sheer drops on either side of the Wall. Her guide, Dahai Han, slipped and nearly fell to his death. On a high-altitude portion of the Wall, the wind picked up so powerfully that she and her guides had to lie down and cling to boulders and fill their pockets with stones so as not to be simply blown down the mountain. Still, this was exactly the kind of task to which Abramović could apply her well-honed resolve. Later, she insisted on climbing a peak that, according to her guides, nobody had ever ascended before. While they refused to climb, she set off alone. Her entourage was no doubt frightened that their foreign charge was putting herself in such danger on their watch. "For the Chinese it was incredible: a woman with no man, by herself, walking the Chinese Wall, and a foreigner. They didn't understand it. But at the same time, I got so much respect."

Abramović received a note from Ulay in the early weeks of the walk. "Walking the Wall is the easiest thing in the world," it said, and nothing else. After her scrapes with death, her knee injury, and the relentless difficulty of her terrain in the east, Ulay's studied Zen-like calmness infuriated her. She took it almost as a provocation. She probably increased her pace.

Despite his placid tone in the note, Ulay was having difficulties of his own out in the endless flatness of the Gobi Desert and the western provinces, where the Wall was little more than a small baked clay mound rounded off and smoothed over by centuries of weather and neglect. The physical act of walking may have been easy,

but Ulay's struggle was with bureaucratic mountains. There were interminable, inexplicable complications and delays in the daily arrangements of getting from the hotels via minibus to the Wall, a journey that might take several hours depending on the remoteness of the Wall. Ulay had a couple of theories about these attempted slowdowns: each province had its own entourage, and each wanted to keep the gravy-train project budget within their borders for as long as possible. Secondly, the Amphis foundation was due to make its final payment to the Chinese government after ninety days of walking—what if the walk was finished long before the ninety days was up? In other words, what was the rush? A delay tactic that Ulay did not resist so much was the long boozy lunches that the crew often took while walking the Wall.

Commuting to and from the Wall was particularly frustrating because Ulay had packed camping equipment. He'd planned to camp, envisioned himself camping, was desperate to camp. But the authorities wouldn't allow it; instead they shuttled him off to bizarre and soulless hotels in nameless towns miles from the Wall. He couldn't commune with the Wall, the landscape, and the peasants as he had wished to. Ulay hated being forced into what he felt was an inauthentic experience of China and the Wall. He had come with good intentions, with a love for the country and an openness to its people. Why was he being treated with a kind of reverse racism, where he was both deified and patronized?

McEvilley first met up with Ulay in Lanzhou, the capital of Gansu Province, in a hotel that they christened the Hotel of the Hundred Virgins, because of the amazing number of beautiful young women lingering around, giggling at them. There was a dance going on in the hotel that night, and after a few "fake" gin and tonics, Ulay and McEvilley resolved upon joining in. The man at the door refused to sell them tickets, but they strode into the hall anyway. McEvilley recounts what happened next:

> Suddenly I was aware of a scuffle on the landing. . . . Ulay was pushed and being pushed by the ticket taker. A local foreign ministry man, Mr. Ch'en, was pawing at him, trying to calm him. Ulay was bright red in the face over his dark tan from the desert. He was lungeing at Mr. Ch'en. Young men in what looked like military uniforms appeared from nowhere and acted very aggressive. . . . [E]nflamed by fake gin and tonics, it seemed downright irrational: they would neither sell us tickets nor admit us without them. (The remaining option, that they would not admit us at all, hadn't occurred to us yet.) The manager of the hotel was called. A crowd gathered. A month of frustration, anger and isolation seemed to be erupting. "This man is an asshole and an idiot," Ulay screamed, pointing at Mr. Ch'en. Knowing Ch'en spoke not one word of English, he let off steam. "The man is a rabbit," he said, catching my eye for the information, "if I had a knife I would cut his throat."[61]

The confrontation ended with Ulay pointing at Ch'en and then turning his back on him, a gesture he knew to be the worst insult he could give to a Chinese person. His outburst was the result of his pent up anger at not being allowed to walk the Wall his way. But McEvilley notes the much bigger reasons for it, which

were both intimate to Ulay and geopolitical in scale. Ulay's vision of an old-fashioned communism of collective brotherhood (which he hoped to be included in) had been replaced by a reality of multiplying petty bureaucrats. As a foreigner in regions where people had never seen a Westerner, Ulay could never hope to integrate and disappear, something he loved so well. He was both honored—at endless official banquets, tours, and ceremonies—and reviled as a poisonous foreign influence. Cultural pollution was the official term for it. As a foreigner Ulay simply was not allowed to do and see certain things. He was not free, even as he performed a piece that was meant to take the most simple and profound act of freedom, walking, to epic lengths. McEvilley noted the contradictory position Ulay found himself in: exemplar of Western romantic individualism and at the same time desperate to immerse (and erase) himself in the local culture.[62]

One night the guides and fixers finally relented and allowed Ulay and McEvilley to camp near the Wall. In the evening, a crowd of teenagers gathered around and proceeded to shout at their tents for several hours. Ulay left his tent door open, sat placidly, looked welcoming, lit a candle, and started writing a poem. The crowd of kids just mocked him all the more, becoming more aggressive and threatening. On the only occasion Ulay and McEvilley needed the security guard, he was asleep in the jeep. The harassment went on into the night and continued again first thing in the morning. This is why the authorities had said camping would be impossible. But they hadn't told Ulay this—partly because they didn't want to offend their guest and partly because his romantic illusions about communing with peasants and nature simply didn't compute in the first place.

Ulay felt that information was always being withheld from him, and that the ulterior motive behind everything was to slow down his walk. He got into a shoving and screaming match on the Wall when his guides suddenly and inexplicably tried to stop him from walking on. Ulay was in his stride, loving the lonely expanse of the desert, feeling as if (as Carr reported), the earth was a treadmill beneath his feet—as if walking the Wall *were* the easiest thing in the world.[63] Why should he stop now? He shook off his polite but insistent guides and walked on, assuming that they were just trying to enforce yet another pointless hindrance on his progress. Still they followed him and pawed at him again to please stop, Mr. Ulay. Enraged, he snapped the staff that he carried with him—upon which was a small white flag, meant to remind him to "always surrender"—and shoved his captors away with it and strode off by himself. Only later did he find out that the area he'd walked through was radioactive. He and Abramović were already being allowed to tread on parts of the Wall no Westerner had ever been to, but Ulay especially maintained, in McEvilley's words, a "greed for authenticity," wishing all barriers to fall before him.[64]

In contrast to Ulay's attrition and idealism, Abramović fostered an attitude of acceptance, voluntary ignorance, and quiet determination. She didn't get embroiled in the daily negotiations and vacillations about plans. She didn't carry a map (Ulay had the most detailed one he could find). When she did confront a bureaucratic

obstacle, she used her charm and gung-ho spirit to slice through the torpor and inspire her crew to movement when they'd rather have spent the day lazing in whatever village they were staying in. At the end of one day's walking, when the crew couldn't locate the jeep—either by sight or by walkie-talkie—and Carr began to get anxious, Marina comforted her with the Buddhistic aphorism: "You think jeep is somewhere and we are nowhere."[65]

Neither Ulay nor Marina were thinking very much about each other. They were both consumed by the difficulties of walking the Wall, and by their very personal responses to China. While Ulay was seeking a sense of family in China, for Marina, everything was already a bit too familiar. The emphatically featureless architecture and carbon copy towns and cities, the deliberate and brutal erasure of beauty and nuance, the stifling interpersonal atmosphere where everybody was living up to a script, the robotic behavior of the bureaucrats she had to deal with in order to keep the walk moving, the lack of joy and laughter, and the loneliness—all of it made Marina exceedingly melancholy. She and McEvilley were amused and depressed when, on a boat ride on a lake near the Wall, their Chinese guides kept trying to divert their attention away from the Wall, visible in the distance snaking over the mountains, and toward the new dam that had triumphantly created the lake they were now floating on. Later, Marina lamented to McEvilley the "'ugliness, the ugliness' of it all, tears running silently down her face. She pointed limply to the transoms over the doors in the hotel, which were of clear glass. The hall lights shone right in. Even a flower in a vase, she said, you never see."[66] When Carr joined her several weeks later, the communist aesthetic in the towns and hotels they passed through was still making her morose. "These straight lines. This socialist aesthetic," she sighed to Carr. "Bad light and hospital green. Why they choose this form of expression?"[67] When she was walking on the Wall she could easily slip into the sublime and empty her mind of communist drudgery before a landscape so beautiful "that whatever you say becomes poetry out of your mouth." But in the villages, talking to locals, she was often appalled. "I could not believe how brainwashed the people were: no culture, no background of the history of Confucius, all the Chinese great philosophers, Lao Tse, nothing. Just that kind of communist reality, which I know so well. Ulay was very happy there."

Their 1979 birthday performance *Communist Body / Fascist Body* (subsequently sanitized to *Communist Body / Capitalist Body*, and then, ultimately, back to *Fascist*) had made clear how Marina was born into communism and Ulay into fascism (then very shortly after the war, capitalism). But, as McEvilley observed, China illuminated the fact that they'd now switched roles. Walking eastward, Ulay was an aspirant socialist, seeking a supposedly authentic existence free from capitalist luxuries; walking west, Marina wore lipstick to dinner each night when she stayed in hotels and often woke up to find she'd been crying in her sleep, in a malaise over the lack of beauty.

There was something else apart from communist blues and the impending meeting with Ulay that occupied Abramović's mind: the pursuit of what would

20.1
Abramović / Ulay, *The Lovers*, China, 1988
(still from the original performance).
Courtesy Sean Kelly Gallery, New York.

become her first solo work since she was thirty years old. She was now approaching forty-two. At a certain point on the walk, she posed her guide Dahai Han on the Wall, styled his hair with a mixture of sugar and water—in the absence of anything better—and took a series of photos that she would later blow up life-size (much like the Polaroids she'd made with Ulay) and title *Le Guide Chinois*. Dahai stood, barechested, making a series of Tantric mudras hand gestures that Abramović imbued with meanings like "holding small emptiness" and "holding big emptiness."

Abramović was also pursuing an interest in the "energy" of the earth that the Wall traversed. "I was aware that there was a different relation between the ground I was walking and my mind," she says. "If clay ground I was feeling different, copper different, quartz different, iron different. I wanted to justify the feeling, so I was always asking the guide if I can meet the oldest people from the villages. I met a few people who were 110, 120, 105 years old, and I would ask them to tell stories about Great Wall. Every story was in a way related to the ground. The green dragon would fight the black dragon. The green dragon was copper, the black dragon was iron. You could literally see the configuration of the ground in the epic stories." It was a lot like the Dreamtime she'd learned about in the Australian desert, where every stretch of land is storied. It was a system of thinking, both mystical and intractably material, that would inspire Abramović in making a series of mineral-based objects throughout the next decade, without Ulay.

Marina and Ulay finally met up, and broke up, in a canyon dotted with Buddhist, Taoist, and Confucian temples at Er Lang Shan, Shennu, in Shaanxi Province, on June 27, 1988, after ninety days of walking (the same number of days they'd performed *Nightsea Crossing*). Marina suspected that Ulay had been waiting there for several days since he thought this spot was particularly photogenic for their reunion. A small crowd watched as Marina and Ulay approached each other without any drama, and embraced. Ulay's embrace was avuncular. For him, the romance was long over, though he did harbor the illusion that they might continue collaborating. Marina wept. "Don't cry," Ulay said, with a hint of reproach. "We've achieved so much." Photographs of the meeting show Ulay with a baseball cap and thick moustache smiling broadly and waving; Marina looking meek and small in his embrace, weakly smiling with exhaustion and resignation.

Marina couldn't leave China fast enough. She went back to Beijing immediately, spent a single night in a five-star hotel, and then flew back to Amsterdam via Hong Kong. Ulay stayed on in China for several months after the walk, in part to look for musicians to make the score for the film that they still planned to make. Ulay fell in love with his translator, Ding Xiao Song, and married her in Beijing in December 1988. Despite the apparent finality of the walk, which they called *The Lovers*, and Ulay's quick transition into a new partnership, Marina and Ulay's dissolution was by no means clean and complete. They would continue to be entangled in exhibitions, sales, and archival disputes, as well as remaining locked in emotional warfare. Marina told friends shortly after the walk that she would suffer from Ulay for at least

as long as she had known him—twelve years. But she would convert this pain into propulsion for the new, second, solo career that lay in wait.

Twelve years after their split, a still-bewildered female friend of Ulay asked him the simple question: "Why did you break up with Marina, the most amazing woman in the world?" Ulay replied, "I thought I deserved less."[68]

20.2
Marina and Ulay meet on the Great Wall of China after walking from opposite ends for the performance *The Lovers*. The meeting marked the end of their personal and professional relationship. Courtesy Abramović archive.

SOLO IN PUBLIC 1988–

PART THREE

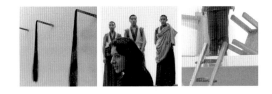

21.1
Abramović lying on her "transient object" *Green Dragon*, 1989, at the Kunsthalle Düsseldorf, 1990. Courtesy Sean Kelly Gallery, New York.

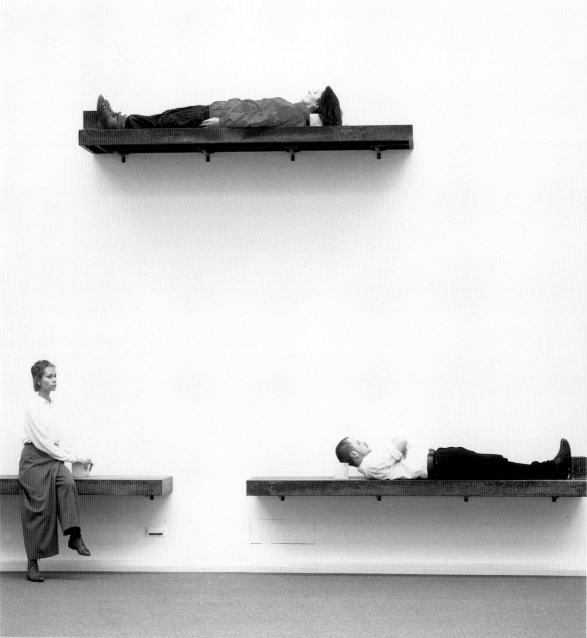

SPIRITUAL / MATERIAL

Back from China, Marina could be found shopping for clothes in Amsterdam arm in arm with a macho and handsome young man named Paco Delgado. They met through Michael Klein, whom Delgado had been working for in his new gallery space in Amsterdam. At the age of forty-one and in the wake of Ulay, Marina had been feeling "fat, ugly, and unwanted." The first signs of age were creeping into her face: the corners of her mouth were slightly downturned if she wasn't smiling, she had to dye her hair more often, and her eyes could betray signs of tiredness and sadness. Delgado provided Marina with the material and romantic affirmation she needed. He encouraged her to start paying more attention to the way she looked: buy finer clothes, get the best makeup, go to expensive hair salons, go to the gym, respect yourself. He became a kind of courtier for Marina, and soon began working for her directly instead of through Klein, living in her huge new house, writing letters for her, helping her produce new work, and scheming on her behalf to elevate her status in the art world and finally cash in on all her years of hard work.

Marina decided to purge her pain over Ulay through constant activity. As well as the task of renovating her new house at Binnenkant 21 (and the stress of paying the mortgage), Abramović had two imminent professional commitments: a large exhibition at the Stedelijk about the Great Wall walk, for which she was determined to produce new work and signal the start of a second solo career, and the production of the film of the walk, an idea she wanted to realize even though it would mean going back to China and seeing Ulay again. She was willing to return to the traumatic scene of the breakup for the sake of posterity; it was also an attempt to master her pain by exacerbating it, like when she had demanded a threesome with Ulay and his lover in Bangkok earlier that year.

A film crew gathered at Schiphol airport in early October, bound for China and carrying a large quantity of excess baggage. The director was the Scottish filmmaker Murray Grigor, and the producer was Eduardo Lipschutz-Villa, a mysterious entrepreneur whom Tijmen van Grootheest—now at the Ministry of Culture and helping to fund the film—seemed to have conjured from nowhere. Lipschutz-Villa asked Grigor if he had a credit card to pay the fees for the baggage, which Grigor did, assuming that everything was budgeted. The shoot lasted a month and cost $2,000 a day, Grigor noted in his diary of the trip. He immediately liked Marina, but, he recalls, "I couldn't help feeling that I was being manipulated at the same time"—into an expensive and underfunded venture, made on the back of Marina's irresistible persuasion and Lipschutz-Villa's vague financial promises.

The crew returned to key points on the Wall: the eastern extremity, to shoot Abramović gazing out into the Yellow Sea ready to start her journey (again); the Yellow River, which Ulay insisted on being paddled all the way across in a little raft, as he had done the first time (Grigor wrote that Ulay was in his Werner Herzog, "*Aguirre, Wrath of God* mode"); and a tiny village somewhere in the west, where "the villagers were so tolerant of our ghastly ethnographic assaults," Grigor wrote, and where "Ulay did his *High Noon* walk up Main Street" as all the locals stared at him. Throughout the trip, Grigor had to manage Ulay's foul moods and Marina's tenacious misery. After an argument with Delgado—who was tagging along on the trip and charging a hefty fee for his dubious photographic skills—Marina pulled Grigor aside and moaned, "I'm splitting with my man . . . why are my relationships so disastrous . . . why can't I be happy . . . my home is too big." Grigor also had to manage Marina's aggressive loathing of Ulay. Two things in particular enraged her: the fact that Ulay had taken a new lover so soon after the walk (though she had done the same), and the fact that when they had moved out of Lauriergracht earlier that year, Ulay had taken all the negatives, videotapes, and films documenting their twelve years of work together. Marina only managed to hold on to a few of their Polaroid works and some prints of performance photographs but none of the master material. She felt like she'd been robbed of her recent history. By the time they got back to Amsterdam—Ulay moved with his new wife, Song, into Pat Steir's empty place on Binnenkant, just a few doors down from Marina—they hated each other so much that they refused to work together on editing the film. Van Grootheest had to take them to a one-day dispute resolution court in Amsterdam to force them to cooperate. Meanwhile, Grigor took a second mortgage on his home to pay for the shoot, and was trying to get reimbursed by Lipschutz-Villa and Frank Lubbers. After setting up the Great Wall walk, Lubbers was now reluctantly helping produce the film of it, but he too was now massively in debt.

Like the original walk, and the shooting of the film, the editing took place in strict physical separation: Ulay stayed on the top floor of Grigor's house, Marina on the middle floor, and they worked with Grigor in isolation on essentially two different films that he then stitched together. *The Great Wall: Lovers at the Brink* was a docudrama with very little interest in the quotidian facts and messy details of walking the Wall that Thomas McEvilley and Cindy Carr had illuminated in their accounts. But the film allowed Abramović and Ulay to conjure their original, ideal vision of walking the Wall. The enormous vistas Grigor captures on camera make Ulay and Abramović appear to be absolutely alone, just as they had wished to be, rather than constantly surrounded by a dozen hangers-on.

Ulay's film was the story of a lone man walking along the wall, caped and hooded in a massive blue poncho and blue hiking trousers, a kind of triangular beacon gliding across the desert. Ulay narrates his part of the film in a voice so gentle and strenuously innocent as to be almost defensive. He romanticizes to no end the peasants he encounters on his walk, saying softly at one point, "I feel like kneeling

down to smile, to show my good intentions. Yet I have to walk on. . . . I admire these warm-hearted people here, who never saw a stranger, and yet his inability of making friends remains unsolved."[1]

Abramović's idealized version of her walk reflects a different kind of fantasy. "The legends of the Wall talks to me more than historical facts," she narrates, describing a creation myth of the Wall in which a "mountain dragon" defeats a "sea dragon," finally plunging its head into the water, forming the start of the Wall at the Yellow Sea. The Wall is meant to be the spine of the vanquished dragon, and she feels the creature's "bloodstream pumping under my feet."[2] On a couple of occasions in the film, Abramović has sudden visions: actors in dragon costumes appear before her like apparitions; later, after she slips on some rubble on an absurdly steep section of the Wall, three figures materialize holding shaped mirrors that reflect the sunlight into her face. As the camera makes a dramatic stuttering zoom into her dazzled eyes, Abramović gives amazingly good cinematic close-up, calling to mind Velimir's long insistence that she was in essence a movie actress "who somehow missed the career."

Over epic vistas of the Wall winding along the top of a desolate mountain range, Abramović says in her narration that the landscape reminds her of "being back home in Montenegro"—a fictional homeland that she often claimed, perhaps because it sounded more authentically backwoods and Balkan than Belgrade, in Serbia, where she was actually from. In such recollections, she was skipping back a generation and imagining the childhood of her parents, who actually were Montenegrin. "I feel I'm so far in the middle of nowhere," Abramović narrates. "This feeling gives me fear but at the same time indescribable happiness. Here I'm now emptying my boat and entering the stream of the blue dragon."[3] In the editing suite, Abramović could crystallize a new meaning for the walk after its original meaning—unification with Ulay—had long since dissolved. She was purifying herself, jettisoning excess psychic baggage—emptying her boat to make it from the ocean into the stream—and steeling herself for a life without Ulay. At the end of the film, during the restaged meeting in the canyon at Er Lang Shan (this time without any spectators), Marina cries real tears. Underneath the narration we can just hear Ulay complain to Grigor: "Murray, we'll have to do it again. She's crying again." Marina recalls, "To me it was reenaction but at the same time it was twice real. It was just as painful."

When Marina and Ulay finally sat down together in Grigor's studio to watch each other's parts of the film, Marina declared, "Ulay, this is so fucking boring," before storming out into the garden. Then Ulay said, "For me, Murray, my parts aren't boring enough." Ulay's section of the film was strictly minimal, never showing how or where he slept and ate along the Wall, only his relentless, virtuous stride. Both Abramović and Ulay claim to have been the minimal influence in the partnership over the years, curtailing the other's tendency to overdo the symbolism or overcomplicate a concept. Now, loosed of each other's influence and editing, Ulay was becoming extravagantly puritanical in his minimalism—a posture that was inauthentic in its own way, given McEvilley's account of drinking, arguments, and compromises

along the walk. And Abramović was becoming more baroque, allowing herself aesthetic and material indulgences that would never have been tolerated in the stringent regime of "Art Vital" and "That Self."

After screening at the 1990 International Festival of Films on Art in Montreal, and appearing on Channel 4 in the UK in February that year, *The Great Wall: Lovers at the Brink* fell into oblivion. The walk never got the attention it deserved, but two years later, it cropped up in Don DeLillo's novel *Mao II*, in which one of the characters says:

> I've heard about a man and a woman who are walking the length of the Great Wall of China, approaching each other from opposite directions. Every time I think of them, I see them from above, with the Wall twisting and winding through the landscape and two tiny figures moving toward each other from remote provinces, step by step. I think this is a story of relevance for the planet, of trying to understand how we belong to the planet in a new way.[4]

As with Bruce Chatwin's unconscious account of *Nightsea Crossing Conjunction* in *The Songlines*, the majority of readers wouldn't know that this was in fact a real event. The performance would sink into legend instead.

Having finished the film, Abramović immediately started a new body of work, which was meant to continue the psychic cleansing of the walk and communicate her experience on the Wall to the public—and, indeed, suggest how we belong to the planet. She began putting minerals and crystals—many of which could be found in the ground she'd walked in China—into interactive, furniture-like objects.

She hadn't performed solo for twelve years, and didn't yet have either the confidence or the concept with which to face the public alone. Through her new objects, the public could perform instead, and feel something of what she had felt on the Wall—brought on, she believed, by the minerals in the earth. Through research in geology and Tibetan and Chinese medicine, Abramović formulated a system of correspondences between minerals and parts of the body: quartz represented the eyes; amethyst puntas, the wisdom teeth; amethyst geodes, the womb; iron, the blood; copper, the nerves. This was Abramović's union of body art and land art. She called her new pieces "transitory objects" rather than sculptures, intending a double meaning: the energy given off by them was supposed to be a means of transit into a meditative, rejuvenating kind of consciousness; and she considered the objects themselves to be temporary, to be discarded once the desired consciousness had been achieved. Even though they were incredibly heavy, solid, expensive, and often burdensome, Abramović saw her transitory objects and the energy they were meant to transmit as a step toward a larger ideological goal: art without objects. This was something she and Ulay had speculated about; now, alone, Abramović was trying to realize it, albeit in material stages.[5] In the twenty-first century, she said, "There will be no sculptures, or paintings, or installations. There will just be the artist standing in front of a public, which is developed enough to receive a message or energy."[6]

In the meantime though, there were the transitory objects—and the hope of sales. In their vicious breakup fights, Ulay had taunted Marina, saying she'd never be able to support herself, that she wouldn't even know how to open a bank account. With her move into sellable objects, just as in her tightening embrace of material pleasures, Marina was entering the spirit of the 1980s a decade late—other performance artists had long since found ways to translate the concerns of their performance practice into objects. The Polaroids with Ulay had been a mere supplement to their performances, and anyway were two-dimensional rather than three-dimensional objects that people could touch. Now, for a while at least, Abramović's transitory objects would be her principal work. All she needed was a gallery to show them in.

Marina first met Victoria Miro in London in the mid-1980s. Expecting her to be an elderly relation of Joan Miró, Marina had commented how young and radiant she was, a compliment Miro would not forget. When they met again in 1989, Miro noticed a change in Marina: "She became much more fashionable and started to think about her makeup and her hair. She became interested in a more superficial glamour." Miro gave Abramović a show in her London space in April 1989—her first solo exhibition since *Role Exchange* in 1976.

Abramović made three transitory objects, each the size of a narrow single bed, made from a greenish patinated copper sheet, with a mineral "pillow" at one end. Each piece was oriented differently, to facilitate a different kind of use: *Green Dragon* was fixed horizontally against the wall, for lying on; *Red Dragon* vertically, with a footrest and seat, for sitting. These pieces were equipped with rose quartz headrests. *White Dragon* had a platform for standing on, and an obsidian headrest. The objects came with instructions: "Stand on the copper base. Rest your head on the mineral pillow until its energy is transmitted."[7] Through the minerals, the meditation, and perhaps also the placebo of the theatrical engagement, Abramović hoped to tap into people's nervous systems directly and replenish their energy levels. Here she was channeling her old friend Joseph Beuys, the original artist shaman, whose personal charisma charged his key materials—honey, felt, and fat—with a vitalizing and protective aura. But Abramović was also developing a thought that had been present in her work since her corridor of machine-gun fire in 1971, and swallowing the pills in *Rhythm 2* in 1974: she'd always been interested in making a direct physiological intervention both in herself and in the viewer/participant with a minimum of mediation.

With the transitory objects though, there *was* an intermediary object, a very heavy and costly one. In the consignment letter to the Victoria Miro gallery for the three *Dragon* works, Delgado stipulated a price of $40,000 each.[8] The Van Abbemuseum was interested in the works until they were told the price. Abramović had leapt from making the most ephemeral work possible on the Great Wall of China—a performance without an audience, a concept that would only ever live in the minds of people lucky enough to find out about it later—to making very solid and prohibitively expensive objects.

None of the objects sold, and Miro later admitted to having reservations about them. As well as their cumbersome physicality, they were unusual for Abramović because they demanded of the viewer/user a suspension of disbelief. Did these devices really have an effect on people who lay, sat, or stood on them? Miro describes it diplomatically and astutely: "The way she would speak about them, and the way she stood or lay on the pieces, was very particular. She seemed to have a very spiritual quality, and when other people stood or lay on the works it wasn't quite the same. But I think you could sense what she was trying to achieve. You were aware that there was this other sensation, though you didn't know how much of it was suggestion." Even though the objects were intended for public use, the implied performer, the ideal user, was Abramović herself. The works were Abramović's most didactic yet, conveying a kind of domineering generosity: the public was free to use them, but ultimately the aim was to feel like Abramović does on them. And often she did perform on the pieces. When she showed the *Dragon* works in Düsseldorf the next year, one was mounted about fifteen feet high on a wall; Abramović lay there, rather like St. Simeon Stylites perched on his pole, while the public used the beds lower down, which were accessible without a ladder. For some, Abramović's act of persuading people to use and believe in the objects was the real art—they were merely symbols of her charisma—though Abramović believed wholeheartedly in their healing and energizing qualities.

For the next seven years, Abramović would make variations and elaborations on her transitory objects. There were tables, chairs, platforms, pillows, and stools, often with exaggerated dimensions and always embedded somewhere with a large, energy-giving crystal or mineral. Rather than "transitory," career-wise these objects could more accurately be termed "transitional." The beneficent didacticism—use this, you'll feel better—could easily slip into a New Age dogmatism in the wrong hands. Aesthetically, the objects seemed to aspire to be beautiful, but their chunkiness and defiant bluntness made beauty impossible. Despite the seriousness in their intention to heal, there was something deliberately but also disavowedly comic about the objects, especially the oversize, Alice in Wonderland–like chairs that made people's feet dangle in the air.

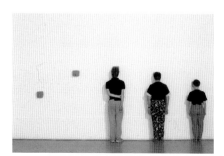

21.2
Marina Abramović, *Black Dragon*, 1990, in use at the Musée National d'Art Moderne, Centre Georges Pompidou, Paris, in 1991. Courtesy Sean Kelly Gallery, New York.

For "The Lovers" exhibition at the Stedelijk in June 1989, Abramović and Ulay worked separately on what was originally a joint venture, just as they had on the movie of the Great Wall walk. They divided the exhibition space in half and produced independent bodies of work. Abramović presented the standing, lying, and sitting transitory objects from the Miro show, plus new triptychs of mineral pillows mounted on the wall, made from snowflake obsidian, hematite, chrysocolla, red clay, rose quartz, and clear quartz. The public was meant to press their head, heart, and sex against the pillows to absorb energy. She also reedited Grigor's film and made it into a video installation consisting of several monitors placed on the floor underneath protective umbrellas. Finally, she showed two human-size red vases (like the ones in *Die Mond, der Sonne*), one reflective and one matte, lying on the floor, joined at the top—they were still symbiotically linked, it seemed, but now felled. She called the piece *The Lovers*. Ulay made a slideshow of photos from China, which Abramović hated ("it was like *National Geographic*"), but she begrudgingly liked his other solo work: footprints cast in glass. They considered having separate catalogues for the exhibition, but in the end had one divided into two parts, with Thomas McEvilley's "Great Wall Talk" article as the bridge. By this time Marina was shunning McEvilley in protest against his continuing relationship with Ulay. "She decided that this grudge she would bear against Ulay was serious and wasn't going to go away, and I shared in that," McEvilley says. "That led to a period of twelve years when Marina wouldn't speak to me, essentially." In the preparation for the exhibition, if Marina and Ulay found themselves in the same room they bristled. "She was really the one who was aggressive about hating," McEvilley recalls. "But when he was attacked, Ulay fought back." Dorine Mignot was the curator charged with holding the project together. "Marina was very sad, very upset and turned upside down," Mignot recalls. "I had never seen her like that before. I really saw some of her anger and desperate feelings turning into a new energy. She said: 'OK, I'm going to show him how good I am. I can do it alone as well.'"

While Abramović was in England for the opening of her show at Victoria Miro, she met the New York–based video artist Charles Atlas. He and Abramović had been commissioned to make a short video piece together for a Spanish TV show called *El arte de video*. On the face of it, it wasn't a good match up: Atlas came from the dance, club, and gay scene in New York, a world of extravagance, abjection, and identity politics; Marina's concerns had always been with strict authenticity, discipline, and transcendence. "But my initial thought," Atlas recalls, "was if she's as brave as she seems to be, she'll accept this challenge." They went to a café together, where Marina ate a large rectangular piece of cake and Atlas chose a dainty round cake. They both noticed this masculine/feminine reversal immediately, and found it hilarious. In this recognition they knew they'd be able to work together.

Atlas visited Marina in Amsterdam, and they developed three possible concepts for a video. One was Atlas's idea: having watched Abramović's old video works, stretching back to her solo career in the mid-1970s, he noticed how good she looked

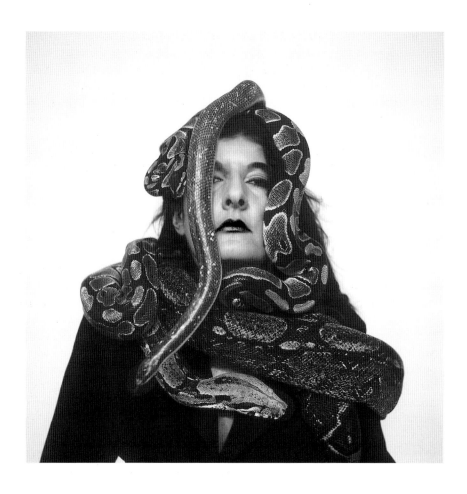

21.3
Marina Abramović, *Dragon Heads*, Caixa de
Pensions, Barcelona, 1993. Courtesy Sean Kelly
Gallery, New York.

in cinematic close-up (as she did in Grigor's film as well). He also loved her performance with Ulay in 1978, *Three*, when they lay down with the python and tried to win its attention. With blunt logic, Atlas concluded that the only way to combine a good close-up of Abramović with the use of snakes was to put the snakes on her head. Abramović took no persuading. She also had two other scenes in mind: aggressively scrubbing her feet, and reciting biographical information in clipped and dramatic one-liners. Abramović struggled to decide which of the three concepts to use. Atlas was bemused by this imagined imperative to cut everything down to a bare minimum, and simply suggested that they use all three ideas in the video, which they called *sss*. It was the most visually complex video Abramović had ever dared to make, with the most cuts; for Atlas, it was the simplest video with the fewest cuts. Atlas was awakening a taste for aesthetic extravagance that had long been latent in Marina. They shot the video in Madrid. Abramović wore a small wooden crown while trying to support the unexpectedly burdensome weight of several snakes—one of which was poisonous—slithering around her head, neck, and shoulders. She fixed the camera with a steely, Medusa-like expression, challenging the viewer to look at her.

The snake-on-heads concept grew into a new series of performances in the early 1990s called *Dragon Heads*. Chrissie Iles, a curator whom Marina had met in Amsterdam in the mid-1980s, invited her to perform the piece at the Museum of Modern Art Oxford in May 1990. It would be Abramović's first performance since breaking up with Ulay nearly two years previously—her longest ever hiatus from performing. Abramović was dramatically spotlit, wearing a short black evening dress, stockings, and heavy makeup. The chair she was sitting on was encircled with ice blocks, meant to keep the snakes away from the audience. Iles had found a local snake handler with a business card labeled "Animal Man," like an Aboriginal shaman. Before the public entered the space, Animal Man draped four large pythons and a huge boa constrictor over the determinedly calm Abramović. One slipped from her head and started to cling around her neck. "I had incredible panic and my pulse was beating and the more my pulse was beating the more the snake was tightening up," Marina says. "So I had to learn to relax in the panic." As the public came in, she managed to swallow her fear: the snakes slid around her, investigating every inch, coiling themselves into luxuriant patterns across her legs, lap, shoulder, head, and neck. The performance lasted an hour. Abramović believed that the path the snakes traveled around her head and torso was no accident: they were following the energy lines in her body, just as she had followed the energy lines of the mythic dragon along the Great Wall, hence the name *Dragon Heads*. Over the next few years and in several galleries in Europe and the U.S., Abramović performed the piece with variations: sitting on a hospital bed, paving the entire gallery floor with ice, and, for the first time since 1977, performing naked.

Abramović's hiatus from performing was hardly a forty days in the desert. She had in fact accelerated her working pace since breaking up with Ulay, investing all her energy in converting her doubts, fears, and insecurities into a manic

productive energy: in 1989 and 1990 her multiplying transitory objects were shown in kunsthalles and galleries in Antwerp, Düsseldorf, Denmark, Paris, and Montreal. Abramović was looking for validation, salvation in fact, in the public image of a seamless transition into a prolific solo career. She refused to embrace her bereft state, to dwell quietly inside it for a while and see what it might produce. Instead, her whole life was now a battlefront in the war against Ulay, and the war against her sadness. It was a fight that required ever-greater investments of energy to sustain. But in her barrage of new commitments and new projects, the sadness persisted. Sitting alone gazing out the huge windows of her house one day, she saw Ulay walk past on the street below with his new wife, Song, who was pregnant. It looked to Marina like Ulay had everything, and that she, rattling around in a massive empty house, with multiple projects on the go and a handsome but opportunistic boyfriend, still had nothing. She couldn't stand to be in the same city as Ulay, and decided to set up a new base in Paris.

She and Ulay were both in an exhibition, though separately, at the Pompidou Center that summer called "Magiciens de la Terre." Aboriginal Dreamtime paintings, Tibetan mandalas, voodoo objects from Benin, and other such pieces were shown alongside works by Western artists with a talismanic or spiritual quality, or some link to non-Western cultures. But only Abramović's transitory objects had an outright use value and an intention to heal. For the curator, Jean-Hubert Martin, Abramović and Ulay had been ahead of the curve in terms of the globalization, cultural exchange, and engagement with primitive cultures that he was seeking to explore. "They were among the few artists at the time who were really deeply interested in meeting artists or personalities from other countries to try to set up a dialogue with them," Martin says. *Nightsea Crossing Conjunction* exemplified this dialogue, and Martin used an image from it to advertise "Magiciens de la Terre."

Almost immediately after that exhibition Abramović and Ulay's two-person show "The Lovers" was scheduled to arrive at the Pompidou. Marina secured a grant from the museum and moved into a nearby atelier (she still oversaw the renovation of her canal house in Amsterdam remotely, making orders by fax). Living in Paris, she organized the installation of "The Lovers" and worked on an exhibition, at Galerie Charles Cartwright, of the mudras photos she'd taken on the Great Wall of her guide Dahai Han. Danica was very happy to attend the opening of this show: at last, her daughter was being recognized in Paris, the center of culture and refinement.

BIOGRAPHY

The Louvre was closed on Tuesdays. Abramović padded around the galleries, which were dim and deserted except for the occasional security guard. She was one of several artists invited to research the museum after hours in order to produce a work inspired by a specific piece, and she was waiting for some ancient artifact to "choose" her. The project never came to fruition for some reason, but for several weeks, Abramović fasted on Mondays to make herself more receptive during her attentive wandering the next day. One Tuesday in the Mesopotamian galleries, she suddenly felt overwhelmingly horny. She was hot, aching, desperate for a man, and considered accosting the security guard. When she left the room, the feeling subsided. But when she returned, it took hold again. She investigated what exactly was in this stimulating area: an ancient fertility totem. The object's original ritualistic function was still having an effect, at least on Marina.

Now in her mid-forties, and freed from Ulay's ambivalence, Marina had a libido that was stronger—and more sensitive—than ever. She still claimed to feel fat, ugly, and unwanted, but having boyfriends fortified her, for a while, against insecurity. Though Delgado was still her main man, Marina had many relationships in the years after Ulay, some of them overlapping, though usually conducted in discrete parts of Europe. There were flying visits and flirtatious faxes (she wrote to the curator David Elliott: "I like to tell you that you are on the list of my three favorite men").[9] Alanna Heiss, the founder of P.S. 1 Contemporary Art Center in New York whom Marina had met on her visits there in the late 1970s, remembers men being hypnotized by Marina, and her loving to play the part of hypnotist. Marina did not exclude women from her thrall, and neither did she compete with them. "I found nothing but satisfaction in Marina's seductive behavior," Heiss recalls. "Not only did I admire it, I liked to watch it going on. She has the ability to achieve almost instant intimacy, if she likes you. It's the same sort of ability that truly great politicians have."

Marina's powers of seduction did not alleviate her misery over Ulay; in fact, it had never been worse. In the late winter of 1991 they both participated—separately of course—in an hour-long documentary for German TV about their breakup, called *An Arrow in the Heart*. Marina was interviewed in her house on Binnenkant, which she had by now renovated with wide open spaces and perfect wooden floors, clean white walls, and long flowing white curtains over the windows. In the opening scene of the documentary, Marina sits on the floor in a large dim room, watching the film of her meeting with Ulay on the Great Wall. "I don't want to see him, I don't want to talk to him," she tells the interviewer.[10] Meanwhile Ulay's half of the film

22.1
Marina at Binnenkant 21 during the shoot of the
documentary on her and Ulay, *An Arrow in
the Heart*, 1991. Courtesy Abramović archive.

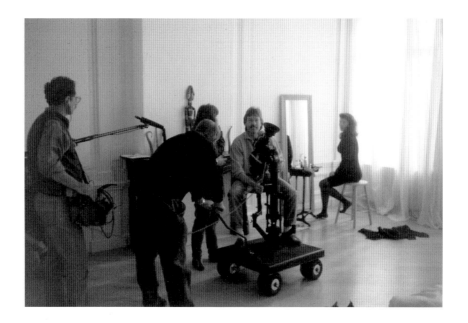

takes place in what looks like a bombed-out warehouse. It was in fact a derelict building in central Amsterdam that Ulay was helping to renovate into an art space (later called W139). He gave his interviews while roaming around the desolate space, sifting among the rubble and broken wood, and starting a little fire to warm himself up—as if this were his habitual environment, rather than a strategically chosen one. "This was a period when Marina hated me to the dirt under my fingernails," Ulay recalls. He must have relished the opportunity to paint himself as the more "real" and vulnerable one of the two, shivering by his campfire like a vagabond, a monk, or a character in a Werner Herzog movie while Marina the miserable diva rattles around her lonely palace. Marina herself did a lot to facilitate this contrast by slipping into her own self-indulgent actorly deportment: long sequences show her wandering around the house aimlessly, gazing out of windows, and looking searchingly into the mirror while putting on makeup, then languorously inspecting how she looks in her slip—an accurate portrayal of her devastation and neediness at the time, perhaps, but rendered in high melodrama.

Asked in the film about the reasons for the breakup, Marina says, "I demanded too much of him. That led to rebellion in his everyday life." Ulay offers, "Anonymity is part of my freedom, not what people project onto the legend Ulay / Abramović," and "The idea of abstinence fascinated me very much but maybe we underestimated what it could do to our relationship." Whereas Marina always felt like the victim in the relationship, vulnerable to Ulay's infidelities and evasions, in the film Ulay reveals how Marina could hurt *his* feelings too. The most painful thing she could do—and did do—was "to ignore me," he says.[11] At the end of the film she does just that. They were supposed to meet—for the first time in over two years—outside the train station in Amsterdam. Filmed from a distance, they approach each other, but at the last second she strides past him without eye contact or acknowledgment.

Marina watched the finished documentary for the first time at Binnenkant 21 one night with her old (and, post-Ulay, ever closer) friend Rebecca Horn, who translated from the German for Marina. She was so upset with Ulay's image in the film as a saintly figure that she immediately got an extreme migraine attack, and stayed in bed for three days.

Several times in this period, Marina traveled to Brazil to procure crystals and minerals for her transitory objects. A three-month trip in 1991 was funded by the Parisian gallerist Enrico Navarra. Delgado had introduced him to Marina, and acted as broker for the deal they struck: Navarra gave Abramović an astonishing $125,000 to produce a new series of mineral works, in exchange for outright ownership of three finished series of objects, and a standard 50 percent share in sales of the rest of the works she made. If these works met their bloated price—three large geodes were valued at $90,000 and an installation of quartz crystals at $75,000—it would have been a good deal for both Abramović and Navarra.[12] But in the dreary art market of the early 1990s, the objects did not sell well. Navarra hardly cared. It was the chance to be drawn up onto Marina's cloud that had piqued his philanthropy. "I was totally

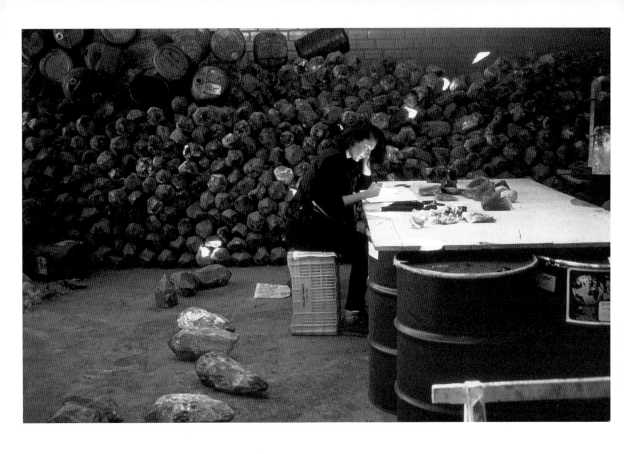

22.2
Marina in her workshop in the mines of Soledad,
Santa Catarina, Brazil. Courtesy Abramović archive.

seduced by her approach to art," he says. "I knew it wasn't going to be easy or good business, but by doing it I had the sensation that I'm not doing only trading."

On the Navarra-sponsored trip to Brazil, Abramović made a photo work outside a mine in the southern state of Santa Catarina: she lay on a bench next to a pile of amethyst crystals, with the intention of absorbing their accumulated energy and "waiting for an idea." (She was wearing the boots she'd used to walk the Great Wall of China). This was a very rare instance of Abramović ever having, or admitting to, a creative block—and even when she did, she managed to make a decent piece out of it, dwelling for a while in her less comfortable mindset of surrender and patience.

Abramović felt guilty about "stealing crystals from the earth" in exotic locations like this, but indicated in an interview her growing sense of social responsibility as an artist as her motivation:

> I am perfectly aware that I am disturbing a fine, precious balance. But on the other hand I think that we live in an age which faces emergency: our consciousness has completely separated from our sources of energy. I want to reproduce this consciousness. If only a very few people develop a new consciousness and approach the idea of unity between body and soul and the cosmos, then the benefit will be so much more than the damage I have caused. Very soon I shall need no more crystals. It would certainly be a catastrophe if everyone started to take crystals out of the earth.[13]

On another trip, Marina visited the remote mountain settlement of Serra Pelada, which had witnessed one of the biggest gold rushes in Brazilian history in the 1980s and now looked to her like Sodom and Gomorrah. Tens of thousands of nearly bare, mud-caked bodies foraged in an enormous chasm that used to be a mountain. She heard a story that Steven Spielberg had tried to film a sequence for an *Indiana Jones* film there shortly before she arrived, but one of the crew had been murdered. (A 1985 *60 Minutes* documentary reported eighty to ninety unsolved murders in the region each month.) In the midst of this lawless atmosphere, dozens of miners also died in mudslides and accidents each month. With death so omnipresent, Abramović conceived of maybe her most ethically risky piece yet, one which in the end she couldn't marshal the logistics to make: a video that would have been called *How to*

22.3
Working with miners in Brazil to cut quartz.
Courtesy Abramović archive.

Die. She wanted to intersperse glamorous deaths from classic operas (re-staged by Abramović) with the real deaths of miners. Opera music would have blasted from the PA system that usually let out a warning siren whenever another deadly accident was unfolding.

Marina returned to Brazil in February 1992, invited by the Goethe Institute on an adventure with a group of artists comparable to the trip to Ponape twelve years earlier. At the airport in Frankfurt, Marina met up with the Portuguese artist Julião Sarmento, whom she had first met in the late '70s in Belgrade and stayed friendly with ever since. When they arrived in Rio after the fifteen-hour flight, Marina insisted that she wasn't tired, and to prove it, promised Julião that she would immediately swim fifty lengths in the hotel pool. Julião was not the least surprised when she dived in and fulfilled her vow. The group of artists on the trip traveled north to Belem, and boarded a boat for a journey up the Amazon. One of the remote settlements the group stopped at was, like Serra Pelada, populated exclusively by men, mining for gold. They happened to arrive on the day of a beauty contest (with visiting prostitutes as contestants) called "Miss Boom Boom." Julião translated this for Marina: Miss Ass. She persuaded the curator on the trip to get her and Julião on the panel of judges for the contest. "We're in a bar, a saloon, in the middle of the Amazon, with maybe a hundred men, all with guns, and looking really mean," Julião recalls. "I try to be very discreet. How was Marina? She was very slim, really in shape. She had a tight dress, red, *red*, with heels like *this*. And I said shit, I'm going to be killed tonight."

Life on the boat was calm and quiet. Marina slept in a hammock, swam in the river (though scared of sharks, she was unafraid of piranhas), and spent long lazy days sitting on the deck staring into the jungle. Filmed by a crew from a German TV station, Marina sat chopping vegetables while the boat chugged upstream. The man behind the camera, Michael Stefanowski, was the complete opposite of Paco Delgado: gentle, kind and unassuming, older, and not conventionally handsome at all; a heavy smoker, curious about but hardly sympathetic to Marina's various pursuits in purity, and certainly not interested in taking a cut from whatever success she had in her career. Stefanowski had first encountered Marina playing with a snake earlier on the trip, with a crowd gathered around her. "It was Marina—she was the center of attention," he says. One day though he attracted *her* formidable attention by catching a blue butterfly in the forest, the kind that even local tribes found almost impossible to catch, and presenting it to Marina as a gift.

Stefanowski was married at the time, though the relationship was "exhausted." He began seeing Marina wherever she was in Europe (Hamburg, Berlin, Paris, or Amsterdam). Marina always called him by his last name, or by her nickname for him, Slatki, meaning sweet, cute. He nourished Marina and neutralized her persistent attacks of insecurity and anxiety. "Marina is two different people: the artist, and the girl—the shy type," Stefanowski says. He was quiet enough to allow sufficient space in the relationship for Abramović the artist, and affectionate and trustworthy enough

to comfort and care for Marina the girl. Of her many relationships in the early 1990s, some of them lasting several years on and off, the one that spanned them all was with Stefanowski. They traveled to Thailand and the Maldives together, Marina reveling in the island paradise, posing for photos with a beach ball, looking like a 1950s glamour model. She asked Stefanowski to marry her. He didn't see the need.

Marina had by now broken up with Delgado, but as a parting shot, in November 1993, he made her draw up a "declaration"—a kind of divorce settlement—stating, "By this Marina Abramović transfer all rights of property over the following art works . . . to Francisco Delgado."[14] The list included the *Dragon* pieces and several other transitory objects. Delgado must have felt he had a right to them since he had facilitated and negotiated their production. It's a sign of Marina's vulnerability that she agreed to even draft this document in the first place.

Around this time, Marina lost another connection to her years with Ulay: her beloved German Shepherd Alba died, but not before Marina orchestrated a wholesome, authentic, and dignified death for her. Alba had grown increasingly frail, and couldn't climb the steps of the house on Binnenkant. Marina took her to spend her last months in Majorca at the home of her friend Toni Muntana Vidal. "We built a house for her so she could be in nature. I didn't want her to die in hospital," Marina says. "We give her the vitamins and she really wanted to die a natural death. She was buried under the tree." This was something like the death that Abramović envisioned for herself—if it was to come slowly and predictably and under her control. If it had to be sudden, she wrote around this time, she'd rather die from a snakebite than a car accident.[15]

In a letter to Victoria Miro, in October 1992, Marina wrote, "For me this year was very demanding, and I worked more than ever in my life. But next year is looking even worse." Marina continued her nomadic lifestyle, but it wasn't the playful and pioneering wandering of before. Her mode of traveling and her daily arrangements were becoming increasingly frantic. Just as she had with Ulay, she continued shuttling between France, Holland, and Germany, but now it was mostly to fulfill her spiraling teaching commitments—her one sure source of income, since the crystal objects weren't selling well. She taught at the University of the Arts in Berlin and then secured a temporary post at the École des Beaux-Arts while living in Paris. When that gig finished (the artist Annette Messager was given the full-time post instead of her), she began teaching in Hamburg.

The surge in teaching duties reflected the new didacticism in Marina's life and work in general. Just as she enjoyed choreographing the actions of the public on her transitory objects, Marina took great pleasure in ordering the lives of her students. She made them confess and confront everything: their motivations to be an artist, their personal habits, fears, and dreams. Marina approached her students with the same commitment and intensity as a performance. It was an exhausting method, and the only kind of relationship that she was interested in having: a total and all-consuming love relationship, but one in which her students became her acolytes, so

22.4
Marina and her friend the artist Rebecca Horn
(left), with Yannick Vu in Majorca, 1993. Courtesy
Abramović archive.

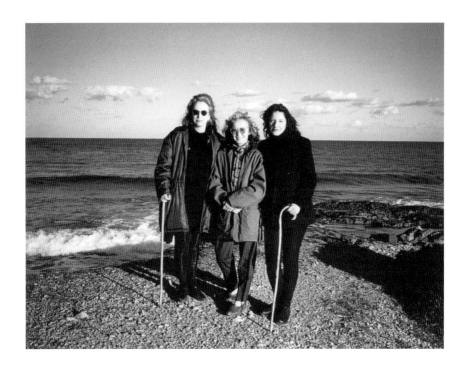

a certain safe distance could be maintained. She put them through rigorous bodily exercises and games of trust designed to build up their will power and "energy" (this was becoming Marina's favorite word) and enhance their powers of concentration. She wanted them to be able to produce the same force field that she did in her performances. But artists working in the live arena at the time generally weren't creating the kind of tense, ethically challenging, physically dangerous, long-duration, or personally cathartic performances Abramović was training her students for; instead they tended toward creating nonconfrontational, fertile *situations*, involving quotidian social interaction like meals at a table. Not much will power was necessary.

Toward the end of 1992 Abramović won a grant from the DAAD (the Deutscher Akademischer Austauschdienst, German academic exchange service), which gave a healthy stipend, an apartment and studio in Berlin, and an exhibition at the Neue Nationalgalerie at the end of her year's stay in the city. Marina left her apartment in Paris and established a new temporary base on Schluterstrasse in Charlottenberg. Rebecca Horn had a studio in Berlin, and Marina spent a lot of time with her, much in need of her strength during these emotionally fragile post-Ulay years. (They traveled together to Majorca and to Hydra, where Horn coaxed her to swim and to "lose the fear of deep sea" and sharks, Marina later wrote—a fear she'd had ever since summering in Premantura as a child.)[16] In Berlin, Marina also struck up an important friendship with Klaus Biesenbach, the founder of the new art institute Kunst-Werke. Like the men Heiss had observed, Biesenbach was beguiled by Marina's vitality and seductive power: "I always thought of her as the grand dame of performance, so when I first met her I imagined a grandmother arriving," Biesenbach recalls. "But then Marina showed up—so that was a good surprise." They had a brief affair, and Marina became a mentor for the youthful and ambitious Biesenbach, though they would gradually form a more equal, nuanced, and critical engagement.

Marina's studio in Berlin was the first she'd had since leaving Yugoslavia. She needed it to produce a new range of transitory objects, and to plan her biggest stage production yet: *Biography*. This was the story of her life and work converted into theater. Abramović and Charles Atlas, the director, first staged *Biography* in Madrid, and developed it through 1992 with performances in Kassel for Documenta 9 (where Abramović also showed a new series of transitory objects on stilts called *Inner Sky*), and in Vienna, Frankfurt, and Berlin. She wrote a fax to David Elliott around this time:

> I was really disappointed that you could not come to see "the Biography," especially the last glorious scene with me six meters above the ground, holding two snakes in my hands, like a Greek statue, and below me four hungry black dogs eating a heap of white bones (it was really difficult to tape small microphones around their necks). For the opening of the Kunsthalle Wien 3,250 people came to the performance, and I felt like a Rock star.[17]

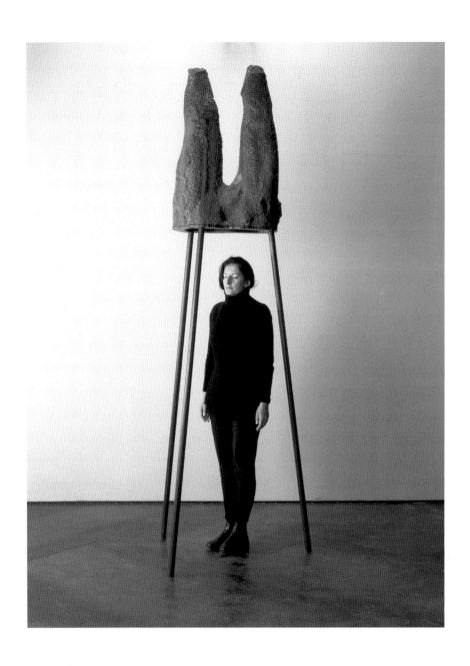

22.5
Abramović using her piece *Inner Sky*, 1991, in her
studio in Berlin. Courtesy Sean Kelly Gallery,
New York.

What Marina didn't say in the fax is that, while suspended high above the stage, holding the snakes and standing with her arms out, cruciform-style, she was topless. This was nothing new in an Abramović performance, but her breasts themselves were new. On one of her trips to Brazil, Marina had gotten enlargements. Atlas didn't notice the difference at first. "Years later when I realized, I was like oh my god, *of course* she wanted to show them off! Maybe that's why it was so easy to get her to do the scene!" (In the many updates and adaptations of *Biography* over the years, this scene was the only one to remain unchanged.) McEvilley noticed her new breasts immediately, and when he asked about them, Marina replied, "Don't ask, just enjoy."

Marina's decision to have the operation had been quite spontaneous. At a dinner on one of her trips to Brazil, Kim Estive—a collector and landowner who hosted Marina and made arrangements for her to visit the various mines—introduced her to a plastic surgeon named Luiz Paulo de Azevedo Barbosa. He had been a student of "the inventor" of breast enlargement surgery, Marina favorably recalls, so she felt in safe hands (and remains friends with him). Though the decision to have the surgery was spontaneous, Marina's compulsive wish for self-transformation stretched back to when she was a child, spinning around in her mother's room, hoping to fall face first and destroy her nose. But it took something more to convert these deeply embedded tendencies into an engineered reality at the age of forty-six. The primary motivation was not so she could continue to bare her skin in performances as she got older—in the transcendent performance state of mind she had never been shy about her body. The compulsion came from insecurity in her personal life. Delgado's makeover of Marina had made her feel beautiful again, but it was a very delicate victory that left her feeling just as inadequate as it did validated: Delgado had inflated the importance of Marina's physical appearance, and then left her for a younger woman.

Although the operation had the desired results—more confidence in her private life—it constituted a public decision as well. Glamour and beauty were imperatives that Marina mostly placed on herself, but ones that she felt more strongly as she immersed herself deeper in the public realm. The surgery was a complete submission to an external image of herself, to an image held in the eyes of other people. The transformation was symptomatic of a change that Velimir, ever an astute if scathing observer of his sister, noticed in Marina starting after the breakup with Ulay. In his eyes, she was losing her interiority, and merely reacting to social and artistic expectations. She was becoming nothing but a mirror for people, reflecting back their desires. "A mirror is like an emptiness," Velimir says. "You see what the mirror reflects; you cannot see the mirror itself. Marina stays like a catalyzer, not really being involved in herself." Velimir thought Marina was disappearing as an individual, though this was not necessarily a negative change. "Probably that is the change that every priest has to go through. You cannot function as a priest if you are an involved person." The metaphor Marina started using—independently of Velimir's judgment—was that of the screen. She was becoming, in life and in her performances, a screen on which people could freely project their expectations.

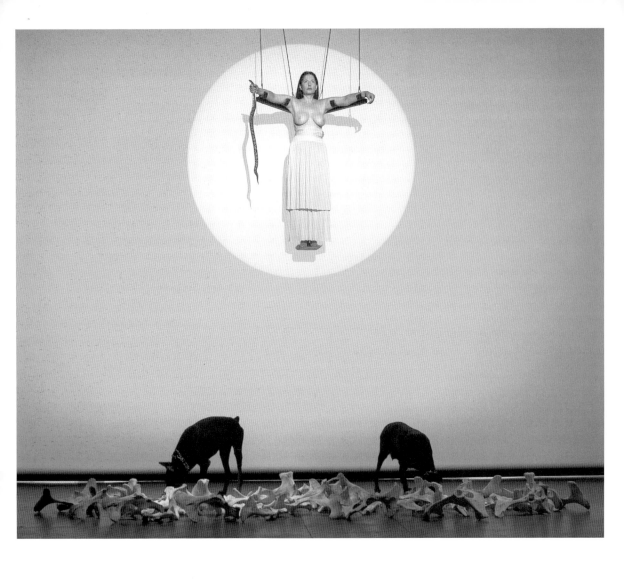

22.6
Marina Abramović / Michael Laub, *The Biography Remix* (Snakes), Festival d'Avignon, 2005.
Photo: Christoph Raynaud de Lage. Courtesy Sean Kelly Gallery, New York.

Biography wasn't a priestly performance of sacrifice or determined passivity like *Dragon Heads,* and it didn't choreograph public healing like the transitory objects. But it was instrumental in Marina turning herself inside out and shaking out the overflowing contents. *Biography* was like a confessional. It was embarrassing, messy, massively self-indulgent, wishful, shameful, redressive, and iconoclastic—shattering the tenets of performance art that she used to hold dear. It consisted primarily of Abramović reperforming old works in tightly edited theatrical scenes. Though she and Ulay had reperformed several pieces during their time together, the idea of making a theatrical production out of their performances would have been anathema to their "Art Vital" dictates of "No rehearsal. No predicted end. No repetition. Extended vulnerability. Exposure to chance. Primary reactions." On stage, none of these rules could apply, except perhaps the last. Abramović loved the possibility of bringing real pain and real blood into an arena that usually hosted simulations. She reperformed the knife game from *Rhythm 10,* and, distilling *Thomas Lips* into two primal scenes, whipped herself and cut the five-pointed star in her stomach (this time in the upright, positive orientation), drawing very real blood each time. Her performances with Ulay were represented by projections split onto two screens, Abramović on one side, Ulay on the other, their old collaboration now divided by the expanse of the stage. Abramović had always relished the crisp aesthetic qualities of her performances, not quite as much as their experiential and ethical elements, but almost. Now, on stage, she could focus more on these formal elements, on the "mark making" that Richard Demarco identified in her work. The purely biographical element of the plays consisted of a recorded narration of dramatic events from Marina's life, with a pithy sentence covering each year:

> 1948: Refuse to walk . . .
>
> 1958: Father buying television . . .
>
> 1963: My mother writes "My dear little girl, your painting has got a nice frame" . . .
>
> 1964: Drinking vodka, sleeping in the snow. First kiss . . .
>
> 1969: I don't remember . . .
>
> 1973: Listening to Maria Callas. Realizing that the kitchen of my grandmother is the center of my world . . .[18]

This blunt storytelling was a chance for Marina to firmly embed certain myths about herself, to distill her childhood into a militaristic regime steeped in communist heroism and religious fanaticism. There were also the rote embellishments, like her grandfather being the patriarch of the Serbian Orthodox Church rather than her great uncle. Abramović's storytelling also included a list of her moods and desires since breaking up with Ulay, together with some leavening self-parody: "Harmony, symmetry, baroque, neoclassic, pure, bright, shiny, high heel shoes, erotic, turning around, big nose, large ass, et voilà: Abramović, dramatic, milk, vodka, pleasure pleasure, let's get taxi."

After performing *Biography* again at the Hebbel Theater in Berlin in 1993, Abramović and Atlas took the play to Hamburg and, in various adaptations through 1994, to theaters in Paris, Athens, Amsterdam, and Antwerp. Abramović would continue elaborating, updating, and restaging it every few years, adding in new episodes from her life, new realizations, new constructions. When Marina talked about *Biography*, it was with a sense of having to justify it: "It was a way to see myself outside of myself, and it helped me to have a distance from the pain" she was suffering from Ulay.[19] The stage gave her permission for once to be playful, extravagant, baroque. It was a kind of therapy, but perhaps only in the way that acting out is therapeutic: she got to make a repeated cry for validation in front of a rapt audience, and they could do nothing but indulge her. Uniquely in Abramović's performance work, the communication between performer and audience was only one-way.

A more persuasive justification for the indulgences of *Biography* was that it allowed Abramović to put front and center what she feared the most: failure and weakness—especially delicate feelings since her life story at that point culminated in the breakup with Ulay. Abramović had the charisma of an actress, but not quite the poise: her earnestness came across as clumsiness on the stage. She wasn't quite the elegant diva she dreamed of being, despite the bold red lipstick and the seductive cigarette she carried. She knew all this, and embraced it. *Biography* involved some dancing, even though both she and Charles Atlas knew that her sense of rhythm wasn't great. Abramović relished the kitschy scene where she stood on stage waving goodbye to her old life: "Bye bye extremes, purity, togetherness, intensity, bye bye jealousy, structure, Tibetans, danger, bye bye solitude, unhappiness, tears, bye bye Ulay."[20]

While performing *Biography* in Berlin, Abramović had the show at the Neue Nationalgalerie that was the culmination of her DAAD award. She exhibited a new set of transitory objects—seven high wooden chairs facing minerals on shelves. Abramović would later document the installation along with a quote from the Dalai Lama: "Once the practice of higher consciousness is achieved . . . then of our own free will we shall refrain from all activities that involve the senses . . . then there will be no need for artists."[21] Abramović both longed for and dreaded this day. In removing her own material presence from her recent sculptural works, and adding the health-giving instructions, she prescribed people's relationship with the artwork and embedded it with her ethics more forcefully than she had for any of her performances. Making the transitory objects and *Biography* simultaneously, Abramović seemed stuck halfway toward fulfilling the priestly role that Velimir identified, where she would dissolve as a person and merely be a catalyst, a mirror, a screen for people to project onto. But try as she might, she couldn't dispel her ego from her practice. In fact it seemed to emerge more persistently and forcefully the more she tried to shoo it away.

The day after the final performance of *Biography* in Berlin, which came shortly after her opening at the Neue Nationalgalerie, Marina woke up, finally free from her recent hyperactive work schedule. But she found she could not move. Her vision was blurred and she couldn't hear properly. "It was a total body collapse," she recalls. The doctor ordered her to rest.

23

BALKANIZATION

After Marina's split with Ulay, her working relationship with Michael Klein also ended. She wanted a complete break with the past, and started looking elsewhere for a gallery. Julião Sarmento repeatedly recommended his gallerist, Sean Kelly, a Brit working in New York. Kelly had trained as an artist before moving into curating, working with the Bath International Festival in England. He then headed the New York branch of the L.A. Louver gallery, and was featured in a 1990 *New York Times* article on the trend of curators becoming dealers.[22] But Kelly parted company with L.A. Louver in late 1991 and was now, like Klein, more of an agent than a traditional dealer with a gallery. He was showing works by Sarmento, Ann Hamilton, and Rebecca Horn in his SoHo loft at the time. Kelly respected Abramović's work, and several people including Sarmento had encouraged him to meet her. He knew a meeting was imminent, but seemed trapped in a kind of fateful anti-serendipity: when he was in Paris and expected to bump into her, Marina had just left; when he was leaving Berlin, Marina was arriving the next day. "In fact I was quite comfortable with the status quo," Kelly later wrote. "Whilst I was a great admirer of Marina's work, as a curator I harbored the disquieting concern that I would be unable to resist the ineluctable pull that I knew to be at the core of Marina's art and personality. In short, I was concerned that I would fall under Marina's fabled magnetic thrall."[23] His intuition proved correct.

Early in the summer of 1992, Sarmento accompanied Marina to New York to finally make the introduction. Kelly remembers Sarmento setting up a mysterious "urgent" lunch meeting in SoHo, without telling him there was going to be a surprise guest there. "I walked in and I saw Julião sitting with a dark haired woman with her back to me," Kelly says, "and as I got to the table she turned round and I knew I'd been set up." Sarmento remembers no such setup; he insists he told Kelly that Marina would be there. Whatever happened, for Kelly the meeting was a moment of mythic importance. Over lunch, he began his knowingly futile resistance to working with her. He had just left a gallery, he wasn't sure if he was going to stay in New York or go back to London with his tail between his legs, he wasn't in a position to take on any artists personally, the art market was in recession after the boom of the 1980s, and, most importantly, he didn't even have a gallery space. "Perfect," Marina said. "I don't want a gallerist with a gallery. I want a gallerist without a gallery. You'll be able to give me much more time." Marina wanted to work with someone who was, like her, about to seriously enter into the New York market, alone, for the first time. She showed faith in Sean Kelly when he was full of doubt.

As a first step, Kelly visited Marina in Amsterdam to look through her pre-Ulay archive to try to figure out what they could sell, and how. The last time she'd shown documentation of her solo performances had been in her 1976 exhibition at de Appel, when Abramović had exchanged roles with a prostitute during the opening. Marina and Kelly spent several days looking through photographs of her eleven early solo performances, from *Rhythm 10* through to *Role Exchange*, selecting images that either encapsulated the spirit of the performance or isolated a particularly gripping moment in it. They conceived of the photographs as autonomous, not so much pictures or diagrams of the original performances but illustrations hinting at them, with their own stand-alone aesthetic value (though each would be coupled with small framed explanations of the performance, written in Abramović's characteristically minimal and dramatic style). For *Thomas Lips* they ended up choosing two images from the many in Marina's archive: a close-up of the bloody pentagram cut onto her stomach, and an image of her whipping herself, spattered with blood. They selected and produced twelve such images from her solo performances and printed editions of sixteen each (plus one set for Marina), ready for the art market and for art history.

After the flurry of *Biography* performances in 1992 and '93, Abramović and Charles Atlas began work on a new venture that required a trip to what remained of Yugoslavia. There were no flights to Belgrade in January 1994, so they had to fly to Hungary and take a bus into Serbia. They were stopped at several checkpoints as they drove down through Vojvodina, past Novi Sad, where Marina used to teach, until late at night the bus finally rolled into Belgrade—a city in the depths of midwinter, hyperinflation, and hypernationalism, and the control center of a brutal ethnic war. Atlas and Marina were greeted off the bus by Vojo, who immediately showed them that he was carrying a gun. Everyone in Belgrade now carried a gun. Though the fighting with Croatia and Bosnia never penetrated the city, it was a hub for arms dealers and in the grip of a gangster-controlled black market. Days earlier, someone had spat at Vojo on the street, saying that it was old Partisans and servants of Tito like him who were to blame for the current mess.

Marina brought her father supplies he'd asked for from the outside world: practical items like light bulbs, toilet paper, coffee, and antibiotics. Danica had asked for luxurious items like Chanel lipstick and perfume. Marina delighted in the contrast, and perhaps most of all, in the matriarchal validation she found for her own love of beauty and glamour. Marina must have felt guilty that she was so distant from the national insanity and poverty now endured by her family, friends, and old SKC comrades. She had slipped away quietly but definitively eighteen years before, leaving her compatriots as they entered the 1980s, when dreams of a Greater Serbia bred in the national consciousness, and she'd been absent while the federation that Tito had built began disintegrating in 1991, when Slovenia and Croatia declared

independence. Now, as Serbia's wars with Croatia and Bosnia deepened, and ethnic cleansing and economic cataclysm unfolded, Marina's only way of connecting to the situation and making some kind of offering to her heritage, or appeasement of her guilt, was through her art. She and Atlas planned to record interviews with Danica and Vojo as material for a new stage play called *Delusional*, a much darker offshoot of *Biography*.

The only functioning video-production crew in Belgrade had connections to Milošević's despised government, but Abramović and Atlas worked with them nevertheless. Nobody else had gasoline to transport the equipment. "We weren't thoughtfully engaging," Atlas says. He felt like he was in a war movie playing a comedy spy going deep into Nazi Germany. At breakfast in the hotel every morning, the restaurant was filled with suspicious-looking, furtive men talking quietly, probably making arms deals. Marina and Atlas wandered the supermarkets, appalled to see the shelves empty except for sugar and detergent. Visiting Marina's old friends, they saw goods hoarded in tiny apartments, living rooms stacked up with toilet paper, bathrooms turned into meat stores. On TV, Croatians and Serbs traded accusations of atrocities. Atlas's and Marina's role in this atmosphere of depravity and misery— passing through, researching, looking—turned a horrific situation surreal.

Danica refused to be interviewed for the film in her home—she was worried about the dirt and germs the film crew might bring. Appropriately, the interview took place instead on stage in a theater. Danica wore her classic outfit—a deep blue jacket with trademark brooch—and had her hair dyed dark brown as usual. She told various stories from her distant past: how she snuck into the movie *Camille* (which came out in 1936, a year before her father and uncles were killed) to watch Greta Garbo; how she loved, as a girl, wandering the enormous patriarchal palace where her uncle Varnava lived; how she assisted with the amputation of a Partisan's hand in the war (he had caught a grenade and was too late in throwing it back at the Italians). "As for pain, I can stand pain," she told the camera. "It is a rare case, especially in a woman giving birth, that the whole hospital doesn't hear her screaming. I never let out a single sound. When they were taking me to the hospital, they said: 'We shall wait until you start screaming.' I said: 'Nobody has, and nobody ever will hear me scream.'" Later she said, "As for death, I'm not afraid of death. Our presence in this world is only temporary. I think that it's beautiful to die on your feet, out of bed, without being ill."

In his interview, Vojo told horrific war stories, the type that Marina grew up hearing with a mixture of awe, jealousy, resentment, and boredom—and the type that Velimir, seeing a conspiracy of theatricality in his family, dismissed as so many fantastical versions of the truism that war is horrible, and people die in it. Vojo's tales gradually become more extravagantly harrowing: men sitting in lines taking maggots out of each other's "wormy wounds" with sticks; typhus sufferers eating horse

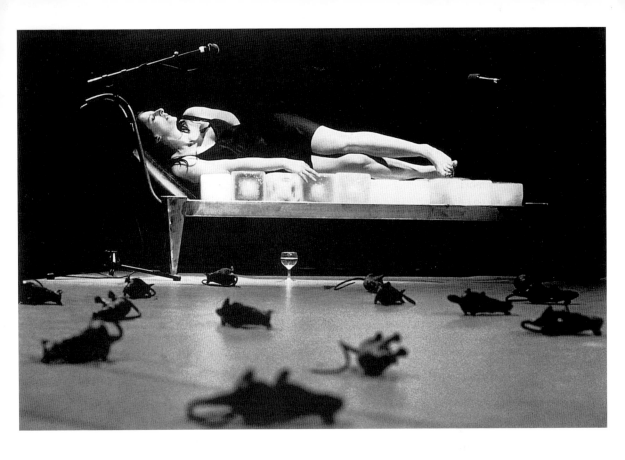

23.1
Marina Abramović, *Delusional*, Theater am Turm,
Frankfurt, 1994. Courtesy Abramović archive.

intestines, rummaging around inside the carcasses of cows, and eventually taking shelter in them, so it looked like the dead cow was breathing again; people starving to death huddled in groups against the cold until the wolves and foxes "tore them to pieces."[24] At a certain point in the interview Vojo waves his gun casually and proudly at the camera. His hyperbolic earnestness was clearly the origin of Marina's galloping, overwhelming rhetoric.

Abramović and Atlas staged *Delusional* at the Theater am Turm in Frankfurt in March 1994. It had a classical five acts, but that was the only conventional thing about it. In the first act the Plexiglas stage was covered with canvas, on top of which sat one hundred and fifty black plastic rats—a toy version of the four hundred real rats sequestered underneath the stage, which would be revealed later. While the interview with Marina's mother was projected at the back of the stage, Abramović lay on a bed of ice, then got up to dance manically to a Hungarian folk song (once more happily flaunting her lack of rhythm) until she was tired and collapsed again on the ice bed. Then a video played of Abramović dressed as a "rat doctor," wearing a white coat, giving a lecture on the reproductive genius of rats, and noting that in New York there were between six and eight rats per person, but in Belgrade there were twenty-five. Next came Vojo's monologue; meanwhile Abramović changed into a costume made by the fashion designer, artist, and 1980s nightclub-scene legend Leigh Bowery, who was a close friend of Atlas's, and who died later that year. The outfit was a tight, transparent-plastic suit, which stretched over Abramović's face too, looking like it was suffocating her. Abramović later pulled off the canvas covering the stage, revealing the rats below. She stripped off the costume, opened a hatch in the stage, and wriggled down into it, naked. Thanks to specially placed mirrors, she appeared to be crawling around with the rats, though she was actually in a sealed part of the stage. The German audience didn't respond well to such overwrought abjection. But Atlas thought that in New York, people would love this, "They would die." At the end of the piece, Abramović, still naked, stood eating a whole onion, raw, skin included, and told a story of her perfect "image of happiness": a domestic scene in which she is pregnant, sitting by the fire and knitting when her husband comes home from the coal mine; then she pours him a glass of cold milk.

With its sequence of disturbing and apparently disjointed scenes, *Delusional* was closer in spirit to *Thomas Lips* than the recent *Biography* plays. For Abramović and Atlas, the connecting thread was shame: shame at the brutality of the Balkans, shame at her narcissism, vanity, and raging sexuality, shame at not being able to match the pure heroism of her parents. The piece didn't try to purge or transcend this shame so much as exacerbate it, wallow and thrash around in it. For Atlas, there was a secondary thread to the play as well, an exposure of Abramović that he felt she never really detected. "*Delusional* was my title," Atlas says. "She liked

the way it sounded. I don't think she knew what it meant, really. She had her whole spiritual thing, and I was a little bit more down to earth. I felt some of it was like lip service." In the bathroom after the premiere, Rebecca Horn said to Marina, "I know a good lawyer for you" to sue Atlas. Marina though felt no betrayal.

TEMPORARY FOREVER

On February 8, 1995, Chrissie Iles sent two faxes. One was to Graeme Murray of the Fruitmarket Gallery in Edinburgh, which would host the Marina Abramović retrospective that Iles was curating after its appearance at the Oxford Museum of Modern Art. Iles wrote:

> I've just returned from four days working with Marina in Amsterdam. We unearthed a lot of early work which is very little known, and it's been very exciting to examine it all. As a result of our excavations, we have added to the show one of her earliest sound works from 1970, a sound corridor which emits machine gun fire when you walk through it.

The other fax Iles sent that day was to Marina, who was in New York working with Sean Kelly: "My four days of peace in Binnenkant is sustaining me still. THANK YOU."[25]

Marina cultivated her five-floor canal-side house as a temple, retreat, guesthouse, studio, archive, office, dinner-party venue, gym, and love nest. Binnenkant 21 was the opposite of the cold, museum-like Makedonska 32 where Marina had grown up. Iles was one of many guests transformed by their stay there. RoseLee Goldberg came to Amsterdam to research her essay for the catalogue for Abramović's upcoming retrospective, and like Iles she was overwhelmed by Marina's hospitality, nurturing, and mentoring. "When I got off the plane and arrived at her house, she had the bath running in this kind of spa downstairs," Goldberg recalls. "She almost put her arms out and said 'Come, I'll take care of you.' It was as though she was putting a lot of her actions into practice, casting a spell on me. What I understood finally was her total ability to seduce. She's really able to change you."

Marina participated in an article titled "The House Is My Body" for a French magazine, analyzing the significance of each of the rooms in her house. The basement contained the "Body Conditioning Space," with an exercise bike, treadmill, and mini-sauna, for "exhausting the body." On the ground floor was the kitchen, which was as important for noneating as for eating (Marina often experimented with minifasts and esoteric, punitive diets, though she was often just as willing to break them as follow them to the letter). The studio was a huge space, empty except for a desk and a chair, and next door was the office, where her long-serving assistant Alexander Godschalk helped her plan the fulfillment of her public duties as an artist. Upstairs: the bedroom. "The bedroom is very important," Marina said.

24.1
Marina with Chrissie Iles in 1992. Courtesy
Abramović archive.

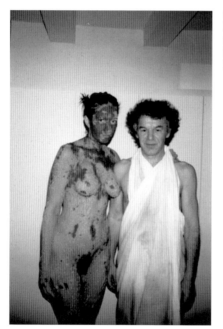

24.2
Marina with Michael Stefanowski in the "body
conditioning space" in the basement of Binnenkant
21 during a "healing" full-body mudpack treatment,
March 1997. Courtesy Abramović archive.

It's a kind of concentration of sleep, dreams and eroticism. If you are not passionate in life, you can't be passionate in art. If you have this sexual or erotic energy in a very strong and condensed way, you project this energy in your work. . . . Making love is an extremely important part of my life—eroticism, sexual desires, passion—the bedroom has to be a space where these ideas are very pure.[26]

The bedroom was sparse except for Marina's collection of ceremonial wooden penis covers that she had picked up on a trip to New Guinea. There were more rooms and levels in fact than the article went into: the dining room, two floors of guest bedrooms, a room with nothing but a fireplace in it, "for staring into the fire," a top-floor apartment rented by Michael Laub's girlfriend, and a roof garden above that. Whenever Laub was in town, which was not often, he and Marina would "go out and complain about life," recalls Stefanowski, who often stayed in the house. Marina threw herself into cleaning, redecorating, and perfecting her house: she saw it as a metaphor for her body, worthy of the utmost attention. It made sense that people felt welcomed in her house: they were living within Marina. Victoria Miro was touched by the intimacy of Binnenkant 21 (and also recalls the girly fun she and Marina had shoe shopping together in the city). Julião Sarmento, another regular houseguest, remembers Marina serving water in a jug full of amethyst crystals, for maximum purity and fortification (it was a habit she probably picked up from John Cage, who garnished his water with gold leaf). "Take the fucking crystals out, Marina," Sarmento would say, much to Marina's amusement. Having her ideal house provided a counterpoint to Marina's perpetual motion, pinging around Europe to teach, perform, and install exhibitions. She called Binnenkant 21 "temporary forever."[27]

Chrissie Iles reciprocated Marina's hospitality by inviting her to stay at her farmhouse in Water Eaton, just outside of Oxford, as they prepared for the retrospective. Thomas Ruller, a Czech artist in the collective Black Market, whom Marina had an affair with when she was in Newcastle to perform *Dragon Heads* a few years earlier, was a brief visitor to the farmhouse. But Marina was growing more attached to David Elliott, the director of the Oxford MoMA, whom she had met a few years earlier in Berlin. Elliott was sharp, prickly even, unsentimental—an admirer of Abramović's work but not susceptible to her pedagogy or need for adulation. Marina appreciated Elliott's resistance to total seduction, and was extremely attracted to his brain. She fantasized about him moving all his books to Binnenkant 21 and living and writing there. But Elliott was married. Marina confided in Iles, and they spent hours discussing the situation—as well as Abramović's work—during their daily visits to the sauna.

Marina and Iles shared a birthday (though they weren't born the same year), a fact that became both an explanation (for Marina anyway) and a catalyst for the close friendship they formed. Marina had in a sense found a new Ulay, another child of November 30: Chrissie was determined, rigorous, forceful, and sensitive like Ulay, but offered Marina a sisterly relationship of intimacy and support on a level she'd never had before in a female friend. As a curator, Iles was instrumental in Abramović's

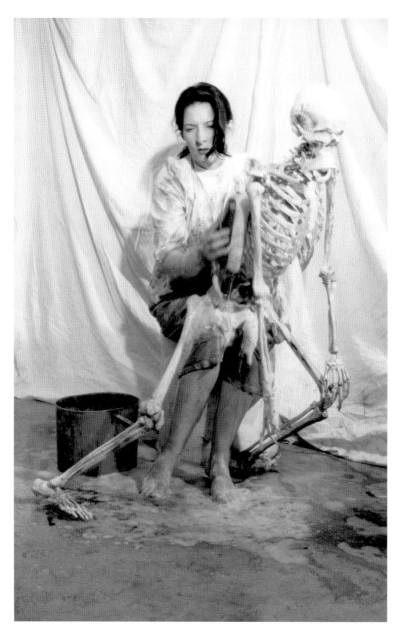

24.3
Marina Abramović, making the video installation
Cleaning the Mirror I, 1995, at the Ruskin
School of Drawing, University of Oxford. Photo:
Heini Schneebeli. Courtesy Sean Kelly Gallery,
New York, and Heini Schneebeli.

work in Oxford and for many years to come. "I never in my life talked to anyone about my work as much as I did with Chrissie," Marina says. "She made things so clear to me." Iles channeled Marina's scattershot energy and undiscriminating enthusiasm into coherent new works in Oxford that embodied her recent interest in purification and energy. Abramović made a trilogy of new performances for the retrospective, all of them for video, called *Cleaning the Mirror I, II,* and *III*. For the first installment, Abramović (wearing Iles's nightdress) cleaned a model of a skeleton for three hours with a brush and soapy water, working her way into every possible crevice, scrubbing maniacally with the same persistence she'd brought to brushing her hair in *Art Must Be Beautiful, Artist Must Be Beautiful*. In *Cleaning the Mirror II*, Abramović lay down with the skeleton on top of her naked body for ninety minutes, a look of placid concentration on her face as the skeleton rose and fell with her breathing.

Marina had read *With Mystics and Magicians in Tibet*, written in 1931 by Alexandra David-Neel, who spent her life traveling in India, Tibet, China, and Japan studying spiritual practices (Marina must have felt an affinity). David-Neel recounts methods apparently used by Tibetan monks to get familiar with death: in the *rolang* ritual, a monk would be locked in a room with a corpse for several days and attempt to reanimate it by lying on it and breathing mouth to mouth with it until, so goes David-Neel's account, the corpse gets up and walks again, at which point the practitioner is meant to bite off the corpse's tongue, killing it for good.[28] Abramović's communion with death was symbolic and meditative, but her intentions were similar: she wanted to embody her mortality, to get physically intimate with it, and to project it out into the world. Abramović became a *memento mori* in herself.

For *Cleaning the Mirror III*, Abramović went to Oxford's Pitt Rivers Museum, a treasure house of anthropological artifacts. She selected a range of tribal and ceremonial objects, which she believed would carry auratic traces of their original incantatory use. Under dim light, as if in a séance, Abramović sat at a table and hovered her hands, reiki-style, over a series of objects that were brought to her one by one by an assistant, among them a medicine box from Nigeria, kadachi shoes made out of emu feathers and used by Aboriginal medicine men, and a bottle of mercury from Sussex, England, supposedly containing a witch.[29] In trying to absorb the energy of the objects, Abramović was casting herself in a shamanic role. Though her performance resembled method acting, she did indeed feel like a receptor and a conduit for the "energy" held in the objects. As the title of the piece suggested, and as her brother had recognized, part of the process for becoming a conduit of energy was to empty herself out and make herself into a kind of mirror, one that made invisible things visible. After the performance (again, only for a video camera), she came down with a fever and was bedridden for days. She believed the illness was a direct result of recklessly exposing herself to so many different "energies" from different regions, traditions, and eras.

To enter Abramović's retrospective at the Oxford MoMA, visitors had to pass through the sound corridor of machine gun fire Iles mentioned in her fax, a

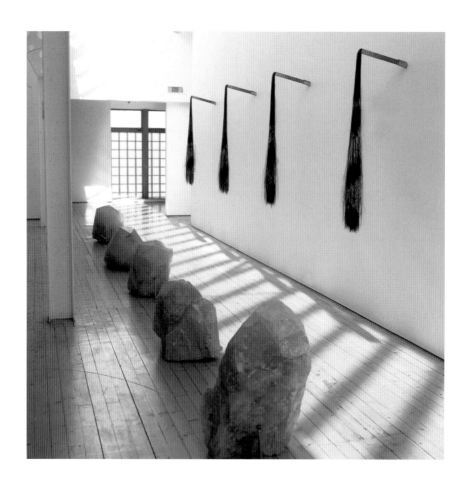

24.4
Marina Abramović, *God Punishing*, installation at
the Museum of Modern Art, Oxford, 1995. Courtesy
Sean Kelly Gallery, New York.

reconstruction of Abramović's 1971 piece. Once through, they entered an exhibition consisting mainly of the transitory objects. There was also one of her recent elaborate video installations, in which monitors showing *Dragon Heads* were placed on tables whose legs ended in crystals, as did the chairs visitors were supposed to sit on to watch the piece. Also in the exhibition were the photographs of her early solo performances, produced with Sean Kelly. Significantly, the exhibition did not contain any of her collaborative work with Ulay. They were still not communicating well enough to manage the task of distilling their archive into an exhibition. Besides, Ulay still held all their work, which continued to infuriate Marina.

On paper, it was the right time for a midcareer retrospective. Abramović was now forty-eight and had around twenty-five years of work behind her. But since her work with Ulay could not be included, there was a huge gap between her early work and the current transitory objects, through which Abramović was still finding her way, post-Ulay. Typical of the patchy quality of the work was the recent piece *God Punishing*. This consisted of five whips made from human hair, hanging on the wall, and five large chunks of quartz on the ground in front of them. Abramović was inspired by a story her grandmother used to tell her about a king ("I don't remember his name—perhaps King Adrian or King Solomon," Marina wrote; it was in fact Herodotus's story of Xerxes, king of Persia, in 483 BC) who lost many of his men during a storm on the high seas. When his remaining fleet made landfall, the king was so angry that he ordered his surviving men to whip the sea "345" times to punish it. "This installation is in some way an homage to that story," Abramović wrote. "I've been thinking that the only way to punish the gods is with our own bodies."[30]

Abramović articulates here with unprecedented clarity a crucial motivation for everything she had done with her body. The pain, the endurance, the absurdity, the experimentation with fanatical, monstrous control and total, humble surrender—it was all a way of rejecting the implacable *givenness* of life, asserting her will against the body and the existence she found herself thrown into. Her actions were a kind of revenge against life. Abramović didn't really believe in a maker so much as in the power of being and feeling *made*, but her performances had always carried a defiant cry of *non serviam*. The body was the best tool to punish the gods because it was a disputed territory: a gift and a burden that she was charged with cosmic responsibility for, yet wanted to own outright. Hadn't she earned this right, having done so much to test and master her body? As a final twist to the joke, Marina believed that punishing the body was the only way to punish the gods "because *we* are the gods."

God Punishing evoked a question—why did she do these things to her body?— that went to the core of her practice like no other piece had done. Yet the form this idea found was, like many of the transitory objects, overwrought and laced with too much humor—or, somehow, the wrong kind of humor. The whips were made with the hair of *Korean virgins*, "because only virgin hair would be good enough to punish the gods," she says. This Orientalism-meets-voodoo, though intended to be funny, was a distraction from the crux of the piece. It was typical of how Abramović's recent

body of work was unready for such a canonical exhibition. No one ever confessed to loving the transitory objects. But Marina loved their playful Puritanism, and lived it out to the full. At the dinner after the opening of the exhibition, attended by a few dozen people, Marina prescribed that only the most minimal, healthy, and organic food be served: vegetarian dishes and water with gold leaf in it. Elliott was desperately bored by the fare and snuck some vodka into the water.

At the same time as her retrospective in Oxford, Abramović had another exhibition at Victoria Miro, this time of the bankable performance edition photographs rather than the expensive and unwieldy transitory objects. But the art market was still lean after the recession of the early 1990s, and only a couple of the photos sold: an image from *Rhythm 0*, with Abramović topless, and the whipping image from *Thomas Lips*, with Abramović spattered in blood. The buyer was Dakis Joannou, the Greek industrialist who would shortly become one of Europe's most important collectors of contemporary art. He paid a total of £5,500 for the photos.[31] This would have represented a good income for Abramović—if she sold work like that on a regular basis.

After stopping at the Fruitmarket Gallery in Edinburgh—where the exhibition included one of her newer series of chairs "for non-human use," an extremely high chair mounted on the roof of the gallery—Abramović's retrospective then traveled to the Irish Museum of Modern Art in Dublin. Sean Kelly flew in from New York to see the show. He landed early in the morning and only got a couple of hours' sleep at the hotel before Marina came knocking. They decided to go to the museum immediately, and went downstairs to get a taxi. Marina had been given some vouchers by the hotel to pay for her taxis. She asked the taxi driver, "Can you take the voucher in this taxi?" Bemused by her heavy Eastern European accent, the taxi driver replied: "I'm not taking a bloody vulture in my taxi." "No, you don't understand," Marina said. "I have a *voucher* to go in the taxi"—but her emphasis just made the misunderstanding worse. Kelly was now in hysterics in the back of the cab. Marina persisted, totally unaware of the cause of the driver's confusion: "What if I sign the voucher for you, then you can take it?" "I don't care what you do to the bloody vulture, I'm not taking any wildlife in my taxi."

25

NORMALITY

"This territory hasn't been touched in New York since Joseph Beuys did *I Like America and America Likes Me*," Kelly told Marina. They were planning her first solo performance in New York, which would take place in his new gallery space in SoHo. Despite the energetic downtown performance scene of the 1980s, with Karen Finley, Annie Sprinkle, and a host of identity-politics divas performing in clubs and alternative spaces like PS122 and Franklin Furnace, and with Tehching Hsieh beating a lonely path at the same time with his one-year performances, Kelly believed there hadn't been any performances of major art-historical importance in New York since Joseph Beuys arrived at Kennedy Airport on May 21, 1974, and was taken by ambulance to the René Block gallery, where he lived for five days in the company of a coyote.[32] Kelly's rampant enthusiasm found its perfect audience in Abramović, but she would have to wait a while to have an impact on the collective consciousness of the New York art world as Beuys had done. Her performance *Cleaning the House* in the grotty basement of Kelly's new gallery in late November 1995 was a warm up for bigger things.

The concept for the performance grew out of Abramović's cleaning of the model human skeleton in Oxford earlier that year. Now, she sat surrounded by cow bones with rotting meat and gristle still on them, stinking out the basement. Over two hours, people shuffled in to witness the traumatic scene: Abramović scrubbing with her normal gusto, letting out occasional gasps and moans of revulsion from the smell.

Abramović was becoming increasingly fixated on cleanliness, as her mother had always been. The influence in her work stretched back in fact to 1969, with Abramović's unrealized proposal to clean people's clothes in the Dom Omladine gallery. *Delusional* had gone the other direction, plunging into the abject—into filth, depravity, and dejection. But here Abramović was heading to the depths not to stay there and sniff around, but to come up purged and cleansed. The "house" of the title was meant as her body, the carrier of her spirit. Offstage and free of cumbersome crystals and furniture, she was mining her core material once again.

Abramović traveled straight from New York to Dallas for a brief residency at the University of Texas, where she made two performances for video drawn directly from scenes in *Delusional*, both of them autobiographical and cathartic in nature. In *The Onion*, Abramović ate a large raw onion, skin and all, like it was an apple, and complained to the camera about her hectic life:

I am tired of changing planes so often. Waiting in the waiting rooms, bus stations, train stations, airports. I am tired of waiting for endless passport controls. Fast shopping in shopping malls. I am tired of more career decisions, museum and gallery openings, endless receptions, standing around with a glass of plain water, pretending that I am interested in conversation. I am tired of my migraine attacks, lonely hotel rooms, room service, long distance telephone calls, bad TV movies. I am tired of always falling in love with the wrong man. I am tired of being ashamed of my nose being too big, of my ass being too large, ashamed of the war in Yugoslavia. I want to go away, somewhere so far that I am unreachable by fax or telephone. I want to get old, really old so that nothing matters any more. I want to understand and see clearly what is behind all of this. I want to not want any more.[33]

Her trip to Dallas was typical of this jet-setter ennui. Marina was alone, stuck in a motel far from the university, and since she couldn't drive, totally dependent on taxis. *The Onion* laid bare both the diva and the vulnerable girl in Marina. She wore bright red lipstick and red nail polish for the performance. Tears streamed down her cheeks as she crunched into the onion, and she grimaced and moaned dramatically. Apart from her shame about Yugoslavia, it was a very privileged list of complaints. Marina was extremely aware of this, and pushed her whining to the point of self-parody.

Image of Happiness, a second short video produced in Dallas, was another flirtation with the idea of the simple life—the kind of life that Ulay had wanted, away from art world glamour. Abramović hung upside down, with only her head in the camera's frame, and recited the storybook scene of ideal domesticity she had first told in *Delusional*, of her being pregnant and waiting for an imaginary husband to come home from the coal mine. "[This] image is something I really wish in one part of myself but it is not all of myself," Marina said in an interview. "It would be a dream to have a husband, family, etc. but the other side of myself is stronger and I threw it away."[34]

Marina craved normality in her everyday life, but only as a means to create the psychic space for the extremity of her performances. And anyway, normality for her was an accelerated, intensified version of what counted as quotidian life for most people. The heightened awareness of death that she cultivated in her performances seemed to lead not to calmness or a state of acceptance, but to an ever tighter grip

25.1
Marina Abramović, *The Onion*, University of Texas, Dallas, 1996. Courtesy Sean Kelly Gallery, New York.

on the her daily life, which she organized with militaristic precision. Her unquench-able desire for achievement and affirmation in the art world pulled her away from anything resembling her domesticated *Image of Happiness*, forcing her to be a very public person, always on, always charming, emptying herself out in order to reflect other people's desires. It was an exhausting dynamic, and the private performances made in Dallas were a means of therapy: Marina was still figuring out the new equa-tions of her existence, pulled between normality and celebrity, eight years after split-ting with Ulay and attaining full permission to lead the public life that he had always resisted. She had bumped into him recently in Amsterdam. He was working at a photo lab called S-Color, producing prints for artists. Marina was to be one of his clients, but she kept their interaction to a minimum. She was embarrassed on Ulay's behalf. He did his best not to care that she found him working there in arguably a worse job than when he was twenty-two in Neuwied: he had *owned* that photo lab.

In Abramović's third video piece in Dallas, *In Between*, she traced lines with a needle on her hands and neck, pricking her finger and spreading the blood out, and then having a "helper" hold the needle as close as possible to her unflinching, wide-open eye. When the video was shown later in institutions in Europe, Abramović made people sign a contract before watching it, stating: "I promise I will stay for the entire duration of the work—forty minutes—and that I will not interrupt the process with my early departure."[35] Abramović had made implicit contracts with her audiences before—most notably in *Rhythm 0*, where gallery visitors were given permission to do anything they wanted to her with any of the seventy-two objects on the table. In her relation work with Ulay, the contract was primarily between the performers, and was set out in the legal-poetic tone of their performance descriptions. Now, in the 1990s, Abramović was starting to demand a covenant relationship with her audience. They were expected to put in a similar—though never possibly equal—amount of concentration when watching the work as Abramović put in when making it. She later turned this contractual negotiation playfully dictatorial in the installation *Escape*, 1998, in which she strapped members of the public into standing, lying, and seated positions in the women's exercise yard of a former prison in Melbourne. They would remain voluntarily restrained—around the ankles, wrist, chest, and neck—for twenty-five minutes at a time, wearing headphones to block out any sound and accelerate a medi-tative state of surrender.

In the late summer of 1996 Abramović was invited to give a lecture at the National Museum in Montenegro. During the trip she made a pilgrimage on foot—accom-panied by a small entourage from the museum and by David Elliott—to the village where her father was born, outside the town of Cetinje. Marina asked an old man which house Vojo Abramović had lived in. He said that he too was an Abramović, and took her to a ruin in a field. Marina found there an oak tree growing out of the remains of a stone wall. She sat by it for a long time, contemplating. "I was thinking of the vitality and strength of the nation and my entire race: if we can grow out of rock we can do anything," Marina says. She posed for photos smelling a flower in

25.2
Marina Abramović, *Escape*, Remanence, a former
Magistrates' Court and City Watch House,
Melbourne, 1998. Courtesy Sean Kelly Gallery,
New York.

25.3
Marina in a village outside of Cetinje, Montenegro,
in 1996, in the ruins of the house where her father
was born. The man with her, a local, also had
the name Abramović. Courtesy Abramović archive.

the grassy ruins. "Then sun was going down and in front of us a white horse and a black horse came and started making love. It felt like I was in a Tarkovsky movie," she says. Elliott could see the importance of the moment for Marina—it was evident in the photo-op she created—but he has no recollection of the materialization of the symbolic horses.

Marina was about to turn fifty, and her birthday that year coincided—not accidentally—with the opening of her traveling retrospective at the Stedelijk Museum voor Aktuele Kunst in Gent. In a flush of newfound confidence in her age, she threw a dinner party with over one hundred and fifty guests, including Ulay. This was the culmination of a rapprochement that had begun when, upon Stefanowski's soothing advice, Marina had invited him, his wife, Song, and their daughter, Luna, to Christmas lunch at Binnenkant 21 the year before. To add to the tension of reconciliation, Stefanowski in turn had invited his estranged wife and *her* new lover (who kept flirting with Marina; her attention though was on Ulay's adorable six-year-old child). But at her fiftieth birthday party, Elliott was Marina's partner; Stefanowski was in retreat, though he still saw Marina on occasion. At fifty, Marina was becoming, if anything, even more attractive to men as her embrace of glamour grew ever stronger, her powers of seduction matured, and she grew in stature professionally and privately.

The party began with tango dancing. "All my life I have wanted to learn to dance the Argentinean Tango—'The Urgent Dance,'" Marina had written in the invitation, along with the request that her guests take lessons before the party.[36] Marina danced with her tango teacher in front of the assembled guests. As her childhood piano teacher first noted, Marina had no musical intuition, and as Charles Atlas had observed, Marina had been a poor dancer, until now. She was publicly conquering yet another fear. But the evening became an instant legend because of two other incidents. After a birthday cake in the shape of Marina was served, Jan Hoet, the director of the museum, was carried into the hall lying naked on a similarly huge platter:

25.4
A cake in the shape of Marina at her fiftieth birthday party at the Stedelijk Museum voor Aktuele Kunst, Gent, 1996. Courtesy Abramović archive.

25.5
Jan Hoet, the director of SMAK, offers his body as a birthday gift to Marina. Courtesy Abramović archive.

he was offering his own body to Marina as a birthday gift. Privately that night, Marina received a more welcome present: Petar Ćuković, the director of the National Museum of Montenegro, invited Abramović to represent Serbia and Montenegro at the Venice Biennale next summer. She was overwhelmed, fortified, vindicated. It must have given her strength for the climactic event of the night: Ulay and Marina did the unthinkable and performed together again. They reprised *A Similar Illusion*, which they'd first done in Australia fifteen years earlier. Ulay considered this his birthday present to Marina (though it was his birthday too). The pair stood frozen together once more in their tableaux vivant embrace, their outstretched arms gradually wilting. "I was in tears, we were all in tears," Chrissie Iles recounts. "They looked amazing together." The reunion was a one-off indulgence, a fleeting resurrection. New conflicts would soon emerge—after all, Marina was only eight years into her prescribed twelve-year period of post-Ulay suffering.

25.6
Abramović and Ulay reunite to perform *A Similar Illusion*, from 1981, at Marina's fiftieth birthday party in Gent, 1996. Courtesy Abramović archive.

WOLF RAT AND GOLDEN LION

In the spring of 1997, Marina and Sean Kelly went to Venice to inspect the Yugoslav pavilion. It was still called that, even though Yugoslavia proper had long since disintegrated in the wave of nationalisms and ethnic conflicts in the early 1990s. The only alliance that remained from Tito's old federation was Serbia and Montenegro, which retained control of the Biennale pavilion in the Giardini, the gardens where most of the national pavilions are situated.

Dining outdoors at a restaurant near Saint Mark's Square one evening, Marina thought she could hear the faint sound of bombing drifting across the Adriatic from Croatia as Kelly tried to convince her that the invitation to represent her homeland was a poisoned chalice. It's extremely doubtful that the sound of artillery could travel all the way across the Adriatic, and that such intense fighting was going on two years after the Dayton Peace Accords had ended the war in the Balkans (though there was sporadic violence in Croatia until 1998). But it's significant that Marina's mythologizing memory gives her discussion with Kelly such a dramatic and painful underscore. Kelly advised Marina that she shouldn't risk the perception of any cooperation with Slobodan Milošević's despised regime, even if it were indirect, through the cultural ministry of Montenegro. She resisted his diplomatic advice. She recognized Serbia's role as an instigator of the violence, but she saw aggression on all sides. By accepting Montenegro's invitation, she wasn't defending any particular side in the wars of the early '90s. Instead, she saw it as an opportunity to perform an act of mourning for the entire Balkan conflict. And on a personal level, the invitation was hard to refuse: her "homeland" of Montenegro was finally recognizing her as its most important artistic export after Yugoslavia had all but ignored her since she left twenty-one years earlier. The next day, while looking around the Yugoslav pavilion, Marina dropped her new camera, smashing it on the hard stone floor. She immediately saw the accident as an omen.

Shortly after returning to Amsterdam, she was alerted to the March 19 issue of the Montenegrin newspaper *Podgorica*, in which Goran Rakočević, the Montenegrin minister of culture, who had facilitated her invitation, turned on Abramović in an article titled "Montenegro Is Not a Cultural Colony." Rakočević had got wind of her preparations with the pavilion curator Ćuković for a bizarre and bloody performance—and an expensive one too, requiring the purchase of three top-quality projectors, and the procurement and refrigeration of one thousand cow bones. Abramović calculated that the piece would cost 150,000 DM (about $100,000). How could Rakočević justify such a cost—even if Abramović had stated that the installation would be given to

the National Museum of Montenegro after the Biennale? In any case, ideology more than economics was Rakočević's main concern. He wrote:

> This outstanding opportunity ought to be used to represent authentic art from Montenegro, free of any complex of inferiority for which there is no reason in our exquisite tradition and spirituality. . . . Montenegro is not a cultural margin and it should not be just a home-land colony for megalomaniac performances. In my opinion, we should be represented in the world by painters marked by Montenegro and its poetics, since we have the luck and honor to have brilliant artists of universal dimensions living among us.[37]

Abramović had lived outside of Yugoslavia since 1976, so Rakočević didn't consider her an authentic national artist. Never mind that she was, as Ćuković pointed out, one of those diaspora artists for whom "at the deepest levels of their beings . . . their homeland murmurs."[38] Marina was a child of Partisans, one of the new Yugoslavia's first born. Her lifelong struggle to reach beyond the bounds of that upbringing was only testament to the strength of her primordial attachment. It was a retrograde insult to imply that Abramović was "not Montenegrin enough," symptomatic of a dubious Balkan nationalism—and an outmoded criteria for participation in the Biennale anyway. Rakočević had mistaken the national pavilions in Venice's Giardini for a world's fair, where nations have to put their sunniest face on display.

A few days after the *Podgorica* article, Abramović sent a two-page statement to various newspapers in Serbia and Montenegro, announcing that she was cutting off "any further communication with the Ministry of Culture of Montenegro and all other Yugoslavian Institutions responsible for the exhibition in the Yugoslav Pavilion." Rakočević had, she wrote, "incompetently . . . tried to misuse my artwork and reputation in some strange purpose, most probably of a political nature," and this "evil intention . . . is not tolerable."[39] The diplomatic dilemma that Kelly had been so anxious about—whether Marina should accept an invitation from such a reviled host—was now moot. Marina was devastated; luckily, she was also furious. She and Kelly would not let her concept for the Biennale vanish along with Montenegrin support. They asked Germano Celant, the curator of the Italian pavilion and of the

26.1
Marina and Danica, 1997. Courtesy Abramović archive.

Arsenale—the two huge venues that weren't subject to any national criteria—if he had any space left that they could use. All he had was the dank, low-ceilinged basement of the Italian pavilion in the Giardini. Marina told Celant: "The worst is the best." She had her venue.

Balkan Baroque was a triumphant synthesis of most of the works and ideas Abramović had been laboring over since she split with Ulay, but which she hadn't been able to express with her usual searing visual power or through her preferred mode of transcendent concentration, what she called her "higher self," until now. From *Delusional*, she projected static images from the interviews with her mother and father (Vojo waving a gun, Danica with her hands folded over her heart). In between these two images, there was a video of Abramović describing a particularly Serbian technique of killing rats, which she'd heard about somewhere or other. The rat catcher creates a "wolf rat" by taking the biggest rat in a family, gouging out its eyes, and starving it so that its teeth grow so large that they nearly suffocate it (a rat's teeth never stop growing; they have to be worn down through nonstop gnawing on food). When the wolf rat is at the point of death—suffocating, starving, and blind— the rat catcher releases it back into its nest, where it massacres its own tribe before moving on to others. After delivering this story, Abramović (in the video) tears off a layer of clothing and dances to Serbian folk music.

From her transitory objects, she took three large copper troughs, which were elegant, minimal, and suggestive of baptism. And from *Cleaning the House*, she took the performance's main component: the idea of maniacally and repeatedly scrubbing cow bones. This time though there was a huge pile of them—seven hundred clean bones forming a mound, which was covered in three hundred fresh, gristly bones for Abramović to scrub. She sat on this pile for four days, seven hours a day, doggedly cleaning the bones with a brush and a bucket of water, crying for long periods, sometimes hysterically, and repeatedly singing folk songs from each of the former Yugoslav republics. Taken together, the video, sculptural, and performance elements formed a punishingly powerful symphony: of Abramović's tangled Orthodox and communist genealogy, of the bawdiness and brutality of her homeland (for Abramović, the baroque was about unrestrained extremes), of her shame at her country's behavior in the war (and perhaps also her shame at the privileged distance she had from the suffering of her compatriots), and of her symbolic attempt, through scrubbing the bones clean, at a kind of penance for the sins of the recent wars. The piece was a collective act of mourning for what had happened recently just across the Adriatic, a rite of passage and a redemption that anyone could share in through witnessing.

It was the smell though that first hit visitors as they entered the basement, and stayed with them as a reminder of the harrowing scene. The bones were cleared away and packed in refrigerators each night, but over the course of the four-day performance, the meat, fat, and gristle on them began to rot and stink in the subterranean

26.2
Marina Abramović, *Balkan Baroque*, Venice
Biennale, 1997. Photo: Elio Montanari. Courtesy
Sean Kelly Gallery, New York.

26.3
Marina with the Golden Lion prize for best
artist at the 1997 Venice Biennale. Courtesy
Abramović archive.

summer heat, spawning maggots. Marina was so repulsed that she didn't eat meat for several years after the performance. When the Giardini closed each night, Kelly shepherded her out of the piece and onto a water taxi, which took her back to the apartment they were renting. Marina was sequestered from the standard art world whirl of the Biennale during the span of her performance, to avoid any distracting encounters. One of the many people looking for her was Paolo Canevari, an Italian artist she'd recently met after giving a lecture in Rome.

Arriving at the apartment each night, Marina spent a long time showering, trying to get some relief from the smell of rancid meat that was working its way into her hair and skin. Late on the penultimate evening, Kelly arrived back at the apartment and told Marina that she'd won the Golden Lion for best artist in the Biennale. She wept in his arms, overcome. But she still had one more day's performance of *Balkan Baroque* left, so she put her joy on hold to get back into the mourning mindset of the piece. The next morning, she reentered the performance as usual before the Giardini opened (as with *Nightsea Crossing*, the public never saw her enter or leave the piece), and pulled onto her relatively clean body the same white slip she'd worn for four days, stained brown and damp with diluted blood, flesh, and fat stains.

The next day, Marina had her hair cut and reverted back to what Kelly calls "full diva mode" for the ceremony to accept the Golden Lion. In her acceptance speech, Abramović defined the expanded aims of her art since the early 1990s: "I'm only interested in an art which can change the ideology of society. . . . Art which is only committed to aesthetic values is incomplete." After the ceremony, a representative from the Yugoslav pavilion congratulated Marina and invited her to a reception at the pavilion, which was exhibiting the landscape painter Vojo Stanić in place of Abramović. "You are very big and you will forgive," the representative said to Marina. She replied, "I am big but I am Montenegrin and you don't hurt Montenegrin pride."

That day, Marina, Kelly, and his wife, Mary, tried to take a stroll across Saint Mark's Square. Every step of the way they were stopped by people congratulating Marina, saying how moved and how grateful they were for her performance. Never before had Abramović connected so deeply and emotionally with such a large audience. Nearly a decade after breaking up with Ulay, she had rediscovered her touch for transcendent performance, and for beguiling her public. Now, instead of confronting herself, as she'd done in her early solo performances, or confronting Ulay, as she'd done for twelve years, she'd graduated to facing outward and engaging openly and generously with the public. They would be her new energy source.

That evening, Marina attended a party for her friend Julião Sarmento, whose work was showing in the Portuguese pavilion. Here, Paolo Canevari finally caught up with Marina. He'd been enraptured by her since he saw her lecture at the Palazzo delle Esposizioni in Rome a few months before. Her account of breaking up with Ulay on the Great Wall had brought him to tears, "But I was interested in the person and didn't really care much about the artist," Paolo says. "I liked Marina as a woman.

I was attracted to her terribly." He was thirty-four when they met; Marina was fifty. At the party, Paolo managed to jostle Marina away from her crowd, and from Stefanowski, who had rushed back to Venice from Germany for the Golden Lion ceremony. He slipped a piece of paper with his phone number into her hand. When Marina returned to Amsterdam, she started dialing it regularly.

SETTLEMENT

Apart from brief truces like the bizarre "family" Christmas at Binnenkant 21, the reunion performance at her fiftieth birthday, and the exhibition of some relation works in a couple of venues in late 1997 and early 1998, Marina remained consumed with hatred or at best deeply suspicious of Ulay throughout the 1990s. "This situation with Ulay was the eight-hundred-pound gorilla in the room," Kelly says. "It colored everything. It made Marina angry every day of her life." Ulay still had possession of the Abramović / Ulay archive—and there was always some infraction by Ulay (real, exaggerated, or imagined) that was infuriating Marina: he had been selling work at a cut rate, to the wrong people, not dividing the proceeds, or he'd been exhibiting the work in sub-par venues, without involving her in the decision making. Their financial dispute stretched back to 1989, when they sold a work to the museum in Antwerp during the tour of the "Lovers" exhibition, and Marina never saw her 5,000 guilder ($3,100) share of the money the museum had paid to Ulay. Ten years on from the split, both Marina and Ulay now wanted what amounted to a divorce settlement to put such disputes to rest. And in Kelly, Marina had the perfect divorce counselor.

While Abramović's solo career was prolific in the 1990s, Ulay wasn't making much work. He continued tentatively in photography and portraiture with a much more political bent than any work he'd made with Abramović, but he mostly withdrew into a private life with his new wife and child, free from the public glare that Marina had always thrived in. Guardianship of the archive was becoming a burden for Ulay, and periodically submastering all the videos was an unwelcome chore. But most importantly, Ulay needed money. Discussions with Kelly about the possibility of Marina buying the archive outright must have begun long before her triumph at the Venice Biennale, because already by August of 1997, Ulay wrote conclusively, and with typically excessive graciousness and placidity, to Kelly: "I have no objections that you deal with the oeuvre in question. On the contrary, I do respect you and your sincerity not only as a dedicated art dealer but also for your vision."[40]

Marina wanted her twelve years back. If she owned the archive, she would have control over the Abramović / Ulay story, and would make sure it gained its rightful place in art history. "To me it wasn't about our emotional problems," she claims. "It was about making sure the story is absolutely straight." Buying the archive was a way of sublimating her desire for vengeance over Ulay into the worthy cause of art-historical responsibility. But the raw ingredients for this alchemy were still pain, loathing, and bitterness.

It took nearly two more years of sporadic negotiations before Marina and Ulay were ready to sign a contract. On April 29, 1999, Marina finally bought the entire archive (all the material in it—amounting to thousands of negatives and transparencies as well as all the videos and film—was painstakingly listed in an appendix to the contract) for the intimidating sum of 300,000 DM ($210,000). Marina gained complete control over the reproduction, exhibition, and sale of the work, though when she did sell it, Ulay was guaranteed 20 percent of the net proceeds. Taking into account Kelly's standard 50 percent dealer's share from sales, Marina would be left with only 30 percent of the proceeds from each sale. But for the sake of controlling the archive, she was willing to concede the cut. For Ulay, it was the perfect deal: he got a lump sum in advance, freedom from the burden of looking after the archive, and the promise of a steady income in the future as Abramović sold the work. It allowed Ulay to be free from his past, to disappear once more—and allowed Abramović to seize the past, to use it as fuel.

The eight-page contract aimed to cover every eventuality: if any work was sold through Ulay's efforts, he would get an additional 13 percent of the proceeds; it was agreed that the contract didn't amount to an "an admission of alleged facts, guilt or liability" with regard to the disputes that had necessitated it; Ulay was entitled to "apply for access to the archive on a 72 hour notice, for the purpose of exhibitions," and "This access will not be denied by Abramović on unreasonable grounds"; Marina had to submit a quarterly statement to Ulay detailing any sales or reproductions, and Ulay was allowed to inspect the original records.[41] The one eventuality the contract didn't cover was that Marina would hardly sell any of the joint works for nearly a decade, thus denying Ulay the income stream he'd foreseen. Marina was so consumed with making new work that she didn't want to invest any time or energy in selling the old work. With Kelly's guidance, this pragmatism gradually developed into a deliberate strategy of patience. They would wait until the value of the joint works increased as a result of Abramović's growing stature as a solo artist. "I'm really good in waiting," Marina says. "Ten years later this work got the value it's supposed to have. Ulay would never wait that long."

Marina took a loan in the full amount to buy the joint works. It was a huge sum of money for her at the time, but Kelly negotiated very favorable terms from a Swedish collector named Willem Peppler: in lieu of interest, Abramović would give Peppler a work of his choosing along with repayment. Kelly first introduced Peppler and Marina in Amsterdam in the early '90s. "I didn't know anything about the work when I met her," Peppler says. "I found her a very striking lady, a very gifted person." The sheer force of her enthusiasm, passion, and political charm induced in Peppler an immediate interest in her work and a hefty philanthropic commitment. He had funded the production of the "performance editions"—the photographs of Abramović's early solo performances—in exchange for receiving a complete set of the images, and later he helped fund *Balkan Baroque* at the Venice Biennale after Montenegro withdrew its state sponsorship. He also bought a pair of Abramović's *Shoes for*

Departure—blocks of amethyst with smoothed-out hollows—but he never thought to actually put his feet in them. It was enough that they seemed to contain Abramović's ideas.

Marina cultivated a mock-maternal relationship with Peppler. She faxed a Christmas greeting to him in 1998—a few months before she signed the contract with Ulay—with "instructions for the holidays":

> Don'ts
> 1. Don't eat too much
> 2. Don't drink too much
>
> Do's
> 1. Remember your dreams
> 2. Remember your self
> 3. Remember to remember

She signs off with "I love you" and "Doctor / Mother Abramović." Marina's contract with Peppler stated that she would pay off the loan in quarterly sums of 25,000 DM. With the naturally curtailed earning capacity of a performance artist, Marina struggled—but succeeded—in making the payments through her teaching, lecturing, performing, and occasional sales of objects and photographs. More money troubles were on the way though as Marina began playing a Peppler-like philanthropic role to her own family.

Meanwhile, Marina was traveling more than ever. She went on several trips to Japan, first as an advisor on the board of a new contemporary art center in Kitakyushu, and then on a whirlwind lecture tour of the country along with the artists Daniel Buren and Hamish Fulton, and the curators Saskia Bos—who was now in charge of de Appel—and Hans Ulrich Obrist. The nomadism Obrist practiced had been inspired in part by the example of Abramović and Ulay and the fearless way they injected themselves into foreign cultures. "I think Marina pioneered this idea of not belonging to a geography," Obrist says. He and Marina shared a manic vitality. "Whenever I meet Marina there is an energy transfer and I feel energized for weeks. It's the same with her performances. I think she has a principal of energy in an almost Joseph Beuys kind of way." They did an interview on a bullet train, discussing the Japanese game pachinko ("It's a completely Zen type of experience"), reperformance ("If you can play Mozart a hundred years later, you can definitely redo performances now or in twenty or fifty years"), and the importance of mixing professional disciplines.[42] In Kitakyushu they took part in a weekend-long symposium on this last topic, called "Bridge the Gap" (between art and science, that is), and Marina performed a version of *Art Must Be Beautiful*, in which she used "mathematician must be beautiful" as the second part of the mantra, much to the amusement of Gregory Chaitin, the designated mathematician in the room.

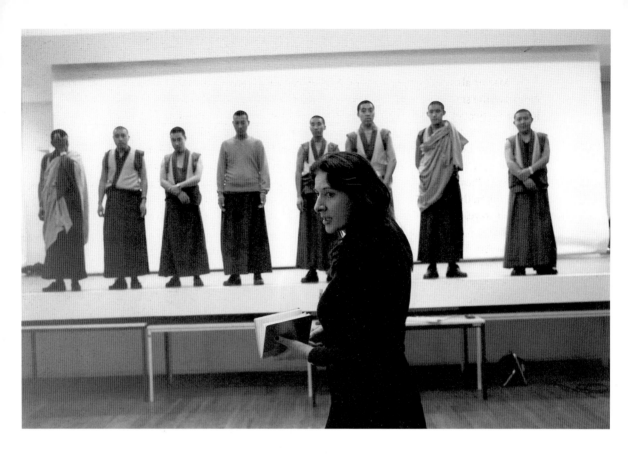

27.1
Abramović directing a group of Buddhist monks
for a performance at Haus der Kulturen der Welt,
Berlin, 2000. Photo: Alessia Bulgari. Courtesy
Alessia Bulgari and Abramović archive.

Marina also took several trips to India in this period, and worked with Tibetan monks in the small town of Mundgod in Karnataka to choreograph a performance for the Festival of Sacred Music in 1999. Not only would the five traditions of Buddhism come together in the performance—this was the idea behind the festival suggested by the Dalai Lama, whom Marina met several times during her trip—Marina also arranged for male and female monks to come together, which was unheard of, in singing the "heart" sutra. She wanted to arrange the monks in a giant pyramid choral formation on the stage. After several weeks of preparation, which included building a special stage, she traveled with the monks and Ling Rinpoche Doboom Tulku to Delhi for the performance. Only there was she informed at the last minute that they couldn't possibly use the pyramid formation since no monks could be placed above any others. "I asked them why they didn't say before," Marina recalls, "and they say we didn't want to offend the guest." It was maybe the most severe jolt she'd received in a long history of working with totally foreign cultures. In a way her ignorance must have been a relief: not everything was pliant to her vision; she was learning more of her own limitations and cultural projections. In any case, they reached a compromise and did the performance, which led to a further collaboration in Berlin at the Haus der Kulturen der Welt two years later.

Around this time, Vojo's stepson emigrated to Canada, and Vojo asked Marina for some money so he and Vesna could follow him there and start a new life, away from the privation and misery of Belgrade in the aftermath of the wars and hyperinflation. Marina gave him 10,000 DM ($7,000) to make the move, and was appalled when he returned to Belgrade not long afterward. She never asked what he'd done with the money; she assumed he had given it all to his stepson. Vesna was now dying of cancer and Vojo's health was declining too: he lost a lot of weight and became weak, hardly able to look after himself. "He was asking for money and saying Vesna was in terrible pain. I was kind of fed up with the whole thing," Marina says. After Vesna died and when Vojo's demise seemed near, he forged the signatures of Marina and Velimir on his will in order to disinherit them and turn over all his money and property to his stepson when he died. Marina and Velimir would never fully understand why he did this, though Velimir speculates that Vesna had asked him to, and Vojo had been careless with money his whole life anyway. "He was an irresponsible communist, losing and gaining property so many times in his life that he simply did not care.... He even probably thought that he was doing good for a poor guy, his adopted son. It's hard to say. He was not soft. He was not spiritual. He killed many people in the war." For Marina, this disinheritance—which she and Velimir discovered before their father's death—was the culmination of an abandonment that had started when she was fifteen years old and discovered him kissing Vesna on the street.

In March 1999, just a few days before the first NATO air strikes on Belgrade, which were intended to halt Serbia's ethnic cleansing of Kosovo, Marina ordered Velimir to reclaim all her old paintings from Vojo's apartment. She no longer trusted her father, and worried that he or others would try to sell the paintings; she was both

27.2
Marina and Velimir with Vojo in his apartment in
Belgrade, 1996. Courtesy Abramović archive.
To Velimir's left is the painting that Marina dedi-
cated to Vojo and Vesni in 1979, and would
reclaim in 1999.

27.3
Marina and Velimir during a happier moment of
his stay in Amsterdam, circa 1999. Courtesy
Abramović archive.

embarrassed by them and overprotective of them. Velimir reluctantly but obediently executed his sister's request. "It was one of the most difficult and saddest days in my life," Velimir recalls. He sat in an armchair getting drunk while a moving man carried Marina's paintings away one by one, leaving bare spots on the walls. On the back of one painting, of Alba in a bizarrely Provençal landscape, there was the dedication "To Vesni and father from Marina." It was dated March 11, 1979, long after Marina had ostensibly given up painting. It was a gift, probably meant as reconciliation for years of mistrust and miscommunication between her and Vojo and Vesna. This painting too was removed, put in the truck, and taken with all the others for long-term storage in Milica's apartment on Hilandarska street.

When the bombing of Belgrade started, Velimir's wife, Maca, insisted that he should take Ivana, their ten-year-old daughter, to Amsterdam, where they could live safely with Marina. Maca didn't go with them because she was having her third treatment of chemotherapy at the time, Velimir says, and bullied him into leaving without her. Marina believed Maca was in remission at the time, and thought Velimir was merely wallowing in self-pity. "He was playing the victim and I was taking it," Marina says. "He was saying his wife is dying of cancer, they were bombing Belgrade, and he was looking all the time at CNN. He was constantly in sorrow." Thus began a feud between brother and sister that became just as entrenched and interminable as Marina's conflict with Ulay.

Marina was in Japan again when Velimir and Ivana arrived at Binnenkant 21. She was making preparations to convert an old house in the countryside north of Tokyo into a kind of spa/monastery, called *Dream House*, where guests were invited to soak in copper baths and sleep in crystal-encrusted cots, and then record their dreams in a public register. It was an intensified version, done as art, of the ultrahospitable, holistic, and beneficently dictatorial environment she cultivated at Binnenkant 21, which Velimir was about to experience. Shortly after Marina returned to Amsterdam and to her brother and niece, she threw a birthday party for Ivana, inviting all the children she could find in her neighborhood. Velimir saw this as strategic generosity, "to show how she is a nice person helping refugees." But Marina adored and even idolized Ivana, who was astonishingly intelligent and so composed that she made adults feel as if they were the child, seeking approval. Ivana began collecting various little objects and displaying them around Marina's formerly minimalist mansion, explaining to her aunt, "Don't you know that children are afraid of empty spaces?" Marina had the idea of moving her office to the basement and making a permanent bedroom for Ivana in its place. Wasting no time on consultations, she ordered the materials, and Paolo—who now lived with Marina—got to work on the conversion. Klaus Biesenbach, a houseguest in this period, recalls another incident that indicates Marina's gusto in domestic projects. Marina was talking to someone down in the basement with such engagement and enthusiasm that Biesenbach thought it must be someone very important in the art world, like the director of the Stedelijk. "And I went downstairs and it wasn't the director of the Stedelijk; it was her carpenter

27.4
Marina and Paolo Canevari at Binnenkant 21.
Photo: Alessia Bulgari. Courtesy Alessia Bulgari
and Abramović archive.

working on her door," Biesenbach says. Velimir found this kind of zeal domineering and Machiavellian. He was furious with Marina's plans to build a permanent bedroom for Ivana, interpreting it as an attempt to "diminish my authority" over her. "It was wicked, evil of Marina," he says.

Still, in the early weeks and months of his stay, the house was relatively harmonious. Paolo would cook for Marina, Velimir, and Ivana, creating a family atmosphere that Marina had never experienced. She was gradually surrendering to the comfort she found in Paolo. They had met up in New York shortly after she won the Golden Lion in 1997. Marina snuck away from her daily meetings with Kelly (she had to be secretive because she was officially still with Stefanowski at the time), claiming that there were some old Serbian friends in town who she had to look after. "She kept on telling me I was too young, too beautiful and Italian," Paolo says. "So she felt in danger, at risk stepping into a new relationship." Paolo was a classically handsome and elegant Italian alpha male in appearance, but extremely gentle and sensitive by nature. He was practical and able with the daily tasks of life for which Marina still had a kind of cultivated ineptitude. And Paolo could tend to Marina's core needs. "I knew his fragility and he knew mine," she says. "I started loving him on a deep level, not like anyone else. With Ulay there was always struggle, tension. With Paolo there was the idea of home and peace. He was caring whether I eat or don't eat. Nobody asked me that before. That really opened me completely."

Their relationship developed as they took vacations in India and Sri Lanka, and they also stayed occasionally in Paolo's apartment in Rome if he had an exhibition there. Now, in Amsterdam, as Marina worked in her office all day, Paolo worked on his art. He deliberately didn't have a studio in Amsterdam—or anywhere. He spent his days puttering around quietly, reading, working on his motorcycles, preparing meals, drawing, and gathering materials to sculpt—he was becoming increasingly interested in tires, inner tubes, and rubber. Marina had difficulty understanding Paolo's slow and solitary approach to his art. Initially, she interpreted his patient, unflustered demeanor as indicative of a troubling lack of ambition. Marina recalls, "It looked like he was waiting for me to finish working so I could spend time with him. But my point was that at this stage in his career *he* should not have any time; I should be the one with time." It took Paolo many years to persuade her that his slowness was in fact a deliberate working method. "It was about the difference between an Italian, pensive attitude and a communist, 'go for it' attitude," Paolo says.

As Stefanowski had been, Paolo was beguiled by Marina, but not in the way of a fan. He was careful to retain some psychological independence from Marina, which she must have found reassuring on some level: he was not seduced by her in an ideological sense, and he was not interested in her because of her achievements or her proclamations. He kept his distance from Marina's political and spiritual thrall, and was especially resistant to the didacticism in her work. Marina had recently started a professorship at the Hochschule für Bildende Künste Braunschweig, in Germany, and gave frequent performance art workshops for her students—in which

they fasted in silence for five days, performing various meditative exercises—in various places around Europe. Paolo always refused to participate in the workshops, much to Marina's disappointment. "I said it more than once and publicly," Paolo says. "Never do what Marina does if you are a part of the 'family.' If you are a student or a follower then it's fine; it can be a great experience. But never mix that part of Marina with your life because that can ruin you. That's basically how I defended myself from Marina's strong, enormous personality."

Around this time, Marina invited an ambitious and unknown French filmmaker named Pierre Coulibeuf into the churn of houseguests at Binnenkant 21. He proposed making a docudrama about Abramović's life. Like the *Biography* stage play, it involved reenactments of performances and the narration of sequences of her life. The movie also featured pure, unadulterated acting, with Abramović playing the role of a diva in her downtime—which turned out not to be downtime at all. The camera smoothly tracks Abramović as she strides next to a canal, looking haughty and vulnerable, somewhat inconvenienced to be outside, the potential victim of sudden and unwelcome adoration from a passerby, perhaps. She is dressed all in black and wears the sunglasses of one accustomed to trying to be anonymous in public. Another shot tracks her in the back of a car speeding impatiently down a motorway; again she wears obscuring sunglasses, and appears mildly stressed and detached, though she has an entourage of handlers and lackeys in the car evidently ready to tend to her unpredictable and urgent needs. Sultry saxophone music underscores a sequence of Abramović sullenly picking out what to wear one day, apparently unsatisfied with every outfit. There are sequences with Abramović running and exercising in a field, working frantically in her studio, dancing in front of a white backdrop, and scrubbing the wooden stairs while wearing a skimpy, threadbare red slip with polka dots. In her own manic style, she was channeling the glamour of Sophia Loren and Maria Callas, whom she had idolized since she was a teenager.

Abramović's vulnerability and awkwardness as an actor, and her occasional self-mockery, is only an excuse though—an enabler—for the film's true desire. Coulibeuf was indulging Abramović's fantasies of herself and inflating her ego to get the golden footage he wanted. The exploitation was mutual, but from Abramović's side there was a degree of innocence in it: she was just being characteristically generous and committed, throwing herself into a project and giving Coulibeuf what she thought he wanted and what she thought would be good for the film. In exchange she would get a cinematic and idealized image of herself.

In a way, Coulibeuf was for Abramović what Hans Namuth was for Jackson Pollock. In the early 1950s, Namuth photographed and filmed Pollock making (and simulating the making of) his drip paintings. Namuth choreographed Pollock's every supposedly authentic and instinctive posture around the canvas, encouraging him to look ever more pensive and painterly.[43] Together they were conjuring the ideal image of a mysterious, soulful artist: the one that Pollock cultivated anyway, and the one that Namuth knew would make for great photographs. Just as Pollock came to

bitterly regret this bargain—feeling disgusted with himself as a phony poseur and with Namuth for exposing and exploiting his vanity—Marina too eventually fell out with her image-maker. She'd understood that Coulibeuf would give her the original footage of the reperformances she did for his film. But he maintained that Abramović had signed all the rights over to him, and won a legal action brought by Marina. Later, Coulibeuf presented the hour-long film in art galleries "as his own artwork," Marina believes, alongside loops of her reperformances extracted from the film without her permission. Her anger with him would continue for years to come, along with more legal proceedings.

During this time, Vojo was becoming more frail and desperate, living alone in Belgrade. He began to have delusional and paranoiac episodes, and fell and broke his hip. On August 29, 2000, he called Marina in Amsterdam, but she wasn't at home. She picked up his message late that night. In a weak and plaintive voice he was asking for help again. She was still angry about the loan he'd apparently squandered, the lack of gratitude he'd shown for it in the first place, and at the end of it all, being disinherited. "I said my god, fuck it. I'm doing all this stuff for him and he never called me. So what does he need now? Again he needs money," Marina says. She didn't call him back. "It's on my soul, it's so strong," she says. "I'll never forgive myself." Early the next morning she left for India with Michael Laub to research a new theater production together (which never came about). She arrived in Delhi late at night. "About 4:30 in the morning I wake up and sit on the bed and I have this strange sensation of flashing light. I got the telegram a day later that he died exactly the same time."

After Vojo's death, Marina's relationship with Velimir collapsed. The teaching job she set him up with at the Rijksakademie fell through, she blamed him, and they began having disputes over money. She helped him secure an apartment in Rotterdam, but that too somehow fell through. At the core of their conflict was Velimir's sense that he was being patronized by Marina's smothering and highly conditional generosity, which he had never asked for in the first place. "I was literally a servant in the house," he says. "When I complained, she became furious and said that I do not love her and do not appreciate her help." Marina felt that he was being ungrateful, lazy, and exploitative. They provoked in each other a monstrous, atavistic power of stubbornness, cruelty, and loathing—all made worse through a familial habit of self-justifying exaggeration and martyrdom. In the end, Marina says, "I changed the key to my house because he was using my money, using the phone. What am I, an idiot?" It was no accident that just as her feud with Ulay was dissipating, a new and even more deeply rooted conflict with her brother was beginning: Marina thrived on a sense of embattlement. Her family certainly gave her cause for it: when Milica died in August 2000, Marina was not informed and so missed the funeral. It was a replay of 1993, when Marina found out from a friend she bumped into at the Venice Biennale that her uncle Djoko had died in a car accident; Danica hadn't told her. (Velimir, always ready to puncture Marina's martyred sense of isolation, insists that she was indeed informed of Djoko's death.)

Marina's relation with her history, which had appeared to be resolving itself with her contract with Ulay and her pilgrimage to her father's birthplace, was back in its normal state of barely suppressed turmoil. She, like Velimir, missed Vojo's funeral, partly because she was in India but mostly because she remained angry with him. As both an attempt at penance and a eulogy for her father, she made a new performance dedicated to him. In a field in Andalusia, on the grounds of a private foundation for contemporary art that she'd been invited to, Abramović sat on a white horse, doing nothing but holding a large white flag and gazing into the distance. The only movement was the occasional shuffle of the horse, and the wind fluttering the flag and her hair. The piece, made for video and without an audience, was called *The Hero*. The white flag represented something she felt Vojo would never do—surrender. It was also something she regretted not doing before his end.

28

BIOGRAPHER

Marina was in India again in early 2002 when Sean Kelly finally managed to get through to her on the phone. He'd found an ideal apartment for her and Paolo in New York. He started describing the place—wall-to-wall windows, not-too-high ceiling, beautiful co-op building, perfect location in SoHo right opposite his own loft—but Marina was more interested in the building's street number. Kelly told her and she did a quick numerological reading. It checked out. She told him to go ahead and sign the papers on her behalf.

Marina had felt uninspired by Amsterdam ever since splitting up with Ulay. In fact, ever since the plane crash that decimated de Appel in 1983, she had been frustrated by the lack of vitality in the city's art scene. Paolo felt equally impatient with Amsterdam. Moving to Rome, though, was not an option; he felt about as comfortable there as Marina did in her birthplace. The obvious option was New York, but Marina was apprehensive. She had lingering resentment toward the U.S. over the NATO bombing of Belgrade in 1999. But more importantly, she thought that Americans would not be aware of her achievements, which had mostly come in Europe. "It was like beginning again," she says. "I had lots of fear. If it was not with Paolo I would never have moved to New York."

Paolo also wanted to establish his artistic career in the city. Since he first met Marina, he was inescapably aware of their different status in the art world. "It was very clear to me that I had to build myself up," he says. But no matter what he did, he was left in a bind by Marina's dominance: if he preserved his quiet independence then he would remain overshadowed by Marina Abramović; on the other hand, as his ambition escalated, he resented the inevitable suspicions that Marina Abramović was taking him under her wing and helping his career, or, even less accurate, that he was instrumentalizing his relationship with her. Still, their relationship was strong enough to withstand this structural tension, and that of the large age difference between them. Marina was more secure than she had been since the late 1970s, and Kelly for one noted the benefits of her new emotional calmness: the old habits of distrust and conquest, fueled by hatred of Ulay, were slipping away thanks to Paolo's quiet steadfastness. In a way, Paolo was the perfect composite of Marina's previous loves: he was undemanding and supportive like Neša, practical and quietly powerful like Ulay, and handsome like Paco Delgado. Most importantly, Paolo had his own integrity: he was careful to preserve his core of intimacy with Marina so that the way she related to the world—which she reflected and performed for so passionately and relentlessly—was not the way she related to him. Paolo was the center of a tiny circle

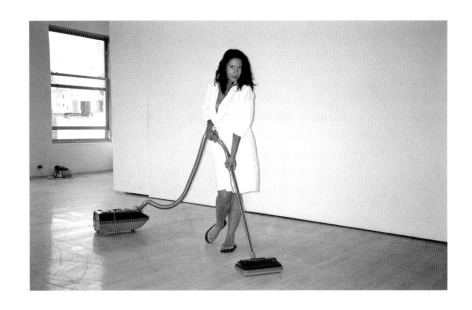

28.1
Marina in her New York apartment, 2002.
Courtesy Abramović archive.

of people—Kelly and his wife, Mary, Chrissie Iles, and Klaus Biesenbach were the others—with whom Marina shared her vulnerability and doubts.

While they never directly collaborated in their practices, Paolo photographed—and helped compose—many of the theatrical and emotionally charged stand-alone images that Abramović was producing more and more of: scenes in Stromboli, where they had a summer home and Marina reveled in the volcanic energy of the island, in which Abramović stands nude in the entrance to a cave on the beach; pseudo-erotic poses, tinged with a deliberate clumsiness, against the minimal backdrop of their SoHo loft; and, on a road trip through Arizona, Abramović standing naked and holding a bull's skull, in homage to Georgia O'Keeffe. While a performance could take years to conceptualize, these photo works were a quick and satisfying creative outlet for Abramović. And it was partly the proceeds from these photos, which sold well through Kelly and through Marina's European galleries—Serge le Borge in Paris, Lia Rumma in Naples, and Kappatos in Athens (all of which she began working with in the late '90s)—that allowed Marina to set up her new life in New York as well as maintain Binnenkant 21 (she only sold the house several years later, finally severing all ties with Amsterdam).

Moving to New York built momentum for a performance Abramović had been cultivating in her mind for some time. It would be an evolution of her transitory objects, aiming to generate the same kind of energy but without the mediation of an object. The mediator would be Abramović herself. *The House with the Ocean View*, her twelve-day performance at the Sean Kelly Gallery in November 2002, was Abramović's clearest expression yet of her elusive ideal of a twenty-first-century art without objects. The piece was about energy, generated by her fasting, her studied and slow movements—adapted from the Vipassana meditation retreats she'd been on with Ulay in India—and her sustained eye contact with the audience. The performance was also a diagram of Abramović's psyche: she was drawing energy from the public for the transcendence of her personal limitations. It was the ultimate solicitation of validation, and she received it in full. In return, the public was allowed and encouraged to project onto Abramović their expectations and desires, only to have them soothingly neutralized in a kind of timeless abyss. In the end, it was a twelve-day energy dialogue without content, just pure empathy. Abramović's aura

28.2
Marina's gallerist Sean Kelly removes a wall in her apartment in New York, 2002. Courtesy Abramović archive.

seeped out into the city: those who returned to the vigil in the gallery each day also carried her in their thoughts as they went about their everyday lives.

I visited the gallery religiously every day for the last five days of the piece (I had only found out about it at the halfway point), and I wrote an article about it for *The Drama Review*, and sent it to Marina.[44] Some weeks later, I got a phone call with a heavily accented voice on the other end. Marina invited me to breakfast in SoHo later that week. She brought a Chinese apple as a gift. She was exuberant and funny, not at all the severe character I'd expected, given the extremity and asceticism of her performances. After performing a quick astrological reading—which was extremely ingratiating and which I later learned she did to most people upon a first meeting—she asked if I wanted to do some work for her. No was not even an option.

At first this entailed working alongside Marina in her and Paolo's large, minimally decorated loft. I took dictation in the small corner office, typing her e-mails and clarifying her eccentric and exuberant English. Often I left the power of the original intact: "This is totally *beyond*" or "The best would be we meet just for a tall cold glass of water." Despite her jumbled verbal constructions, if I made a typo or grammatical error, she was often the first to spot it. Marina divided her time between New York and Amsterdam, but whenever she was in town I went to her loft a few times a week. She arranged things so she was always extremely busy: fielding phone calls in various languages (as well as Serbian, English, and French, she spoke good Italian, but had determinedly never learned German from Ulay or Dutch from her years in Amsterdam); leaping up to get green tea, rice cakes, almonds, or cherries; firing questions at Paolo as he sat calmly at the kitchen table, drawing or tinkering with parts from his motorcycles; getting anxious over imminent meetings with Kelly, with publishers and curators, or with her accountant; visiting the beauty salon (once she summoned me there and dictated while her feet were in a small bubbling hot tub, her hair wrapped in foil and her nails being painted); taking a break for a session with her personal trainer; leaving me at the computer while she began cooking lunch (there was always a good lunch) for a visiting artist friend; being consumed by the fuss of just arriving from or preparing to leave for Europe; and, on just one occasion, abandoning the work session altogether since it was such a beautiful spring day.

28.3
Paolo Canevari in Stromboli, circa 2007.
Courtesy Abramović archive.

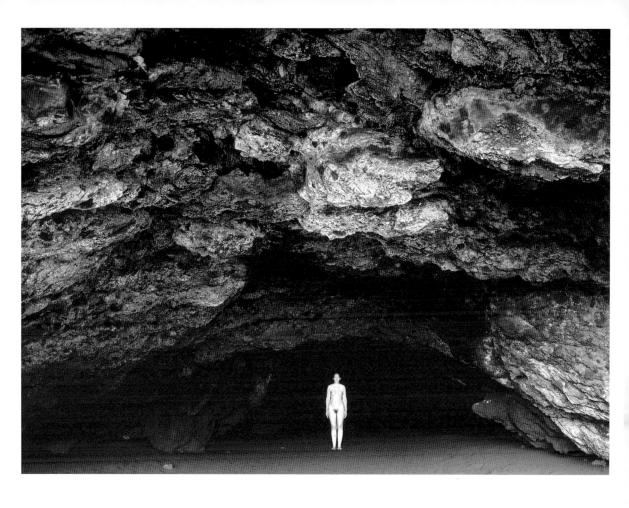

28.4
Marina Abramović, *Nude in the Cave*, 2005.
Courtesy Sean Kelly Gallery, New York.

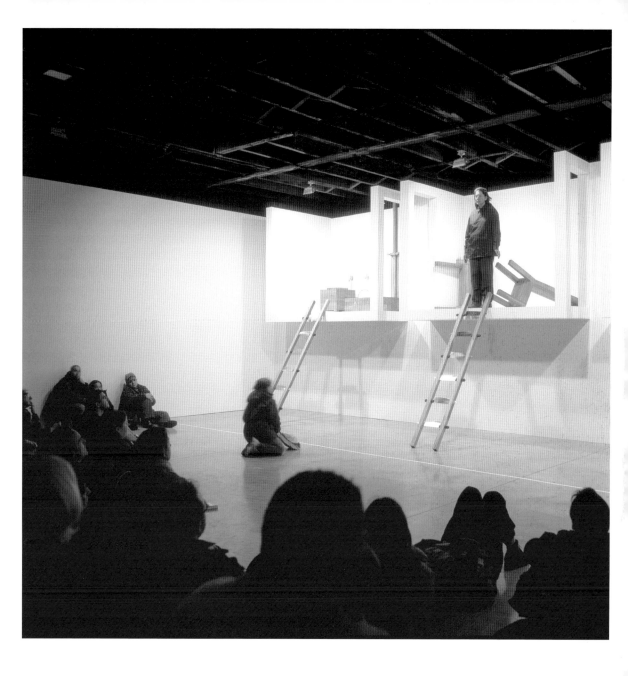

Despite being so flighty and theatrically busy, her concentration on work was formidable and overpowering. I felt exhilarated and drained at the end of a three-hour typing session, like a hurricane had just blown through. I also felt Marina drawing me in maternally as part of her ever-extending, chosen "family."

Every chance meeting at a gallery or a dinner, and especially after a performance—Marina would never let these go. She e-mailed everyone who gave her their card, everyone whose "energy" she had liked. Marina operated through overwhelming and disarming love. The e-mails I typed were full of lines like "I miss your energy" and "How's your love life? Don't forget, it's important," and "Thinking of you." The most casual acquaintance felt immediately intimate with Marina, flattered, adored, and blessed by her attention. Marina's approach was both sincere and strategic. She nurtured her new friendships with Susan Sontag and Björk—both regular visitors to *The House with the Ocean View*—by ordering them books on the Serbian scientist Nikola Tesla. Toward the end of a long ping-pong of invitations, lunches, and thank-you messages with Glenn Lowry, director of the Museum of Modern Art, Abramović dictated: "It was so nice of you to come to dinner last night. You look in good shape and totally sexy." As I was typing it, she said, "Can I say that? What you think? Fuck it, I'm almost sixty—I can do what I want!"

Marina obsessively preserved every e-mail from her galleries, from museums, from her video production company, from her photo archivists, from book publishers, curators, critics, students, and from her bank and frequent flyer program. I filed them both on the computer and in the constantly expanding folders on her shelves. Marina relished her "KGB-style" enthusiasm for filing, and she got a charge from going to Staples to buy ever more folders, dividers, trays, Post-It notes, and various other organizational paraphernalia. Her favorite store in Manhattan was and is The Container Store.

Soon, Marina proposed a new project. For a book about *The House with the Ocean View*, she wanted a diary written of her daily life in the gallery. Every single thing she did over the course of the twelve days had to be "transcribed" from the videotapes in exhausting detail and with unflinching precision. She wanted the language to be as banal and repetitive as possible. In this way, she hoped that the experience of the performance—movement from boredom through repetition to concentration and transcendence—could be recreated on the page. In true Vipassana style, the reader might achieve hyperconscious awareness of Abramović's slow, deliberate movements. Even though I would be writing every word of it and not Marina, the diary had to be in her first-person voice. But I would never be interpreting how she felt or what her intentions were; I would only be describing her physical actions.

So I started going back to the Sean Kelly Gallery to watch the videotapes of the performance (there had been a camera recording each balcony, every moment while the gallery was open, but not at night). It was a brutally cold winter and I would walk the complete breadth of Manhattan, from my apartment at First Avenue and Twenty-sixth Street over to the gallery at Tenth Avenue at Twenty-ninth, through

the wind and snow. Taking a bus or the subway (or even wearing gloves) never occurred to me—it would have eased the endurance factor in the performance I was creating for myself. To make the trip worthwhile, I spent at least three hours at a time watching the tapes and typing. This also gave me enough time to tune into the meditative atmosphere conjured even by the tapes alone.

I sat in the kitchen area of the gallery, sandwiched between the dismantled wooden boards that had been Marina's living space, watching the tapes on a big TV with my laptop on my lap. Each tape lasted ninety minutes, and there were six tapes for each day (except for one of the days, when the gallery had stayed open late into the night). I allowed myself to fast-forward through the parts when Marina was motionless, either locked in a stare, sitting on her chair, or standing still in the shower, but I had to rewind and watch repeatedly all the movements that required more systematic description. I calculated that it would take at least six hours to chronicle everything that happened on each day, and started to panic at the magnitude of the task. That would make a total of seventy-two hours spent in front of the two screens. People who worked at the gallery, including Kelly, often trotted back to the kitchen to make coffee and guffaw at what Marina was asking me do—though they weren't at all surprised either that she *had* asked for it or that I had agreed to it.

Watching the tapes, I started to notice that despite her apparent concentration and slowness, Abramović never did any one thing (sit, stare, stand, shower) for more than about ten minutes. She was virtually flitting about her three platforms, skipping impatiently from one meditative task or position to another. Everything was an entry into an activity or a passage out of it: she was perpetually on her way to or from the bathroom, filling up her water glass at the sink in her bedroom, drinking, walking back and forth, getting ready to shower or getting dressed after a shower, getting ready to sit, preparing herself to stand at the front, brushing out the creases in her pajamas, getting ready to pee, peeing, filling up the bucket to flush the toilet, rearranging the furniture, and on and on. There was hardly ever a sustained period of absolute do-nothing. Still, the most basic rituals became fascinating, and she never replicated them perfectly, despite her best efforts. This was annoying for my purposes because the more she did, the more I had to write. My plan was to observe enough so that I could write one uniform über-description for each of her activities and just copy and paste this every time she did that thing. Each activity would come under a heading like "Sitting on the chair" or "Drinking water" or "Peeing."

When I'd chronicled up to day five, I showed the "transcript" to Marina. She loved it so much she asked me to start again. Instead of having one fixed description for each of her rituals, she wanted a new description for every time the ritual was performed, one that took note of the different nuances each time. "No compromise!" Marina wrote in an e-mail (verbatim):

> I do not care how big it is going to be. This performance was obsessive and long and the description should be obsessive an long as well. Probably at the end we are going to

print it as a separate book. I don't know jet. I only know that I have to have it. Take this as a meditation exercise . . . and you will go through deep transformation at the end of this job. . . . You are on the right way. Please continue. We finish when we finish. (but it should be finished at least by the end of June).[45]

So where there had been one "Sitting on the chair" passage for day one, there would now be seventeen slightly different "Sitting on the chair" passages, because she had sat down on the chair seventeen times that day, in seventeen slightly different ways. Fine. Her e-mail was persuasive. Using the new tell-everything method, each day was yielding at least ten thousand words of description. The diary may be as near a perfect written record of the performance as I could make, but it was completely unreadable in its entirety, and when I started to describe every tiny bodily movement that went into lying on the bed, for example, the act seemed completely alien:

I stand in front of the bed a third of the way from the bottom end. I turn clockwise so I am facing the audience. Then in one fluid movement I sit down on the bed, raise up my feet, move my hands back to balance myself and twist round 90 degrees, lower my body down until it is flat and rest my head so it is touching the pillow directly. I lie straight on my back. My hands are resting flat on the bed on either side of my body. I look up at the ceiling.[46]

The tapes held a few surprises, like Abramović erupting in laughter for no apparent reason (later I found out that the gallery's associate director, Amy Goetzler, was dealing with a problem with the plumbing in Abramović's bathroom, and was holding up a sign for her off camera that read "Don't flush the toilet"). On one occasion, apparently just after the gallery had closed, since it was near the end of the last tape for that day, Abramović broke her own rules. Paolo approached the platform and crossed the white line that kept the public from approaching the knife ladders. Abramović leaned down to embrace him and they whispered to each other. I transcribed this part, and put it under the heading "Breaking the rules," but it was discreetly edited out from the 145-page "transcript" that appeared in the book.

Abramović had been teaching at the art school in Braunschweig since 1998. Every year, she took her students on a performance art workshop in some remote location. The boot camp was designed to cleanse the body and cultivate the kind of mental and physical resolve necessary for performance art—or at least for Abramović's transcendental strain. The ideology of her "Cleaning the House" workshop is summed up in a story she absorbed from the fifteenth-century writings of Cennino Cennini on Renaissance painters. Marina recounted in an interview:

If artists get a commission to paint the wall of the church or the castle of the king or any of these big works, then they have to make certain preparations in order for the work to be a success. He proposed that the artist should not eat meat three months before he starts such a job. Two months before he should stop drinking wine. One month before he should not

have any sexual intercourse, and three weeks before painting he should put his right hand in plaster, not move it at all. Then on the day when he starts to paint he should break the plaster, take the pencil, and he can make a perfect circle. So this was one of the ways of cleaning the house.[47]

I joined Abramović and her students for a Cleaning the House workshop in Andalusia, at the foundation where Abramović had made the video *The Hero* in 2001. As one of the thirty-eight participants, I had to sign a contract swearing that I would not eat or speak for the five days of retreat. Reading, sex, and the use of cell phones were also forbidden. Water and herbal tea were allowed. And we were instructed to take laxatives the day before the fasting began. Marina had been giving these workshops for over ten years and was consistently tough with her students: in Sweden once, she had refused to let two students back into the house who had snuck away to a bar one night.

After a last supper of rice and steamed vegetables the night before the workshop began, Abramović gave us a short lecture. We may only come to her with serious physical problems. Headaches and nausea don't count; they were to be expected as the starving system detoxifies. "And I don't care about your mental problems," she said. "The one thing we don't ask is why we are doing this."

Shortly after dawn on the first day, Abramović padded into our dormitory (she slept in a smaller but equally spartan room next door), rattling a small wooden percussion instrument. We followed her to the equestrian field for morning exercises. I was already hungry. We gathered in a large hall normally used for banquets and dancing. Here we started the first of many meditative exercises: Abramović instructed us to take one hour to write our names, with the pencil never leaving the paper and never stopping. Only once did she tell us how much time had passed before the hour was up.

As the heat faded in the early evening, we embarked on an ambitious trek to the sea, which was about six miles away. After two hours of walking in silence down dusty tracks, across scratchy fields and dried, crispy flood plains, we arrived at an uncrossable river and silently, collectively realized that we wouldn't make it to the sea. Abramović said nothing, except "OK, let's turn around," but I couldn't help inferring some kind of Zen lesson. Abramović said very little throughout, just the bare minimum to explain the exercises. Another one: spend one hour staring into a mirror. Write down every thought that crosses your mind, but don't hold on to that thought. Abramović later made us walk through the forest backward, holding our mirrors in front of us to show the way through reflection.

On the third day, I temporarily forgot about being hungry for a while. I was almost disappointed to have none of the promised detox symptoms. Instead, I felt irrationally euphoric as we did our clumsy morning wake-up exercises, and maybe felt something of the lightness Abramović and Ulay reported during their *Nightsea Crossing* fasts. We did our own mini-version of that performance: I sat opposite a

28.6
The first meal (nothing but white rice) after five
days of fasting at Abramović's workshop "Cleaning
the House" in the grounds of Fundación NMAC,
Andalusia. Photo: Alessia Bulgari. Courtesy Alessia
Bulgari and Fundación NMAC.

severe, short-haired Italian woman with intimidating composure. I managed never to look away for one hour, but the stare felt combative rather than illuminating.

Later, Abramović asked us to write down any questions we had. A tough-looking red-haired woman wrote, "Why is this workshop so easy? It's like a holiday camp." Abramović said, "In the heat you have to do everything slow. And I learn from *House with Ocean View* that doing less is really doing more. You have to confront yourself." In workshops in colder climates, Abramović focused on strenuous, bracing physical activity like swimming naked in icy rivers and running blindfolded in the snow. Here in the heat, much of the time was spent doing nothing. Hunger and listlessness took over as we slumped on our bunk beds in the oppressive heat. I desperately wanted to sleep but it felt like a too-easy escape from consciousness—we were trying to live up to Abramović's example, after all. I dwelled instead on the question that Abramović said "we don't ask": Why *were* we doing this? Maybe it was a craving for discipline in an exhaustingly permissive world. Maybe her students believed that they had to be as disciplined as Abramović in order to make performances. Wandering around one afternoon, I saw a workshopper sitting precariously in a tree. It reminded me of the moments in *House with the Ocean View* when Abramović stood at the edge of her platform in front of the knife ladder trying to defeat the dizziness she felt after days of fasting.

The most traumatic exercise was standing naked (except for a blindfold) in the forest for one hour on the boiling afternoon of the fifth and final day. We were meant to immerse ourselves in nature and "feel that we are not the center of the universe." But I felt the exact opposite: horribly claustrophobic in my body, panting and panicking, anxious about sunstroke and starvation. The only thing I could do to concentrate my mind was to count my heartbeats. I counted three thousand. They were relentless, erratic thumps, rattling my stomach, neck, and head. I counted just to kill time, or to confront the fact that I felt annoyingly, uncontrollably alive. And there was the added anxiety of knowing that the official workshop photographer, Abramović's friend Alessia Bulgari, was sneaking around taking photos of us while we were blindfolded and nude.

That evening, we sat down to make a "Golden Ball" from seven almonds, three coriander seeds, two black peppercorns, one white peppercorn, and a dribble of honey. Then we wrapped the Ball in a sheet of 24-carat gold leaf. Tibetan monks eat a Golden Ball after they have been fasting to stimulate their brains, Abramović told us. (She and Ulay had eaten a sandwich covered in gold leaf on their birthday in 1978.) Abramović told us to go to a beautiful, solitary place to eat. I went to a field at sunset and ate the Golden Ball in four bites. Later, when we are allowed to speak again, a workshopper named Doreen Uhlig told me that she ate her Golden Ball outside a dusty little café in the village at the bottom of the hill. She wanted something mundane in the midst of the strenuous profundity of the workshop.

On the fifth morning, we found a long table set up in the banquet hall. The exciting smell of rice was leaking in from the kitchen but people were surprisingly

reluctant to take their seats. Abramović emerged with a huge vat in her arms and put a dollop of rice on each of our plates. She told us to close our eyes and "use the right hand" to eat the rice, slowly. The tears streamed down my face (I wasn't alone in this) as I ate what felt like a holy, elemental gift. I was grateful for reentering the world—and doing so on what I felt was a more hyperconscious plane, at least for the moment. Thinking about this moment later on, I was embarrassed and slightly resentful at being subsumed so totally in the ideology of the workshop.

A day or two after the workshop ended, still basking in the euphoria of detoxification, but more of being able to eat again, I shared a taxi with Marina and Paolo—who still refused to participate in Marina's workshops—to the airport in Jerez. We left the grounds of the country club (Marina had moved from the dormitory to the club's luxury hotel with Paolo after the five days of the workshop were up) at about 4:00 a.m. Paolo had with him a blindfold for sleeping in the taxi; Marina was raring to go, carrying a sugar-, caffeine- and artificial color–infused can of Fanta for the journey. Fanta seemed sinful after this regime of mental and physical purification. A couple of days ago we would have been pondering the effect of the color orange on our nervous systems, and the false, transient energy provided by the sugar. I joked about this to Marina and she said gleefully, "Baby, come on, the Fanta is beyond," taking a big gulp.

29

PERFORMANCE ART AS A PERFORMING ART

In a 2003 episode of *Sex and the City*, Carrie and her girlfriends visit a gallery in Chelsea, eager to admire an artist they'd heard about who had been starving herself in austere silence for several days. To them, it sounded like normal New York breakup behavior elevated to an artwork. They enter the Sean Kelly Gallery and step into a remake of Abramović's *House with the Ocean View*. Abramović is played by a much younger actress, wearing the same kind of monochrome outfit, standing on the same platforms, reconstructed for the cameras. She has the same thick dark hair, but artfully mangled into a wild mess, unlike Abramović's always tidy deportment. Her stare over the audience has a similar intensity, but is much more dramatic and pouty than Marina's blank, longing gaze. Carrie whispers to her friends how the artist, who remains unnamed, probably sneaks cheeseburgers late at night when nobody's around.

Almost a year after the performance was finished, Marina was thrilled for it to be restaged for the cameras. Even if her piece would inevitably be watered down and made mildly comic for television, she wasn't precious about the recreation. The producers had asked permission to reconstruct the piece, and had brought it to life again for a moment—and for a mainstream audience who might never have heard of performance art. In this sense, the *Sex and the City* skit was close to an ideal mode of the kind of reperformance structure Marina had been thinking about since the very first *Biography* stage play eleven years earlier.

Abramović's soldier-like determination in continuing with performance art for decades after her original colleagues had moved on wasn't only for the sake of achieving her own goals as an artist. She felt a grave responsibility for enshrining performance art in the story of art in the twentieth century, where it rightly belonged. (When the Museum of Modern Art reopened in its expanded home in Manhattan in 2004, Marina was disappointed but not surprised to find that videos, photographs, or relics of performance art weren't on display anywhere in the permanent collection.) But in order to achieve greater longevity and canonical recognition for performance art, Abramović faced two problems. First, the vast majority of performance artists didn't last long in the practice; so performance was perceived as just a phase in their career, or for others, merely an auxiliary to their material practice. The other major difficulty with etching performance art into art history is that the medium is by nature transient and ephemeral, automatically transferred into something else (video, film, photography, sound, objects) the moment it is preserved. The performance theorist Peggy Phelan wrote, and Marina agreed, that "performance's only life is in the

29.1
Marina's former student Viola Yesiltac and Ulay's
son Jurriaan Löwensteyn reperform *Rest Energy*
in *The Biography Remix*, directed by Michael Laub,
Rome, 2004. Courtesy Abramović archive.

present."[48] For most of those concerned, this meant honoring the ephemeral essence of performance, allowing it to slip into memory, sustained—or freshly evoked for new audiences—only by documentation that acknowledges its inherent inadequacy and difference from the performance itself. For Marina, keeping performance alive in the present meant something else: reperformance.

Marina had been trying to organize reperformances of other artists' work at least since 1998, when she proposed the idea to the Institute of Contemporary Arts in London (it didn't work out). And she had been talking to the Guggenheim Museum about the idea since 1999, when she strategically attended a dinner at the Venice Biennale where she knew Thomas Krens, the Guggenheim's director, would be present. Reperformance was always on Abramović's mind as she continued to make new iterations of her *Biography* stage play. In 2004 her old friend Michael Laub directed a new version, *The Biography Remix*, featuring Abramović and her students from Braunschweig reperforming her works. Jurriaan Löwensteyn—Ulay's son whom Marina only found out about in 1987, when he was sixteen years old—took the role of his father in the play, performing the bow-and-arrow piece *Rest Energy* first with Abramović and then with one of her students, Viola Yesiltac. It was a step too far for Abramović to reperform the pieces with Ulay himself, though he later hinted that he would have been willing had she asked him. Also in 2004, Abramović made a re-performance of sorts of her 1974 piece *Rhythm 5*. She returned to Belgrade and made a pentagram this time not out of fire but out of prone schoolchildren, all dressed in black. Abramović stood in the middle of the star wearing a skeleton costume—a remark on the bleak future she saw for Belgrade's children. The work was one among a suite of new videos called *Count on Us*. In another, Abramović, again wearing the skeleton costume, conducted the children as they sung a ridiculous—but real—hymn to the United Nations. The works also included a couple of homages to the oft-overlooked Serbian scientist Nikola Tesla, inventor of the radio and remote control. Marina's fascination with Tesla—greatly informed by Velimir, who edited the journal *Tesliana*, and by his wife, Maca, who was director of Belgrade's Tesla museum—was with his success in various means of projecting energy over distance, something she always wanted to achieve in her art. Chrissie Iles included these video works in the 2004 Whitney Biennial, which she co-curated.

In November 2005, after years of conceptualization, preparation, and persuasion, Abramović staged the cheekily titled *Seven Easy Pieces*, a marathon seven-night run of performances, each lasting seven hours. Five of the pieces were re-creations of works from the 1960s and '70s by other artists, one was a reperformance of one of Abramović's own works, and the last would be a new piece. In re-creating classic performance art pieces, Abramović wanted to ask an iconoclastic question: Can performance art be treated like a performing art—something to be repeated and reinterpreted by anyone with adequate experience, skill, and conviction, like the script of a play or a musical score? Abramović believed so—that the extremely personal, expressive, and transformative acts of performance art could be liberated from

29.2
Marina Abramović, *Count on Us—Star*, 2004.
Photo: Attilio Maranzano. Courtesy Sean Kelly
Gallery, New York.

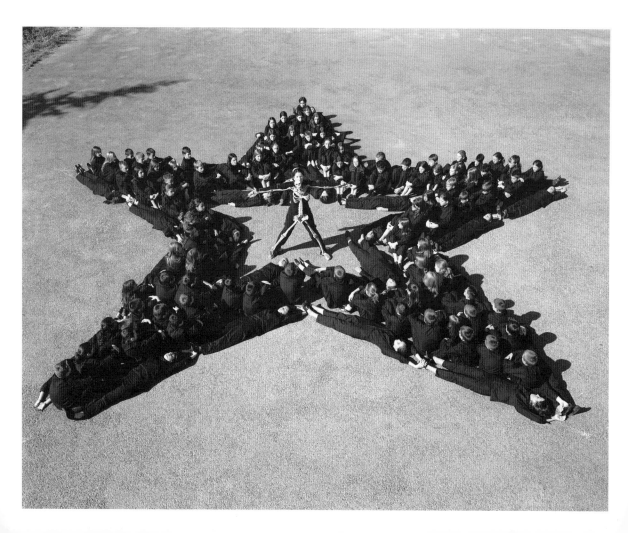

their author. This approach grated somewhat with the fact that her own perfor-mances had always been based on her unique, unmatchable physical presence and will power, and on the fact that no one would be able to do these performances, or do them as well, as Abramović herself.

Abramović also wanted to set an example: she would only perform other artists' works with their express permission. In 1998 the fashion photographer Steven Meisel had re-created images from *Relation in Space* for the cover of *Vogue Italia*. The first Marina knew about it was when she saw the images in the magazine: two lanky models, semiclothed in designer gear, brushing past each other, colliding and recoiling in photos that reconstructed Abramović and Ulay's performance documentation with disturbing precision. Marina was incensed that Meisel had so brazenly copied her and Ulay's aesthetic without attribution, an indication of the original context, or even a thank-you.[49]

In the years leading up to *Seven Easy Pieces*, Abramović was engaged in a long campaign to secure permission from several of her peers in performance to remake their works. She was particularly intent on reperforming Chris Burden's legendary 1975 piece *Transfixed*, in which he had nails driven through his hands as he lay on the back of a Volkswagen Beetle. "I really wanted the idea of the woman being crucified," Marina said at the time, "because it's always images of men being crucified. But to have the image of the woman would be a good thing for this century."[50] Burden said no, without offering an explanation.

Vito Acconci proved more cooperative: he granted Marina permission to re-perform his 1972 piece *Seedbed*, in which he lay under a ramp in a gallery in New York, masturbating for hours at a time, and miked up so his muttered fantasies could be relayed to people walking above him. Marina's old friend Valie EXPORT happily allowed her to redo *Action Pants: Genital Panic* from 1969, in which she had prowled around a porn cinema in crotchless leather trousers, confronting the male denizens with a real live version of what they were looking at onscreen (many of them fled the scene). Bruce Nauman gave permission to reperform his 1974 piece *Body Pressure*, which consisted of instructions, printed on a large sheet of pink paper, to press one's body against a wall. Reperformance by others was the essence of this piece; Nauman had never actually performed it himself. The estate of Gina Pane allowed Abramović to reperform the first part of *Self-Portrait(s)* from 1973, called *The Conditioning*, in which Pane lay for half an hour on a metal frame a few inches above rows of burning candles. In the remaining two parts, Pane had cut her lip while murmuring "I don't want anything to be perceived," and then cut into her cuticles while a film of her nails being painted bright red was projected on the walls—along with implicating shots of people in the live audience. Marina only performed part one, the most searing image and the most manageably repeatable action over the course of seven hours.

It was more difficult getting permission from Joseph Beuys's widow, Eva Beuys, to redo his performance from 1965, *How to Explain Pictures to a Dead Hare*. Beuys had covered his head in honey and gold leaf (two of his energy-giving materials)

and "explained"—though he remained silent throughout—the pictures on the walls of Galerie Schmela in Düsseldorf to a dead hare that he cradled in his arms. When Marina turned up on Eva Beuys's doorstep in Düsseldorf in the middle of a snow-storm, she opened the door and said "Frau Abramović, my answer is no, but it is cold so you must come in for a coffee." Marina replied, "Frau Beuys, I don't drink coffee but I would love some tea." (Coffee gave her migraines.) Once Marina got in the house, there was only one possible outcome. She convinced Eva of the sincerity and care of her project, how it was specifically meant to set an example for the proper reproduction of other artists' work.

Abramović drew up a contract stating that there would be no reproductions of images from her reperformances, except in the catalogue and the film (there would be a film of the performances made by veteran filmmaker Babette Mangolte). And there would be no artwork made or sold as a result of the reperformances (except of her own work). Thus it would be a restaging that would only have life in the present.

This complex back story grounded the action of *Seven Easy Pieces* that unfolded at the Guggenheim. It was a weighty and worthy history lesson for the public to absorb before they could properly appreciate Abramović's meditative actions on the circular stage at the bottom of Frank Lloyd Wright's rotunda. An atmosphere of heightened empathy, familiar from *The House with the Ocean View*, gathered in the soaring atrium, particularly as the performances stretched deep into the night, the crowd dwindled, the background hum softened, and the attention and devotion intensified. Many people would come at 5:00 p.m. to watch the beginning of the performance, go and have din-ner, then come back later on, staying until the museum closed at midnight (when the public was ushered out and Abramović remained on stage—except on the last night). Abramović again created a durational performance that permeated the consciousness of the city. The Guggenheim became a shrine demanding visitation at least once a day, and the public could carry the performance with them even when they weren't there.

The series started with the most austere piece, Nauman's *Body Pressure*. Abra-mović had prerecorded Nauman's written instructions, and her stern voice rang out in the atrium every few minutes: "Press as much of the front surface of your body (palms in or out, left or right cheek) against the wall as possible . . ." Standing on the circular stage, and watched by a couple of hundred people, Abramović flung herself repeatedly at a glass wall on cue, smushing her face and body against it. For the allot-ted seven hours, she put maximum physical effort into a piece that wasn't originally about endurance but more about subtle perceptions of physical space. This set the tone for the series: Abramović would stamp her identity on the pieces and make them her own. Stretching her seven easy pieces out over seven hours necessarily turned them all into Abramović-style endurance performances, meditative and repetitive loops of seemingly banal activity that would force its way onto a transcendent plane.

For Vito Acconci's *Seedbed* the next night, Abramović masturbated under the stage for seven hours, completely out of sight like Acconci and—miked up for all to

hear—talking dirty. Abramović also theorized about what it meant for a woman to be performing this piece. "Acconci produced semen. I produce moisture," she said. (Marina later gave me the task of transcribing the seven-hour-long masturbatory monologue.) There was a jovial atmosphere in the rotunda as the public lined up to spend some time on the stage above Abramović. As she talked herself up into another orgasm, using her fantasies about the people above her as erotic fuel, people started to do the stamp-stamp-clap of "We Will Rock You" to help her along. Close to midnight, a dramatic wail echoed through the rotunda, and Abramović said triumphantly, "Nine! That's it. I can't move any more. I am finish." Then there was postcoital cuddle talk: "I'm in the embryo position. My legs are together. I don't masturbate anymore. I'm so warm. You helped me feel this. You helped me get in a space where I never been before. I'm so grateful." If Acconci's original had been full of filthy, secretive, and aggressive muttering, Abramović made her version about healthy communal sexual healing—empathy rather than opportunism.

The next night, her version of Valie EXPORT's *Action Pants: Genital Panic* didn't re create the original performance itself but the iconic documentary photo EXPORT made afterward, and which came to stand for the piece as a whole: the artist sitting with her legs apart showing her genitals in the hole in her trousers. She was wearing a leather jacket, her hair was huge and wild, and she was grasping an AK-47–type gun. Abramović assumed this same position, adding to it a meditative, hyper-alert sensibility, sometimes staring at one spot or one person, sometimes twitching, her eyes darting around the room. She was alternately like a nervous animal sniffing the air, and a guard sitting sentry. At one point she engaged in a prolonged, *Ocean View*–style stare with somebody, and they were both left in tears. At other moments in the evening, the audience grew impatient with Abramović's lack of activity. Her confrontational stance without any follow-through was a provocatively passive-aggressive image. Someone shouted out from high up on the ramp: "Put the gun down or use it," to which someone replied, "She *is* using it." Later, someone else shouted: "Why the silence? Is this a church? Why are we passively accepting this image?" The man then stomped down the ramp and stood in front of the stage staring at Abramović, but still she did nothing. Her blankness remained: she was encouraging mass transference, as usual, but offering nothing in return.

What Abramović certainly didn't do was stalk around the rotunda harassing men, taunting them with the site of her apparently available pussy, as EXPORT had done in the cinema in the original. That was deemed too risky, perhaps presciently, since someone did try to climb up on the stage to sit in the empty chair that was set invitingly next to Abramović. That person was quickly grabbed and escorted out by one of the bulky security guards.

On her fourth night at the Guggenheim, as Abramović lay on an iron bed frame above a row of candles for her performance of Gina Pane's *Conditioning*, a black square gradually burned into the back of her shirt. She would periodically roll

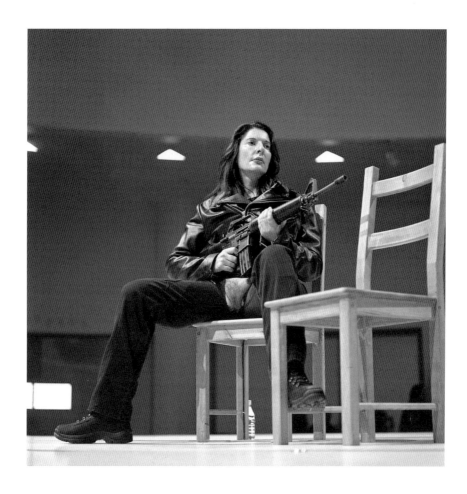

29.3
Abramović performing *Action Pants: Genital Panic*
(1969) by Valie EXPORT, in *Seven Easy Pieces*,
Guggenheim Museum, New York, 2005. Photo:
Attilio Maranzano. Courtesy Sean Kelly Gallery,
New York.

off the frame when the heat of the candles below became too much. In these inter-ludes she would replace the burned-down candles with fresh ones. During one of these breaks, Abramović suddenly looked up directly at the audience and said, "I need a knife." A young man reached into his backpack, pulled out a pocketknife, opened it up, and slid it across the stage to Marina. She took it and used it to clean the gummed-up inside of the candleholders. It was the first time I'd ever seen Abramović step out of performance mode during a performance. In doing so, she had created an instant bond with the public: she had literally cried out in need and someone had re-sponded quickly and practically. There was something touching about this moment of reciprocity and vulnerability, maybe precisely because it concerned something neither Abramović nor the Guggenheim had accounted for—the necessity of a knife to replenish the candles—in the midst of this heavily produced event. Abramović had broken through the theatricality into intimacy, and she'd done it not by being strong but by being weak.

In reperforming Beuys's *How to Explain Pictures to a Dead Hare*, Abramović stomped slowly around the stage in her Great Wall of China hiking boots with a steel plate attached to her right sole (on the bottom of her left sole was, following Beuys, a piece of felt). She obsessively rearranged three Beuysian (though blank) chalkboards and occasionally whispered inaudibly to her rapidly defrosting hare. But as with the EXPORT reperformance, Abramović again focused on static imagery: she repeatedly constructed a tableau vivant of Beuys with one pedagogical finger raised while look-ing lovingly at the hare. The moments when Abramović held the hare's ears with her teeth and crawled slowly around the stage was a forgotten element from the original piece, which she had discovered when Eva Beuys showed her ultrarare footage of Beuys's performance.

Abramović had wanted to exhume *Rhythm 0*, her most dangerous performance, for *Seven Easy Pieces*. Ironically though, she couldn't get permission to restage her *own* performance: a gun and a bullet available for public use was more than the Guggenheim could risk. Instead, she reperformed *Thomas Lips*—not for the first time, although her rendition of the piece in Amsterdam in December 1975, the day she met Ulay, was largely unknown, and certainly was not communicated in the lit-erature surrounding *Seven Easy Pieces*. To stretch the performance out over the allot-ted seven hours (it was originally two hours long), Abramović performed the stages of the piece in shortened, incremental versions, and in a loop. She went through the whole cycle of eating honey, drinking wine, cutting her belly, whipping herself, and lying on the ice cross at least a dozen times over the course of the night. And she adapted the original by adding a new stage to the sequence of self-torture. After cut-ting the star on her belly (which she did gradually over the seven hours, following lines drawn in marker pen on her skin), she dabbed the blood with a white sheet, tied it to a stick (her walking stick from the Great Wall), stepped into her boots (also from the Great Wall), put on her mother's Partisan cap from the war and—still na-ked apart from the boots and the cap—held the bloodied flag of surrender up while

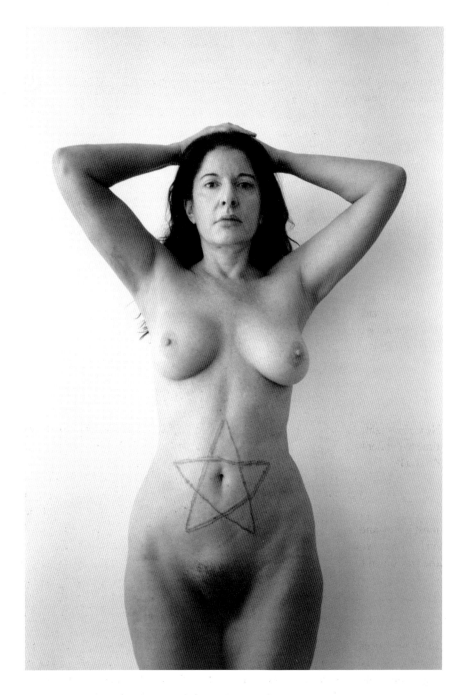

29.4
Marina Abramović, *Nude with a Cut Star*, 2005.
(Marina at home the morning after performing
Thomas Lips at the Guggenheim.) Photo:
Paolo Canevari. Courtesy Sean Kelly Gallery,
New York.

an a cappella Serbian folk song echoed through the atrium. The translated lyrics were available at the front desk:

O Lord, save thy people
Blessed is Thy name
Forgive us, Lord, our sins
Committed on the Earth.

Look upon us, Slavic souls
Suffering in the world
Nobody understands us,
Our fate's not worth a penny.

Remember the times of glory,
In Thy name to wars we went,
The war is our eternal cross,
Our life is of a true faith.

The war is our eternal cross
Long life our Slavic faith.[51]

Near midnight, Abramović once more reached the point in the cycle where it was time to cut her belly. She had already made at least two full star shapes by now. "Why do you have to do it again?" someone shouted out in the silent rotunda.

Abramović's seventh easy piece was a new performance, *Entering the Other Side*. Coming after the self-inflicted trauma and high drama of *Thomas Lips*, it was maybe the calmest and least demanding piece she'd ever done—but also one of the most gaudy and baroque. Abramović perched at the top of a huge blue cone placed on her stage, wearing an electric blue dress that appeared to continue and cascade all the way down to the floor, about twenty feet below her. It was an image of extravagant glamour unsurpassed even by her theater pieces in the 1990s: Abramović was like a fairy on top of a cake. Standing in this all-encompassing dress, raised up to the first level of Frank Lloyd Wright's ramp, Abramović performed slow, regal, sweeping movements with her arms for seven hours. It was a bit like tai chi in its meditative, soothing concentration. With every movement of her arms, it was as if she was trying to gather up the watching public, bless them, shower them with a force field of energy. Unlike the grave, ashen expression of the previous night, Abramović's face was placid, a gently overflowing spring of love—a transmitter and a receiver of energy.

Like *The House with the Ocean View*, the piece was based on the principle of generating a unifying empathy in a physical space purely through presence, concentration, emptiness, and duration. Toward midnight, Abramović broke the low-level humming silence in the room with a short speech: "Please, just for the moment, all

of you, just listen. I am here and now, and you are here and now with me. There is no time." But for these purposes, the elaborate, fairytale prop that was the dress was a spurious, impossible-to-ignore distraction. The scene was like a distillation of Velimir's critique of his sister: that she cannot achieve the true spiritual elevation she wants because she's so attached to the validation of material pleasure—and, even more difficult to transcend, the validation of the audience. When midnight struck (and it did, in a theatrical gong over the speakers), Abramović climbed down inside the cone and emerged from under the stage to rapturous applause, which went on for what felt like an age. She was melted by it, and began embracing tearful people in the audience.

KNOWLEDGE OF DEATH

Marina always has a new joke to tell. This announcement, which she usually makes toward the end of a lunch or dinner party where new and only vague acquaintances are present, always triggers anxiety in those who have been through this before. Apart from the brutal black humor, which often goes well beyond risqué political incorrectness, Marina's delivery is deliberately blundering, comically so. The jokes are mostly about the Balkans, an area usually treated with pious or bewildered detachment, seemingly too complicated and horrific for anyone but a Slav to approach. Marina detects this refined oversensitivity, and so goes straight for the jugular each time. One such joke went like this, verbatim, typically mangled by bad timing, wrong emphasis, and halting English—so that it takes an extra couple of seconds to get it (and even then it's more puzzling than funny):

> During the war this guy's wife is not coming back for five days. Nowhere to be found. He's totally worried. Shit. Where she is? So for five days she's not anywhere to be found. Then after the five days she arrives, totally out of breath, and says, "You cannot believe it, I was walking on the street and I was caught by entire United Nations army, who just fuck me, seven days, nonstop, everybody." He says, "How you can be fucked seven days when you only left five days ago?" She says, "I just came back to tell you!"

The summer before *Seven Easy Pieces*, Abramović had returned again to Serbia to make a video work called *Balkan Erotic Epic*, which illuminated her blunt, comic, and maybe ironic essentialist attitude about her homeland. The video, made in high-gloss production, consists of short scenes apparently based on Balkan folklore and superstitions, which Abramović claimed to have discovered through extensive research—though the sources remain mysterious. There are scenes of naked men humping fields, and women flashing their genitals to the earth during a rainstorm and massaging their bare breasts while looking heavenward (which Abramović also did in her own solo scene). Such activities were apparently done "since ancient times," Abramović narrates, to ensure the fertility of the land. For one scene, which was explicitly Abramović's invention, she lined up ten men in a row, with their flies undone and their semierect penises poking out. The soundtrack is the chilling song that was played periodically during the reperformance of *Thomas Lips* at the Guggenheim, about war being the eternal cross of the Serbian nation, "O Lord Save Thy People." It was sung by the Serbian actress and singer Olivera Katarina, a diva of the 1960s and '70s in the same vein as Marina's beloved Maria Callas. While it looks like the

30.1
Marina Abramović, *Balkan Erotic Epic*, Belgrade,
2005. Photo: Milan Dakov. Courtesy Sean Kelly
Gallery, New York.

men are getting aroused by a mournful song about the victimization of their country, Abramović had in fact put on a porno movie.

Balkan Erotic Epic evokes a Balkania of blood, soil, and semen, where a primal sexuality links the south Slavs to the land. Virility, conquest (of the opposite sex), honor, and survival are paramount, along with a sustaining sense of victimhood. Abramović let all these politically incorrect myths run wild in her film. On one level she adored the primitive power she assigned to her nation, and shared in its sense of being the underdog, permanently embattled. But she also despised and ridiculed this mentality, stuck as it was hundreds of years in the past, when Serbia was still resisting Ottoman rule. She herself had suffered from the pursuit of an essential, "authentic" Montenegrin art when she was kicked out of the nation's pavilion in Venice in 1997. Here she was trying to indulge, enjoy, and parody what that so-called authenticity might mean. To her old friends in Belgrade this latest project of Marina's felt like an outsider's gaze or a bad joke at best, and at worst a throwaway betrayal, a casual exploitation. Marina though was glad that she had both an insider and outsider perspective. For her, laughter was the only way to deal with the weight of her country's psychic baggage, and the disapproval of her old comrades in the New Art Practice was inevitable.

Marina showed *Balkan Erotic Epic* at the Sean Kelly Gallery less than a month after performing *Seven Easy Pieces* at the Guggenheim. Among all the funny skits projected on the gallery walls, there was one much darker sequence: Abramović had her hair combed forward, thick over her face, shrouding it entirely and falling down below her neck, so it appeared as if her head had been swiveled 180 degrees. She was bare-chested and held a (replica) skull in her hands. She started to slap the skull against her stomach, slowly at first, then faster and harder, until she was practically beating herself with it. The insistent repetition was disturbing, demented even. It was as if Abramović were trying to force knowledge of death into herself, bodily.

Marina and Paolo married in April 2006 in a small civil ceremony in New York in a friend's grand town house near the Metropolitan Museum of Art. Marina was the woman of Paolo's life, he said; he'd recently gotten tattoos with her name covering his left arm. Marina was approaching her sixtieth birthday and, after being together nearly ten years, had finally felt secure enough to say yes when Paolo asked her to marry him. If she had been young enough, she would have had children with Paolo too. "I grow so slow," she says, finally feeling a maternal twinge. The big celebration in this period though was not for her wedding, which was only attended by about ten guests, but for Abramović's public life. Ten years on from her infamous fiftieth birthday party in Gent, when Jan Hoet had presented himself to her naked as a gift and she had performed again with Ulay, Marina was ready for another epochal birthday celebration. This one would establish her in the New York firmament of art stars. The Guggenheim at first considered Abramović's guest list for the occasion too ambitious, but the rotunda ended up being crammed with more than three hundred

30.2
Marina and Paolo's wedding, April 2006.
Courtesy Abramović archive.

30.3
Marina before her sixtieth birthday party, wearing
a dress made for her by Riccardo Tisci of Givenchy.
Photo: Chance Yeh / PatrickMcMullan.com.
Courtesy Patrick McMullan.

and fifty art world luminaries and friends from various stages of Marina's life, sitting at forty tables. Ulay was there again.

Abramović had democratically randomized the seating—guests pulled their table number lottery-style from a large glass bowl as they entered the rotunda. After several elaborate toasts—including one to the two other children of November 30 present, Chrissie Iles and Ulay—the angelic androgynous singer Antony Hegarty performed two overwhelmingly beautiful songs. Marina privately resolved that he should sing at her funeral. Later, Björk and Antony sang a duet of "Happy Birthday" for Marina; Laurie Anderson's husband Lou Reed had been asked to join in but didn't want to risk stealing the limelight from Marina. As in her best performances, Abramović made the guests feel exultant and blessed. And as in her performances, the outside world and a normal sense of time disappeared. I asked someone for the time and found out it was past midnight, hours later than I'd expected.

Ulay was gregarious, touring tables with the controlled recklessness of someone very experienced at being drunk at public events. But a just-contained bitterness was leaking from him, despite the relentless smiles. I wondered why he would come to an evening that amounted to an apotheosis of Marina Abramović. Moreover, wasn't Abramović's invitation just as much a gesture of mastery—exploiting Ulay's penchant for self-laceration—as it was one of reconciliation (they'd been arguing again about the archive) and a rightful public acknowledgment of his importance? I had never met Ulay at this point. I didn't want to make him feel scrutinized, or even less the center of attention, by introducing myself as writing a biography of Marina. Instead I said, "I used to be Marina's assistant." I'd given him a slam dunk: "So did I," Ulay replied, and walked off merrily and determinedly.

In the summer of 2007 Canevari had a video selected for the exhibition in the Arsenale at the Venice Biennale. He had made the video in Belgrade while Marina was shooting *Balkan Erotic Epic*. In the ruins of the old Yugoslav Defense Ministry, bombed by NATO planes in 1999 and now an untouched martyred landmark in central Belgrade, Canevari filmed a boy playing football with a rubber skull. It was a popular piece in the Biennale, and the Museum of Modern Art in New York added it to their permanent collection. It was the peak of Canevari's career so far, and Marina celebrated by putting on a surprise party for him on a yacht. Inevitably though, Marina quickly became the center of attention at the party, since dozens of old friends and acquaintances from three decades of past Biennales were milling around. Paolo was accustomed to this by now, and seemed to dwell happily enough in Marina's shadow; his quiet mode of being was in fact contiguous with how he asserted his independence from Marina. The party was in a way typical of Marina's generosity: she gave freely, frequently, but also naively. She always believed she was innocently helping people when she tried to organize their lives or support their careers, and never recognized the domineering aspect of her generosity that was an inevitable result of the power differential between Marina and most other people.

This had come up when Velimir lived with her in Amsterdam. But it was most apparent with her students. To help them enter the art world after graduating, Marina set up a structure in 2003 called the Independent Performance Group, through which she organized events in various museums, including P.S. 1 in New York and Marta Herford in Germany; some former students performed at the Venice Biennale under the aegis of IPG a few days after Paolo's boat party. But IPG never gained real independence from Abramović: they could not match her energy, and did not want to follow her vision or, as some complained, forever be associated with her name. So Abramović was left to continue organizing events—and picking up tabs—for the underenthusiastic IPG to the point where she inevitably felt unappreciated and disbanded the group.

Teaching was one extra burden that Marina had recently shed: she quit her professorship at the Hochschule für Bildende Künste in Braunschweig, finding her life too busy and university life too sluggish (she thought she could achieve more with her students curating them independently, and in 2003 had produced a massive compendium of their work—under her name—titled *Student Body*). With each new achievement in New York—*House with the Ocean View*, her inclusion in the Whitney Biennial in 2004, and then *Seven Easy Pieces* at the Guggenheim—Marina's everyday life became more frenetic and looked less and less like the calm and connected way of living that her performances seemed to propose. Velimir, whom Marina did not invite to her sixtieth birthday party since they were still feuding, found Marina's increasing addiction to work wrongheaded and distasteful. "When you work you somehow have the illusion that you will not die," he says. "It was exactly Tito's way as well: I don't have time to get old because I'm constantly working. I think Marina does not realize that she already achieved what she could. . . . When somebody's getting old, he should restrain his activities. The Dalai Lama said that in the moment when an artist achieves a higher consciousness they will willingly abandon working." Abramović herself had quoted the Dalai Lama on this point in her second monograph, *Public Body*. But all the performances, photographs, videos, objects, installations, and workshops she produced that pointed toward this transcendent empathy with other people and with the natural world couldn't quite heal the old wounds of parental abandonment, and the desperation for achievement and recognition that resulted from them. Marina still held fast to the other side of the Buddhist dialectic: "Strive without ceasing"—the Buddha's last words to his disciples.

Abramović always saw her quotidian, private life as something to be sacrificed for the public duty that is her artwork, and for the "higher self" that emerges in her performances. "I think my situation is no different from any other performer's situation, from Maria Callas to Uma Thurman. You step into another kind of mental and physical construction when you perform—your concentration is so high, which it cannot be in daily life." Marina embraces "daily life"—trashy movies, food, fashion—as the antidote to the extremity of her performances. (During the day before each performance of *Seven Easy Pieces*, according to Marina's assistant, Declan

30.4
Marina and Paolo at Danica's funeral, Belgrade,
August 2007. Courtesy Abramović archive.

Rooney, she stayed in bed most of the time with the covers pulled up high, watching daytime TV.) But as the demands of her public life increase, the space for such normality shrinks, and the only escape for Abramović is, paradoxically, back into performances. "This is why I want my performances to be longer and longer," she says. In performance, she can access the authentic Marina Abramović, the one who exists purely for the public. Klaus Biesenbach, who she drew closer to once they both moved to New York, puts it another way: "I think she saw herself as an institution from the very beginning. I think she doesn't see herself that much as a person. I always say that a beautiful Van Gogh painting doesn't belong to a private collection, it belongs in a big museum. And I think somebody like Marina doesn't belong to a single person, she belongs to everyone." Everyone except herself, that is, but this was a price she had always been willing to pay.

Much of this sense of public responsibility Marina had learned from Danica, who was now slowly dying in a hospital in Belgrade. The last time Marina had visited her in her apartment, she suspected that Danica no longer went to bed, but just slept in her chair. "I think she was incredibly afraid to lie down because she thought that if she lay down, she was going to die." When Marina visited Danica in the hospital, she would ask, "Are you OK?" Danica would steadfastly reply, "I'm fine." "Do you feel any pain?" "Nothing hurts me." "Do you need anything?" "I don't need anything." Nevertheless Marina arranged for her to get massages to ease the pain she must have felt, being bedridden for months. Danica started calling the masseuse "Velimir." Marina claims that Velimir never visited his mother, even though she had signed everything in her will over to him—perhaps Danica thought Marina didn't need the money; she never knew for sure—and despite the fact that he lived in the same city whereas Marina was on another continent. Velimir disputes this, saying he visited regularly after hours. On her final visit, later in the summer of 2007, Marina was horrified to see her mother's bedsores, old wounds that would not close or heal. Still Danica said she felt no pain. Marina's anger at Velimir's perceived neglect got worse. She took photographs of her mother's bedsores and harbored the idea of getting large prints made and hanging them in Danica's apartment, ready for when Velimir took possession of the place.

Danica Abramović died on August 3, 2007. It was far from the kind of death Marina wished for her mother, or the death she imagined for herself: it had been drawn out, stubborn, and Danica was in denial for most it, and then senile. She never surrendered control, something that Marina always aspired to as the end goal of her fanatical controlling impulse. But Danica's death was revelatory: it showed Marina that her mother was a different person from the one she had fought with and been so resentful of for most of her life. When Marina went to Danica's apartment to sort through her possessions, she found a box of correspondence, starting in 1975, between Danica and a lover Marina had never known about—a man Danica had met before Vojo. The letters were full of the emotion Marina had always assumed her mother incapable of. He called her "my dear beautiful Greek woman," and she called him

"my Roman man." She found Danica's poetry and idle musings. One note-to-self, perhaps written during the worst times with Vojo, read, "Thinking: If animals live a long time together, they start loving each other. But people start hating each other." Marina must have thought of Ulay upon reading this. She also found medals for wartime feats of bravery that Danica had never spoken of, most notably a Medal of Honor for evacuating forty-five wounded citizens from a burning truck during the liberation of Belgrade, carrying them into a new truck, and delivering them to the hospital in Dedinje. And Marina found a detailed bibliography of early articles on her work in *Politika* and elsewhere, which her mother assembled in the the late 1960s and early '70s. While outwardly Danica was hostile toward the direction of Marina's artistic career, in private she was recording with militaristic order and precision a list of references to her daughter in the press (she was mentioned eight times in *Politika* in 1970, for example, for her various exhibitions). The love and recognition Marina craved from her mother had always been there, even though Danica never allowed her to feel it. At the funeral, attended by several members of Danica's Partisan division together with friends and family, Marina gave a reading over her mother's open grave: "I didn't understand you as a child, I didn't understand you as a student, I didn't understand you as an adult, until now in my sixtieth year of life you started shining in the full light like a sun that suddenly appeared behind gray clouds after rain."[52]

BEFORE MARINA ABRAMOVIĆ DIES

Abramović is managing her legacy in advance. Shortly after her sixtieth birthday party, with the money she got from selling Binnenkant 21, she bought a huge derelict theater in the quiet town of Hudson, in upstate New York. She plans to renovate the building into the Marina Abramović Institute, with the mission of "the preservation of performance art." It has been a long time since the building, completed in 1933, was a theater; more recently it was a warehouse for antiques and an indoor tennis court—the words "Community Tennis" adorn its crumbling neoclassical frontage. Another artist might choose to preserve this charming sign of the building's former use rather than emblazoning it with her own name. But Abramović's declarative title and defiant intention for her institute is an epigram of her overall purpose, and of her problematic: making the inherently transient and historically fragile medium of performance art permanent, and liberating it from a specific author and ego, including hers. The struggle is not yet complete. But Abramović is leaving the running of the institute to someone else. She will be present but not in control.

It's both ironic and entirely fitting that Marina Abramović, the self-proclaimed grandmother of performance art—a practice that always opposed the stage—should choose an old theater as the venue for her legacy to be played out. Abramović has of course been working regularly in the theater since the early 1980s, and will continue making new versions of her *Biography* stage play. But there will be no stage in her renovated building. Abramović wants to turn the space over to workshops, exhibitions, artist residencies, and ever-changing events that aim to cultivate durational performances by a new generation of artists. Abramović has always accepted that the moment of body art passed after the 1970s. But she has never been so accepting of the fact that the experience of sheer *duration* hasn't remained an important aspect of contemporary art. It's as if Abramović has realized, as she gets older and approaches death, that duration will be ultimately more powerful than endurance. Endurance and its demonstrative pain was confrontational, altering the consciousness of the performer more than the audience; and, as her peers of the 1970s discovered, it's not easy to sustain through a career, let alone beyond that career. But duration, as engaged by Abramović, can create a shared experience, supercharging a space with overwhelming empathy and creating a perfectly suspended present, one that might be grasped. Working with duration, Abramović can seize the one thing she will always have, at least until she dies: time.

NOTES

Introduction

1 C. Carr, *On Edge: Performance at the End of the Twentieth Century* (Hanover, NH: Wesleyan University Press, 1993), 27.

Part One

1 I. Bozić et al., *History of Yugoslavia* (New York: McGraw-Hill, 1974), 548.

2 Radmila Radić, "Religion in a Multinational State," in *Yugoslavism: Histories of a Failed Idea 1918–1992*, ed. Dejan Djokić (London: Hurst and Company, 2003), 201.

3 Bozić, *History of Yugoslavia*, 548.

4 Paul Pavlovich, *The History of the Serbian Orthodox Church* (Toronto: Serbian Heritage Books, 1989), 228.

5 Ivan Mužić, *The Catholic Church in Kingdom of Yugoslavia* (Split: Crkva u svijetu, 1978), 134.

6 Nikíta Sergeevich Khrushchev and Sergeĭ Khrushchev, *Memoirs of Nikita Khrushchev: Statesman, 1953–1964* (University Park: Pennsylvania State University Press, 2007), 511.

7 A 1980 medical paper studied the case of a child in the U.S. who suffered repeated internal bleeding in his right elbow with no apparent cause. "Hysterical character features such as colorful, seductive, and demanding do not fit the character of this 9-year-old child"—though they do apply to Marina around that age. The report notes the benefit the child got through his atypical bleeding: parental attention. "Our findings indicate that this child converted severe psychologic stress into a symptom that had as its consequence bleeding. The child was made vulnerable by virtue of the death of an earlier sibling with leukemia, characterological problems of both parents, and their response to his disease, and an organic defect in coagulation." Robert Chilcote, MD, and Robert L. Baehner, MD, "Atypical Bleeding in Hemophilia: Application of the Conversion Model to the Case Study of a Child," *Psychosomatic Medicine* 42, no. 1:II (Supplement 1980) (New York: Elsevier North Holland, Inc, 1980), 227, 221.

8 Carl K. Savich, "German Occupation of Serbia and the Kragujevac Massacre," October 18, 2003, http://www.antiwar.com/orig/savich3.html

9 Milovan Djilas, *Wartime* (San Diego: Harcourt Brace Jovanovich, 1977), 117.

10 Marina Abramović, *Artist Body* (Milan: Charta, 1998), 360.

11 Ibid., 259.

12 Ibid., 300.

13 Kristine Stiles, Klaus Biesenbach, and Chrissie Iles, *Marina Abramović* (London: Phaidon, 2008), 42.

14 Ješa Denegri, "Radical Views on the Yugoslav Art Scene, 1950–1970," in Dubravka Djurić and Miško Šuvaković, eds., *Impossible Histories* (Cambridge, Mass.: MIT Press, 2006), 199.

15 Letter from Marina Abramović to Danica Rosić, summer 1963. Abramović archive, Hudson, New York.

16 Chrissie Iles, ed., *Marina Abramović: Objects Performance Video Sound* (Oxford: Museum of Modern Art Oxford, 1995), 137.

17 Marina Abramović, *Public Body* (Milan: Charta, 2001), 32.

18 Carey McWilliams, "Tito Digs the Students," *The Nation*, July 22, 1968.

19 Milovan Djilas, *The New Class: An Analysis of the Communist System* (New York: Harcourt Brace Jovanovich, 1983), 37.

20 D. Plamenić, "The Belgrade Student Insurrection," *New Left Review* 54 (March–April 1969): 44.

21 Ibid., 62–63.

22 Ibid., 54.

23 Ibid., 65.

24 On Tito's wage concession, see "The Revolution Gap," *Time*, June 14, 1968, http://www .time.com/time/magazine/article/0,9171,900122–1,00.html

25 Quoted by Zoran Popović and Jasna Tijardović in "A Note on Art in Yugoslavia," *The Fox*, no. 1 (1975), 49.

26 Quoted by Suzana Milevska in "Tito & Buzek, Postmodernists?" http://www.buzek.org/ tito-buzek.htm

27 Bojana Pejić, "Socialist Modernism and Its Aftermath," in *Aspects/Positions* (Vienna: Museum moderner Kunst Stiftung Ludwig, 1999).

28 Djurić and Šuvaković, *Impossible Histories*, 321.

29 Maja and Reuben Fowkes, "Croatian Spring: Art in the Social Sphere," paper given at the conference "Open Systems: Art c. 1970," Tate Modern, London, September 2005.

30 Abramović, *Artist Body*, 54.

31 Diploma certificate, Abramović archive.

32 All quotes on the exhibition are from *Drangularium*, exh. cat. (Belgrade: Studentski Kulturni Centar, 1971), no page numbers.

33 Abramović archive.

34 Iles, *Marina Abramović*, 137.

35 Ibid.

36 Djurić and Šuvaković, *Impossible Histories*, 561.

37 Ješa Denegri, "Art in the Past Decade," in *The New Art Practice in Yugoslavia: 1968–1978* (Zagreb: Gallery of Contemporary Art, 1978), 10.

38 Abramović archive.

39 Paul Schimmel et al., *Out of Actions: Between Performance and the Object, 1949–1979* (New York: Thames & Hudson, 1998), 91.

40 Abramović archive.

41 Ibid.

42 RoseLee Goldberg, *Performance Art: From Futurism to Present* (London: Thames & Hudson, 2001), 165.

43 Abramović archive. This performance has been wrongly assigned in previous literature to 1974.

44 "Marina Abramović Untitled," interview with Chrissie Iles, Munich, February 8, 1996, *Grand Street*, no. 63 (1996): 193.

45 Abramović archive.

Part Two

1 Marga van Mechelen, *De Appel: Performances, Installations, Video, Projects, 1975–1983* (Amsterdam: de Appel, 2006), 81.

2 Abramović told Chrissie Iles: "When I met him, half his face was shaved with a moustache and short hair and the other part had long hair and make-up." "Taking a Line for a Walk," *Performance*, no. 53 (April–May 1988): 16.

3 Thomas McEvilley, *Ulay: The First Act* (Ostfildern, Germany: Cantz, 1994), no page numbers.

4 Ibid.

5 Uwe Laysiepen, *Uwe's Polaroid Pictures of 5 Cities* (Amsterdam: Wed. G. van Soest N.V., 1971), no page numbers.

6 Ulay, *File on Ulay: Oeuvre and Archive 1970–1979*, DVD, 2007.

7 McEvilley, *Ulay: The First Act*.

8 Van Mechelen, *De Appel*, 63.

9 Ibid., 81.

10 "Piskede kropped rød og rev sig blodig [Whipped herself red and scratched herself bloody]," *Ekstra Bladet* (Copenhagen), December 17, 1975.

11 Interview with Pablo J. Rico, April 1998, in *The Bridge* (Milan: Charta, 1998), 76.

12 Interview with Helena Kontova, October 1977, in *Flash Art*, no. 80–81 (1978).

13 All quotes relating to *Kino beleške*: Irwin, eds., *East Art Map* (London: Afterall, 2006), 398.

14 This work has been mistakenly dated 1975 in all Abramović's résumés and books, placing it before she met Ulay. According to a record of performances in the April Meetings kept by the Studentski Kulturni Centar archive, Belgrade, *Freeing the Voice* actually took place on April 21, 1976, five months after Abramović met Ulay.

15 *Flash Art*, 1978.

16 *Role Exchange* is another performance mistakenly dated 1975 in books on Abramović. Records in the Abramović archive indicate that it actually took place in 1976.

17 Marina Abramović / Ulay, Ulay / Marina Abramović, *Relation Work and Detour* (Amsterdam: Ulay / Marina Abramović, 1980).

18 "Art theft was an 'action.'" All in McEvilley, *Ulay: The First Act*.

19 Louwrien Wijers, *Ben d'Armagnac* (Zwolle: Waanders, 1995), 120, 130.

20 Van Mechelen, *De Appel*, 103.

21 Juan Vicente Aliaga, "The Folds of the Wound: On Violence, Gender, and Actionism in the Work of Gina Pane," *Arte Contexto*, no. 7 (2005): 72.

22 *La performance oggi: settimana internazionale della performance, Bologna, 1–6 giugno 1977* (Bologna: Galleria Communale d'Arte Moderna di Bologna, 1977), cited by Chris Thompson, "Appropriate Ending: Ben d'Armagnac's Last Performance," *PAJ: A Journal of Performance and Art* 26, no. 3 (2004): 59.

23 Abramović archive.

24 *Flash Art*, nos. 80–81 (1978).

25 The naming of the duo in this book follows a retroactive arrangement: "Reference must be made to 'Ulay / Abramović' regarding joint works from the period 1976 to 1980. Reference must be made to 'Abramović / Ulay' regarding joint works from the period 1981 to 1987," *Agreement between Uwe Laysiepen and Marina Abramović, April 29, 1999*, 1999, 3. Abramović archive.

26 Ulay / Abramović, *Relation Work and Detour*.

27 Abramović archive. From Abramović's diary, January 1978, Sardinia. She attributes the quote to Yukikazu Sakurazawa, *Book of Judgment*.

28 Ulay / Abramović, *Relation Work and Detour*.

29 Letter from Abramović to her mother, April 5, 1978. Abramović archive.

30 Abramović, interviewed by Louwrien Wijers, May 10, 1978, New York, unpublished, Abramović archive.

31 De Appel archive, Amsterdam.

32 Thompson, "Appropriate Ending," 50.

33 Abramović archive.

34 Van Mechelen, *De Appel*, 161.

35 From the record *Vision #4: Word of Mouth*, Crown Point Press, 1980. Accessed at http://www.ubu.com/sound/vision.html

36 Fred Hoffman et al., *Chris Burden* (London: Thames & Hudson, 2007), 166.

37 *Word of Mouth*.

38 Vito Acconci, talk at P.S. 1 Contemporary Art Center, New York, 2003. Accessed at http://www.wps1.org/new_site/content/view/1389/140/

39 Richard Coleman, "You recall the artists who hope to stare at a reptile for 16 days? Well . . . It's showtime, folks! Marina and Ulay have found a snake," *Sydney Morning Herald*, July 4, 1981.

40 With Daniel Vachon, Toyne later wrote a book on the local land rights movement: *Growing Up the Country: The Pitjantjatjara Struggle for Their Land* (Fitzroy, Victoria: McPhee Gribble, 1984).

41 Abramović archive.

42 Winifred Hilliard, *The People in Between: The Pitjantjatjara People of Ernabella* (New York: Funk & Wagnalls, 1968), 108.

43 Mircea Eliade, *From Primitive to Zen* (London: Harper Collins, 1967), 511.

44 Coleman, *Sydney Morning Herald*, July 4, 1981.

45 All diary quotes: Abramović archive.

46 C. Carr, *On Edge: Performance at the End of the Twentieth Century* (Hanover, N.H.: Wesleyan University Press, 1993), 17–18.

47 Abramović archive.

48 Marina Abramović, *Public Body* (Milan: Charta, 2001), 72.

49 Van Mechelen, *De Appel*, 279.

50 Bruce Chatwin, *The Songlines* (London: Vintage, 1998), 155.

51 Van Mechelen, *De Appel*, 309.

52 Thomas McEvilley, "Great Wall Talk," in *The Lovers* (Amsterdam: Stedelijk, 1989), 75.

53 Abramović archive.

54 Carr, *On Edge*, 29.

55 Adrian Heathfield and Tehching Hsieh, *Out of Now: The Lifeworks of Tehching Hsieh* (Cambridge, Mass.: MIT Press, 2009), 62–228.

56 Ibid., 6.

57 Abramović archive.

58 C. Carr, "The Hard Way," *Village Voice*, November 25, 1997, 69.

59 Douglas C. McGill, "Art People," *New York Times*, February 21, 1986.

60 Iles, "Taking a Line for a Walk," 16.

61 McEvilley, "Great Wall Talk," 82.

62 Ibid., 98.

63 Carr, *On Edge*, 35.

64 McEvilley, "Great Wall Talk," 98.

65 Carr, *On Edge*, 46.

66 McEvilley, "Great Wall Talk," 106.

67 Carr, *On Edge*, 42.

68 As recounted by Thomas McEvilley, in conversation with the author, February 2008.

Part Three

1 *The Great Wall: Lovers at the Brink*, DVD, directed by Murray Grigor (Edinburgh, Amphis Foundation and Channel 4 Television, 1989).

2 Ibid.

3 Ibid.

4 Don DeLillo, *Mao II* (London: Vintage, 1992), 70.

5 Carr, "The Hard Way," 69.

6 Caroline Tisdall, Louwrien Wijers, and Ike Kamphof, eds., *Art Meets Science and Spirituality in a Changing Economy* (The Hague: SDU, 1990), 298.

7 Abramović, *Public Body*, 114.

8 Victoria Miro gallery archive.

9 Marina Abramović fax to David Elliott, March 4, 1993. Modern Art Oxford archive.

10 *An Arrow in the Heart*, DVD, directed by Keto von Waberer (Berlin, 1992).

11 Ibid.

12 Abramović archive.

13 Doris von Drathen, "World Unity: Dream or Reality. A Question of Survival," in *Marina Abramović*, ed. Friedrich Meschede (Stuttgart: Hatje Cantz, 1993), 227.

14 Abramović archive.

15 Marina Abramović, *Departure: Brasil Project 1990–91* (Paris: Galerie Enrico Navarra, 1991).

16 Abramović, *Artist Body*, 446

17 Abramović fax to Elliott, September 19, 1992. Modern Art Oxford archive.

18 Abramović, *Artist Body*, 390–391.

19 Marina Abramović, *The Biography of Biographies* (Milan: Charta, 2004), 12.

20 Ibid., 52.

21 Abramović, *Public Body*, 189.

22 Michael Brenson, "Why Curators Are Turning to the Art of the Deal," *New York Times*, March 4, 1990.

23 Marina Abramović, *The House with the Ocean View* (Milan: Charta, 2004), 1.

24 Abramović, *Artist Body*, 361.

25 Modern Art Oxford archive.

26 Marina Abramović, "The House Is My Body," *Galeries Magazine*, no. 62 (Summer 1995), 77–78.

27 Carr, "The Hard Way," 69.

28 Alexandra David-Neel, *With Mystics and Magicians in Tibet* (London: Penguin, 1936), 127–129.

29 Abramović, *Artist Body*, 339.

30 Abramović, *Public Body*, 206.

31 Victoria Miro gallery archive.

32 Schimmel et al., *Out of Actions*, 83.

33 Abramović, *Artist Body*, 344.

34 Katy Deepwell, "An Interview with Marina Abramović," *N. Paradoxa*, no. 2 (February 1997), http://web.ukonline.co.uk/n.paradoxa/abramov.htm

35 Abramović, *Artist Body*, 348.

36 Abramović archive.

37 Quoted in Bojana Pejić, "Balkan for Beginners," in *Primary Documents* (New York: Museum of Modern Art, 2002), 334.

38 Ibid., 333.

39 "Statement of Marina Abramović on the invitation by Yugoslav Commissar of the Yugoslavian pavilion on the Venice Biennial, Mr. Petar Cuković, director of the National Museum of Montenegro, Cetinje, Yugoslavia," March 24, 1997, Abramović archive.

40 Abramović archive.

41 Ibid.

42 Abramović, *Artist Body*, 41–51.

43 Steven Naifeh and Gregory White Smith, *Jackson Pollock: An American Saga* (London: Barrie Jenkins, 1989), 651.

44 James Westcott, "Marina Abramović's The House with the Ocean View," *The Drama Review*, Fall 2003, 129.

45 E-mail to the author, March 23, 2003.

46 Abramović, *The House with the Ocean View*, 51.

47 Marina Abramović and Marko Pogačnik, "Cleaning the House," *M'ARS (Magazine for the Museum of Modern Art, Ljubljana)* 3, no. 4 (1993), 44.

48 Peggy Phelan, *Unmarked: The Politics of Performance* (London: Routledge, 1993), 146.

49 Jörg Heiser, "Do It Again," *Frieze*, October 2005, 176.

50 Unpublished part of an interview with the author for *Artinfo*, November 9, 2005, http://www.artinfo.com/news/story/1537/marina-abramovic/

51 Abramović archive.

52 Ibid.

REFERENCES

Interviews Conducted between January 2007 and February 2009

Ivana Abramović, Marina Abramović, Velimir Abramović, Laurie Anderson, Charles Atlas, Klaus Biesenbach, Dunja Blažević, Barbara Bloom, Jan Brand, Paolo Canevari, C. Carr, Richard Demarco, Ješa Denegri, David Elliott, RoseLee Goldberg, Tomislav Gotovac, Antje von Graevenitz, Murray Grigor, Tijmen van Grootheest, Alanna Heiss, Jan Hoet, Chrissie Iles, Sean Kelly, Jürgen Klauke, Michael Klein, Christine Koenig, Hartmund Kowalke, Ursula Krinzinger, Rob La Frenais, Michael Laub, Serge Le Borgne, Eduardo Lipschutz-Villa, Jurriaan Löwensteyn, Frank Lubbers, Tom Marioni, Jean-Hubert Martin, Thomas McEvilley, Dorine Mignot, Era Milivojević, Victoria Miro, Ruud Monster, Enrico Navarra, Hans Ulrich Obrist, Cordelia Oliver, Bojana Pejić, Willem Peppler, Ad Peterson, Zoran Popović, Paul Ramsay, Ksenija Rosić, Tanja Rosić, Julião Sarmento, Michael Stefanowski, Pat Steir, Miško Šuvaković, Raša Todosijević, Biljana Tomić, Phillip Toyne, Gijs van Tuyl, Ulay, Gera Urkom, Rene Welker, Louwrien Wijers, Robin Winters.

Books, Articles, Films, and Lectures Cited

Abramović, Marina. *Artist Body*. Milan: Charta, 1998.

——. *The Biography of Biographies*. Milan: Charta, 2004.

——. *The Bridge*. Milan: Charta, 1998.

——. *Departure: Brasil Project 1990–91*. Paris: Galerie Enrico Navarra, 1991.

——. "The House Is My Body." *Galeries Magazine*, no. 62 (Summer 1995).

——. *The House with the Ocean View*. Milan: Charta, 2004.

——. *Public Body*. Milan: Charta, 2001.

——, and Marko Pogačnik. "Cleaning the House." M'ARS (Magazine for the Museum of Modern Art, Ljubljana) 3, no. 4 (1993).

Abramović, Marina / Ulay, and Ulay / Marina Abramović. *Relation Work and Detour*. Amsterdam: Ulay / Marina Abramović, 1980.

Acconci, Vito. Talk at P.S. 1 Contemporary Art Center, New York, 2003. http://www.wps1.org/new_site/content/view/1389/140/

Aliaga, Juan Vicente. "The Folds of the Wound: On Violence, Gender, and Actionism in the Work of Gina Pane." *Arte Contexto*, no. 7 (2005).

Božić, Ivan, et al. *History of Yugoslavia*. New York: McGraw-Hill, 1974.

Brenson, Michael. "Why Curators Are Turning to the Art of the Deal." *New York Times*, March 4, 1990.

Carr, C. "The Hard Way." *Village Voice*, November 25, 1997.

———. *On Edge: Performance at the End of the Twentieth Century.* Hanover, N.H.: Wesleyan University Press, 1993.

Chatwin, Bruce. *The Songlines.* London: Vintage, 1998.

Chilcote, Robert, MD, and Robert L. Baehner, MD. "Atypical Bleeding in Hemophilia: Application of the Conversion Model to the Case Study of a Child." *Psychosomatic Medicine* 42, no. 1:II (supplement 1980).

Coleman, Richard. "You Recall the Artists Who Hope to Stare at a Reptile for 16 Days? Well . . . It's Showtime, Folks! Marina and Ulay Have Found a Snake." *Sydney Morning Herald*, July 4, 1981.

David-Neel, Alexandra. *With Mystics and Magicians in Tibet.* London: Penguin, 1936.

Deepwell, Katy. "An Interview with Marina Abramović." *N. Paradoxa*, no. 2 (February 1997).

DeLillo, Don. *Mao* II. London: Vintage, 1992.

Denegri, Ješa. "Art in the Past Decade." In *The New Art Practice in Yugoslavia: 1968– 1978.* Zagreb: Gallery of Contemporary Art, 1978.

———. "Radical Views on the Yugoslav Art Scene, 1950–1970." In Dubravka Djurić and Miško Šuvaković, eds., *Impossible Histories.* Cambridge, Mass.: MIT Press, 2006.

Djilas, Milovan. *The New Class: An Analysis of the Communist System.* New York: Harcourt Brace Jovanovich, 1983.

———. *Wartime.* San Diego: Harcourt Brace Jovanovich, 1977.

Drangularium. Belgrade: Studentski Kulturni Centar, 1971.

Drathen, Doris von. "World Unity: Dream or Reality. A Question of Survival." In Friedrich Meschede, ed., *Marina Abramović.* Stuttgart: Hatje Cantz, 1993.

Eliade, Mircea. *From Primitives to Zen.* London: Collins, 1967.

Fowkes, Maja and Reuben. "Croatian Spring: Art in the Social Sphere." Paper given at the conference "Open Systems: Art c. 1970." Tate Modern, London, September 2005.

Goldberg, RoseLee. *Performance Art: From Futurism to Present.* London: Thames & Hudson, 2001.

Grigor, Murray, dir. *The Great Wall: Lovers at the Brink.* DVD. Edinburgh: Amphis Foundation and Channel 4 Television, 1989.

Heathfield, Adrian, and Tehching Hsieh. *Out of Now: The Lifeworks of Tehching Hsieh.* Cambridge, Mass.: MIT Press, 2009.

Heiser, Jörg. "Do It Again." *Frieze*, no. 94 (October 2005).

Hilliard, Winifred. *The People in Between: The Pitjantjatjara People of Ernabella.* New York: Funk & Wagnalls, 1968.

Hoffman, Fred, et al. *Chris Burden*. London: Thames & Hudson, 2007.

Horvitz, Robert. "Chris Burden." *Artforum* 14, no. 9 (May 1976).

Iles, Chrissie, ed. *Marina Abramović: Objects Performance Video Sound*. Oxford: Museum of Modern Art Oxford, 1995.

———. "Marina Abramović Untitled." *Grand Street*, no. 63 (1996).

———. "Taking a Line for a Walk." *Performance*, no. 53 (April–May 1988).

Irwin, eds. *East Art Map*. London: Afterall, 2006.

Khrushchev, Nikita Sergeevich, and Sergeï Khrushchev. *Memoirs of Nikita Khrushchev: Statesman, 1953–1964*. University Park: Pennsylvania State University Press, 2007.

Kontova, Helena. "Marina Abramović–Ulay." *Flash Art*, no. 80–81 (1978).

Laysiepen, Uwe. *Uwe's Polaroid Pictures of 5 Cities*. Amsterdam: Wed. G. van Soest N.V., 1971.

McEvilley, Thomas. "Great Wall Talk." In *The Lovers*. Amsterdam: Stedelijk Museum, 1989.

———. *Ulay: The First Act*. Ostfildern: Cantz, 1994.

McGill, Douglas C. "Art People." *New York Times*, February 21, 1986.

McWilliams, Carey. "Tito Digs the Students." *Nation*, July 22, 1968.

Mechelen, Marga van. *De Appel: Performances, Installations, Video, Projects, 1975–1983*. Amsterdam: De Appel, 2006.

Milevska, Suzana. "Tito & Buzek, Postmodernists?" http://www.buzek.org/tito-buzek.htm

Mužić, Ivan. *Katolička crkva u Kraljevini Jugoslaviji* [The Catholic Church in the Kingdom of Yugoslavia]. Split: Crkva u svijetu, 1978.

Naifeh, Steven, and Gregory White Smith. *Jackson Pollock: An American Saga*. London: Barrie Jenkins, 1989.

Pavlovich, Paul. *The History of the Serbian Orthodox Church*. Toronto: Serbian Heritage Books, 1989.

Pejić, Bojana. "Balkan for Beginners." In *Primary Documents*. New York: Museum of Modern Art, 2002.

———. "Socialist Modernism and Its Aftermath." In *Aspects/Positions*. Vienna: Museum moderner Kunst Stiftung Ludwig, 1999.

Phelan, Peggy. *Unmarked: The Politics of Performance*. London: Routledge, 1993. "Piskede kropped rød og rev sig blodig" [Whipped herself red and scratched herself bloody]. *Ekstra Bladet* (Copenhagen), December 17, 1975.

Plamenić, D. "The Belgrade Student Insurrection." *New Left Review*, no. 54 (March–April 1969).

Popović, Zoran, and Jasna Tijardović. "A Note on Art in Yugoslavia." *The Fox*, no. 1 (1975).

Radić, Radmila. "Religion in a Multinational State." In Dejan Djokić, ed., *Yugoslavism: Histories of a Failed Idea 1918–1992*. London: Hurst and Company, 2003.

"The Revolution Gap." *Time*, June 14, 1968.

Savich, Carl K. "German Occupation of Serbia and the Kragujevac Massacre." October 18, 2003. http://www.antiwar.com/orig/savich3.html

Schimmel, Paul, Kristine Stiles, Guy Brett, Hubert Klocker, and Shinichiro Osaki. *Out of Actions: Between Performance and the Object, 1949–1979*. New York: Thames & Hudson, 1998.

Stiles, Kristine, Klaus Biesenbach, and Chrissie Iles. *Marina Abramović*. London: Phaidon, 2008.

Thompson, Chris. "Appropriate Ending: Ben d'Armagnac's Last Performance." PAJ: A Journal of Performance and Art 26, no. 3 (2004).

Tisdall, Caroline, et al., eds. *Art Meets Science and Spirituality in a Changing Economy*. The Hague: SDU, 1990.

Toyne, Phillip, and Daniel Vachon. *Growing Up the Country: The Pitjantjatjara Struggle for Their Land*. Fitzroy, Victoria: McPhee Gribble, 1984.

Ulay. *File on Ulay: Oeuvre and Archive 1970–1979*. DVD. 2007.

Vision, no. 4: *Word of Mouth*. Oakland, Calif.: Crown Point Press, 1980.

Waberer, Keto von, dir. *An Arrow in the Heart*. DVD. Berlin, 1992.

Westcott, James. "Marina Abramović's *The House with the Ocean View*." *The Drama Review*, Fall 2003.

Wijers, Louwrien. *Ben d'Armagnac*. Zwolle: Waanders, 1995.

INDEX

Boldface page numbers refer to images. Headings in *italics* refer to Abramović's (and Ulay / Abramović's) works.

AAA-AAA, 137, **138**

Aboriginals, 157–159, 162–163, 173, 175–178, 181, 217, 218, 243

Abramović, Danica, 9–11, **10**, 13, **14**, **20**, 21–23, **22**, 25, 29–32, 35, 38, 41, 45, 47, 49, 52, 64, 100, 133, **174**, 234–235, **256**, 257, 271
 cultivation of Marina's artistic interest, 24, 27, 53, 55, 218
 death of, **306**, 307–308
 and hygiene, 15
 and Marina's performances, 67, 72–73, 77, 135, 158
 meets Vojo, 17, 19–20
 and Tito, **46**

Abramović, Ivana, ix, 267, 269

Abramović, Velimir, ix, xi, 15, 16, 21, **22**, 23, **28**, 29, 30, 43, 64, 108, 121, 133, 196, 235, **266**, 289, 305
 in Amsterdam during NATO bombing of Belgrade, 267
 critique of Marina, 211, 229, 232, 298
 and Danica's death, 307
 feud with Marina, 269, 271
 filming Marina destroying *Sound Environment White*, 57, **58**
 on parents' meeting, 19–20
 poetry and public life, 33
 reclaims Marina's paintings, 267
 and Vojo's death, 265, 272

Abramović, Vojin (Vojo), 10, **12**, 13, **14**, **18**, **20**, 21, 27, 29–31, 35, **36**, 47, 64, 133, 249, **252**, 257, 265, **266**, 267, 307–308
 Belgrade in 1994, 234–237
 death of, 271–272
 meets Danica, 17–19
 and 1968 student protests, 36–38

Acconci, Vito, 72, 73, 117, 155, 291, 292–293

Anderson, Laurie, 117, 121, 147, 148, 150, 304

Anima Mundi, 175, 178

Arrow in the Heart, An, 219–221, **220**

Art Must Be Beautiful, Artist Must Be Beautiful, 95–98, **95**, 104, 106, 135, 140, 243, 263

"Art Vital" manifesto, 109, 115, 132–133, 135, 145, 148, 212, 231

Atlas, Charles, 229, 253
 Biography, 227, 232
 Delusional, 237–238
 SSS, 215, 217
 visit to Belgrade, 234–235

Balance Proof, **131**, 132

Balkan Baroque, 257, **258**, 259, 262
 film, 270–271

Balkan Erotic Epic, 299–301, **300**, 304

Balkan wars (1990s), 234–235, 255–257

beauty, 40, 63, 95–96, 127, 140, 176, 203, 214, 224, 229, 234, 276

Beuys, Joseph, 41, 62–63, **66**, 67, 82, 121, 143, 213, 247, 263
 in *Seven Easy Pieces*, 291–292, 295

Biesenbach, Klaus, 227, 267, 269, 275, 307

Binnenkant, Amsterdam, 197, 209, 219, **220**, 225, 239–241, **240**, 253, 261, 267, **268**, 270, 275, 309

Blavatsky, Madame, 41, 116

Blažević, Dunja, 49, **50**, 53, 57, 97, 98
 and "Drangularium," 51
 encourages Abramović to perform, 63
 phone calls from Danica, 72

bleeding, 16, 19, 23, 25, 82, 143, 311n7

Bloom, Barbara, 145, 180

Bodhgaya, India, 172–173, 197

Brand, Jan, 140–142

Breathing In / Breathing Out, 119, **120**, 121, 132

Breathing Out / Breathing In, 132, 135
Brooklyn Museum, 140, 142, 146, 179
Buddhism, 104, 113, 116, 141, 165, 191,
 197, 203, 205, 265, 305
 Tibetan, 180, **264**
 Zen, 41, 151, 263
Burden, Chris, 72, 102, 117–118, 121, 147,
 149–150, 155, 168, 291

Cage, John, 59, 147, 149–150, 189, 241
Canevari, Paolo, ix, 259, 260, 275, **276**,
 282, 286, **296, 306**
 in Amsterdam, 267–269, **268**
 marries Abramović, 301, **302**
 moves to New York, 273
 refusal to participate in workshops, 270
 at Venice Biennale, 2007, 304–305
Carr, Cindy, 189
 on Great Wall of China, 199, 202–203,
 210
Celant, Germano, 256–257
Charged Space, 140–141, 146
City of Angels, 175, 178, 183, 189
Cleaning the House, 247, 257
 workshop, 282–285, **284**
Cleaning the Mirror I, II, and III, **242**, 243
Clemente, Francesco, 65
Come Wash with Me, 42
communism, 11, 20–21, 35, 37, 69, 82,
 116, 150, 151, 193, 202–203
Communist Body / Fascist Body, 146, 203
Coulibeuf, Pierre, 270–271
Count on Us, 289, **290**
Ćuković, Petar, 254
cutting, 72, 82, 91, 94, 97, 295

Dalai Lama, 162, 173, 232, 265, 305
D'Armagnac, Ben, 116–117, 121, 140,
 142–143, 183
Deak, Edit, 140
de Appel Gallery, ix, 97, 263
 and Abramović, 85, 93–94, 100, 104,
 106, 234
 and Abramović / Ulay, 115, 117–118,
 143, 145, 146, 178–180

plane crash, 180, 273
 and Ulay, 92, 103–104, 113, 116
Death
 of Danica Abramović, 307
 of Vojo Abramović, 271
 of Alba, 225
 confrontation of, xiii, 45, 71, 73, 151,
 154, 169, 200, 223–225, 243, 301,
 309
 of D'Armagnac, 142–143
 and de Appel, 180
 fear of, 16, 248–249
 in *Fototot*, 103
 of Hildegard Laysiepen, 173–174, 186
 of Matta-Clark, 141
 parents' attitudes toward, 235, 237
 of Pejatović-Rosić, 15
 protection from, 162
 of Aleksa Rosić, 11
 of Uroš Rosić, 11
 of Patriarch Varnava, 11
Delgado, Paco, 209–210, 213, 219, 221,
 224–225, 229, 273
Delusional, 235–238, **236**, 247–248, 257
Demarco, Richard, 59, 62–63, 77, 79, 231
Denegri, Ješa, 41, 51, 56, 97
deserts, 217
 Gobi, 181, 199–202, 210
 Great Victorian, Australia, 157–166,
 160, 161, 169, 175, 199, 205
 Thar, India, 173
Dimitrijević, Braco, 73
Documenta, 122, 171, 227
Dragon Heads, **216**, 217, 231, 241, 245
"Drangularium," **50**, 51, 53, 55
Dream House, 267

Elliott, David, 219, 227, 241, 246, 249, 253
Escape, 249, **250**
Expansion in Space, 122–123, **124**
EXPORT, Valie, 73, 83, 183, 291, 293, **294**

fasting, 166–169, 173, 186, 189–190, 239,
 275, 283–285, **284**
feminism, 79, 96–97, 104, 129

Françoise-Piso, Paula, 89, 91–92, 105, 174
Freeing the Body, 111, **111**, 113
Freeing the Horizon, 53
Freeing the Memory, 100
Freeing the Voice, 99, 104, 137, 313n14
funerals, 64, 141, 146
 of Danica Abramović, **306**, 308
 of Marina Abramović, plans for, xiii,
 304
 of Vojo Abramović, 272
 of Ilić, 48
 of Hildegard Laysiepen, 174
 of Milica Rosić, 271
 of Tito, 151
 of Patriarch Varnava, 11

Gilbert & George, 73, 91, 183
Goldberg, RoseLee, 64, 118, 239
Gorgona, 40, 41, 47
Gotovac, Tomislav, 42, 64, 146, 150
 Showing Elle Magazine and other
 works, 43, 56, 62
Graevenitz, Antje von, 94, 146
Great Wall: Lovers at the Brink, The, 209–
 212, 215, 217
Grigor, Murray, ix, 209–211, 215, 217
Grootheest, Tijmen van, 209
 Nightsea Crossing Conjunction, 176–
 177
 producing *The Lovers*, 181–182, 193
group of six, 39–42, 45, 47, 49, 56–59,
 63–64
Groznjan, Croatia, 52–53, 103, 121, 135,
 157, 197
Guide Chinois, Le, 205

Hegedušić, Krsto, 47–48
Heiss, Alanna, 219, 227
Hero, The, 272, 283
Herzog, Werner, 113, 210, 221
Hoet, Jan, **253**, 301
Horn, Rebecca, 73, 221, **226**, 227, 233, 238
House with the Ocean View, The, 1–5, 275,
 278, 280, 285, 287, 292, 297, 305
How to Die, 223–224

Hsieh, Tehching, 182–183, 247
Hudson, New York, theater, 309

Iles, Chrissie, ix, 239, **240,** 275, 289
 Abramović's fiftieth birthday, 254
 Abramović's sixtieth birthday, 304
 curating Abramović, 217, 241, 243
Ilić, Srebrenka, 48, **50**
Image of Happiness, 248–249
Imponderabilia, **120**, 121, 140, 144, 149
In Between, 249
Incision, 137, **139**, 140, 144, 146
Installation One, 146
Installation Two, 146
Interruption in Space, 113, 115, 122

Jagger, Bianca (Bianca Pérez Mora
 Macías), 88, 91
Jonas, Joan, 65, 73, 147, 149, 155

Kaiserschnitt, 137
Kaprow, Allan, 72, 73
Kelly, Sean, ix, x, 4, 234, 239, 245, 246,
 247, 269, 273, 275, **275**, 276, 281.
 See also Sean Kelly Gallery
 brokers contract with Ulay, 261–262
 meets Abramović, 233
 and Venice, 255–259
Klauke, Jürgen, 86, 87, 91–93, 129, 174
Klein, Michael, ix, 179, 182, 187, 197, 209,
 233
 organizes Polaroid exhibitions, 193
Klein, Yves, 41, 42, 43, 55
Koenigs, Christine, **114**, 115, 117, 119,
 123, 145, 155, 177
 and Abramović's "cloud," 119
 tells Abramović about Ulay's lover, 187
 tells Abramović about Ulay's son, 194
Kounellis, Jannis, 73
Kowalke, Hartmund, ix, 125, **126**, 127,
 146
Krinzinger, Ursula, 79, 82, 97, 117, 129,
 137
KwieKulik, 183

Laub, Michael, 145, 151, 175, 179, **230**, 241, 271, **288**
 Biography Remix, 289
Laysiepen, Hildegard, 86, 173–**174**, 186
Laysiepen, Uwe. *See* Ulay
Laysiepen, Wilhelm, 86
Light / Dark, 129, **129**, 137
Lipschutz-Villa, Eduardo, 209–210
Lovers, The, 3, 199–206, **204**, **206**, 215, 218
Löwensteyn, Henny, 87–88, 108, 194
Löwensteyn, Jurriaan, 87, 194–196, **288**, 289
Lubbers, Frank, 176, 178, 181–182, 197–198, 210
Luther, 172

Makedonska street, Belgrade, 9, 15, 26, 31, 43, 52, 65, 119, 133, 239
Marioni, Tom, 63, 147
Martin, Jean-Hubert, 218
McEvilley, Thomas, 4, 178–179, 182, 186
 and Great Wall of China, 199–203, 210–211, 215, 229, 315n68
Mignot, Dorine, 171, 215
Milivojević, Era, 39, 47, **50**, 52, **54**, 59, 64
 tapes up Abramović, 55–56
Miro, Victoria, 213–215, 225, 241, 246
Modus Vivendi, 188, 191–193, **192**
Mond, der Sonne, Die, 196, 215
Museum of Modern Art Oxford, 217, 239, 241–244, **244**, 246, 316n9

NATO bombing of Belgrade (1999), 265, 267, 273, 304
Nauman, Bruce, 57, 113, 291, 292
Navarra, Enrico, 221, 223
New Art Practice, 56, 301
Nightsea Crossing, 2, 178, 180, 182, **185**, 196, 205, 259, 283
 and abstinence, 186
 first performances, 165–169, **167**
 last performance, 193–194
 in New York, 189–190
 Nightsea Crossing Conjunction, 176–178, **177**, 181, 212, 218
 strain, 171–173
Nitsch, Hermann, 72, **78**, 79, 82, 129
November 30th, 9, 85, 94, 105, 116, 132, 241, 304
numerology, 116–117, 273

Obrist, Hans Ulrich, 263
OHO, 40–41, 51, 62
Oliver, Cordelia, 79
Onion, The, 247–248, **248**
Orthodox Church, Serbian, **8**, 10–11, 13, 82, 231, 257

Paik, Nam June, 59, 73, 121
pain, 231–232, 245, 309
 in life, 180, 196, 206, 209, 211, 261, 271
 migraines, 25–26, 159
 parental examples, 17, 25, 235, 265, 307
 in performances, 62, 67, 72, 73, 89, 96, 100, 105–108, 118, 123, 166–169, 171–173, 182
painting, 21, 24, 26–27, 29, 33–35, **34**, 38–40, 53, 57, 62–64, 73, 87, 191, 231, 283
 cloud paintings, 40, 42, **44**, 45, 48, 51
 and group of six, 41, 55
 Informel, 27, 29, 43, 47
 reclaiming paintings from Vojo, 265–267
 truck accidents, 33, 40
Palestine, Charlemagne, 65, 121
Pane, Gina, 72, 97, 117–118, 121
 in *Seven Easy Pieces*, 291, 293
Paripović, Neša, 53, 63–64, 79, 97, 100, 103, 105, 119, 273
 and group of six, 39, 47, **50**, 56
 marries Abramović, 47–48, **47**, 52
partisans, 17, 19, 21, 234, 256
Pejatović-Rosić, Krsmana, 15
Pejić, Bojana, 49, 56, 121
Peppler, Willem, 262–263
Peterson, Ad, 77, 118, 125, 146
Polaroid works, 73, 76, 191–196, **192**, 205, 210, 213

Politi, Giancarlo, 71
Ponape, 147–151, 162, 224
Popović, Zoran, 39–40, **50**, 51, 53, 55–56, 62, 63, 97–98, 99
Positive Zero, 178–179

Rakočević, Goran, 255–256
Relation in Movement, 125, **126**
Relation in Space, 101, **102**, 113, 149, 157, 199, 291
Relation in Time, 127, 137
reperformance, 263, 271, 287–297, **288**, **290**, **294**, **296**, 299
Rest Energy, 151, **153**, 154, **288**, 289
Rhythm 5, 2, 67–69, **68**, 71, 82, 289
Rhythm 4, **70**, 71, 96, 98
Rhythm 10, **60**, 62, 65, 79, 96, 231, 234
Rhythm 2, 69, 71, **107**, 213
Rhythm 0, 2, 73, **74–75**, **77**, 96, 104–105, 246, 249, 295
Role Exchange, 104, **106**, 116, 213, 234, 313n16
Rooney, Declan, 305–306
Rosić, Aleksa, **8**, 11
Rosić, Ksenija, ix, x, **10**, **14**, 16, 19–20
Rosić, Petar (Patriarch Varnava), **8**, 10–11, 13, 20, 235
Rosić, Tatjana, 73, 195
Rosić, Uroš, **8**, 10, 15
Russian roulette, 29, 45, 62, 92

Sarmento, Julião, 224, 233, 241, 259
Schmitt-Zell, Uschi, 86, 92, 111, 173, 174
Sean Kelly Gallery, ix, x, 275, 280, 287, 301. *See also* Kelly, Sean
seduction, 45, 47, 99, 187, 189, 219, 223, 227, 232, 239, 241, 253, 269, 311n7
Seven Easy Pieces, 289, 291–292, **294**, 295, 297–298, 299, 301, 305
Smals, Wies, 85, 92–94, 115, 117, 137, 143, 146
 death of, 180
sound works, 55, 57, 71, 99, 104
 Sound Ambient White—Video, 59
 Sound Environment White, 53, **58**, 59

Stedelijk Museum, Amsterdam, 77, 118, 132, 146, 171, 176, 181, 193, 195, 199, 209, 215, 267
Stefanowski, Michael, ix, 224–225, **240**, 241, 253, 260, 269
Steir, Pat, 101, 147, 149, 179, 189–190, 196, 197, 210
Stromboli, 275, **276**
Student Cultural Center (Studentski Kulturni Centar, SKC), 38, 39, 49–59, **54**, **55**, **58**, 65, **66**, **68**, 72–73, 97–99, 117, **120**, 121, 234
 April Meeting, 67, 69, 99, 119, 147
 Kino beleške, 97–98
Šuvaković, Miško, ix
symbiosis, 119, 132, 174, 183, 188

tableaux vivants, 171, 175, 178, 254
Talking About Similarity, 105, 108–109, 115, 132
teaching, 65, 73, 85, 116, 187–188, 225, 263, 282, 305
Television Is a Machine, 64
Terminal Garden, 189
Terra degli Dea Madre, 183, 189
"that self," 148, 151, 154, 191, 212
theater, 4, 20, 26, 30–31, 49, 53, 56, 79, 235, 309
 and Abramović / Ulay performances, 123, 135, 163, 171, 178–179, 188
 and Abramović performances, 227, 232, **236**, 237, 271, 297
 Belgrade International Theater Festival, 42
Thomas Lips, **80**, **81**, 82, 96, 129, 234, 237, 246
 the man, 79
 reperformance at de Appel, 85, 94, 98, 135
 reperformance in *The Biography*, 231
 reperformance in *Seven Easy Pieces*, 295–297, **296**, 299
Three, 143–144
Three Secrets, 33, 191
Tito, Josip Broz, 9, 10, 11, 17, 29, 35, 39,

40, 45, **46**, 49, 56, 67, 150, 255
and Danica Abramović, 45, **46**
and Vojo Abramović, 10, 19, 20, 21, 35, 234
Cominform period, 13
comparison with Abramović, 305
death of, 151
and 1968 student protests, 37, 38, 49
Titoism, 21, 35, 56, 97, 116
Todosijević, Raša, 39, 40, **50**, 51, 56, 62, 63, 67, 69
Tomić, Biljana, 51, 53, 56, 71
Toyne, Phillip, 157–158, 162
transitory objects, 212–215, 218, 225, 227, 231–232, 245–246, 257, 275
 Black Dragon, **214**, 225
 God Punishing, **244**, 245
 Green Dragon, **208**, 213, 225
 Inner Sky, 227, **228**
 mining minerals and crystals in Brazil, 221–224, **222**, **223**
 Red Dragon, 213, 255
 White Dragon, 213, 225
Tuesday / Saturday, 193
Tuyl, Gus van, 116, 125, 146

Uhlig, Doreen, 285
Ulay (Uwe Laysiepen)
 Auto-Polaroids, **84**, 89, **90**, 91–92
 early collaborations, 87–89, 91–92, 129, 174
 Exchange of Identity, 93
 family, 86–87, 143, 173–174, **174**, 180, 186, 194, 203
 Fototot, **94**
 Fototot I, 103–104
 Fototot II, 104
 and Françoise-Piso, 89, 91–92, 105, 174
 and Bianca Jagger, 88, 91
 and Klauke, 86–87, 91–93, 129, 174
 and Henny Löwensteyn, 87–88, 108, 194
 and Jurriaan Löwensteyn, 194–195
 meets Abramović, 85, 94

The Metamorphose of a Canal House, 89
 and Polaroid, 85–93, 151, 159
 and Schmitt-Zell, 86, 92, 111, 173, 174
 Seriaal Gallery, 92, 93, 180
 There Is a Criminal Touch to Art, 112–113
Urkom, Gera, 39–41, 45, 47, **50**, 51–53, 55–57, 62, 63
 rescues Abramović from fire in *Rhythm 5*, 67

van, Citroën HY, 109–111, **110**, 112–113, 115, 121, 123, 125–127, **126**, 129, 132–133, **134**, 137, 143, 145, 155, 157, 164, 171, 173
Venice Biennale, 24, 39
 1976, 100–103, **103**, 143, 199
 1993, 271
 1997, 254–260, **258**, 261, 262, 301
 1999, 289
 2007, 304–305

Warm / Cold, 77, 79, 94, 125
Wijers, Louwrien, 116–117, 123, 135, 141, 142–143, 146
Wilke, Hannah, 140
Winters, Robin, 117, 187–188
Witnessing, 169, 171, 178
Workrelation, 142–143

Yesiltac, Viola, **288**, 289

Zagreb, 27, 31, 49
 Abramović's post-diploma, 47–48, 51–52, 57
 Gotovac and, 42–43, 56
 Museum of Contemporary Art, ix, 69, 127
Zoutkeetsgracht, Amsterdam, 145–146, **147**, 151, 157, 171, 177, 179